A GUIDE FOR FILM MAKERS AND FILM TEACHERS

SECOND EDITION

KRIS MALKIEWICZ

Line drawings by Jim Fletcher

New York London

Sydney Toronto

Tokyo Singapore

Prentice Hall Press 15 Columbus Circle New York, New York 10023

Copyright © 1973, 1989 by Simon & Schuster Inc.

All rights reserved, including the right of reproduction in whole or in part in any form.

PRENTICE HALL PRESS and colophon are registered trademarks of Simon & Schuster Inc.

Library of Congress Cataloging in Publication Data

Malkiewicz, J. Kris. Cinematography.

Bibliography: p. Includes index. 1. Cinematography. I. Title. TR850.M276 1989 778.5'3 88-32371 ISBN 0-13-133687-8

Manufactured in the United States of America

10 9 8 7 6 5 4 3 2

Second Edition

ACKNOWLEDGMENTS

I wish to express my thanks to Bob Rogers, whose collaboration was fundamental in the realization of the first edition of this book. I would also like to thank several friends whose advice and encouragement contributed to the first edition—Brian Moore, Pat O'Neill, Haskell Wexler, Don Worthen, Frank Stokes, David Smith, Roy Findlon, and Milan Chupurdija.

I am deeply grateful for the help given to me by several generous people in the preparation of this second edition. My thanks go to Francisco Menendez for his editorial help and to Benjamin Bergery, Myron Emery, Grant Loucks, Larry Roberts, and Craig Smith for their expertise in the various areas of film making.

Finally, I am grateful to the manufacturers, suppliers, and laboratories that contributed photographs, charts, and information.

	PREFACE	ix
1	CAMERAS	1
2	FILMS AND SENSITOMETRY	50
3	FILTERS AND LIGHT	62
4	LIGHTING	79
5	PICTURE QUALITY CONTROL	127
6	SOUND RECORDING	132
7	CUTTING AND LAB WORK	141
8	THE BASICS OF OPTICAL PRINTING	170
9	VEHICLE AND UNDERWATER CINEMATOGRAPHY	181
10	PRODUCTION	185
11	VIDEO TRANSFER	191
	GLOSSARY	193
	BIBLIOGRAPHY	205
	INDEX	207

PREFACE

When a person is asked to explain something that he knows best in practical application, he often has to rethink the whole process and all the principles involved before he can communicate what he knows clearly and logically. I was fortunate enough to learn this basic fact of teaching before I attempted to write this book. I have taught film making, and my students' questions have both helped me learn how to teach the subject and forced me to clarify in my own mind many aspects of it. I hope that the reader, who cannot just raise his hand if he is puzzled, will benefit from this.

.............................

.............

One difficulty in teaching cinematography is that whenever the teacher explains one technical aspect, there seems to be a need to explain many others as well. I have tried to avoid too many digressions. This book concentrates on the work of the cinematographer —the man behind the camera or in charge of the shooting. It does touch briefly on techniques of sound recording, cutting, and production logistics, because some knowledge in these areas is necessary for the serious cameraman, especially in view of the increasing trend toward personal film making, where a single creative individual performs the multiple functions of a film crew. Equipment miniaturization makes oneman film making more and more practical, opening the door to an era of "auteurs" in the true sense. But this is a technical book, and therefore it does not venture into film directing.

Nevertheless, I cordially invite film makers who direct their own films but know little of camera techniques to read it, if for no other reason than to make the lives of their cameramen much easier. In the quest for more innovative, experimental techniques, it is extremely useful to know the existing principles before one tries to break them. The only really important outcome of film making is what happens in the heads of the audience. That is what counts. But the long and painstaking route to the audience leads through the lens and film in a camera. This book will try to help you take that route and record your creative vision with fewer frustrating disappointments and more competency and joy.

CAMERAS

..........

The cinematographer's most basic tool is the motionpicture camera. This piece of precision machinery comprises scores of coordinated functions, each of which demands understanding and care if the camera is to produce the best and most consistent results. The beginning cameraman's goal should be to become thoroughly familiar and comfortable with the camera's operation, so that he can concentrate on the more creative aspects of cinematography.

This chapter must cover many isolated bits of practical information. However, once the reader has become familiar with camera operation he will be able to move on to the substance of the cinematographer's craft in subsequent chapters. In the meantime the reader is well advised to try to absorb each operationoriented detail presented in this chapter, because operating a camera is *all* details. If any detail is neglected, the quality of the work can be impaired.

PRINCIPLE OF INTERMITTENT MOVEMENT

The film movement mechanism is what really distinguishes a cinema camera from a still camera. The illusion of image motion is created by a rapid succession of still photographs. To arrest every frame for the time of exposure, the principle of an intermittent mechanism was borrowed from clocks and sewing machines. Almost all general purpose motion-picture cameras employ the intermittent principle.

Intermittent mechanisms vary in design. All have a pull-down claw and pressure plate. Some have a registration pin as well. The pull-down claw engages the film perforation and moves the film down one frame. It then disengages and goes back up to pull down the next frame. While the claw is disengaged, the pressure plate holds the film steady for the period of exposure. Some cameras have a registration pin that enters the film perforation for extra steadiness while the exposure is made.

Whatever mechanism is employed requires the best materials and machining possible, which is one reason why good cameras are expensive. The film gate (the part of the camera where the pressure plate, pull-down claw, and registration pin engage the film) needs a good deal of attention when cleaning and threading. The film gate is never too clean. This is the area where the exposure takes place, so any particles of dirt or hair will show on the exposed film and perhaps scratch it. In addition to miscellaneous debris such as sand, hair, and dust, sometimes a small amount of emulsion comes off the passing film and collects in the gate. It must be removed. This point is essential. On feature films, some assistant cameramen clean the gate after every shot. They know that one grain of sand or bit of emulsion can ruin a day's work.

The gate should first be cleaned with a rubber-bulb syringe to blow foreign particles away. (Many cameramen use compressed air supplied in cans; the cans must be used in an upright position or they will spray a gluey substance into the camera.) An orangewood stick, available wherever cosmetics are sold, can then be used to remove any sticky emulsion buildup. The gate and pressure plate should also be wiped with a clean chamois or cotton cloth—never with linen. Never use metal tools for cleaning the gate, or for that matter for cleaning any part of the film movement mechanism, because these may cause abrasions that in turn will scratch the passing film.

The gate should be cleaned every time the camera is reloaded. At the same time the surrounding camera interior and magazine should also be cleaned to ensure that no dirt will find its way to the gate while the camera is running.

The intermittent movement requires the film to be slack so that as it alternately stops and jerks ahead in one-frame advances there will be no strain on it. Therefore, one or two sprocket rollers are provided to maintain two loops, one before and one after the gate. In some cameras (such as the Bolex and Canon Scoopic) a self-threading mechanism forms the loops automatically. In Super-8 cassettes and cartridges the loops are already formed by the manufacturer. On manually threaded cameras the film path showing loop size is usually marked.

Too small a loop will not absorb the jerks of the intermittent movement, resulting in picture unsteadiness, scratched film, broken perforations, and possibly a camera jam. An oversize loop may vibrate against the camera interior and also cause an unsteady picture and scratched film. Either too large or too small a loop will also contribute to camera noise.

Camera Speeds

The speed at which the intermittent movement advances the film is expressed in frames per second (fps). To reproduce movement on the screen faithfully, the film must be projected at the *same* speed as it was shot. Standard shooting and projection speed for 16mm and 35mm is 24 fps; standard speeds for 8mm and Super-8 are 24 fps for sound and 18 fps for silent.

If both the camera and the projector are run at the *same* speeds, say 24 fps, then the action will be faithfully reproduced. However, if the camera runs *slower*

than the projector, the action will appear to move *faster* on the screen than it did in real life. For example, an action takes place in four seconds (real time) and it is photographed at 12 fps. That means that the four seconds of action is recorded over forty-eight frames. If it is now projected at standard sound speed of 24 fps, it will take only two seconds to project. Therefore, the action that took four seconds in real life is sped up to two seconds on the screen because the camera ran slower than the projector.

The opposite is also true. If the camera runs *faster* than the projector, the action will be slowed down in projection. So to obtain slow motion, speed the camera up; to obtain fast motion, slow the camera down.

This variable speed principle has several applications. Time lapse photography can compress time and make very slow movement visible, such as the growth of a flower or the movement of clouds across the sky. Photographing slow-moving clouds at a rate of, say, one frame every three seconds will make them appear to be rushing through the screen when the film is projected at 24 frames per second. On the other hand, movements filmed at 36 fps or faster acquire a slow, dreamy quality at 24 fps on the screen. Such effects can be used to create a mood or analyze a movement. A very practical use of slow motion is to smooth out a jerky camera movement such as a rough traveling shot. The jolts are less prominent in slow motion.

To protect the intermittent movement, never run the camera at high speeds when it is not loaded.

SHUTTER

A change in camera speed will cause a change in shutter speed.

In most cameras the shutter consists of a rotating disk with a 180° cutout. As the disk rotates it covers the aperture while the film advances into position. Rotating further, the cutout portion allows the frame to be exposed and then covers it again for the next pull-down. The shutter rotates constantly, and therefore the film is exposed half the time and covered the other half. So when the camera is running at 24 fps, the actual period of exposure for each frame is 1/48 of a second (half of 1/24). Varying the speed of the camera also changes the exposure time. For example, by *slowing* the movement to half, or 12 fps, we *increase* the exposure period for each frame to 1/24 of a second. Similarly, by *speeding up* the movement to double the normal 24 fps to 48 fps, we *reduce* the exposure period

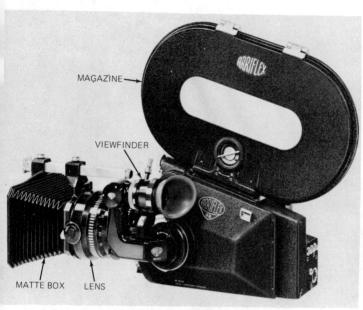

1.1 Arriflex 16 BL camera. (Courtesy of Arnold & Richter)

APERTURE

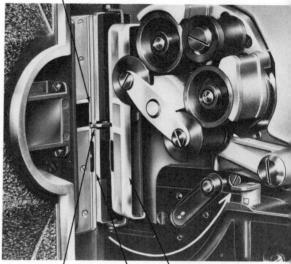

REGISTRATION PIN PRESSURE PLATE PULLDOWN CLAW **1.2** Arriflex camera gate. (Courtesy of Arnold & Richter)

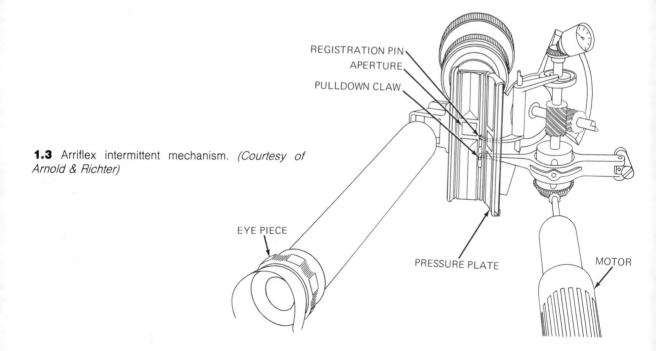

CINEMATOGRAPHY

to $\frac{1}{96}$ of a second. Knowing these relationships, we can adjust the f-stop to compensate for the change in exposure time when filming fast or slow motion.

A change in the speed of film movement can be useful when filming at low light levels. For example, suppose you are filming a cityscape at dusk and there is not enough light. By reducing your speed to 12 fps, you can double the exposure period for each frame, giving you an extra stop of light that may save your shot. Of course, this technique would be unacceptable if there were any pedestrians or moving cars in view; they would be unnaturally sped up when the film was projected.

Some cameras are equipped with a variable shutter. By varying the angle of the cutout we can regulate the exposure. For example, a 90° shutter opening transmits half as much light as a 180° opening. Some amateurs who do not intend to have prints made make fade-outs and fade-ins on their original film by using the variable shutter. Professionals have all such effects done in the lab.

Shutter movement is directly responsible for the stroboscopic effect. Take the example of the spokes of a turning wheel. Our intermittent exposures may

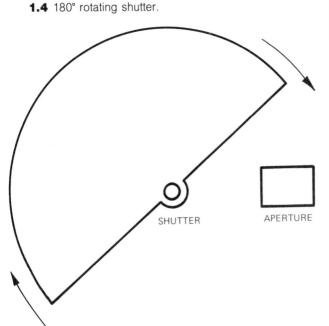

1.5 Eclair NPR adjustable shutter. Notice the calibrations visible through the empty lens socket. *(Courtesy of Eclair International)*

catch each *succeeding* spoke in the same place in the frame, making the spinning wheel appear to be motionless. Another variation, called skipping, results from movement past parallel lines or objects such as the railings of a fence. They may appear to be vibrating. These effects will increase with faster movement and with a narrower shutter angle.

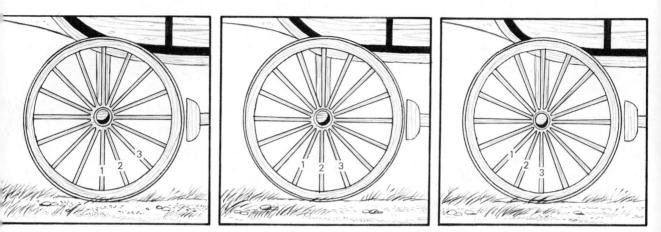

1.6 Stroboscopic effect.

VIEWING SYSTEMS

In many cameras (like the Arriflex and Eclair) the shutter performs a vital role in the viewing system. The front of the shutter has a mirror surface that reflects the image into the viewfinder when the shutter is closed. The great advantage of this system is that *all* the light goes alternately to the film and to the cameraman's eye, providing the brightest image possible. The surface of the mirror shutter should be cleaned only with an air syringe or other source of compressed air; nothing should be allowed to touch it.

Other systems (like the Bolex Reflex) use a prism between the lens and the shutter so that a certain percentage of the light is constantly diverted to the viewfinder. The disadvantage of this system is that it reduces the amount of light going both to the viewfinder and to the film, since the beam is split. An exposure compensation is required to allow for the light "stolen" from the film by the viewing system. It is usually very slight. For example, in the Bolex Rex-5 the loss is about a third of a stop. You should consult the operator's manual for the specific camera to learn the exact compensation.

The viewing systems discussed so far allow the cameraman to look through the taking lens. Many cameras of older design do not have this "reflexive" viewing system. As a result the camera may not see exactly what the viewfinder sees. Referred to as "parallax," this is especially a problem in close-ups or with telephoto lenses. However, most nonreflex cameras have an adjustment that can partly correct parallax.

MOTORS

The film transport mechanism, the shutter, and other moving camera parts are operated by the motor. There are two basic types of motors, spring-wound and electric. Spring-wound cameras run approximately twenty to forty feet of film per wind. The advantages include a compact design and reliable performance under difficult conditions such as cold weather.

Electric motors are available in a variety of designs. The four types that are generally used are (1) variable speed (wild), (2) interlocked, (3) stop frame (time lapse), and (4) synchronous (constant speed), which are the most commonly used. Variable speed motors have an adjustable speed control that may range from 2 to 64 fps or more. (Above 64 fps are considered high-speed motors.) The interlocked motor synchronizes the camera with other devices, such as back or front projectors. The stop frame or time lapse motor is usually connected with an intervalometer to allow the setting up of whatever exposure intervals are needed for time lapse photography (such as filming the growth of plants).

The most advanced type of synchronous or constant speed motor is designed with a crystal control to regulate the speed with extreme precision. When the camera motor and the tape recorder are both equipped with crystal controls, you can film "in sync" with no cables connecting the camera to the recorder. Furthermore, several crystal control cameras can be held in sync to one or more crystal recorders, allowing for multicamera coverage with no cables to restrict the

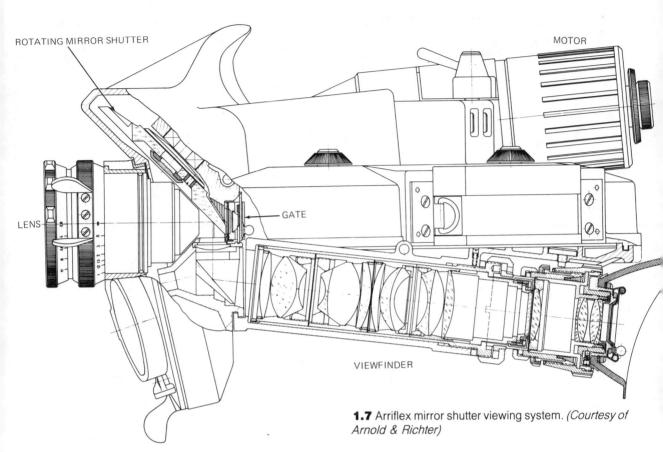

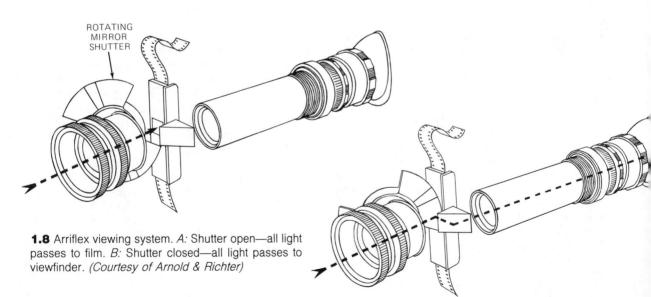

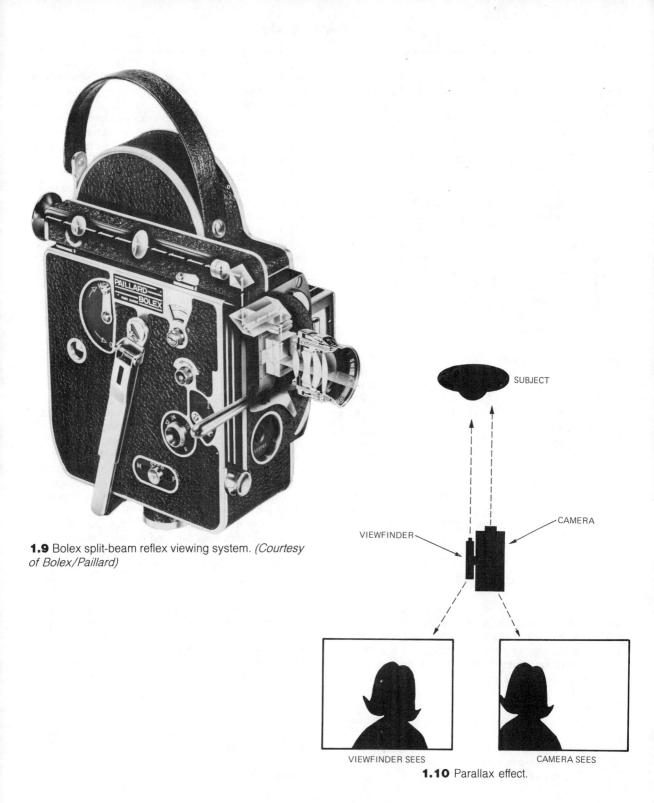

8

distances between them. Some crystal control motors even combine several functions, allowing the operator to change from constant speed crystal sync to variable speed or single frame at the touch of a switch.

BATTERIES.

Most 16mm camera motors operate on DC current supplied by batteries. Nickel-cadmium (NiCad) batteries are the most technologically advanced and therefore the most widely used. Their life expectancy varies, depending on the conditions of use and maintenance, but on the average about five hundred cycles of recharging and discharging should be expected.

There are slow "overnight" chargers that require fourteen to sixteen hours, quick chargers that will charge batteries in one-half of this time, and truly fast chargers that can do the job in one hour.

It is essential to familiarize oneself with the charger on hand. Many chargers will damage a battery when left on charge for longer time than required.

It is advisable to have at least four charged batteries on hand so that they can be rotated with enough time for slow charging. Only high-quality fast chargers should be used, such as the Anton-Bauer LifesaverTM Quick Chargers and Fast Chargers.

The battery belt, consisting of built-in nickel-cadmium cells, is a most convenient power source for portable 16mm and 35mm cameras. All Super-8 cameras house the battery in the camera body, doing away with the cable connecting the battery as a separate unit. This logical trend is rapidly expanding into 16mm designs.

MAGAZINES

Most of the smaller 16mm cameras will house up to 100-foot loads (on daylight spools) inside the camera body. The larger 16mm cameras are usually equipped with film magazines ranging in a capacity from 200 to 1,200 feet. Having several magazines allows for a more efficient production, particularly when more than one type of film stock is used on a given day. The camera assistant loads several magazines in advance so that the magazine change will slow down the production minimally.

Remember, when considering magazines, the two decisive factors are capacity and design. The shape and placement of the magazine is sometimes important too. For most shooting situations it doesn't matter, but when you are shooting in cramped quarters, such as from the cockpit of a plane or from under a car, the bulkiness of the camera can make a difference. Here a cameraman may want a camera with magazines that are smaller or that mount to the back or bottom of the camera rather than the top.

At one time all magazines had to be loaded in total darkness. Today, loads of 200 and 400 feet are available on daylight spools that require only subdued light when loading. Film not on daylight reels necessitates either a darkroom or a changing bag. The changing bag must be of adequate size and absolutely light-tight. It should be stored in a special case or cover to keep it spotlessly clean and dust free. (Don't let your dog sleep on it.) Any hairs, dirt, or dust in the changing bag can easily enter the magazine being loaded and from there travel to the gate.

Before loading an unfamiliar magazine, practice loading it with a roll of waste film that you don't want, first in the light and then in the dark, to simulate the loading of unexposed stock.

Some magazines have their own take-up motors to wind up the film as it reenters the magazine after passing through the camera. Such motors should be tested with a waste roll before the magazine is loaded with unexposed film. Run this test with the battery to be used in filming. This test is advisable because a battery may sometimes have enough charge to run a camera with a 100-foot internal load or an empty magazine but then fail to operate the magazine and camera when it is loaded.

Also, before loading clean the magazine with compressed air, camera brush, and a piece of sticky paper in order to remove dust, film chips, or hair, and make sure that the rollers are moving freely. (Never wear a fuzzy or hairy sweater when cleaning camera equipment or in the darkroom.)

After loading the magazine it is advisable to seal the lid with black camera tape. This is partly to prevent light leakage on old magazines, but mainly to prevent an accidental opening. When you are loading magazines in a hurry, it is easy to confuse loaded ones and unloaded ones. Taping the loaded magazines immediately after loading will save you the annoyance of opening a supposedly empty magazine and ruining a roll of film.

It is also customary to stick a white 1-inch tape on the side of a magazine with information such as the number of the magazine, the type of film stock, the length of the roll and its number, whether it is day or

9

night effect, and the name of the camera assistant. This will help in the preparation of a camera report to accompany the film to the lab.

In spite of the greatest care in cleaning and loading, even the finest camera designs will occasionally jam. The film will stop advancing somewhere along its path and the oncoming film will continue to pile up at that point, creating a "salad" of twisted and folded film. If the camera jams, remove the film from the camera interior, checking carefully to see that chips of broken film are not stuck in the gate, around the registration pin, or anywhere else. Remove the magazine to a darkroom or put it in a changing bag. You will need a spare take-up core or spool (whichever you already have in the camera) and a can with a black paper bag to unload the exposed film and rethread the magazine.

Never spool up any film with broken sprocket holes. It may jam in the processing machine in the lab and ruin a considerable amount of footage, not only yours but other customers' as well. If you suspect any damage inside your roll of film, write a warning clearly on the can to alert the lab technicians.

One simple procedure that helps prevent camera jams is to make sure there is no slack between the take-up roll and the sprocket roller. If there is, when the camera starts the take-up motor may snap the film taut, breaking it or causing the camera to "lose its loop" and become improperly threaded. There is usually some way of rotating the take-up roll to make it taut before you start to shoot.

Whenever unloading a magazine, be sure to leave the center piece (on which the film core sits) on the spindle where it belongs, and do not send it to the lab with your film. This is very important. If you send this costly little center piece to the lab, you will have trouble trying to reload the magazine without it.

Super-8 film comes in cartridges and cassettes. Not much can be done if a cassette jams, but you can prevent jamming to a great extent by making sure the cassette fits easily into the camera.

LENSES

Beginners in film making are quite often confused by the various aspects of camera lenses. They are intimidated by the mathematical formulas that appear in many photography books whenever lenses are under discussion. But today the film maker's life is easier. Readily available tables provide all the information that previously required mathematical computation. Common sense is all you need to understand lenses.

The basic function of a lens can be explained as a pinhole phenomenon. If you removed the lens from your camera and replaced it with a piece of black cardboard with a pinhole in it, you could take a picture, provided the exposure time was long enough. The picture on film would be upside down and the sides would be reversed. This is the first thing one should know about lenses: they produce images that are reversed both vertically and horizontally. The advantage of the lens over the pinhole is that where a pinhole allows only a very small amount of light to reach the film, the lens collects more light and projects it onto the film. In this way shorter exposure and better pictures are achieved.

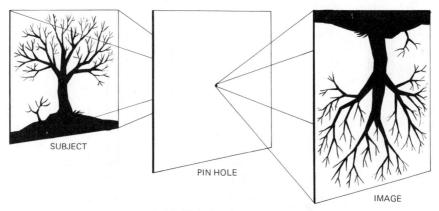

1.11 Pinhole phenomenon.

F-stops

The maximum amount of light a lens is capable of transmitting depends on the diameter of the lens and the focal length. By focal length we mean the distance from the optical center of the lens to the film plane when the lens is focused at infinity. The focal length divided by the diameter of the lens gives us a measure of the maximum aperture. It's quite simple. For example, a lens 1 inch in diameter with a focal length of 2 inches will pass the same amount of light as a lens 3 inches in diameter with a 6-inch focal length, because the maximum aperture, or f-stop, for both lenses is f/2 ($2 \div 1 = 2$; and $6 \div 3 = 2$ also).

We can reduce the amount of light by means of an iris placed in the lens. By closing the iris we reduce the effective diameter of the lens, thus reducing the amount of light passing through the lens. Now the f-stop equals the focal length divided by the *new* diameter created by the iris. Therefore, if a 2-inch-focal-length lens has an iris adjusted to a $\frac{1}{8}$ -inch opening, the f-stop is f/16, because $2 \div \frac{1}{8} = 16$. A 4-inch lens with a $\frac{1}{4}$ -inch iris opening would also be f/16, because $4 \div \frac{1}{4} = 16$.

So the f-stop calibration is not a measure of the mere iris opening but instead expresses the relationship between focal length and iris.

It is important to note that the smaller the iris opening is, the more times it can be divided into the focal length. Therefore, as the iris opening becomes smaller, the f-stop number becomes higher. So a lower f-stop number means more light and a higher f-stop number means less light.

F-stops are calibrated on the lens. They are commonly 1, 1.4, 2, 2.8, 4, 5.6, 8, 11, 16, and 22. *Each higher f-stop cuts the light by exactly half.* For example, f/11 allows half as much light as f/8. Conversely, f/8 allows twice as much light as f/11. If the difference is more than one stop, remember that the light doubles between each stop. So f/4 will yield 8 times as much light as f/11, because f/8 is twice f/11, f/5.6 is twice f/8, and f/4 is twice f/5.6. Therefore, f/4 is 8 times more light as f/11 because $2 \times 2 \times 2 = 8$. It doubles with each step.

Lens Speed

The lowest (widest) f-stop setting will vary between lenses, depending on their focal lengths and diameters. For example, one lens may start at f/1.9 and another at f/3.5. (Often, as in these cases, the starting number is in between the usual calibrations.) "Lens speed" refers to the widest setting (lowest f-stop) a lens is capable of. For example, a lens that opens to 1.9 is a relatively fast lens, and one that opens only as far as 3.5 is a relatively slow lens. Because telephoto lenses are longer, their diameter will usually divide several times into their focal length, making their lowest

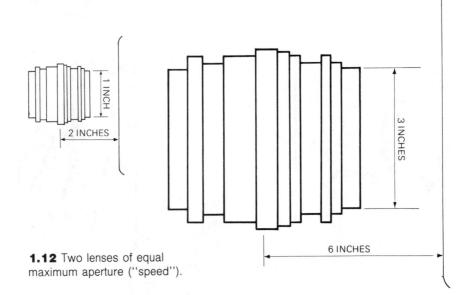

f-stop high. Therefore, telephoto lenses tend to be slow, while wide-angle lenses tend to be fast.

T-stops

Some lenses have T-stops as well as f-stops. The two are almost equivalent. T-stops are more precise because they are calibrated for the individual lens. The lenses are individually tested with a light meter to determine how much light is transmitted at various settings, and the T-stops are marked on the barrel of the lens. F-stops, on the other hand, are determined by the mathematical formula and are not calculated for the individual lens. Therefore we should consider Tstops as very accurate f-stops. When calculating the exposure or consulting the tables, f-stops and T-stops can be considered equivalent.

Focusing

Apart from f-stops, nearly every lens has a calibrated ring representing focusing distances. The exceptions are some wide-angle lenses, such as 10mm and shorter, that have a "fixed focus"—that is, there is no need to adjust focus. With a well-adjusted reflex viewing system we can focus quickly and accurately by rotating the focus ring while looking through the lens. Another

1.13 Focal distances are measured from the subject to the film plane, sometimes indicated on the camera body by the mark ϕ .

method, used particularly in older cameras without reflexive viewing systems, is to measure the distance between the subject and film plane (marked on the camera by the symbol ϕ) and set the focus ring accordingly.

The settings achieved by focusing through a reflexive viewing system and by measuring and turning the focus ring may not agree. This may be due to a slight inaccuracy in the focus ring adjustment. In such cases, *if the viewing system is accurate,* one should depend on it rather than on the focusing calibrations.

DEPTH OF FIELD AND CIRCLE OF CONFUSION

If we were to photograph only one distant point, such as a light, the lens would be in focus when it projects a point onto the film.

Because the lens can be focused for only one distance at a time, objects closer and farther away will be slightly out of focus. In figure 1.14 a second, closer light would have its image formed behind the film plane and be represented on the film as a circle. A third light, farther away, would form its image in front of the film plane and also appear on the film as a circle. These circles are called "circles of confusion," and they vary in size depending on how far out of focus they are. The "confusion" is that circles smaller than 1/1000 inch confuse our eye and are seen as points in focus. This allows us to see pictures of three-dimensional objects that appear in focus.

We have a range in which objects will appear sharp. It runs between the closest and farthest objects represented as circles of confusion smaller than 1/1000 inch. This range is called "depth of field" (and is sometimes incorrectly called "depth of focus").

The depth of field varies with the effective diameter of the lens opening and hence with the f-stop. By "effective diameter" we mean the actual size of the iris opening, not the f-stop number. If you want to change lenses without changing the depth of field, you must use the same iris opening, which will be a different f-stop. For example, an 8-inch lens shooting at f/4 has a 2-inch-diameter iris opening. If you now want to change to a 4-inch lens and retain the same depth of field, you must shoot with the same 2-inch-diameter iris, which for your 4-inch lens is f/2. This is a rare problem, and if it ever comes up, consult a depth-offield chart. The example is offered here to illustrate that depth of field is dependent on the iris opening.

12 CINEMATOGRAPHY

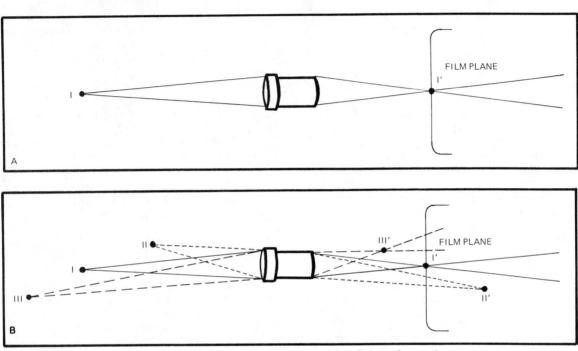

1.14 *A*: One point focused on the film plane. *B*: Lens focused on point I. Points II and III will appear out of focus.

This chart shows the general principles that govern depth of field:

Less Depth of Field			
Telephoto lenses			
Low f-stop (wide aperture)			
Subject close to camera			
Larger format (such as 35mm)			

With greater depth of field more elements in the picture are in sharp focus. This causes the image to appear harder and of higher contrast. Therefore, using a higher f-stop number introduces apparently higher contrast. See figure 1.16.

Depth-of-field characteristics for lenses of various focal lengths under different conditions are available in many publications, such as the *American Cinematographer Manual*. Given the focal length and f-stop and the subject-to-film-plane distance, we can determine the range of the depth of field and the dimensions of the field of view at that distance.

For each lens and f-stop the chart also gives the hyperfocal distance. This is the point of greatest depth of field. It is a precalculated figure indicating that if the given lens at the given f-stop is focused at this hyperfocal distance, everything from half this distance to infinity will be in acceptable focus. For example, if for a given lens and f-stop the hyperfocal distance is twenty feet, by focusing at twenty feet we would obtain everything in focus from ten feet to infinity.

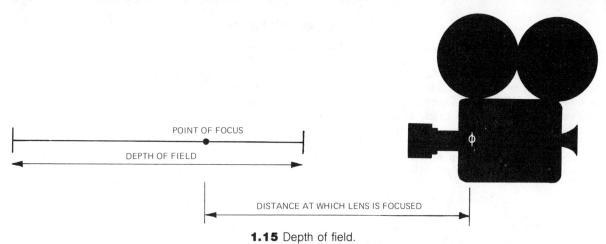

1.16 Information obtained from the depth-of-field chart.

LENS FOCAL LENGTH: 25mm (Field of View is based on FULL 16mm Aperture: .402" x .292")										
Hyperfocal Dist.	36'8''	28'10''	20'2"	14'5''	10'1"	7'4''	5'0''	3'8''		
de la construcción de la	f/2	f/2.8	f/4	f/5.6	f/8	f/11	f/16	f/22		
LENS FOCUS (FEET)	NEAR FAR	NEAR FAR	NEAR FAR	NEAR FAR	NEAR FAR	NEAR FAR	NEAR FAR	NEAR FAR	FIELD OF VIEW	
50	22'9'' INF.	19'6'' INF.	15'1'' INF.	11'8'' INF.	8'8'' INF.	6'6'' INF.	4'8'' INF.	3'6" INF.	14'2"x18'9'	
25	16'6'' 161'	14'9'' INF.	12'1'' INF.	9'9'' INF.	7'7'' INF.	5'11" INF.	4'4'' INF.	3'3" INF.	7'1"x9'5"	
15	10'8'' 25'2''	9'11'' 30'11''	8'8'' 56'9''	7′5″ INF.	6'1'' INF.	5'0'' INF.	3'10" INF.	3'0" INF.	4'3"x5'8"	
10	8'0'' 13'8''	7′5″ 15′2″	6′9′′ 19′6′′	5'11'' 31'6''	5'1'' INF.	4'3'' INF.	3'5'' INF.	2'8'' INF.	2'10"x3'9"	
8	6'7'' 10'2''	6'3'' 11'0''	5′9′′ 13′1′′	5'2'' 17'6''	4'6'' 35'10''	3'10'' INF.	3'2'' INF.	2'6'' INF.	2'3"x3'0"	
6	5'2'' 7'2''	5'0'' 7'6''	4′8′′ 8′5′′	4'3'' 10'1''	3'10'' 14'3''	3'4'' 29'4''	2'9'' INF.	2'4'' INF.	1'6"x2'0"	
5	4′5″ 5′9″	4'3'' 6'0''	4'0'' 6'7''	3'9'' 7'6''	3'4'' 9'7''	3′0′′ 14′8′′	2'7" INF.	2'2'' INF.	1'5"x1'10"	
4	3'7'' 4'5''	3'6'' 4'7''	3'4'' 4'11''	3'2'' 5'5''	2'11'' 6'5''	2'8'' 8'5''	2'3'' 16'9''	1'11" INF.	1'1"x1'6"	
3	2'10'' 3'2''	2'9'' 3'4''	2′8′′ 3′6′′	2'6'' 3'9''	2'4'' 4'2''	2′2″ 5′0″	1'11'' 7'1''	1'9'' 8'2''	9"x12"	
2	1'11'' 2'1''	1'11'' 2'2''	1'10'' 2'3''	1'9'' 2'4''	1'8'' 2'6''	1'7" 2'9"	1'5'' 3'3''	1'3'' 3'10''	6"x8"	

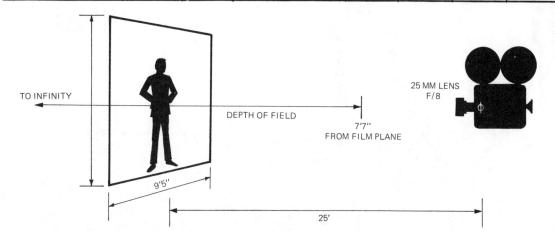

A similar principle is valuable when "splitting the focus" between two objects at different distances. They will both be equally sharp if we focus for a point not halfway between them but a third of the separation distance from the closer object. For example, two objects at ten and sixteen feet respectively would both be equally in focus if you focus for twelve feet. This is often referred to as the one-third-distance principle.

Optimal Range

Every lens has an optimal range of f-stops that yield the sharpest image. This usually starts about two stops from the widest opening and runs to about f/11. Below and above this range the lens will tend to produce slightly less sharp images. Stopping down extends the depth of field, but beyond f/11 or f/16 it also decreases the maximum resolution, thereby canceling out the increase in sharpness. This is especially true of wideangle lenses. Most professionals when shooting indoors like to set the f-stop somewhere in the optimal range (for example, f/4) and then adjust the light levels for the proper exposure.

Zoom Lenses

The cinematographer uses a variety of focal lengths. Older camera designs accommodate three or four lenses on a rotating plate called a turret, which allows for quick changing between lenses. In newer cameras the turret is giving way to a one-lens design, the varifocal lens or zoom lens. It contains not only the primary focal length but all the in-betweens as well as the zoom effect.

The first thing to be considered when describing a zoom lens is its range—for example, 12 to 120mm. We can also express it as a ratio, in this case one to ten (1:10).

The Angenieux 12 to 120mm achieved great popularity in the 16mm film industry. A 10mm lens became its customary companion. Newer zoom lenses like the Angenieux 9.5 to 95mm or the Zeiss Vario Sonnar 10 to 100mm represent a better choice to many cameramen, who are willing to sacrifice the telephoto end of the range in order to increase the wide-angle end. For Super-8 cameras the Schneider Variogon 7 to 68mm and the Angenieux 8 to 64mm are good choices.

Zooming smoothly is an art. There are many mechanical aids available. Zoom lenses come with either zoom levers or cranks or both. For smoother movement a lever can be extended, for example by taping a pencil to it. For very smooth zooming, several types of battery powered motors are available with variable speed controls. One type is operated by two buttons (in and out) with speed controlled by a dial. Another type features a "joy stick." The latter is preferable because the speed of zooming and the direction (in or out) are controlled by the one stick, depending on which way and how hard you push it. Other combinations are available.

Some cameramen prefer to zoom by turning the zoom ring with a full grip. If you use this method you must be careful not to move other rings on the lens, such as the f-stop and focus.

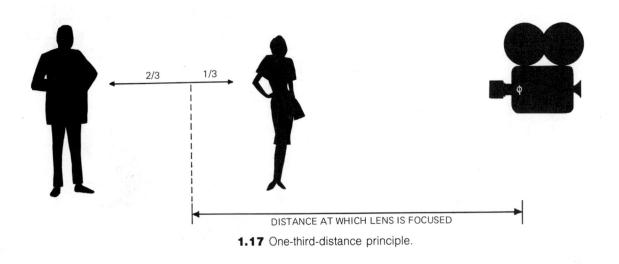

While zooming in or out, a very slight horizontal panning movement may be needed to keep the subject centered. This is due to a "fault," called side-drift effect, that is inherent to most zoom-lens designs. Some lenses, like the Zeiss 1:10, are free of side-drift effect.

All zoom lenses require the same focusing procedure: you open the aperture fully, zoom all the way in on the subject, and closely examine the sharpness. After focusing, it is easy to forget to return the f-stop to its proper setting. This is a very common mistake among beginners.

Generally, zoom lenses do not focus closer than a few feet. For example, the Angenieux 12 to 120 will only focus as close as about five feet away. The exceptions are the "macro-zoom" lenses, such as the Canon Macro Zoom Lens Fluorite (12 to 120mm; f/2.2), or for Super-8 film, the Bolex 160 Macro-zoom (8.5 to 30mm; f/1.9).

For all practical purposes, the modern zoom lenses, when stopped between f/4 and f/16, are as optically perfect as primary lenses.

Optical Attachments and Close-up Work

For close-up work, "macro" lenses focus as close as a few centimeters away without the use of special attachments. Using macro lenses we can fill the screen with a cigarette pack. (In England they're called "pack" lenses.)

Regular lenses will require one of several types of attachments in order to focus closely.

Extension tubes or bellows can be used to focus practically as close as the front element of the lens. They are introduced between the lens and camera body. But because extension tubes and bellows upset the normal optics, they cannot be used with optically complicated lenses, including all zooms and many wide-angle lenses. When the subject is closer than ten times the focal length of the lens, an exposure compensation is required and depends on the rate of extension. The correction can be found in tables supplied with the devices or in the *American Cinematographer Manual.*

A third way of dealing with this problem is through the use of close-up attachments called diopters. These are like small one-element lenses that attach to the front of the lens in use. Their convex side faces the subject. The small arrow on the rim should point away from the camera. Diopters come in series (+1, +2,and +3, etc.). Each higher number allows for closer focusing. When diopters are combined, the higher number should be closest to the camera. No exposure compensation is required. Compared to extension tubes or bellows, diopters are the least satisfactory as far as optical quality. Yet unlike extension tubes or bellows, diopters can be used on zoom and wide-angle lenses.

A split-field diopter covers only half the lens, enabling the camera to be focused very close and far away simultaneously. It is frequently used in commercials, where, for example, the soap package may be in the foreground with a housewife using it in the background. The one drawback is that the "soft" line at the split of the diopter must be hidden by lighting and composition. Also, zooming becomes difficult and panning impossible.

There are other optical attachments in current use. The magnification of a telephoto or zoom lens can be increased with a telephoto extender. For example, a 200mm lens may be made into a 400mm. Such attachments require two stops additional exposure each time the focal length is doubled. When a telephoto extender is used, the best resolution is usually obtained when the lens is stopped down (around f/11). The usual focal lengths of some zooms can also be shortened by retro-focus wide-angle attachments, and these do not require an exposure compensation. However, cameramen usually do not like either telephoto extenders or retro-focus attachments, as they soften the picture, decreasing the resolution.

Focal Lengths and Perspective

Perhaps the most important physical element related to creative lens use is perspective. A lens that is "normal" for a given film gauge will reproduce reality with perspective similar to that seen by our human eye. In the case of 16mm film, a 25mm lens is normal. In Super-8, a normal lens is about 12mm, and in 35mm film, a normal lens is 50mm.

Lenses shorter than normal for a given film gauge are considered wide-angle, and those two or more times longer are telephoto.

Picture perspective is frequently misunderstood; it depends on the camera-to-subject distance and not on the lens. From the same distance, three different lenses—wide, normal, and telephoto—change the area of view but do not change the perspective. By using the same three lenses and changing the distances to the subject, we can retain the same field of view but with different perspectives. 1.20

One can see from figures 1.18 to 1.25 that a wideangle lens exaggerates depth and a telephoto collapses it. For example, a person walking toward the camera will seem to approach faster with a wide-angle and slower with a telephoto. This is caused by the distance, not the lens. In a telephoto shot the person is almost always farther away than in a wide angle shot. When similarly framed, the person walking toward the telephoto may be twenty-five yards away, while the person moving toward the wide-angle lens is only five feet away. If the wide-angle approach is redone at twentyfive yards, the person (very small in the frame) will move just as slowly as with the telephoto. Therefore, remember that the degree of distortion is controlled by the distance, not the lens.

1.18–21 Long, medium, and wide-angle lenses used from the same position. Note that there is no change in perspective.

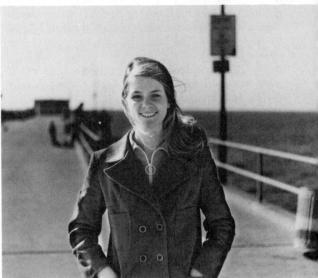

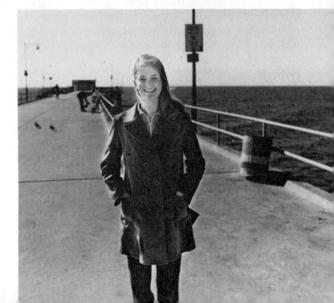

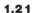

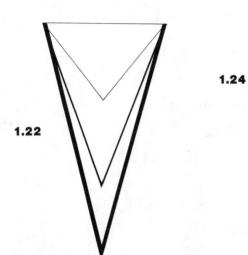

1.22–1.25 Long, medium, and wide-angle lenses used from different positions in order to obtain similar framing. Note that the perspective changes as the distance changes. Also, notice the depth of field diminishing with longer lenses. *(Photos by Bob Rogers)*

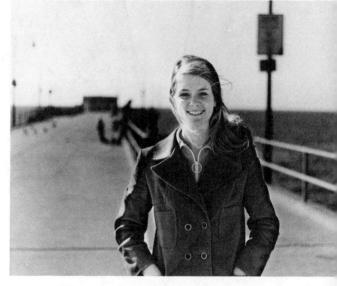

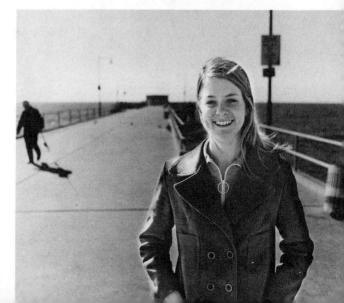

1.25

1.27

This is further illustrated in figures 1.26 to 1.33 by a comparison between the effects of zooming and dollying. When dollying, the spacial relationship between the subjects in the frame—that is, the perspective changes because the distances change. When zooming, the focal length is changing, yet the effect is like a gradual enlargement of one part of the frame without any change in perspective. For this reason a zoom effect has a flat look.

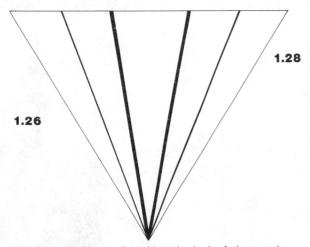

1.26–1.29 Zoom effect. Note the lack of changes in perspective.

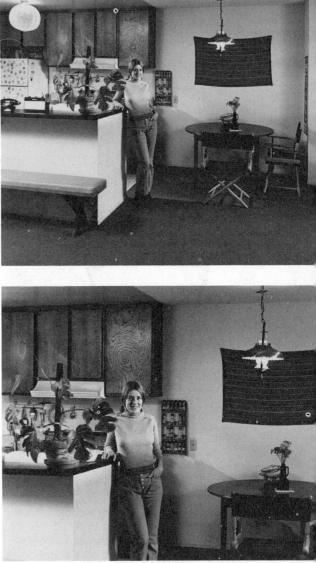

1.30–1.33 Dollying effect. Note visible changes in perspective. Because a wide-angle lens was used, the close-up was taken from a short distance, resulting in facial distortion. *(Photos by author)*

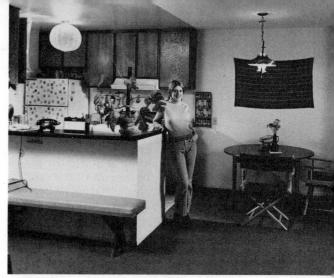

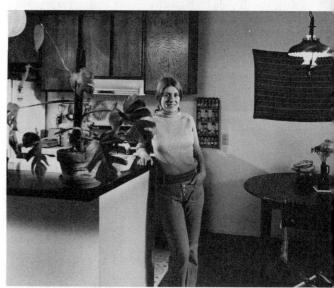

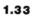

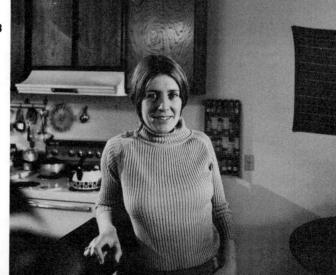

To make a zoom movement appear more threedimensional it can be combined with a slight camera movement up, down, in, out, or to one side. A panning movement also helps, in addition to zooming past or through a foreground such as a row of trees or a picket fence that goes out of the picture as you zoom in. Other times a flat effect may be desired. In this case the cameraman should make a point of avoiding foreground objects and keeping the camera rigidly framed while zooming, or he will accidentally diminish the flat effect.

Practical Lens Use

No lens will yield high-quality results unless it is given proper care and attention.

In all cameras, lens performance depends to a great extent on the viewing system. If prisms in this system are loose or the eyepiece is not adjusted to the operator's sight, even the most excellent lenses cannot be expected to give satisfactory results. The best way to adjust the eyepiece is to remove the lens, point the camera toward a uniformly bright area (sky. wall. etc.), and after loosening the eyepiece locking ring (if there is one), rotate the eyepiece adjustment until the grain of the ground glass or the engraved lines in the viewing system appear sharpest to the operator's eye. Then tighten the locking ring to keep this setting from drifting. In cameras with nonremovable lenses, adjust the evepiece while aiming at a distant object, focused at infinity and with the f-stop wide open. The eyepiece is designed so that cameramen who wear glasses can usually adjust it for their eyesight and shoot without glasses.

When using a reflexive viewing system, the eyepiece must be covered while the camera is running. Usually the cameraman is covering it with his eye while shooting, but if he should take his eye away during the shot, or if the camera is mounted for a shot without an operator (such as on the bumper of a racing car), the eyepiece must be covered or light will enter it while the camera is running, travel through the system, and fog the film, ruining the shot. This is very important. Many cameras have some provision for closing off the eyepiece. The Arri-S has a small door that swings shut across the eyepiece. The Bolex Rex has an internal door that blacks out the viewing system when the operator turns a knob on the side of the viewer near the front of the camera. Many operators when looking away only for a moment will slip their thumb in between eye and finder and then look away. A light ghostlike apparition and an overexposed effect on the film are possible signs of light entering the viewfinder.

A matte box is mounted in front of the lens to shade it from unwanted direct light. It is usually equipped with a filter holder. Alternatively, some wide-angle lenses and zooms use a lens shade that attaches directly to the front of the lens.

Follow-Focus

Most cameramen (or their assistants) have a hand on the focus adjustment all the time, ready to compensate for any subject movement. If the camera-to-subject distance changes during the shot, the operator, looking through the viewing system, will have to readjust the focus. This is called "following" or "pulling" focus. In more complex situations where the camera operator cannot pull focus himself, an assistant, called a focus puller, will do it for him, following the markings made on the floor during rehearsal. A combination of fast-moving actors and a dolly or hand-held camera can require a considerable amount of agility at times.

Lens Maintenance

You can clean a dirty lens, but there's not much you can do with a scratched one. So it is wise to clean lenses carefully.

A stream of clean air, such as from an air syringe, is by far the safest way of cleaning a lens. Remember that canned compressed air (from a photo shop) must be used in an upright position or it may spray a gluey substance onto the lens.

A very soft brush, such as one made of camel's hair, is second on the list. It must be used *only* for lens cleaning. Avoid touching its bristles, as fingers are naturally greasy. Your soft lens brush should not be used on the camera, gate, or magazines, because any brush sheds, and the fine, flexible hairs of a lens brush will "travel" in the camera and may be wound into moving parts. A brush for camera cleaning should have stiffer bristles that are less apt to be wound into the machinery.

When using a lens brush or air, always hold the lens facing downward so that the dust does not resettle on the lens. This helps when cleaning cameras and magazines too.

Fingerprints and other stains will have to be removed with a photographic lens tissue. (*Never* use a silicone-coated tissue such as those sold by optometrists for cleaning eyeglasses, because it may permanently discolor the lens coating.) Before using the lens tissue, moisten either the lens with your breath or the tissue with a special lens-cleaning solution. Use lenscleaning solution sparingly; too much may partly dissolve the cement holding the lens elements. Special solutions are available from camera shops, or you can use rubbing alcohol from a drugstore. Rubbing alcohol is not as good as special solution, because it contains menthol and other ingredients that will be left on the lens by the evaporating alcohol. One excellent way to use the lens tissue is to roll it like a cigarette, break it in half, and use the fuzzy end like a brush.

Lenses should be kept clean at all times, even when stored, because fingerprints and other stains left on the lens for long periods may become imbedded in the blue coating of the lens.

Lens Mounting

One of the most sensitive parts of a lens is its mounting. For proper optical alignment with the film, the lens must be precisely locked onto the camera. Much care must be taken to make sure this mounting is not wrenched out of alignment. Repairing such damage is expensive and time-consuming and may never restore perfect mounting.

Because zoom lenses and some wide-angle lenses are of retro-focal design—a complicated optical configuration—they are vulnerable to even the slightest mounting inaccuracy. A retro-focal design is desirable because it permits a larger physical lens size for more expedient handling, while retaining a short focal length. For example, a 5.7mm lens is usually about 4 inches long. If it was actually only 5.7 millimeters

1.34 Lens mounts. From left to right: Regular Arriflex, Arriflex Bayonet, Eclair, and C-mount.

1.35 The Arriflex S/B camera has one bayonet socket (about to receive bayonet-mount lens) and two regular Arriflex sockets, such as the one *at the upper right.* (*Courtesy of Arnold & Richter*)

long, it would be a very inconvenient size. In the case of zoom lenses, the increased size is necessary to accommodate the wide-angle end of the zoom range. (Retro-focal limitations prevent us from using extension tubes or bellows with zooms and some wideangles.)

If a zoom lens is imprecisely mounted it may not remain in focus when zooming in or out. Incorrectly mounted wide-angle lenses will simply not be in focus.

Most Super-8 and some 16mm cameras are now manufactured with a permanently mounted zoom lens. This restricts the cameraman in his choice of lenses but does mean the mounting is usually accurate.

Among 16mm cameras with changeable lenses, there are four common lens mounts. The C-mount is the smallest and therefore the least strong and most sensitive. The Arri mount is stronger and positively locks into the camera. The Arri bayonet is a subsequent improvement over the regular Arri mount; a bayonet lens attaches to the camera even more securely and accurately. The regular Arri lenses will fit into either the bayonet or the regular Arri lens sockets, but a bayonet lens requires a bayonet socket and will not fit into a regular Arri mount. A fourth type, an Eclair mount, twists snugly into the camera but without the audible click.

When buying a lens to be used on many cameras, a very good choice is the Arri mount. With an Arri-to-C-mount adapter, an Arri-mount lens can be used with any standard C-mount camera. The standard Eclair NPR camera usually has two mounts, one

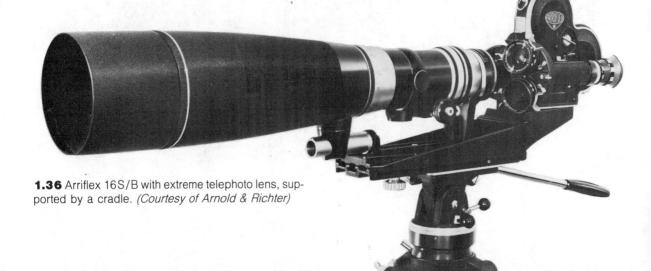

Eclair and one C, so the Arri lens with C adapter will also usually go onto the Eclair camera. Such a combination is the most versatile. However, when adapters are used the accuracy of the mounting is almost always at least slightly impaired. Therefore, whenever possible, zoom and wide-angle lenses should have the proper mount for the camera to be used.

Lens Supports

Long and heavy lenses, such as 250mm or more (especially in C-mount), should rest on a lens support to prevent their length and weight from wrenching the mount out of alignment. A support will also be required for the heavier zooms, such as the Angenieux 12 to 240mm, and also for some of the shorter zoom lenses when they have C-mounts.

The heavier, more sensitive lenses, such as zooms, must be stored in a case to prevent jarring the elements. If the zoom is to be stored mounted on the camera, then the case must firmly support the lens in order to avoid straining the mount.

CAMERA SUPPORTS

On the screen, any camera unsteadiness becomes very obvious because the picture is being magnified many hundreds of times. To control camera steadiness, many supporting devices and techniques have been developed. By choosing among them, the cameraman may pick the right equipment for his needs.

Tripods are the most commonly used supports. They come basically in four sizes: standard legs, sawed-off legs, baby legs, and "top hat" or "high hat." They also come in different degrees of sturdiness for cameras of different weights.

Leg lengths are adjustable, so the tripod can be leveled when set up on uneven ground. To tighten the leg length adjustment, always turn the top of the lock

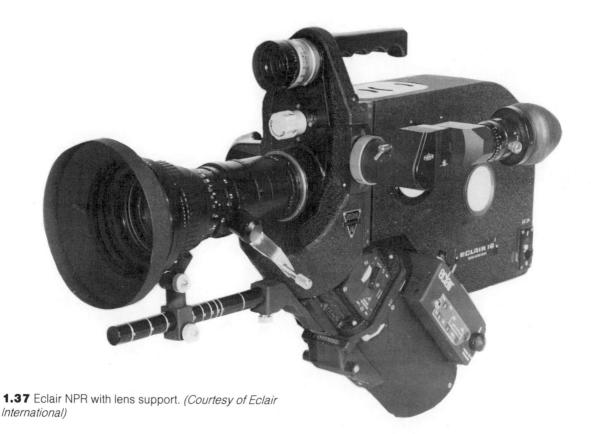

1.38 Eclair NPR with mounted zoom lens in padded case. (*Photo by author*)

to the outside. It can be incorrectly tightened by turning it the other way, but serious bending and disfiguration will damage the tripod. Furthermore, it will not be tight and may collapse, ruining the camera as well.

Some tripods are equipped with a ball-joint leveling device. This is very convenient and can save time by allowing the cameraman to level just the top of the tripod without having to adjust the legs perfectly. This device can be dangerous, however, if it is used carelessly. There is a tendency to level only the ball joint, leaving the tripod legs in a precarious imbalance. For safety, the legs must be almost level before the final adjustment is made with the ball joint.

1.39 Tripods: standard legs, sawed off legs, and baby legs. (*Courtesy of O'Connor Camera Support Systems*)

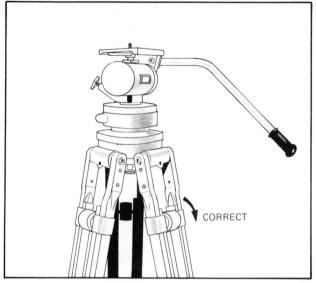

1.40 Correct direction for tightening tripod leg.

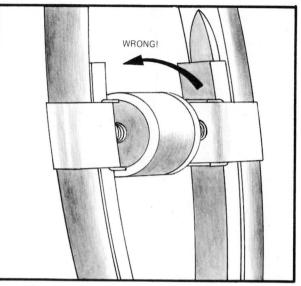

1.41 Incorrect way of tightening tripod leg.

1.42 Ball-joint leveling device. Position is exaggerated for purpose of demonstration.

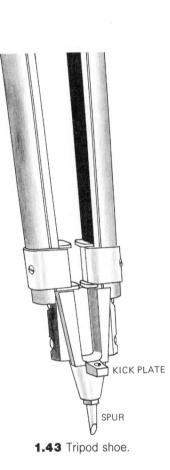

1.44 Spreader.

1.45 Tape used as a spreader.

The spreader is an essential part of the tripod equipment. It locks onto the "shoes" to prevent the tripod legs from slipping. In place of a spreader, one could use camera tape, a rope, or even a piece of rug or heavy cloth. Sandbags or plastic waterbags are always useful for steadying tripods or stands. Occasionally a length of chain with a turnbuckle can also be used to secure the tripod to a platform.

In situations where baby legs are not low enough or the camera is to be mounted on, say, the wing of an airplane, a high hat is practical. A number of other mounts have been developed for a variety of specialized needs.

For traveling shots, several types of dollies are available. They differ in sophistication and expense.

1.46 String used as a spreader.

1.47 Blanket used as a spreader.

1.48 Metal tripods with spreader and spike guards. *(Courtesy of O'Connor Camera Support Systems)*

1.49 Hi-Hat mounted on a "Hitch Hiker" spreader. (Manufactured by Birns & Sawyer)

The Elemack Cricket and the FGV Super Panther⁽⁶⁾ are good examples of dollies adaptable to various shooting situations. With jibs, they serve as small cranes.

The wheelchair has become a favorite location dolly for small-budget productions. Another inexpensive but good dolly is a simple platform with wheels, known as a western dolly or doorway dolly.

Dollies are usually run on steel tracks and/or plywood sheets laid on the floor. Using a wide-angle lens helps to obtain a smooth-looking movement.

Occasionally an automobile is used as a dolly. In this case, bumps can be smoothed out by reducing the air pressure in the tires. When filming at a right angle to the direction of vehicle movement, the auto speed appears almost twice as fast as in reality. Therefore running the camera at a higher speed will both smooth out the movement and compensate for the illusion of increased speed.

When shooting from a helicopter or moving car, antivibration mounts can be used to stabilize the camera. In especially unsteady situations, an amazing gyrostabilized lens system called Dynalens is available.

1.50 Samcine Limpet camera mount. (Courtesy of Samuelson Film Service Ltd.)

1.52 FGV Super Panther[®] dolly with FGV Lightweight Jib. (Courtesy of FGV Panther Corporation of America)

TRIPOD HEADS

Cameras are mounted onto the tripod legs through the use of tripod heads, which also provide for smooth panning and tilting movements. (Turning horizontally is panning, while turning vertically is tilting.)

The tripod head must be chosen with the camera in mind. Different heads are designed to support different weights. You can take the manufacturer's suggested weight as a guide, but when selecting a head it is always a good idea to test it with the camera mounted to see how it will behave. Maneuverability and smoothness when panning and tilting are important, but equally vital is the "positive lock." Locking can be tested by tilting the camera forward so that it points below the horizon and locking it in this position. It should remain locked. If the camera is too heavy for the head, it may overpower the lock and continue tilting down until the front of the camera is resting against the tripod leg, and the weight of the camera when tilted down that far may cause an imbalance that pulls the tripod over, seriously damaging the camera.

Three basic types of tripod heads are available: friction heads, gear heads, and fluid heads. Friction heads, as their name implies, use surface resistance to smooth their movements. Gear heads employ mechanical advantage and are mainly used in 35mm and 65mm. For serious work in Super-8 and 16mm, fluid heads are the best. They use adjustable hydraulic resistance to give their movements a smooth flow.

There are two types of head-to-leg mounts. They are called *flat base* and *claw-ball* (ball joint). Claw-ball is becoming increasingly popular due to the ease and speed it offers in leveling the camera head. Adapters are available for using these two systems interchangeably.

After setting up the tripod the camera is mounted on the head, by a screw that extends from the head and goes into the bottom of the camera. On some heads, such as the O'Connor 50, part of a plate with the screw comes off the head and is separately screwed onto the camera. Then the camera, with this mounting plate attached, is locked onto the head. There are two sizes of screws: American and the slightly larger German. Some cameras have two threaded holes so that they can accept either. In addition, a small and inexpensive adapter is available that will enlarge an American screw to German size. This adapter should be a standard accessory carried by all cameramen.

1.54 Tyler 16mm Vibrationless Mini Mount. *(Courtesy of Tyler Camera Systems)*

1.55 A friction head. (Courtesy of Arnold & Richter)

1.56 Mini-Worrall gear head. *(Courtesy of Cinema Products Corp.)*

1.57 Mini-Worrall gear head features hinges at both ends, permitting very efficient forward (shown here) and backward tilting of the camera. *(Courtesy of Cinema Products Corp.)*

1.58 Miller 20 fluid head. (Courtesy of Miller Fluid Heads (U.S.A.), Inc.)

1.59 Miller 30 fluid head. (Courtesy of Miller Fluid Heads (U.S.A.), Inc.)

To make sure all the mounts are compatible, *always* set up the camera on the assembled tripod before leaving the equipment room or rental house. This simple practice will save you many headaches. Don't wait until you're on location to find you have different types of mounts that cannot be put together and no place to get an adapter. This applies not just to tripods, but to *all* equipment.

1.60 O'Connor fluid head model 30-B. (Courtesy of O'Connor Camera Support Systems)

1.61 O'Connor fluid head model 50-D. (Courtesy of O'Connor Camera Support Systems)

HAND-HELD WORK

When hand-holding the camera, our principal concern is controlling the camera for the exact degree of steadiness we desire for the effect, whether it be smooth or jostled and vibrating.

Hand-held shots can be made steadier by using most of the tricks discussed earlier, such as running the camera at a higher speed or using a wide-angle lens. Jumbled, helter-skelter subject action is often associated with a hand-held shot, such as walking through a panicked crowd. Such activity will often camouflage jerky camera movements.

Steadiness is not our only consideration in handholding. Sharpness is also a problem. The 24-fps camera speed produces a ¹/48-second exposure period, which is long enough to cause a relatively fast subject or camera movement to register as slightly blurred on film. Normally this is not noticeable because each single frame is not visible long enough on the screen. However, a jerkily hand-held camera will contribute to even more pronounced image blur. Thus resolution suffers when the camera is hand-held awkwardly.

Steady hand-held work depends to a great extent on the maneuverability of the camera. Ideally the cameraman's body and the camera should be as one. Many cameras and devices have been designed to achieve this unity.

Various body pods have been designed to transfer the camera weight directly to the body, freeing one or both hands to allow for focusing and zooming.

1.62 Aaton XTR camera resting on the operator's shoulder.

1.63 Aaton XTR held at waist, machine-gun fashion.

1.64 Aaton XTR used in ground-level shot.

1.65 As seen in these photographs, the rotating eyepiece adds great versality to a hand-held camera.

1.66 One type of body pod that leaves the operator's hands free. (*Photo by Bob Rogers*)

The highest sophistication in camera stabilizing equipment came with the invention of the Steadicam[®] and the Panaglide.[®] These allow the operator to walk or run, to climb stairs or shoot from moving vehicles while keeping the camera steady. The camera becomes virtually an extension of the operator's body, allowing for boom movement up or down of almost three feet and for panning a full 360°. The operator views the image on a video monitor when guiding with a gentle hand movement a camera that seems to be floating on air. The assistant is able to keep adjusting the focus ("pull focus") by a radio-operated remote control.

The only drawback to these systems are their weight. The Steadicam system with a 16mm camera weighs approximately fifty pounds. Operators need to be physically able to move in a harness supporting the whole system; a strong back is required for this job.

1.67 A Bolex with a pistol grip. (Photo by author)

1.68 Steadicam[®] camera stabilizing system allows the camera to become an extension of the operator's body to produce smooth moving pictures in a variety of filming situations. *(Courtesy of Cinema Products Corp.)*

TIME MANIPULATIONS IN CINEMATOGRAPHY

Until now we have discussed ways of controlling the image recorded by the camera, covering the manipulation of focus, perspective, camera positions, and movements. There remains the time dimension. It has infinite possibilities and therefore allows for great ingenuity in its use.

Near the beginning of this chapter we introduced time lapse and slow-motion photography and described how it could expand or collapse time.

Some general purpose cameras have speeds up to 75 fps available from a wild motor. This is adequate for some slow-motion purposes, but if higher speeds are necessary, there are two general types of cameras to be considered: intermittent movement and rotating prism types. Intermittent cameras are the kind we have already described; they arrest each frame for the period of exposure. For this reason they are limited to a top speed of about 600 fps but usually less. The rotating prism camera features a continuous film flow. The film never stops, and the prism rotates to project the image on the passing film. Because the film does not have to stop and start for each exposure, higher speeds are possible, ranging up to 10,000 fps for 16mm film. Special scientific cameras have been designed for much higher speeds, but they are seldom of any practical use to the average film maker.

At high speeds many problems arise. As the exposure time becomes minimal, a great deal of light is required. There is also a "reciprocity failure"; at higher speeds the exposure time–f-stop relationship gradually changes so that computing the exposure may be difficult. Exposure tests are necessary. To further complicate matters, at very high speeds the reciprocity failure may be different for each layer of color in the emulsion, thus distorting the color.

Film stock for extremely high-speed photography must have "long pitch" perforations. This means the distance between the sprocket holes is slightly greater.

In addition to slowing or speeding a movement, film can be used to remove portions of it. One term cinematographers use for the creative elimination of in-between intervals of movement is "pixilation." Pixilation is much like animation in that it is often taken one or more frames at a time, but unlike animation, its subject is frequently a moving object like cars or people. Where time lapse cinematography seeks only to speed up action, pixilation removes specific parts of the movement, modifying the apparent nature of the action. For example, an overused pixilation effect is achieved by taking a single frame every time an actor jumps up into the air. Because he is never seen except at the height of his jump, he appears to be suspended above the ground.

Another pixilation technique involves running the camera several frames at a time. Between each interval the actor walks to a different area in the field of view. The result is that he appears for a moment in each position.

Either of these pixilated effects can be achieved by shooting single frames, shooting several frames at brief intervals, or using an optical printer to print only the selected frames from normally shot footage. The creative variations on pixilation are endless and open to experiment.

Most cameras can run backward, providing the opportunity to invert time. Reverse action can be used to make a difficult maneuver possible or to achieve an effect. In one film, a director had the camera run in reverse while filming an actor walking backward in a crowd of normally walking pedestrians. When the film was projected forward, the actor became the only person who was walking forward in the crowd of pedestrians walking backward.

Impossible actions are made possible, such as a man effortlessly jumping straight up onto a roof. The actor starts on the roof, walks to the edge, jumps down, and walks away, all backward. The action is filmed with the camera running in reverse so that when correctly projected, the actor walks to the building, jumps straight up onto the roof, and walks across it.

Another very important use of reverse action is in making complicated maneuvers easier. The most common example is a rapid pan to a very precise framing. If shot forward, we might spend a great deal of footage before we hit just the perfect framing the director wants at the end of the shot. However, filming in reverse, we could start on that precise framing and pan away to the first, less critical angle, achieving the shot while saving time and footage.

Not all cameras feature an ability to run backward. But reverse action can still be achieved. In 16mm or 35mm the action can be filmed and later reversed in an optical printer. Or reverse motion can be achieved by filming with any camera held upside down. If the image is recorded upside down, we can turn the film over in the projector and show it tail-first. It will be right side up, but the action will be reversed. In the case of single-perforated film stocks, the picture will also be turned around left to right. Double-perforated stocks could be turned over, correcting the left-toright position, but this would put the emulsion on the opposite side, causing focal problems in printing. When using the upside down, reverse action method, the best ways to deal with the left-to-right exchange are to avoid lettering or anything else that would give it away, or to shoot through a mirror. There is also the possibility of having any lettering printed backward or even exchanging the sides in an optical printer.

The possibilities suggested by time manipulation are endless, and we have touched on only a few. The film maker is limited only by his own imagination. (For further information on special effects cinematography, see the Bibliography.)

FRONT PROJECTION

Until recently, the process of adding a separately shot background behind a studio foreground has been an expensive luxury practical only to the major film studios. Now with the rapid development of front projection, low-budget productions can afford the use of exotic backgrounds and otherwise expensive sets. This was made possible by the development of a highreflectance screen material such as Scotchlite by 3M. Such screens consist of millions of flint glass bead lenses, enabling the screens to reflect over 200 times more light than is reflected by a person's white shirt. Furthermore, virtually all the light is reflected directly back to the source.

In front projection, a very thin, optically perfect glass is placed at 45° in relation to the projector to combine the optical axes of the camera and the projector. When the camera and projector are perfectly aligned and equipped with compatible lenses, the image from the projector is reflected by the optical glass onto the screen. The screen returns almost all the light back through the glass into the camera. The 45° glass will reflect away from the camera a certain percentage of light coming from the screen and subject, making exposure compensation necessary. Because of the high-gain reflection, the projection can be of low intensity and will therefore not show on the actor. Because the camera and projector are aligned on the same optical axis, the actor's body will cover his own shadow.

Compared to back projection, the lighting for front projection is much easier. Because a high-reflectance

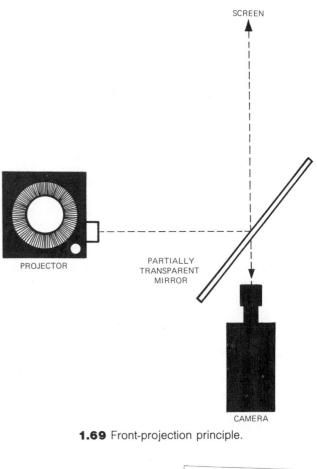

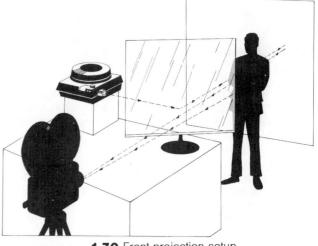

1.70 Front-projection setup.

screen reflects light back into its own source in a very narrow angle, there is no need to worry too much about side lights washing out your projected background. Even a conventional 45° key light presents no problem, because any of its light that happens to hit the screen will not be reflected into the projector/ camera but will be sent back to the key light.

Because of the narrow angle of reflection, the screen does not need to be taut. It can even be slightly moving and yet return a constantly steady image. Furthermore, seams in the material don't show. This allows us the further luxury of using many planes of depth. Each flat can be cut to the precise shape of the object to be projected on it, and then it is covered with high-reflectance material. The actor can now walk behind it for a truly three-dimensional effect.

A system of this type can be assembled at a relatively low cost and without professional help. The advantages are enormous.

CHOOSING A CAMERA

Having spent the first part of this chapter covering some of the basic camera features and capabilities, we now will try to bring it all to focus. Selecting a camera is similar to choosing a car. You should consider many aspects before committing your money. There is much to be said for renting rather than buying equipment, since needs vary from one filming assignment to another. There are rapid changes in camera design and there is a constant flow of new models, which would be available at rental houses. The decision to rent or buy a camera also depends on how extensively one plans to use it.

Still, many amateurs and professionals prefer to own their own cameras. In this way, if they take good care of their equipment, they can be confident about its dependability. Sometimes they will own their own "stand-by" camera (usually a simple but rugged piece of equipment, such as a Bolex Reflex or a Bell & Howell 70 series), and rent their main camera, such as an Arri, Aaton, Panaflex[®], etc.

Every few months, camera manufacturers bring out new designs and improvements in older models. Therefore this book cannot hope to provide an up-todate consumer's report on every current camera. You will have to investigate the features offered by the designs of leading manufacturers at the time you buy. In addition to providing promotional literature, equipment rental houses can often be very useful in helping

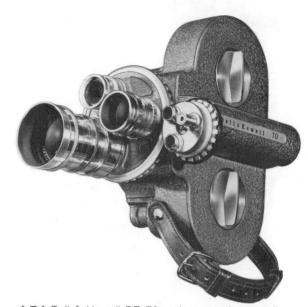

1.71 Bell & Howell DR 70 spring-wound, non-reflex 16mm camera. (Courtesy of Bell & Howell)

1.72 Bolex H-16 SBM 16mm spring-wound camera, with reflexive viewing system, optional electric motor, and 400-foot magazine. *(Courtesy of Bolex/Paillard)*

1.73 Bolex H-16 EBM electric 16mm camera with 400-foot magazine and a battery built into the handgrip. *(Courtesy of Bolex/Paillard)*

1.74 Beaulieu R16B (PZ) 16mm camera with Angenieux 12-120mm auto lens with built-in power zoom. *(Courtesy of Hervic Corp./Cinema Beaulieu)*

1.75 Canon Scoopic 16 camera for 100-foot daylight spool loads with built-in, interchangeable battery. *(Courtesy of Scoopic Division, Canon U.S.A., Inc.)*

1.76 Sound barney for Arri 16SR camera. (Courtesy of Birns & Sawyer, Inc.)

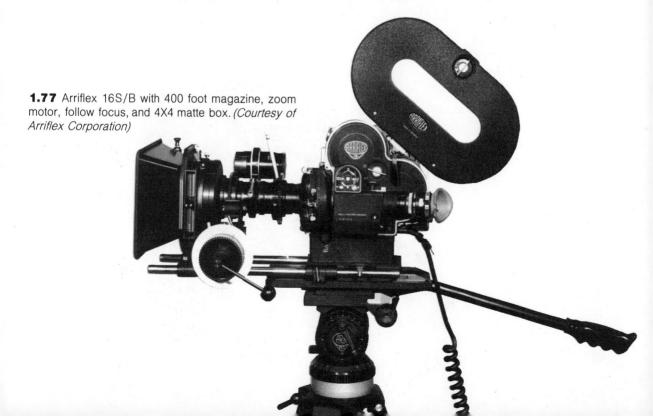

1.78 Minicam-16 often used as a "point-of-view" action camera. *(Courtesy of Alan Gordon Enterprises, Inc.)*

1.79 Eclair CM3 camera adaptable to either 16mm or 35mm operation, with 400-foot magazine. *(Courtesy of Eclair International)*

1.80 Actionmaster/500 accepts 200-foot, 400-foot and 1,200-foot magazines. *(Courtesy of Photo-Sonics, Inc. Burbank, Calif.; distributed by Instrumentation Marketing Corp.)*

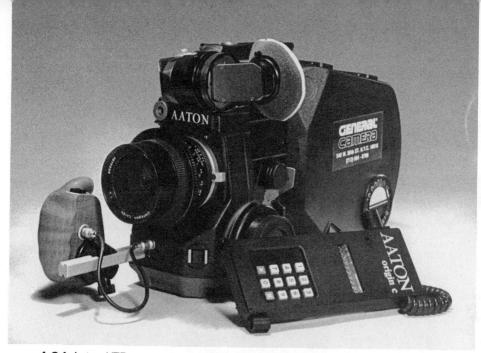

1.81 Aaton XTR camera with 400 foot magazine and an Origin C, the master clock used for Aaton Time Code operation. *(Courtesy of General®* Camera)

1.82 Arriflex 16SR2, with a 400-foot magazine. It features an extended measuring range light meter (16-1000 ASA). *(Courtesy of Arriflex Corporation)*

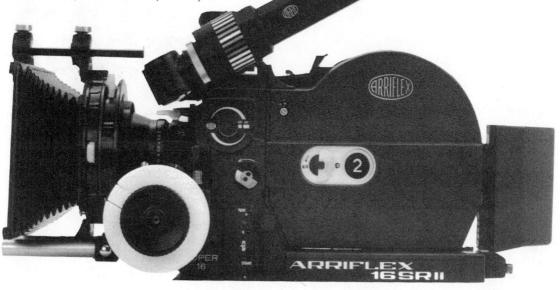

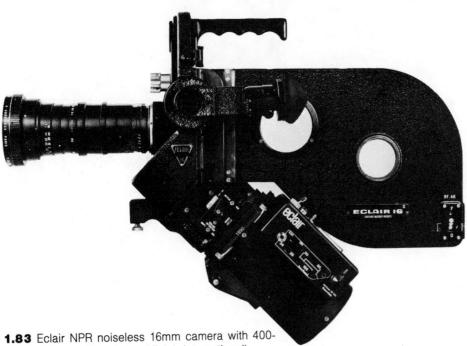

1.83 Eclair NPR noiseless 16mm camera with 400 foot magazine. *(Courtesy of Eclair International)*

1.84 Eclair ACL noiseless 16mm camera with 200-foot magazine. 400-foot magazine also available. *(Courtesy of Eclair International)*

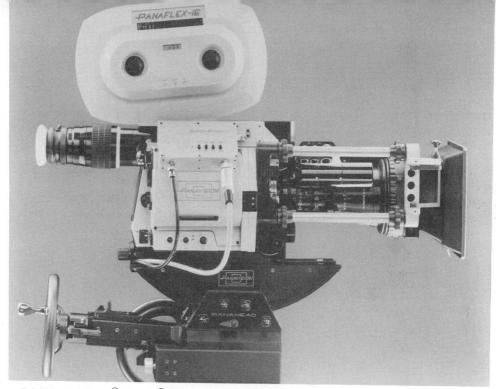

1.85 Panaflex-16[®] Elaine[®]. A studio camera, similar in operation to 35mm Panavision cameras. Uses magazines of 200, 400 and 1,200 feet. Available with built-in video assist, which allows for simultaneous video viewing during the shot. *(Courtesy of Panavision).*

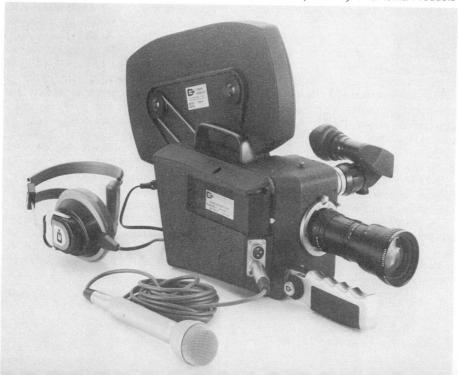

1.86 CP-16R/A Reflex. Uses magazines of 400 and 1,200 feet. (Courtesy of Cinema Products Corp.)

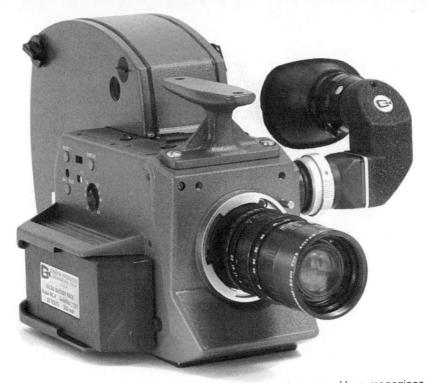

1.87 16mm GSMO ultra-light and extremely compact camera. Uses magazines of 100, 200, and 400 feet. *(Courtesy of Cinema Products Corp.)*

you to familiarize yourself with the features and capabilities of different pieces of equipment. Their technicians and repairmen can be of enormous value in pointing out weak points in design or advising precautionary techniques that can save you time, trouble, and money.

When selecting a camera to rent or buy, the primary consideration is the job at hand. No camera is perfect for all tasks. To make some sense of the multitude of 16mm cameras, we have to consider them in terms of their function and level of sophistication.

Several cameras that generate a high level of noise are nevertheless excellent tools for filming without synchronous sound recording. At times their noise can be dampened by a barney. The well-known cameras in this category include Arriflex 16S/B, Eclair CM3, Bolex H-16 and H-16 EMB, Beaulieu R16B, Bell & Howell 70, Canon Scoopic MS, Mini-cam 16, and high-speed cameras such as Photosonic Actionmaster/500 (25 to 500 fps) and Arriflex 16 HSR.

For sound shooting a variety of noiseless cameras were designed with the ever-growing advances in technology. These are self-blimped so that their noise level is decreased, even below 30 db. They are equipped with crystal sync motors that keep constant speed at exactly 24 fps or 25 fps, and they change to other speeds at a flick of a switch.

Features to look for, depending on production needs, may include a single sound system (recording sound inside the camera on a magnetic stripe laminated on the edge of the picture film); a video assist that uses a beam splitter to allow for a monitor display of the filmed scene during the actual shooting; and a time code system that marks on the film's edge the date and every passing hour, minute, and second of the day in clearly visible numbers. (See description of Time Code in chapter 6.)

Other general features that make the operator's life easier include bright viewfinder systems, clearly displayed footage counters, and maximum ease in film threading. When hand-held shooting is required, a camera designed to fit and balance well on the cameraman's shoulder will contribute toward a steady picture and greater comfort for the film maker.

Here are some of the most often used cameras in the self-blimped group: Aaton XTR, Arriflex 16SR2, CP-16R, GSMO, Eclair ACL, Eclair NPR, and Panaflex Elaine[®].

CAMERA TROUBLES AND TESTS

Even the most sophisticated cameras will occasionally fail to operate properly. Usually this is caused by a rather simple malfunction. Amateur cameramen frequently jump to conclusions, suspecting the worst, when the problem is actually some simple thing like a low battery or a bad connection. Therefore, do not panic until you've checked the obvious things first.

Most camera troubles will fall roughly into five categories:

- 1. The camera will not run. This could be caused by:
 - a. Dead or low battery
 - b. Broken on/off switch
 - c. Broken power cable or loose plug connections
 - d. Dirty connection between the camera body and the magazine take-up motor (applies to Arri and Beaulieu)
 - e. Buckle switch not reset (some cameras have this safety device, which automatically stops the camera if a jam occurs)
 - f. Burnt-out or otherwise damaged motor
 - g. Extremely cold weather (the camera should be winterized by changing the lubrication from oil to graphite in a camera shop before shooting in very low temperatures)
- 2. The projected picture is unsteady. Caused by:
 - a. Film loops too small or too large
 - b. Film stock that has shrunk because of improper storage
 - c. Faulty synchronization of the shutter and pulldown claw (causes a vertical blur)
 - d. Pressure plate too tight or too loose
- 3. The film is scratched. Caused by:
 - a. Dirt or emulsion buildup somewhere along the film path
 - b. Rollers in the camera or the magazine are stuck
 - c. Film gate scratched or damaged
 - d. Film loops too large or too small
 - e. Film not properly threaded
- 4. The film is fogged. Caused by:
 - a. Light leak from an improperly closed camera or magazine door
 - b. Reflexive viewfinder open to light—often because cameraman took his head away from the eyepiece
 - c. Behind-the-lens filter slot that has been left open (especially on Bolex or wide-angle lenses)
 - d. Improper loading or unloading that may have exposed the film to light

- e. An empty lens cavity left open in the turret
- The picture is out of focus. This is usually the camera operator's fault, but can also be caused by:
 a. Lens not flush in the turret
 - b. Lens out of alignment
 - c. Viewfinder out of adjustment
 - d. Pressure plate not locked in correct position when the camera was loaded

Most of these troubles can be avoided by a thorough check. Before the day of shooting, *all* the equipment should be assembled and examined to make sure it is compatible and in working order. Shooting a camera test is a vital step in preparation. It must be done and screened before the shooting begins so that there is ample time to deal with any problems. The main objectives of the test will be to check lens performance and picture steadiness. If two or more cameras are used, it is imperative that the frame lines be compared to make sure that footage from the two cameras can be intercut without the frame line shifting on the screen.

Lens sharpness is best checked by shooting a test chart or even a newspaper with the lens aperture wide open (lowest f-stop). In the case of a zoom lens, the entire focal range (zoom range) must be tested.

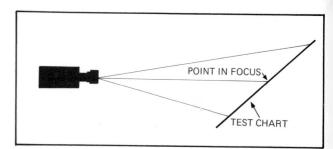

1.88 Lens tested with chart at 45°.

At the same time, test the reflex viewing system and lens calibration by turning the test chart to a 45° angle. Focus visually (or by measured distance) for a marked spot. If the viewing system or the calibrations on the lens barrel are out of alignment the footage will be focused either closer or farther away than the marked spot.

48 CINEMATOGRAPHY

A steadiness test is valuable to check registration stability. It involves exposing the same footage twice, filming a test chart. If the two exposures appear to "breathe" (vibrate) relative to each other, the camera does not have good registration. A quick registration check is achieved by "framing up" the picture while it is projected, so that the frame line is visible in the middle of the screen. Poor registration will cause the frame line to vibrate slightly.

Further tests of such things as emulsion characteristics, lighting, and make-up are also recommended. For that matter, anything that is in doubt should be tested whenever possible. It is often cheaper to spend a little money on test footage than it is to pay for having a day's or a week's work redone.

CAMERA OPERATION AND CARE

Even the most comprehensive tests cannot eliminate human errors. Most mistakes are due to careless oversights. The camera operator has to keep track of so many small details that he is eventually bound to forget something. When he does, it will be a simple and obvious error.

The beginner is especially prone to such mistakes. Professional cameramen develop a systemized routine of checking everything immediately before shooting. I have my own list of things to check before filming:

- 1. Level tripod
- 2. Clean gate
- 3. Close gate
- 4. Sprockets engaged
- 5. Footage counter reset after loading
- Forward/reverse properly set on both camera and magazine motors
- 7. Motor speed set
- 8. Magazine take-up taut
- 9. Viewfinder eyepiece focused for eye
- 10. Matte box not visible in frame
- 11. Filter slot covered or closed
- 12. Filter in place
- 13. Check frame for composition, mike boom, set limits, etc.
- 14. Check focus
- 15. Check f-stop

The last three are the most important, as they are constantly being changed during the shooting day and are therefore the most likely to be wrong when you start to shoot.

The Ditty Bag

The ditty bag contains all the small items a cameraman feels he should have in his immediate reach while filming. The items may vary depending on personal choices, but most ditty bags are similar in content. Mine contains:

An American Cinematographer Manual (known as the cinematographer's bible)

Air syringe and/or can of compressed air Orangewood sticks

- A pair of fine tweezers and a dental mirror (for careful removing of film chips and hairs from inaccessible places; these are the *only* metal instruments used for cleaning)
- A small flashlight
- A *camera brush* made of fairly stiff hair (*not* camel's hair)
- A *lens brush* made of extra-soft hair (such as camel's hair)

Lens tissue

Cotton swabs (for cleaning lenses only!)

Lens-cleaning fluid

A compact magnifying glass (cleaning aid)

Assorted screwdrivers

Needle-nose pliers

A crescent wrench

Black camera tape

White camera tape

Gaffer's tape

Grease pencils, marker pens, ball points, and pencils Camera report cards (can be simple index cards) Chalk (kept separate because of dust)

Scissors

Spare cores

Spare daylight-load spools

A 50-foot cloth measuring tape

An assortment of spare parts and adapters, such as a German/American tripod screw adapter, a spare core center piece, etc., depending on the type of equipment being used

Stop watch

Contrast-viewing glasses for black-and-white and color

Apart from the ditty bag, these items might also be necessary on location or in the studio:

Spare light meter Spare light meter battery Spare changing bag Spare film cans with black paper bags Spare power and sync cables Extension cables for mikes Extension cables for lights All sorts of adapters for electrical supplies; most important, the common two-wire to two-wire-and-ground adapter Spare bulbs and fuses Spare batteries, such as for tape recorder Spare camera battery with charger Spare magazine take-up belts Spare lens caps Spare rubber evecup Spare supply of filters Spare tape recorder take-up reel Soldering iron

Voltmeter, or at least, a voltage tester Headache tablets (aspirin, etc.)

This list could go on forever. The point is that you should scale your equipment to your production, remembering that you *want* to be overprepared. Camera operation depends on many small details. If one malfunctions, all your footage may be ruined.

Lists of this sort are always of enormous value and should be made up before the day of shooting to make sure that nothing is forgotten.

Here again, as throughout this chapter, we are reminded of the great concentration and attention to detail required from the camera operator in order to maintain control in his work. Only after thoroughly mastering the techniques and mechanics of his craft can a cinematographer develop the consistency necessary to achieve an individual stylistic approach, which is the goal of the cinematographer's art.

FILMS AND SENSITOMETRY

The cinematographer's choice of film stock is a major factor in determining how the image will be recorded, and film therefore contributes greatly to the cinematic style. The cinematographer must not only appreciate differences among stocks but be familiar with every property of the film so that he will know how to manipulate it to achieve the appearance and qualities he wants. Therefore, in our discussion of film stocks we will be concerned with every characteristic relevant to the control of image quality, starting with the most basic.

The two fundamental components of film stock are the base and the emulsion. The base is usually made of cellulose triacetate. Some stocks are also manufactured on a thinner, stronger "estar" base. Unfortunately this polyester base cannot be spliced using regular film cement. Either tape or fusion splices have to be used. Tape splices are not acceptable for the negative preparation, as they would show up on the print. Fusion splices require special equipment that is not readily available. Estar-based stocks are more practical for release prints because they are more durable.

The emulsion consists of a thin layer of gelatin in which light-sensitive silver-halide crystals are suspended. This emulsion is attached to the base with a transparent adhesive called the subbing layer. This emulsion undercoat usually contains absorber dyes or a thin silver layer. Without this, bright points, such as car headlights, would penetrate the emulsion, reflect from the back of the base, and create a halo around their images. These reflections are instead dissipated to a certain extent into the absorber dyes. Usually not all halation is absorbed from stronger sources.

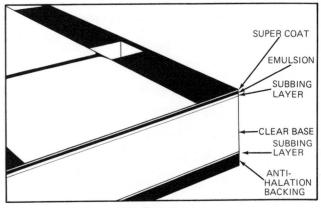

2.1 Film structure.

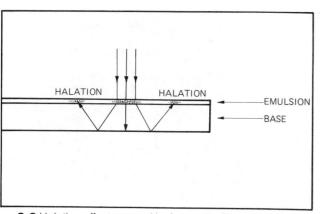

2.2 Halation effect, caused by internal reflections in the film.

PRACTICAL SENSITOMETRY

The science of measuring an emulsion's reaction (sensitivity) to light is called sensitometry. The basic principles of practical sensitometry do not require an extensive knowledge of mathematics or physics. They only require common sense.

As a first step toward a study of sensitometry we should explain roughly how a film is able to record an image. Any scene contains a conglomeration of points reflecting various amounts of light toward the camera. As this light strikes the silver-halide crystals in the emulsion, it causes changes that remain invisible until the film is developed. These hidden changes make up the "latent image." When the film is developed, the areas in which silver-halide crystals received the most light produce more metallic silver than areas that received less exposure. Consider a photograph of a man in a white shirt and black pants. The film is black-andwhite negative. The white shirt reflected a lot of light, causing great changes of silver halide into metallic silver. Meanwhile, the black pants reflected only a small amount of light, causing minimal changes in the emulsion. The face had a light reflectance in between the previously mentioned extremes and so caused a medium change in the emulsion. The developed negative will represent the white shirt as a very dense area with a lot of metallic silver appearing black. The pants will be the opposite-less metallic silver, hence more transparent. This is why we call it a negative. White objects appear black on film, while black objects appear bright (clear).

Reversal film, on the other hand, results in a positive image on the camera original. It is developed much like a negative, and at one point is in negative form. However, the processing does not stop here. The metallic silver of the negative image is removed in a bleach bath and the remaining (unexposed) silver halides are exposed to a weak light in the processing machine. The film is then developed again. This time the image is positive. Black is black and white is clear.

THE CHARACTERISTIC CURVE

Many beginners have been misled into believing that for any scene there is only one proper light level and one correct exposure. This notion is reinforced by automatic exposure systems, which magically divine the correct setting for the entire scene. This unfortunate idea is misleading and will hamper the film maker's understanding of exposure.

Every scene contains an infinite number of reflected brightnesses. White objects reflect much light and dark objects reflect little light. The film will faithfully record only a part of the range the human eye is capable of adapting itself to. Take, for example, a scene in which the range runs from a bright sky to a black telephone in a shadow. From one vantage point our eye can probably see these extremes because it readjusts itself when looking at each one. As we glance up from the telephone our eye closes its iris and refocuses for the brighter sky. It is difficult, however, to see both clearly at exactly the same time. The film has the same problem. If two such extremes are in the field of view at once, it is impossible for the film to record both faithfully. The range of light levels in many scenes is greater than the range the film can correctly record.

Therefore, in filming a scene we must decide what objects are the most important and calculate an exposure that will place the brightness levels of those objects within the range that the film will faithfully reproduce.

To define the optimal range of each film, we will determine how increasing amounts of light cause deeper reactions in the emulsion. We chart the levels of exposure against the resulting densities in the processed film, arriving at a graph known as the "characteristic curve." It is not a practical on-the-set aid, yet its thorough comprehension is indispensable in helping us understand how the film emulsion interprets the subject's brightness range.

52 CINEMATOGRAPHY

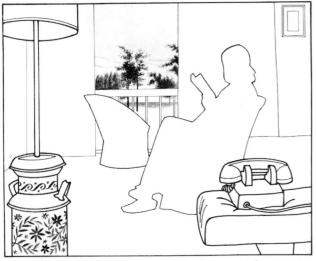

2.3 Graphic representation of extremes in the scene brightness range that were not distinguished in the photo. See figure 2.6.

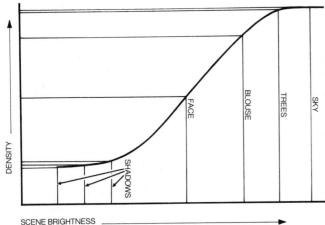

^{2.4} Scene brightnesses located on a characteristic curve.

The curve is established by placing a short strip of an unexposed film into an instrument called a sensitometer, where it is exposed to increasing levels of light. The film is then processed, and the density resulting from each light level is measured with a device known as a densitometer. By plotting the results on a graph we arrive at the characteristic curve, describing the relationship between light levels and densities for this particular emulsion.

2.5 Negative. (Photo by author)

2.6 Positive print. (Photo by author)

Let us consider an everyday exposure problem and relate it to the characteristic curve (see figures 2.3 through 2.6). In figure 2.3, I was confronted by a huge range of brightness in the scene. I decided that for this scene it was most important for the person in it to be represented faithfully, so I used an exposure that would bring the face within the optimal range of the curve. The blouse was brighter and the skirt was darker, but they too fell within the range and were recorded proportionately lighter and darker. However, designs on the lamp stand and the telephone in the shadow were so far underexposed that all details were lost. This is because at the low end of the curve (called the "toe"), where the lamp stand and telephone were, the shadows were "squashed." Note in figure 2.4 how a large difference in scene brightness was represented as a minute difference in densities on the film, and thus detail was lost. The same is true of the other extreme, where the trees outside were lost because at the high end of the curve (called the "shoulder") the great difference between the trees and the sky was represented on film as only a small difference in density, and therefore the two are not distinguishable from each other.

Ideally the curve might be a straight 45° line, not squashing anything, but in fact no such film exists. The nearest to this ideal is the straight-line portion of the curve (between A and B in figure 2.7). Actually this portion between the toe and shoulder is rarely perfectly straight. However, any scene that stays under the limits of the straight portion (e.g., between A_1 and B_1 in figure 2.7), will be faithfully reproduced in *correctly related* densities. That is, an increase in the brightness will cause the image to be proportionately brighter, without squashing.

Some scenes, such as a foggy landscape, may be so narrow in brightness range (low contrast) that they could fit into the straight-line portion of the curve twice over. In practical terms this means that such a scene could be exposed anywhere within the straightline portion and still yield a negative with correctly related densities. It is very common for a photographer using black-and-white negative film to give such a scene a minimal exposure, positioning the brightness range on the lower portion of the curve yet still within the straight-line portion. In this way he obtains a fairly thin (not dense, more clear) negative that gives more finely detailed reproduction. The lab technician will later compensate for this minimal exposure by printing it lighter. This technique is only used for blackand-white negative film. When shooting in color negative or any reversal emulsion, the important brightness range should usually be placed near the middle of the straight-line portion to obtain the best rendition.

In negative, the horizontal length of the emulsion's straight-line portion (A_1 to B_1 in figure 2.7) and the size of the scene brightness range (for example A_1 to X_1) together determine latitude. In this example the latitude is from X_1 to B_1 . In negative, latitude is any range outside the scene's brightness range yet still

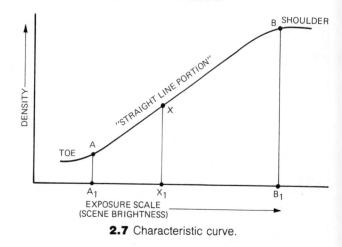

within the straight-line portion. In the original example in figure 2.4, there was no latitude because the scene brightness range was greater than the straightline portion.

It should be noted that we have been talking about negative film only. Latitude for reversal films is thought of differently. Reversal films are much less tolerant of overexposure and underexposure. There is not a wide range of acceptable exposures. When using reversal film, we place the most important brightness range (objects) in the center of the straight-line portion and think of latitude as the adjacent tolerance range (acceptable over- and underexposure). In other words, latitude is a measure of how far clearly separated details extend into the bright and dark areas (i.e., how large the optimal range is).

Therefore, when calculating exposure we are not exclusively interested in one reflected light level. Our real consideration is a range of brightness levels present in the subject, from which we choose one. We calculate an exposure for it that will place it and the other adjacent levels on the curve where they will be represented in correctly related densities. For example, in the situation of figure 2.6, if we had decided that the view outside the window was the most important element to see clearly, we could have calculated an exposure that would have brought the trees near the center of the straight-line portion, as in figure 2.8.

There are two complications we have previously ignored in the interest of keeping things simple. First of all, color employs not one but three emulsions—one for each of the primary colors, blue, green, and red, each of which has its own characteristic curve. Ideally

53

CINEMATOGRAPHY 54

2.8 Exposure calculated for trees outside. Compare with figure 2.6. (Photo by author)

they should be parallel and very close together. but this is not always the case (see figure 2.9).

The second previously unmentioned complication is that because reversal films yield a positive image, their curves slant opposite to negatives (figure 2.10). That is, in negative a low light level yields a low density (clear area on the film), while a high light level causes a dense area on the film. In reversal, however. this is opposite. A white object is recorded as bright (clear) and a dark object is recorded as dark (dense), so the curve slants in the opposite direction, from upper left down to lower right.

EXPOSURE VALUES

It was earlier stated that the exposure value (f-stop) was selected so that the important light levels would be placed within the optimal range of the characteristic curve. To understand how this is done, it must be noted that the "scene brightness" side of the graph represents the light actually reaching the film-that is, the amount of light allowed to pass by the f-stop. The horizontal and vertical (density) scales increase logarithmically, as do f-stops. (Logarithms are common in film making; many film makers understand and use them without realizing it.) If a scale is logarithmic, it simply means that each succeeding step doubles the

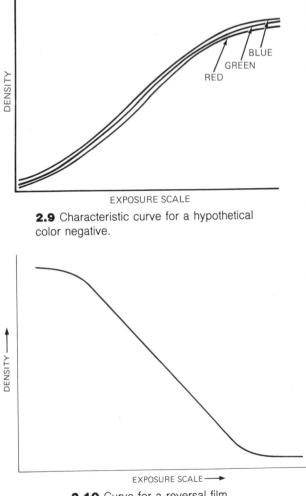

2.10 Curve for a reversal film.

value of the previous one. Logarithms could also triple or quadruple between steps, but in film making we are almost always talking about "logs" that double the value with each increasing step. Take the example of f-stops. As you remember from chapter 1, each wider f-stop setting doubles the amount of light passing through the lens. Therefore, f-stops are designed in a logarithmic progression.

Light is measured in logarithms because it naturally increases that way. Suppose we start with one light bulb on and then turn on a second. Of course the illumination appears to increase. To make the light appear to increase again by the same amount, we must

turn on *two* more bulbs. To increase it the next time will require four more bulbs if the increase is to appear as great as each of the previous steps.

Step number:	1	2	3	4	5	6	7
Number of bulbs:	1	2	4	8	16	32	64

This is a logarithmic scale. The light doubles with each succeeding step. Yet the light *appears* to increase by the same amount between each step, making a logarithmic scale the most convenient system for discussing light.

Because f-stops and the scene brightness scale of the characteristic curve are both calibrated in logarithms, the two can be related. It happens that each stop equals 0.3 on the horizontal scale. That is, between 0.00 and 0.6 there are two stops. Between 0.00 and 2.4 there are eight stops. We could determine where the various scene brightnesses would fall on the horizontal scale. For example, a given object, such as a face, might be exposed so as to fall on the middle of the scene brightness scale. An object one stop brighter in the scene would fall one .3 division to the right of the face on the scene brightness scale. An object reflecting two stops less light will fall .6 to the left on the horizontal scale, and so on. Remember that the scene brightness scale of the characteristic curve refers to the amount of light actually reaching the film. Therefore, if we now reduce the exposure one f-stop, all the scene brightnesses will shift .3 to the left on the horizontal scale. Similarly, if we increase the exposure by one f-stop, all the brightness would shift .3 to the right.

Consider the example in figure 2.4. We decided that the face was the most important object in the scene and therefore calculated an exposure that brought the face within the straight-line portion of the characteristic curve. We could instead have used an f-stop that would have brought the trees within the straight-line portion, but the face would be lost in the shadows (see figure 2.8). Therefore, by selecting the proper f-stop, we are able to "position" the brightnesses of our subject within the straight-line portion of the characteristic curve. Thus, to calculate the exposure we need to know the brightness of the subject and the sensitivity of the film.

The overall degree of sensitivity of a film is expressed by the position of the characteristic curve in relation to the horizontal scale (scene brightness). Our

goal is to find some way of arriving at an f-stop that will place the range of important scene brightnesses within the straight-line portion. Therefore, for practical purposes the sensitivity of each film is rated by an ASA (American Standards Association, now called the American National Standards Institute) exposure index, sometimes also referred to as the EI number.

Faster films are more sensitive and have higher EI/ASA numbers. They are designed for filming under low light level. Because they require less light, the straight-line portion of their characteristic curve will appear slightly to the left (see figure 2.11). Slower emulsions are less sensitive and have lower EI/ASA numbers. They are designed for shooting scenes with brighter illumination levels.

The EI/ASA value doubles as the sensitivity of the film doubles. For example, an exposure index (EI/ASA) of 200 represents an emulsion twice as fast as one of EI/ASA 100. EI/ASA 200 describes a film four times as fast as EI/ASA 50.

Notice how f-stops relate to EI/ASA values. For example, we have a set amount of light (say 800 footcandles), which will remain at that level. Then for the following EI/ASA values we would use the following f-stops:

EI/ASA	EI/ASA	EI/ASA	EI/ASA	EI/ASA
25	50	100	200	400
f4	f5.6	f8	f11	f16

Every time the exposure index (EI/ASA) doubles, it means the film is twice as sensitive, therefore requiring *half* as much light. As each succeeding f-stop cuts the light by half, we can see how f-stops relate to EI/ASA; every time the EI/ASA doubles it signifies that one stop less light is required.

Therefore, we sometimes describe a film as so many stops faster or slower than another film. For example, a film of EI/ASA 200 is eight times faster than a film of EI/ASA 25 ($25 \times 8 = 200$), but we may also say this by stating that the film of EI/ASA 200 is three stops faster than the film of EI/ASA 25 (25 doubled three times equals 200). This tells us that a film of EI/ASA 25 requires three stops more light than one of EI/ASA 200. This relationship is vital. Although it may seem puzzling at first, it will seem quite simple once you have mastered it.

2.11 A fast and a slow emulsion. This fast emulsion starts reacting to light one stop (0.3 increment) before the slow emulsion. Notice that of these two hypothetical emulsions, the fast emulsion has a slightly longer useful portion. Notice also that the faster emulsion has a higher fog level (i.e., higher minimum density inherent to the emulsion).

DAYLIGHT VERSUS TUNGSTEN EXPOSURE INDEX

The exact color of light differs depending on the source. Our eye compensates for the difference between the color of sunlight and the color of tungsten illumination. The film, however, is quite sensitive to variations in the color of the light, and therefore blackand-white films are given two EI/ASA values, one for daylight and one for tungsten. Color film will magnify color variations, yielding unacceptable results, unless we use the proper filter to modify the incoming light, tailoring it to the color requirements of the emulsion. This will be discussed at much greater length in chapter 3.

FORCED PROCESSING

The EI/ASA number is only the manufacturer's *recommended* sensitivity. The sensitivity can be changed by increasing or decreasing the period of development. Increasing the developing time will have the effect of

increasing the EI/ASA. This is called "pushing" or "forced processing." Most emulsions can be pushed two stops (multiplying the sensitivity by four), but pushing will result in quality losses, such as higher grain, less sharpness, and changes in color and contrast (higher contrast in negative film and lower contrast in reversal film). The amount of quality loss depends on the amount of pushing and the type of emulsion being used. Because of this, most labs protect their quality reputations by refusing to push more than two or sometimes three stops.

The effect of pushing shows up in a family of characteristic curves. Here in figure 2.12, for example, light level A would normally yield a density of X, but by pushing the film one stop it results in a density of Y. Note that these curves are not parallel.

The more the negative film is pushed, the steeper the characteristic curves become. This means that we can expect an increase in contrast with increased pushing of negative.

Pushing reversal causes a slight decrease in top densities. The blacks in the scene are recorded as gray, resulting in lower contrast.

Excessive pushing will also desaturate color, giving the film a muddy look.

For a practical example of how to use a film with the intention of pushing it, suppose you are using a film of EI/ASA 50. You want to shoot a scene where there is not enough light. If you had a film of EI/ASA 100 you would be all right. So you decide to use the EI/ASA 50 film and push it one stop in the development. One stop pushing doubles the exposure index to 100. Set the light meter to EI/ASA 100 and expose the entire scene accordingly. When you send this roll of film to the lab, clearly indicate that it has been exposed at EI/ASA 100 and request one stop pushing. This information should be written on the film carton, on the can, and on the lab report.

Pushing is occasionally described as "developing to a higher gamma." Gamma is a measure of the slope of the straight-line portion of the characteristic curve, which, as you can see in figure 2.12, becomes steeper with more pushing. A higher gamma indicates a steeper curve. Therefore, a higher gamma means more contrast. The gamma standard for the majority of camera negatives is 0.65. (This is not vital to our discussion, but for those interested in knowing where this figure comes from, it is the tangent of the acute angle between the straight-line portion and the horizontal axis of the grid.) Print stocks are slower and of much higher gamma.

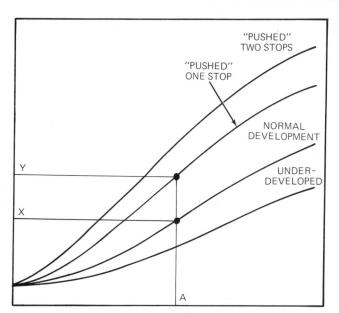

2.12 A "family" of characteristic curves.

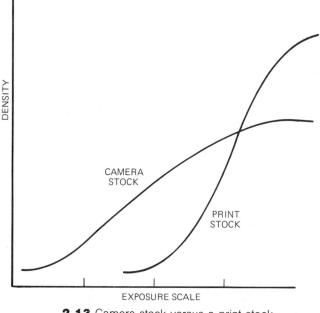

2.13 Camera stock versus a print stock.

Postflashing

When we are filming an action moving from bright sunlight to a dark shade with no means to light the shade, the brightness range of the scene will exceed the latitude of the film emulsion. The answer to this problem is to use the postflashing technique in the lab. It consists of reexposing the film to a weak light before development. This additional small exposure will not affect the already well exposed sunny parts of the scene, but it will have a visible effect on the underexposed shadows. By changing the deep blacks into shades of gray, it will reduce the overall contrast of the image. See figure 2.13.

Postflashing can be applied either to the camera original, whether negative or reversal, or it can be done to an interpositive or print. Postflashing an interpositive or a print affects the highlights. Instead of making the shadows lighter it makes the highlights darker. It will still lower the overall contrast but it will have a different look. By using color gels on the light employed in post-flashing, we can manipulate the color of shadows, or if we are flashing the print, the color of the highlights.

DEFINITION

Until now we have been mainly discussing sensitometry—that is, ways of measuring a film's sensitivity. Yet when we compare film stocks we are equally interested in another aspect, the film's definition. It is a key factor in determining the texture of the images as they appear on screen. The photographic definition of a film depends on three contributing factors: the grain, the sharpness, and the resolving power.

Graininess is one of our primary concerns. When the grains of metallic silver forming the image are visible, they create a texture like boiling sand when projected. The degree to which these grains are visible will depend upon their size and their concentration (density). As explained earlier, the grains of silver halide are struck by light and then processed to yield an image formed by grains of metallic silver. It seems that the larger a silver-halide crystal is, the more easily it is affected by light. Faster emulsions achieve their increased sensitivity partly by using generally larger crystals. Therefore, faster emulsions show more grain than slower emulsions.

As one could well imagine, pushing will also increase grain. This is because additional speed has been obtained by increasing the densities through prolonging the development time. The extended development time tends to make the grains clump together. Some films (usually the slower emulsions, which have finer grain to begin with) will take pushing better than other stocks.

Grain characteristics differ between the black-andwhite and the color stocks, as well as between the negative and the reversal emulsions. An overexposure will produce more graininess in black-and-white than in color negative. Slight overexposure will actually produce lower grain in color negative. On the other hand, underexposed color negative will require making a less dense print, leading in turn to an increased graininess. Hence, shadowed areas have a general tendency to show more graininess than the parts of the frame exposed to the higher light levels.

In black-and-white reversal, emulsions show less grain than the negative stocks of comparable speed. The opposite is true in color films. Here the reversal emulsions display more graininess than do the color negatives. In discovering the grain characteristics of a given film stock, tests and practical experience are more reliable than the manufacturer's promotional literature.

Sharpness is another key factor influencing photographic definition. It represents the precision with which the emulsion records sharp edges in the scene. An "acutance" test measures sharpness by using a densitometer to determine how quickly the density drops across a sharp shadow line, such as in a picture of a knife edge. A reversal film will yield a sharper image than a negative of the same EI/ASA rating.

Resolving power is the third factor contributing to the overall picture definition. It is the film's ability to record fine detail. Resolving power is measured by photographing a chart composed of fine sets of parallel lines, separated by spacings of the same width. The lines and spacings become gradually thinner from set to set. After processing, the film is examined under a microscope to determine the maximum number of lines per millimeter that the film is capable of distinguishing. For example, Plus-X Negative Type 7231 can resolve 33 lines per millimeter if the contrast ratio between the lines and the background is 1.6 to 1, or 112 lines per millimeter if the ratio is 1,000 to 1. As we see in this example, the resolving power is dependent on the subject's contrast. In addition, it will be influenced by other factors. A fairly slow, fine-grain emulsion, properly exposed and processed normally, will usually deliver high resolution. However, over- or underexposure, over- or underdevelopment, or the use

of a faster film would reduce the resolving power. It should further be noted that lens quality also contributes to the overall resolution of the image.

Super-16

A key factor in apparent definition is the size of the film format. For example, a frame of 35mm film is approximately four times larger in area than a frame of 16mm film. If projected onto equal-size screens, the 16mm film must be enlarged much more than the 35mm film. As a result, the grain appears larger and the details less distinct in 16mm than in 35mm.

For reasons of economy and equipment maneuverability, some feature films are shot in 16mm and then blown up to 35mm for theatrical release. This unfortunately introduces a noticeable loss in quality. The Super-16 format was specially developed to minimize this loss.

When normal 16mm is blown up to wide-screen 35mm, the great magnification results in more graininess and poorer image quality. The problem is further aggravated by the fact that the top and bottom of the 16mm frame are lost in changing the image to the wide-screen ratio (see figure 2.14). Super-16 extends the image into what was formerly the sound track area. This provides for not only a larger image, but one that is already in wide-screen ratio. Thus, the Super-16 format requires less magnification when blowing up to 35mm wide-screen, and hence there is a much smaller loss in quality.

In adapting a 16mm camera to the Super-16 format the lens must be recentered and the aperture modified. Not all camera designs are easily converted.

Film Stocks

At first glance, the list of available motion-picture stock can be overwhelming to the beginner. But after becoming familiar with different film emulsions, one will be able to relate each film stock to the specific tasks or situations for which it can be used. Many factors will influence the choice of a film stock.

The two initial choices concern the options of color or black-and-white film and of using reversal or negative emulsions.

The decision of color versus black-and-white is in its nature both aesthetic and financial. To shoot a film in black-and-white becomes a visually strong graphic statement, particularly today, when the vast majority of films are shot in color. To some extent black-and-

59

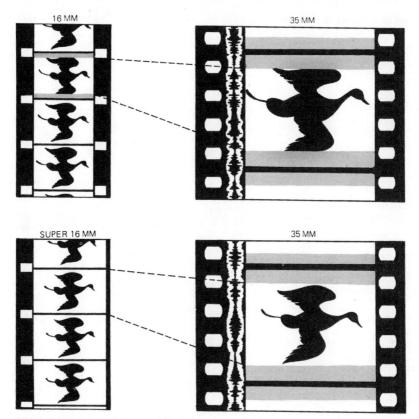

2.14 Advantage of Super-16 original when blowing up to 35mm for release.

white is becoming a lost art, and fewer labs are equipped for and knowledgeable enough to handle black-and-white film stocks. And yet, once every few years we see an ambitious film shot in this medium, often to provide a nostalgic look or to create the visual mood preferred for a given story.

On a more practical level, the decision to shoot on a black-and-white stock may be the result of budgetary restrictions. Both the black-and-white camera stock and the subsequent prints are much less expensive than color. When you decide to film in black-andwhite, you will need to shop around for the best available lab. You will be able to find out which lab deals best with the black-and-white film, both in processing and printing, by sending short rolls of identical tests to a few different laboratories.

Today, most professional film work is shot on negative, whether color or black-and-white. Not only do negative emulsions offer much wider exposure latitude than reversal stocks but there is also a large range in color and density correction in printing from a negative that is not available with the reversal emulsions.

A major advantage offered by the reversal stocks is the possibility of projecting the camera original, which comes out from processing as a positive. This is done when time is a decisive factor, but otherwise, to protect the original the normal practice of only projecting prints is followed.

Another advantage of working with a reversal stock is the possibility of superimposing white "burned in" titles in just one printing step (to be discussed in chapter 8).

Reversal emulsions are physically tougher and are less easy to scratch than the negative emulsions. Dust specks on reversal print black, whereas dirt on negative prints as more visible white dots on the screen.

At this writing, the majority of film productions shot in the United States are shot on Eastman Kodak film stocks, but Fuji films are also gaining a well deserved popularity.

60 CINEMATOGRAPHY

16mm Color Negative Stocks

- K Eastman Color Negative Film, Type 7291 3,200° K Tungsten Lamps—El 100 Daylight—El 64 (with Wratten #85 filter)
- ^{*} Eastman Color High Speed Negative Film, Type 7292
 3,200° K Tungsten Lamps—El 320
 Daylight—El 200 (with Wratten #85 filter)
- ✓ Fujicolor Negative Film F-64, Type 8610 3,200° K Tungsten Lamps—El 64 Daylight—El 40 (with Fuji LBA-12 or Kodak Wratten #85 filter)
- Fujicolor Negative Film F-64, Type 8610 3200° K Tungsten Lamps—El 64 Daylight—El 40 (with Fuji LBA-12 or Kodak Wratten #85 filter)
- ⁴ Fujicolor Negative Film F-64D, Type 8620 Daylight-El 64
- ✓ Fujicolor Negative Film F-125, Type 8630 3,200° K Tungsten Lamps—EI 125 Daylight—EI 80 (with Fuji LBA-12 or Kodak Wratten #85 filter)
- Fujicolor Negative Film F-250, Type 8650
 3,200° K Tungsten Lamps—El 250
 Daylight—El 160 (with Fuji LBA-12
 or Kodak Wratten #85 filter)
- Pujicolor Negative Film F-500, Type 8624 3,200° K Tungsten Lamps—El 500 Daylight—El 320 (with Fuji LBA-12 or Wratten #85 filter)

16mm Color Reversal Stocks

("Chrome" in the name always indicates color reversal emulsion; "Video News" indicates that the film is suitably balanced for television broadcasts.)

Eastman Ektachrome Video News Film, Type 7240 (Tungsten) 3,200° K Tungsten Lamps—El 125 Daylight—El 80 (with Wratten #85B filter)

Eastman Ektachrome Video News Film High Speed, Type 7250 (Tungsten) 3,200° K Tungsten Lamps—El 400 Davlight—El 250 (with Wratten #85B filter) Eastman Ektachrome Video News Film, Type 7239 (Daylight)

- Daylight-El 160
- 3,200° K Tungsten Lamps—El 40 (with Wratten #80A filter)

Eastman Ektachrome High Speed Daylight Film, Type 7251

Daylight-El 400

3,200° K Tungsten Lamps—El 100 (with Wratten #80A filter)

16mm Black-and-White Negatives

(Black-and-white emulsions are generally more sensitive to the blue part of the visible spectrum, hence the higher Exposure Index numbers for daylight than for tungsten light.)

- K Eastman Plus-X Negative Film, Type 7231 Daylight—EI 80 Tungsten—EI 64
- Eastman Double-X Negative Film, Type 7222 Daylight—El 250 Tungsten—El 200
- Eastman 4-X Negative Film, Type 7224 Daylight—EI 500 Tungsten—EI 400

16mm Black-and-White Reversal Films

Kodak Plus-X Reversal Film, Type 7276 Daylight—El 50 Tungsten—El 40

Kodak Tri-X Reversal Film, Type 7278 Daylight—El 200 Tungsten—El 100

Kodak 4-X Reversal Film, Type 7277 Daylight—El 400 Tungsten—El 320

FILM STORAGE AND HANDLING

To prevent undesired changes in the film stock, such as changes in color, sensitivity, and fog level, and to prevent shrinkage, all films should be properly stored and handled. Color film is especially sensitive to high temperatures and extremes in humidity. FILMS AND SENSITOMETRY 61

All films should be stored in a refrigerator, sealed airtight in their cans. Humidity of 70 percent or more should be avoided, as it may cause the cans to rust and damage the labels and the cartons.

For storage up to six months the recommended temperature is 55° F (13° C) or lower. For longer periods film stocks should be kept in a freezer at 0° F to -10° F (-18° to -23° C). When the film is taken out from the refrigerator, it must be allowed to warm up to room temperature before it is opened, or moisture may condense on its cold surface. This will take a single roll of 16mm film from thirty minutes to one hour. In a place with high temperature and humidity, extend this time to one-and-a-half hours. A carton of several cans may take twelve hours or more to warm up.

When shooting on location the film is usually preloaded into camera magazines, which should be kept in dustproof and moisture-tight metal magazine cases. These cases must be left in a cool place. When your car is parked in the sun its trunk becomes like an oven, so never keep your film there, even for a short period.

Before filming in really hot or humid areas or extremely cold areas, familiarize yourself with the appropriate Kodak pamphlets *and* the section in the *American Cinematographer Manual* dealing with film handling in these conditions.

When bulk film and magnetic tape has to travel on commercial airlines, advise the airline officials that it is perishable in extreme heat and that it should not be X-rayed or submitted to strong magnetic fields. Also write these instructions and the contents on the outside of the case in large red letters.

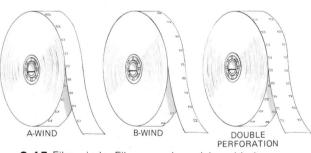

2.15 Film winds. Film wound emulsion side in.

Kodak literature warns us against storage areas where certain gases may be harmful to film stocks. They list such gases as formaldehyde, hydrogen sulfide, sulfur dioxide, ammonia, illuminating gas, motor exhaust, vapors of solvents, mothballs, cleaners, turpentine, mildew or fungus preventatives, and mercury.

Film deteriorates fastest between exposure and development, and so it should be processed as soon as possible after being shot.

FILM ORDERING INFORMATION

Schools and independent film makers can buy raw stock directly from Kodak at a substantial discount. Eastman Kodak Company Educational Marketing Division in Rochester, New York, can give you the address of the local distribution center. Also inquire at the Fuji Photo Film dealerships about the Fuji student discounts.

When ordering film, make sure to specify the type of perforations and "wind" that are correct for your camera. Almost all cameras require film wound *emulsion side in*. Single-sprocket cameras use either B-wind film or double-sprocket film. Some cameras will accept double-perforated film only. Very few cameras will accept A-wind film. It is mainly for printers.

"Pitch" refers to the distance between sprocket holes. High-speed cameras and print stocks require long pitch.

Emulsion is made up in batches, which yield thousands of feet of film. When ordering raw stock for a given production, it is advisable to secure all the footage with the same batch number. Different emulsion batches may have slightly different characteristics.

Film is cheaper when bought in bulk. It is common for amateurs to buy film in rolls of 400 feet or more and then break it down into 100-foot spools. This is often more trouble than it is worth. It should be pointed out, however, that when winding unexposed stock from reel to reel in a darkroom, there is a chance that spots and patterns will be caused by static electricity on the film. This can be prevented by grounding the rewind arms and winding the film slowly at an even speed.

FILTERS AND LIGHT

.............................

A cinematographer's primary concern is the manipulation of color, contrast, and texture. These qualities can be controlled either by changing the way in which the light falls upon the subject (as we will discuss in the next chapter), or by introducing a filter between the subject and the camera. To understand how light can be manipulated by filters, we will start by exploring just a little bit of light theory. Then we can discuss specific filters and their functions. (*Note:* There are several filter manufacturers, and some have different designation systems. For the sake of simplicity I will use Kodak Wratten filter numbers, unless I specify otherwise.)

THE ELECTROMAGNETIC SPECTRUM

The electromagnetic spectrum extends from cosmic rays to telephone impulses and beyond. Within this enormous range of wavelengths there is a narrow range of visible energy, called light. The rest is darkness to our eye. At each end of this visible spectrum there are invisible wavelengths—ultraviolet and infrared—that are not visible to the human eye but can be recorded on film.

The most common human experience of the entire visible spectrum is the rainbow. All the colors of the

rainbow are generated by the sun. *Together they appear white.* But when dispersed by the moisture in the air or refracted by a prism, the wavelengths are spread, thus creating a rainbow effect.

FILTER THEORY

The color of an object comes from the light falling on it. When white light (which contains all the visible wavelengths) falls on an object, some hues are absorbed. The other colors are reflected, giving the object an apparent color. For example, when white light strikes a "blue" object, the surface of the object reflects the blue light and absorbs all the other visible wavelengths, mainly red and green.

The color of the object will change when the light falling on it is not white. For example, when a "blue" object is illuminated by light *not* containing blue wavelengths, the object will appear black.

This brings us to the basic principle of filters. Filters modify light by absorbing certain colors and allowing others to pass.

When using filters we think of the spectrum as three primary colors: blue, green, and red. Any other color is a mixture of these three. We manipulate the primary colors by using their so-called complementaries: yellow, magenta, and cyan.

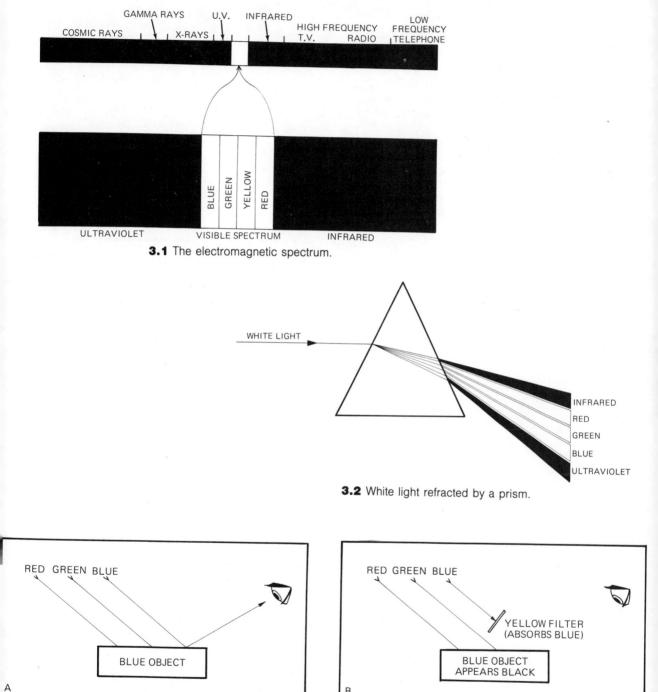

3.3 The color of an object depends on: A, the color absorbed by the object; B, the color of the light falling on the object.

В

64 CINEMATOGRAPHY

Yellow is called "minus blue," because a yellow filter stops blue and passes green and red, which together make yellow light.

Magenta is called "minus green," because a magenta filter stops green light and passes blue and red, which together make magenta light.

Cyan is called "minus red," because a cyan filter stops red light and passes blue and green, which together make cyan light.

These are the basic principles of filter formulas. In practice we do not always deal with pure primary and complementary colors, and so a wide variety of filters have been designed, each for a specific and limited job. There are three main areas of filter use: black-andwhite, color, and all-purpose. But before going further we must first consider filter factors.

Filter Factors

All filters absorb a certain amount of light reaching the film. Depending on the rate of absorption, the compensation in exposure is expressed as the filter factor. The filter factor represents the number of times we need to increase the exposure. When the factor doubles we increase the exposure by one stop.

Factor	Compensation
2 2.5	1 stop 1 ½ stops
3	12/3 stops
4	2 stops
5	21/3 stops
6	22/3 stops
8	3 stops
10	31/3 stops

For example, if the exposure for a picture is f/11 with no filter and we then decide to use a filter with a factor of 2, the exposure will have to be increased one stop to f/8.

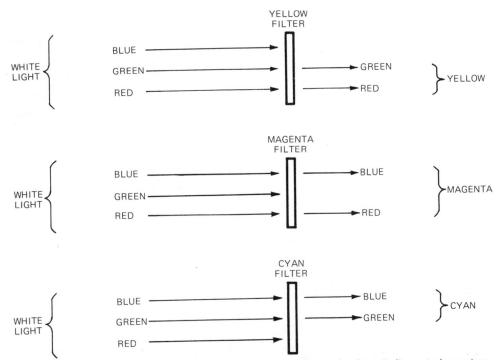

3.4 Subtractive filter principle. A filter passes its own color and subtracts its complementary.

When using more than one filter we *multiply* their factors, not add them. An alternate method is adding the required f-stop compensations for the filters.

For example, suppose we were combining two filters with factors 2 and 4, respectively. If we multiply the factors $(2 \times 4 = 8)$, a factor of 8 requires 3 stops compensation. If we add compensations, factor 2 requires 1 stop compensation, factor 4 requires 2 stops compensation, and 1 stop plus 2 stops equals 3 stops compensation. The same result is obtained by multiplying factors.

Exposure compensation tables are provided in the filter manufacturer's literature and in the *American Cinematographer Manual.*

USING FILTERS FOR BLACK-AND-WHITE FILM

Black-and-white film reproduces color in shades of gray. The human eye is not equally sensitive to all colors, seeing some colors, such as green, as brighter than other colors, such as blue. Similarly, black-andwhite films also have their own peculiarities. For example, they see blue as brighter than green and will record blue objects in a lighter shade of gray than green objects, the opposite of the human eye.

In black-and-white photography, filters are used to manipulate the emulsion's response to colors. You may *correct* the emulsion's response to match that of the human eye, or you may augment *contrast* between two colors that would otherwise appear as the same shade of gray.

Because black-and-white emulsions are "oversensitive" to blue light, the most common problem is the overbright sky. In such cases the sky appears as dead white. To correct this, we use a yellow filter, which absorbs blue light, thus slightly darkening the sky. Because the shadows are illuminated by blue light from the sky, they will also be darkened, thus increasing the overall scene contrast.

The orange filter goes further in darkening the sky and shadows. If we want to make cloud formations very visible, an orange filter can be used to accentuate the clouds by overdarkening the sky. A red filter will render the sky black and greatly accent clouds and contrast for a night effect. Of course, these effects are based on the elimination of blue light. If the sky is overcast (that is, white and not blue), such filters will not successfully darken the sky. (It should be noted that at altitudes above 3,000 feet the blue sky is much darker and often no filter is necessary to correct it. Even a light yellow filter may make it quite dark.)

Another very important use of the orange filter is for penetrating haze. Normally, haze is created by tiny water and dust particles suspended in the atmosphere. It scatters the shorter wavelengths of light, most notably blue. Because it absorbs blue, the orange filter can

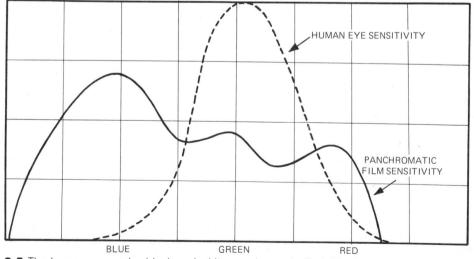

3.5 The human eye and a black-and-white panchromatic film differ in sensitivity to colors.

be used to diminish the effect of haze. However, haze cutting must be done with moderation, as haze gives a picture three-dimensional aerial perspective. If *all* haze were eliminated (such as with a red filter), the picture would appear flat.

When the subject is farther away from the camera, there is more atmosphere (hence potential haze) between the camera and the subject. For this reason, lenses longer than 250mm will frequently require an orange filter for outdoor use. This is because the subject is usually a considerable distance away when such a lens is used.

To *increase* haze, as when one wants to exaggerate atmospheric depth, a pale blue filter will help.

For portraits, filters are often used to improve or modify skin tones. In close-ups the orange filter will darken blue eyes and eliminate all or most of the freckles and skin blemishes. A #15G filter is commonly used for this purpose. A green filter, on the other hand, would darken the skin for a suntan effect while emphasizing freckles and blemishes.

Filters can be used to improve the rendition of foliage. In nature our eyes can distinguish many shades of green. Without filters, black-and-white film emulsions tend to darken greens and eliminate tonal gradations. A green or a green-yellow filter will help to differentiate the green tones but will not lighten foliage as much as we might expect. Actually foliage reflects much red light and infrared radiation, and therefore an orange or red filter will brighten greens. If infrared film is used with an infrared filter, the foliage will appear as white.

FILTERS FOR COLOR USE

In black-and-white photography, colored filters can be used to augment contrast or in some other way alter the way in which the emulsion translates colors into shades of gray. However, when filming in color the film will record the color of the filter. Therefore, in color work the principal task of filters is to keep the colors faithful.

As we mentioned before, white light contains all the colors of the spectrum. But the *exact* color of the light depends on the *temperature* of its source. For example, if we heat up a piece of metal it will glow red. If we heat it up even more it will glow white. The sun is burning "white hot" and therefore glows white. The tungsten filament in a light bulb, however, is burning at a lower temperature and therefore only emits a reddish yellow light.

Our eye adapts so easily between these color temperatures that we see them both as white unless they are placed side by side. If such a comparison were made, the outdoor light would appear to contain just a bit more blue light and the artificial light would show more reddish. Color film will not adapt so easily between these different sources. Therefore, an emulsion must be designed for a specific color temperature.

To define the exact color temperature of a given light source, scientists compare it to a "black body." This laboratory instrument is dead black when cold. As it is heated, it starts glowing, changing color as the temperature rises. The temperature is measured in degrees Kelvin. Each color radiated by the black body can be described by its color temperature in degrees Kelvin. We think of red as a warm color and blue as a cold color, but the Kelvin degree ratings show them as just the opposite. Some color temperature ratings of common light sources are:

Source	Color Temperature
Candle flame 60-watt household bulb Film-studio lights Photoflood lights Sunset in Los Angeles Noon summer sunlight Hydrargyrum Medium Arc-length lodide (HMI)	1,500° K 2,800° K 3,200° K 3,400° K 3,000° to 4500° K 5,400° K 5,600° K
Lamp Blue sky light Clear blue northern sky	approximately 10,000° K up to 30,000° K

Color emulsions are balanced either for tungsten light—code B ($3,200^{\circ}$ K)—or for "daylight"—code D ($5,600^{\circ}$ K)—film type. By this we mean that $3,200^{\circ}$ K light will appear white on color film balanced for $3,200^{\circ}$ K. Normal daylight will appear white on film balanced for daylight.

If the light source and the emulsion balance do not match, the color reproduction will be biased. For example, if a "tungsten" emulsion $(3,200^{\circ} \text{ K})$ is shot outdoors in noon daylight $(5,600^{\circ} \text{ K})$, the entire scene will appear to be bluish. The opposite is also true. A

				A second s
Filter Color	Filter Number	Exposure Increase in Stops*	To obtain 3200 K from:	To obtain 3400 K from:
Bluish	82C + 82C 82C + 82B 82C + 82A 82C + 82 82C 82B 82A 82A 82	$ \begin{array}{c} 1 \frac{1}{3} \\ 1 \frac{1}{3} \\ 1 \\ \frac{1}{3} \\ \frac{2}{3} \\ \frac{2}{3} \\ \frac{1}{3} \\ \frac{1}{3} \\ \frac{1}{3} \end{array} $	2490 K 2570 K 2650 K 2720 K 2800 K 2900 K 3000 K 3100 K	2610 K 2700 K 2780 K 2870 K 2950 K 3060 K 3180 K 3290 K
No Filter Necessary			3200 K	3400 K
Yellowish	81 81A 81B 81C 81D 81EF	1/3 1/3 1/3 1/3 2/3 2/3	3300 K 3400 K 3500 K 3600 K 3700 K 3850 K	3510 K 3630 K 3740 K 3850 K 3970 K 4140 K

KODAK Light Balancing Filters

*These values are approximate. For critical work, they should be checked by practical test, especially if more than one filter is used.

3.6 Kodak light-balancing filters. (Courtesy of Eastman Kodak)

daylight-balanced film shot indoors under tungsten illumination without the proper correction filter will yield an orange picture.

In such situations we must use a *color conversion filter* to correct the color balance of the light entering the lens. The most common conversion by far occurs when indoor $(3,200^{\circ} \text{ K})$ film is being shot outdoors. This requires an orange #85B filter, which "warms up" the daylight, lowering the color temperature of the incoming light to 3,200° K in order to agree with the film. A #85 filter is slightly "cooler." It lowers the daylight color temperature to 3,400° K, leaving the light with a larger content of blue.

Although rarely done, the opposite conversion daylight emulsion used under $3,200^{\circ}$ K lights—can be accomplished by using a Wratten #80A blue filter.

When the orange #85B filter cuts the exposure down by $\frac{2}{3}$ stop, the #80A blue filter requires a compensation of 2 stops.

Color conversion filters are used for broad modifications of color. More exact corrections in color temperature are done by the lab timer in the printing process. The type of filter used during printing is called a color compensating, or CC, filter. These come in six basic colors, three primary (red, green, blue) and three complementary (cyan, magenta, yellow). They are available in seven densities. Occasionally, they may be used while shooting—for example, if a particular lens produces a slight color cast, or when the emulsion has to be color balanced to some unusual light source, such as fluorescent or a mercury vapor light.

Some minor color changes can also be accomplished by using light-balancing filters. These are designed to obtain a bluer (#82 series) or yellower (#81 series) rendition of color. For example, daylight emulsions are balanced for noon daylight. However, color temperature of daylight changes from reddish at sunrise to bluish at noon and back to reddish at sunset. From about two hours after sunrise until about two hours before sunset these changes are minor. But in the early morning and late afternoon the color changes rapidly. Some cinematographers like to correct these changes while shooting in order to avoid a discrepancy in color between shots that must later be edited together. This way, even the dailies printed from the original footage with only broad color correction will look acceptable when screened.

It is sometimes undesirable to completely "correct"

color temperature. For example, if we are filming a reddish sunset, it is better to leave it uncorrected than to change it into white daylight. Sometimes a partial correction is desirable by replacing an #85B filter with a yellowish light-balancing filter #81 EF, sometimes referred to as $\frac{1}{2}$ #85.

The key question to ask is whether the nonwhite light is motivated. If two actors are standing near an open fire, it is entirely reasonable that their faces should be illuminated by reddish light. In fact, at times we may use color filters to distort the existing color, to make the image more logical. For example, if an actor is outside at night, supposedly illuminated by moonlight, a light blue filter gel may be used on the light for psychological realism.

To determine the proper light-balancing filter for converting a given light to the correct color temperature required for a given film, we use a color temperature meter.

3.7 Minolta Color Meter II. A three-color temperature meter which indicates appropriate correction filters. *(Courtesy of Minolta Corporation)*

This meter will determine the exact color temperature of the light falling on the subject. It should be pointed directly into the light source being measured. The less expensive color temperature meters measure only two colors—red and blue—and indicate which filter is required to achieve the proper color balance. These meters cannot handle fluorescent light, in which green content will affect the image substantially. For measuring lights that have unusual spectral characteristics, such as fluorescent and mercury vapor, threecolor meters were designed to measure red, green, and blue.

Many cinematographers consider the color temperature meter a luxury that they can survive without. Others see it as an important tool in controlling the color standards of their lighting.

A standard that should be be of great concern to any film maker is to enforce the uniformity of color temperature among all the light units that he is using. A conscientious cinematographer or his gaffer will find, for example, that the new HMI[™] lights may be close to 6.000° K, while an old one can be down to 4,800° K. Smaller units (750-watt, 1,200-watt, 2,500watt) are often too green. Checking the globes with a color temperature meter will allow the cinematographer to balance them out with color gels. It is advisable to mark the recommended corrections on a piece of tape placed on the yoke of each light. If the cinematographer decides that he wishes all his HMIs to give a bit "warmer" light, he may balance them to lower the color temperature to, say, 5,200° K with proper gels (on top of the previously discussed individual lamp corrections).

MIXED LIGHT SOURCES (DAYLIGHT, FLUORESCENT, AND TUNGSTEN LIGHT)

Fluorescent light is an odd light source that rates a discussion of its own. Its peculiar characteristics make it somewhat of a headache when filming in color.

As we mentioned at the beginning of this chapter, white light contains all the colors of the rainbow. Tungsten light also contains all the colors but in a different proportion—more red and less blue. The majority of fluorescent tubes, on the other hand, do not contain the entire spectrum. The electrified gas inside a fluorescent tube emits only a few distinct wavelengths. This light is rich in green but deficient in red. This statement holds true when dealing with the most often encountered varieties of fluorescent tubes, namely Daylight, Cool White, and Warm White. There are, though, a number of newer fluorescent lamps characterized by so-called "continuous spectrum light," which emits a light comparable to tungsten or daylight. Optima[®] 32 (Duro-Test[®] Corporation) is an example of a fluorescent tube closely matching 3,200° K tungsten light, as opposed to Vita-Lite (by the same manufacturer), which matches daylight. Also not far from matching daylight is Chroma 50 Chromaline[™] (General Electric).

When a budget and time allows it, such fluorescent tubes can be rented and installed to meet production needs. Unfortunately, in the majority of cases the film maker is faced with locations where replacing the existing tubes would be prohibitive in both money and time. Other strategies have to be used to match the light sources to each other and to the type of film being used.

Let's look at a hypothetical scene and three lighting situations. For the sake of simplicity we will use the color designations of two gel manufacturers, Lee Filters and Roscolab.

Scene One

The first scene, shown in figure 3.8A, takes place in an interior illuminated by the most commonly encountered Cool White fluorescent tubes and by daylight coming through the windows of the location. We are planning to use HMI lamps as additional sources.

We are shooting this scene on color negative $(3,200^{\circ}$ K). We can call this our first lighting scheme, a daylight-plus-green plot. The windows will be gelled with Rosco #3304 Tough Plusgreen/Windowgreen and the same gel will be used on the HMI lamps. Tungsten lights will be gelled with Rosco #3306 Tough Plusgreen 50, or with #241 Lee Fluorescent. The only light source that will be without a gel is the fluorescent light. We could also use additional fluorescent tubes as fill light.

With all sources matched to fluorescent Cool White, all that remains to be done on the camera is to use a fluorescent-to-tungsten converting filter known as FLB (such as FL-B[®] Tiffen[®]) to convert the incoming lights to 3,200° K. Should our film stock be a day type emulsion, the camera filter to use would be the FLD. These filters (FLB and FLD) require exposure compensation of one stop. If we cannot afford this one stop loss due to low light levels, we could make a partial correction using a #20 magenta filter to remove some of the green, leaving the rest for the lab to correct in postproduction. One should always remember that printing from a negative allows a greater latitude in color corrections than in the use of reversal. Some film makers opt to have the lab do all fluorescent correction on prints from a negative. Prior consultation with the particular lab, however, is a must in such a case.

Scene Two

Our lighting scheme for scene 2 is shown in figure 3.8B. This time the windows will be left unfiltered and all the other light sources will be matched to daylight. The Cool White fluorescent tubes will now be covered with Rosco #3308 Tough Minusgreen gels to filter out the excessive green. HMI lamps will remain unfiltered as they are matching daylight, and tungsten lights will be gelled with Rosco #3202 Full Blue, or Lee #201 Full C.T. Blue, to convert their color temperature to daylight.

If the camera is loaded with tungsten balanced film, a #85B filter will have to be used on the lens, since all the light sources will be converted to daylight. In this scheme, covering all the fluorescent tubes with Rosco #3308 Tough Minusgreen gels may become a logistical problem. We could try to avoid doing this by overpowering the scene with our daylight-balanced lights (HMI, FAY) and leaving the fluorescent tubes ungelled. This works particularly well when the scene is covered in shots that do not reveal large spaces and when the fluorescent fixtures are not visible in the frame. A color temperature meter that measures red, green, and blue colors will prove handy in such an operation.

Scene Three

Our third scheme of color balancing, the scene in figure 3.8C, will aim at having all the sources converted to 3,200° K.

The windows will be gelled with Rosco #3401 Roscosun 85, or with Lee #204 Full C.T. Orange, and the Cool White fluorescent tubes will be covered with Rosco #3310 Fluorofilter gels. The tungsten lights will remain unfiltered and the HMI lamps will be gelled with Rosco #3106 Tough MTY or Lee #236 HMI. With all the light sources converted to 3,200° K, no filter is needed on the camera lens.

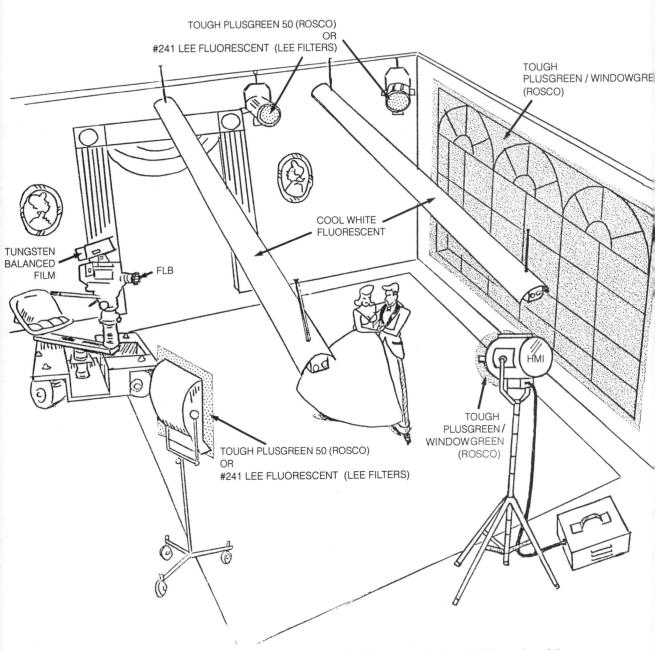

3.8A All light sources in this scene are balanced with proper gels to match the color of the fluorescent tubes. Lens is equipped with an FLB filter to convert the light entering the lens to 3,200°K required for the tungsten balanced film stock. (*Drawing by Robert Doucette*)

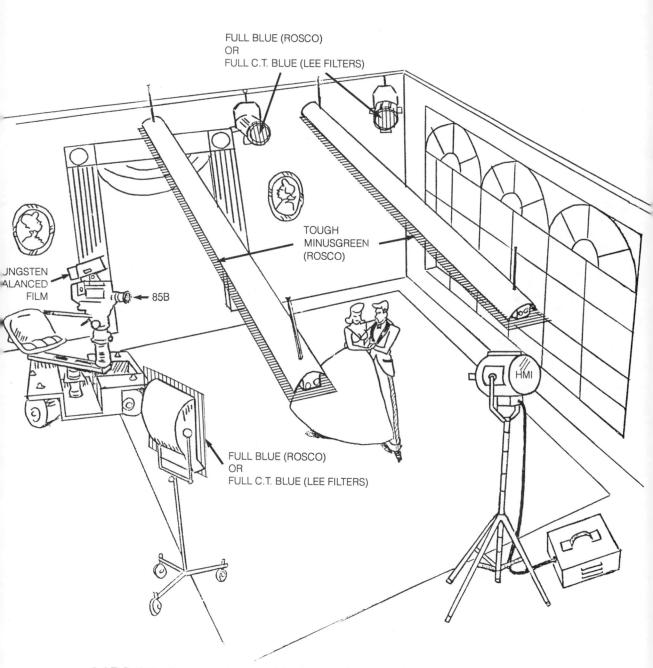

3.8B Both the fluorescent tubes and the tungsten lamps are balanced with gels to match the color temperature of daylight. HMI lamp produces a daylight-matching light without any correction. Lens is equipped with an 85B filter to convert the daylight entering the lens to 3,200°K required for the tungsten balanced film stock. (*Drawing by Robert Doucette*)

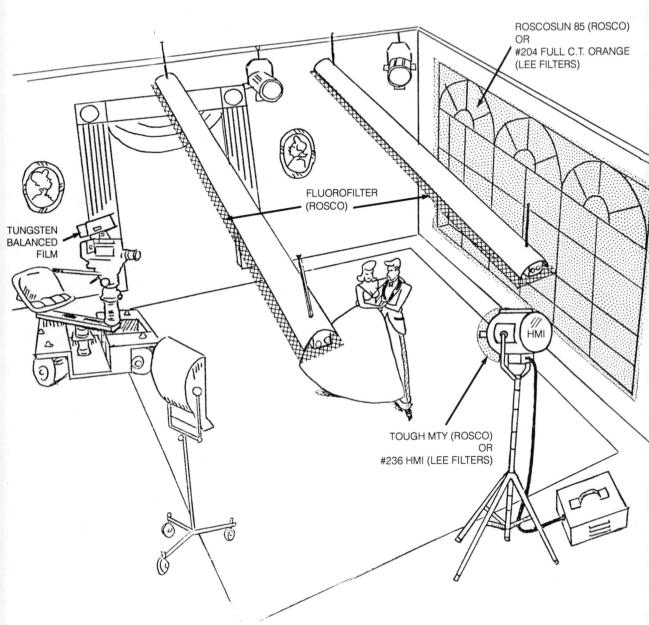

3.8C The daylight sources (window and HMI lamp in this scene) and the fluorescent tubes are all converted to 3,200°K with proper gels, to balance them to tungsten light. With all the lights matching tungsten, there is no need for a color conversion lens filter. 3,200°K balanced film stock will match this overall lighting scheme.

ALL-PURPOSE FILTERS

Some filters are suitable for use with either black-andwhite or color films. These include ultraviolet, neutral density, diffusion, and polarizing filters.

Ultraviolet filters are sometimes referred to as haze filters because ultraviolet light is scattered by atmospheric haze. When unfiltered it will cause distant landscapes to appear flat and open shade will show a bluish cast. The effects of ultraviolet radiation are particularly pronounced in the mountains. The filter most often used for cutting haze and slightly warming the scene is #1A. Fog is different from haze and will not be penetrated by this filter. It is important to bear in mind that all filters in the yellow, orange, and green series also stop ultraviolet radiation. Therefore, when we are already employing a #85B filter, it will also take care of the ultraviolet light.

Neutral density filters are designed to cut down overall brightness and reduce all colors equally. They are often used when the light intensity is too high for the given emulsion (for example, when shooting on a fast emulsion outdoors in bright sunlight). Neutral density filters are also used to avoid having to stop the lens down too far. There are two reasons for doing this. Lens optics are better at f/11 than at f/16 or f/22. Furthermore, stopping down increases the depth of field, which may not be desirable if, for example, we want to separate the subject from the background. Neutral density (ND) filters are calibrated by their density. The most frequently used are ND 0.3, ND 0.6, and ND 0.9, representing exposure reductions of one, two, and three stops, respectively. Some other filters are manufactured in combination with neutral density filters. For example, a #85N3 is a single filter combining a #85B with a ND 0.3 filter.

A neutral density filter that does not cover the whole frame comes as a graduate or an attenuator. The "grad" has a soft bleed line that separates the ND part of the filter from the clear part. Custom designed filters may have this dividing line at different levels and angles to fit a particular horizon line. The graduate is most often used to darken the sky. Used vertically, a graduate can be used to darken the sunny side of the street or a particularly bright building. For a sunset effect an orange graduate is available.

The attenuator is designed to give gradual darkening of the frame. It may be two stops darker on one end (ND 0.6) and then lose its density gradually until the other end becomes clear glass. There is no exposure compensation required with grads or attenuators. Unfortunately, panning and other camera movements may betray the presence of this filter, so the camera should usually remain stationary when it is being used.

Neutral density filters absorb light. *Diffusion filters*, on the other hand, scatter light and thus reduce resolution. Such devices were quite often used in older Hollywood films to soften the faces of aging actresses. Sixteen-millimeter is not as sharp as the 35mm format,

Neutral Density	Percent Transmission	Filter Factor	Increase in Exposure (Stops)
0.1	80	11/4	1/3
0.2	63	11/2	2/3
0.3	50	2	1
0.4	40	21/2	11/3
0:5	32	3	12/3
0.6	25	4	2
0.7	20	5	21/3
0.8	16	6	22/3
0.9	13	8	3
1.0	10	10	31/3
2.0	1	100	6 ² / ₃
3.0	0.1	1,000	10
4.0	0.01	10,000	131/3

KODAK WRATTEN Neutral Density Filters No. 96

3.9 Kodak Wratten neutral density filters #96. (Courtesy of Eastman Kodak)

74 CINEMATOGRAPHY

and therefore diffusion in 16mm is not necessary for quite the same reasons. It is rather used for strong desaturation of color and for special effects.

Diffusion filters come in a range of gradations. In addition to commercially made filters, many materials have been used for diffusing "scrims," such as black net, white gauze, pantyhose, and piece of optical glass smeared with petroleum or glycerin.

Like diffusion filters, *fog-effect filters* scatter light. However, they are designed for the special task of creating fog by scattering light from the bright picture areas into the shadows, thus creating a grayish appearance and flares on the highlights. No exposure compensation is required because the light is merely scattered, brightening the shadows.

Different in structure are *double fog filters*. They create the effect of fog without reducing the image definition as much as regular fog filters. At their lower density range ($\frac{1}{8}$, $\frac{1}{4}$, $\frac{1}{2}$, or 1) the fog effect is minimal, but they help to cut down contrast and desaturate harsh colors.

Neither fog nor double fog filters create a very convincing effect of actual fog, which in nature progressively hides objects as they recede in depth. To help this problem, Harrison & Harrison designed a Scenic Fog Filter, which could be described as a fog graduate. When the less dense half of the filter covers the lower section, the foreground objects are less affected. If this position is reversed, however, the lower part part is foggier, creating the effect of low-lying fog.

Low-contrast filters are useful for dealing with heavy contrast on an exterior, particularly when the shots may have to be matched with previously shot footage of the same area on a smoggy day.

Interesting filters coming out of England are the Frost Filters from Wilson which affect the black values less than low contrast filters and rather soften the edges of the highlights.

Most of these diffusing or contrast cutting filters do not require more exposure. On the contrary, lowered contrast, especially in already low-contrast subjects, may appear as overexposed images and therefore some minor exposure reduction is sometimes needed to prevent slight flaring. On the other hand, the light-diminishing characteristics of homemade diffusion devices—such as a clear glass smeared or sprayed with glycerin, or nets such as pantyhose—should be tested by holding the "filter" in front of an exposure meter.

The effectiveness of all these diffusion filters depends on the f-stop, the focal length of the lens, and the subject's size in the frame. Stopping down decreases the effect of diffusion or fog. On the other hand, the wider the lens opening, the more the "blooming" effect the fog filter will produce.

Fog and diffusion effects will also increase with longer focal length for the same filter grade. This actually works quite well when a longer lens is used for a close-up, because in close-up work the detail to be diffused is larger, requiring greater diffusion than in a long shot. When viewed through a reflex camera, the diffusion (or fog) effect usually looks heavier than the final result. More accurate evaluation is possible when looking through a combination of the viewing glass (to be discussed in the next chapter) and a given filter. Familiarizing oneself with the effects of different filters by shooting extensive tests is highly recommended.

Unlike fog and diffusion filters, which scatter light rays, the *polarizing filter* "straightens" the light into parallel planes in which the light vibrates in the same direction.

- 1. Light vibrates in all directions along its axis (path). See figure 3.10.
- When light reflects from surfaces like glass or water it becomes polarized (i.e., vibrates in only one direction).
- A polarizing filter correctly positioned can stop polarized light.
- 4. This filter will *pass* previously unpolarized light, *polarizing it in the process.*
- 5. This light will be the image that reaches the film.

A polarizing filter (polarizer) can be used to minimize the reflections in glass (such as in shop windows) and is most effective when the angle between the optical axis and the glass surface is about 34° (see figures 3.11, 3.12, and 3.13). If the surface is being photographed "straight on" (about 90°) the filter will have little or no effect (see figures 3.14 and 3.15). This filter must be used in moderation, however. Complete elimination of all glare and reflections dulls the picture, giving it a flat look. If overdone, it could even make the surface disappear. For example, if you are photographing a beautiful clear pond and use a polarizing filter to make the bottom more visible, the pond might appear not to have any water in it.

Unlike glass or water, metal surfaces do not polarize light, and so to eliminate glare from metal surfaces, polarizing filters must be put on both the camera lens and on the light sources.

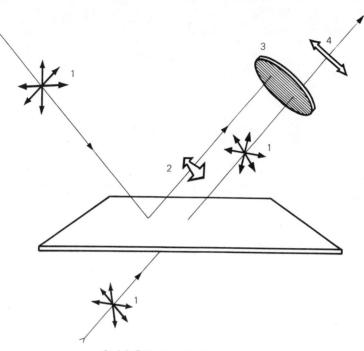

3.10 Polarized light theory.

When setting a polarizing filter, it is rotated to obtain the desired degree of effect. It will have either a dot or a handle that when pointed toward the source of light (such as the sun) gives maximum glare elimination. This effect is most pronounced when the sun is at 90° to the lens-subject axis (see figure 3.16).

In color photography, polarizing filters (of the colorless variety) have several important functions. Blue sky can be effectively darkened if the sun is 90° from the optical axis (see figure 3.17). If we are shooting either toward the sun or 180° away from it ("down sun"), the effect is minimal. The white clouds against a blue sky will be accentuated when the sky is darkened. However, if the sky is white, as it often is down near the horizon or on overcast days, the polarizer will have little or no darkening effect.

In color photography a polarizing filter is also used for haze penetration.

Because a polarizer will eliminate glare from the surface of objects that normally would have a certain amount of it, such as leaves, flowers, certain textiles, etc., the color saturation will often increase.

A fader device for amateur cameras can be made

from two polarizing filters. The two filters are placed on the lens and counter-rotated for a gradual elimination of light. This is not a professional practice, however, and serious film makers have such effects done in the lab.

The filter factors for polarizing filters are not constant. The basic factor is about $2\frac{1}{2}$ (i.e., $1\frac{1}{3}$ stops), regardless of the filter's position. An additional factor of up to 2 (i.e., one more stop) may be needed, depending on the rotation and light angle. The total factor can be measured by placing the filter in front of the light meter at the same angle of rotation as it will be on the lens. When taken from the camera position, such a reading is fairly accurate. A "spot meter" (to be discussed in the next chapter) is ideal for this purpose, as it allows you to take the reading while you are looking through the meter to see the degree of glare reduction.

Beginners frequently make the mistake of overcompensating for a polarizing filter. Therefore, one should remember to use caution to avoid overexposing the picture and thereby losing color saturation and washing out detail.

3.11 34° without filter. (Photo by author)

3.12 34° with filter. (Photo by author)

3.13 When the window is photographed "straight on" the filter will have a minimal effect.

ANYONS TH

3.14 90° without filter. (Photo by author)

PI BICTURES PILY

3.15 90° with filter. (Photo by author)

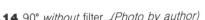

FILTERS AND LIGHT

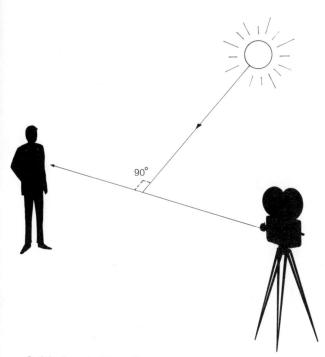

3.16 A polarizing filter most effectively eliminates glare when the sun (or other light source) is 90° to the lens-subject axis.

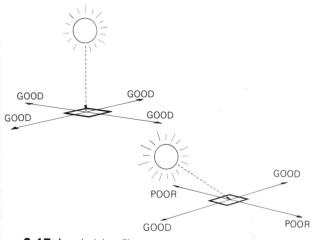

3.17 A polarizing filter most successfully darkens a blue sky when the lens-subject axis is 90° to the sun.

PHYSICAL CHARACTERISTICS AND MAINTENANCE OF FILTERS

Filter gels are optically the best constructed filters because they are thin. Unfortunately, they are soft and easily scratched. Once damaged, they cannot be repaired and must be replaced. Fortunately, gels are the least expensive type of filter. To prevent damage, they should be handled by their edges. Fingerprints on the surface cannot be removed. A soft camel's hair brush or an air syringe might be used to remove dust, but not much else can be done. Gels are also sensitive to moisture or prolonged direct sunlight. As a result they should be stored flat in a dry place.

When a gel is cut to fit a particular filter holder, it should be placed between two pieces of paper and cut with sharp scissors. A filter slot inside the camera gives an advantage of having the gel more protected from dust and the possibility of scratching. At the same time, if the slot is very close to the film plane there is a danger that any filter imperfection will register on the film. There is also concern about the back focus, which will shift by about one-third the thickness of the gel. This could affect the focusing of wide-angle lenses, particularly at the wide end of a zoom range. When using a fixed focal lens on a reflex camera, this small focal shift can be compensated for when focusing by eye. Stopping down the lens will also improve its performance.

Glass filters cannot surpass the optical quality of a gel, but they are much easier to handle. They come in three designs. One type consists of a colored gel cemented between two sheets of optical glass. This filter should never be washed or exposed to moisture. This may result in the swelling of the gelatin and the ruining of the filter.

An excellent type of glass filter is made by laminating two pieces of optical glass together, with organic dyes mixed in the cement.

The cheapest and least satisfactory filters are made by adding the dye directly to the glass during the manufacturing. In this process it is difficult to control the exact color rendition given by these filters.

When shooting footage that is to be edited together, it is a good idea to stick to one brand and design of filter. Different brands may have slightly different colors.

As lenses vary in size, so do the filters. One must be sure to get the proper size and type of filter so that it will fit onto the equipment being used.

77

Above all, the quality of the filter is most important. It is ridiculous to spend several thousand dollars on an excellent lens and camera and then save money by getting a poor filter or by using a gel that is slightly damaged and should be replaced.

Remember that gels manufactured for use on light sources are not good enough optically to be used on camera lenses. To make sure that filters are of the highest quality, cinematographers should be well informed about the leading manufacturers in this field. The catalogs of such companies as Harrison & Harrison, Lee Filter, and Tiffen are a great source of information about the range of available filters and their characteristics.

LIGHTING

.........

Lighting is the most important element in cinematography. It is the task to which a cinematographer gives his primary attention. He studies the characteristics of his film stock so that he may predict what effect it will have in translating his scene onto the screen. He then manipulates the lights accordingly. Filters are an aid in modifying that translation. But it is lighting that shapes the reality in front of the lens, giving it depth or flatness, excitement or boredom, reality or artificiality. Cinematography attempts to create and sustain a mood captured on the screen. In this respect, lighting is at the heart of cinematography.

CHARACTERISTICS OF LIGHT

As discussed earlier, a certain overall *quantity* of light is necessary to register the picture on film. However, the way in which the scene will be portrayed on screen depends on the *quality* and *distribution* of the light. There are three distinct aspects to be considered: whether the source is "hard" or "soft," the angle of the "throw" (the path the light follows), and the color of the light.

A source can be described as hard or soft, depending on the type of shadows it creates. Light that travels directly from the filament of the bulb to the subject with only a lens in between will usually cause sharply defined deep shadows. If the light is bounced off some diffusing reflecting surface, or if it is diffused by some translucent substance suspended between the light and the subject, the shadows will be weaker and less sharp. The diffusing surface acts as a multitude of small sources, all washing out one another's shadows.

The hardness or softness of light depends on the size and distance of the effective source. For example, if the effective source is a large surface from which the light is bounced, it creates a softer illumination than would be obtained if the light came directly from the filament of the bulb. The most extreme example of a soft light is a blue or overcast sky. As for distance, the sun-by no means a small source-creates sharp shadows because it is so far away that its rays are almost parallel when they reach the earth. On the moon, where there is no atmosphere to scatter and diffuse the sunlight, this hard quality is most pronounced. The sky is black, shadows are dramatically dark, and contrasts are extreme. On earth the atmosphere scatters the sunlight. Our sky acts as an enormous soft source that fills in the shadows left by the sun. If the sun is completely diffused by the atmosphere, as on an overcast day, the gray sky is the only source and the soft light creates a shadowless effect.

The second aspect of light quality is the angle of the

80 CINEMATOGRAPHY

throw. The direction from which the light comes will suggest the mood of the scene, the time of day, and the type of location. It will also model the objects in the scene, bringing out their shape and texture, or perhaps intentionally not revealing shape and texture.

The third aspect of a light source is its color. Often the creative use of color is not aimed at realism, or the situation justifies a color light source other than the proper color temperature. In such cases, gelatin filters might be used on the light *sources*.

Studying the light around us in every type of location, time, weather, and season is the best way of learning about these light characteristics. The second best way is to watch films with lighting in mind (preferably without sound).

STYLES IN LIGHTING

In the traditions of motion-picture lighting, it is possible to distinguish various stylizations, just as in the work of the great masters of painting. The three most pronounced styles used by cinematographers are highkey (such as in the paintings of Turner, Whistler, and some of Degas), low-key (such as in the paintings of Rembrandt and Caravaggio), and graduated tonality (such as in the paintings of Ingres).

A high-key scene is one that appears generally bright. It is best achieved in cooperation with the art director, as the sets and costumes should be in light tones. The lighting for a high-key effect will often employ much soft, diffused illumination with relatively few shadows. It is important to include at least a few dark areas to indicate that the highlights are not simply overexposed.

If, on the other hand, only a few areas of the frame are well lit and there are many deep shadows, the effect is *low-key*. There is a popular fallacy that to achieve a low-key effect one has merely to underexpose. In fact, it is the *ratio* of dark shadow area to adequately lit areas that creates a low-key effect. Here again the art director can help, this time by providing darker sets and costumes.

Graduated tonality is intended to produce a tonal effect of gradated grays. It is often achieved by soft light evenly illuminating the scene, creating weak shadows with the tonal gradations often painted onto the sets or created in the actor's costumes and makeup. Sometimes artificial shadows are painted on.

These three stylizations by no means cover all the approaches to lighting the film.

4.2 A soft light. Light from the bulb reflects from the

large inner back surface, creating soft illumination.

Long before shooting, the director and the cinematographer should discuss the style or approach to be taken in the film. This will depend to a great extent on the mood and character of the story, or perhaps of each scene. For example, a drama is most often done in a low key while a comedy is usually more effective in a high key. All sorts of films could be done in gradated tonality. There are no set rules about what style should be used with what type of film. It is all up to the director and cinematographer.

LIGHT FUNCTIONS

In creating and maintaining a style, the haphazard approach is bad. We have to know exactly what each lamp is doing for us and why we are putting it in a given spot. To simplify things a terminology was developed, naming the functions of the lights.

The key light is the main source of light for a given character while at a certain place in the scene. (If the character moves about he may have several key lights.

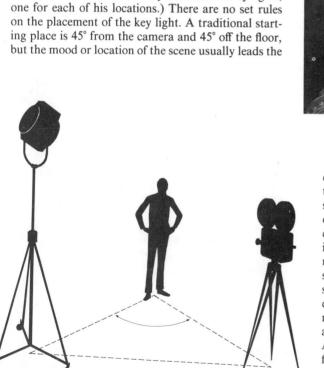

4.3 Key light "outside the actor's look." The actor's sight line runs between the camera and the light.

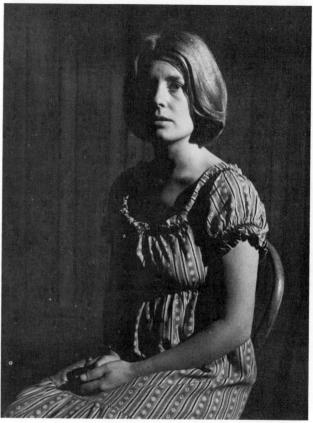

4.4 Key light only.

cinematographer to put it elsewhere. Another rule of thumb suggests that the key should come from "outside the actor's look." That is, if the actor is looking off camera, which is usually the case, the key should come from the other side of his line of sight so that he is looking between the camera and the key light. This means the downstage side of his head will be in shadow, giving his features a pleasant three-dimensionality, but this rule, like the 45° rule, is very frequently ignored. It is very interesting to note that many of the masters of painting most frequently use a "key light" coming from the left side of the canvas. A cinematographer rarely has so much freedom. The final position of the key light will depend on the mood, the actor's features, the set topography, the supposed time of day, etc. The key's position will determine the shadow pattern on the face.

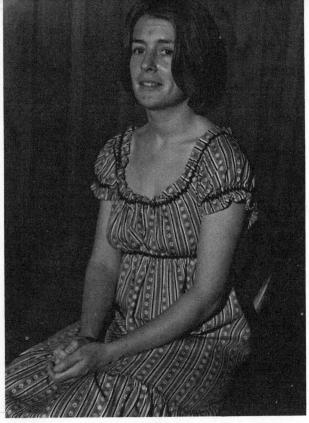

4.5 Fill light only.

A *fill light* is used to fill in the shadows created by the key light. It should not create additional shadows and therefore usually comes from fairly near the camera. In Hollywood studios, fill light was sometimes introduced by a frame of bulbs around the lens. This practically eliminated the possibility of creating shadows visible through the lens. Today, soft-light sources are often used for fill. The shadowless quality of soft light allows for greater freedom in placing the fill and is especially useful in television studios where all lights are hung from above and the action must be properly lit for several cameras at a time. When trying to achieve dramatic low-key effects the fill light is frequently omitted.

The third principal light is the *back light*, which is designed to separate the actors from the background. This adds three-dimensionality to the picture. This light is often omitted by cameramen who believe in realism and do not want an unmotivated source of light illuminating the picture. The back light is positioned above and behind the actor. It illuminates the top of his shoulders and head.

Similar in function but different in placement is the *kicker light*. It works from a three-quarter-back posi-

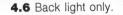

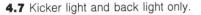

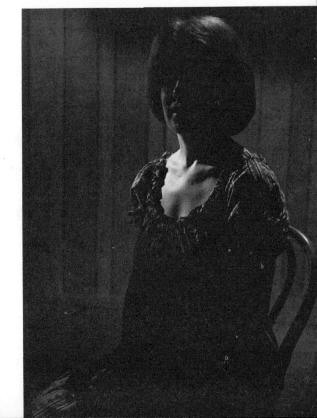

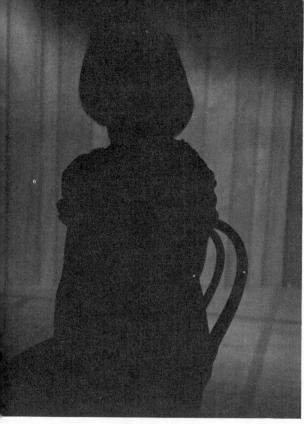

4.8 Set light only.

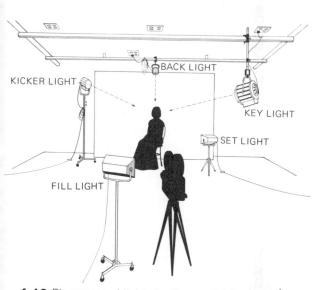

4.10 Placement of lights for figures 4.4 through 4.9.

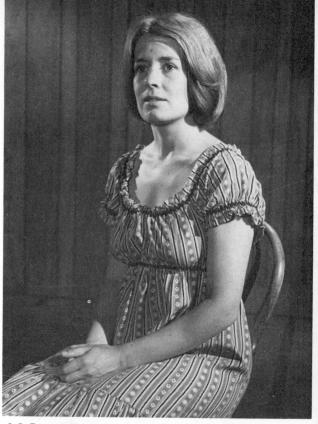

4.9 Portrait illuminated by key, fill, back, kicker, and set lights. *(Photos by author)*

tion on the opposite side of the key light. It is often placed lower to the floor than the back light. The use of back lights and kickers depends entirely on the situation. Sometimes one, both, or neither will be used. They are introduced at the discretion of the director of photography.

The lighting may also require effects lights—for example, a clothes light to bring up the texture of a costume. Another effect light, the *eye light*, is usually a small hard-light source either positioned near or mounted right onto the camera. It acts as a weak fill light that mainly fills in the actor's eye sockets. Its reflection provides a lively sparkle in the actor's eye. It is recommended when photographing an actor with dull or deeply set eyes. Some cinematographers mount the eye light on the camera, just above the lens, and use it in every shot because they like its effect.

Set lights illuminate the walls and furniture. There may also be *practical lamps* (lamps that are part of the scene), *backdrop lights* illuminating painted or photographed backdrops seen through a window or doorway, and other special light sources such as fireplaces, passing car headlights, etc.

LIGHT MEASUREMENT

To be in control of our lighting we must learn how to judge its intensity. Light meters allow us to match light levels to a particular film stock and to get consistent results from scene to scene.

There are two distinct types of light measurements: incident and reflected. *Incident light meters* measure the intensity of the illumination coming from the lamp and express the reading in foot-candles. *Reflected light meters* measure the light reflected from the subject and yield a reading in candles per square foot, or foot-lamberts.

The more widely used incident meters, like the Spectra or the Sekonic, have a hemispherical "light collector" in front of the light-sensitive cell. This plastic device is designed to represent the general curvature of a human face. When pointed from the subject directly toward the camera it registers the amount of light falling on the face. In addition to the hemispherical collector, these meters could be used with a flat

4.11 Spectra-Pro incident light meter. Can also be used as a reflected light meter. *(Courtesy of Spectra Cine, Inc.)*

4.12 Sekonic L-398 Studio Deluxe Light Meter. This incident light meter can also be adapted for use as a reflected light meter. *(Courtesy of R.T.S., Inc.)*

disk, preferred by some cameramen for measuring individual lights. The incident light meter gives a very objective measurement, unaffected by the skin or background color, and therefore it is constant from scene to scene. An incident light reading is extremely convenient when working to a given illumination level, setting the f-stop, and then manipulating the lights to arrive at the proper foot-candle values. We can quickly check those values while walking about the scene with the sphere of the meter pointed toward the camera.

One thing to remember when using an incident light meter is that the reading will not be influenced by the background. Especially when filming outdoors in the shade, an overbright background may spoil the shot, and therefore an incident light reading must be intelligently interpreted. For example, it may be desirable to modify the reading by a half to three-quarters of a stop to allow for an overbright or overdark background.

For reasons such as these, many cinematographers prefer reflected light meters for outdoor work, while

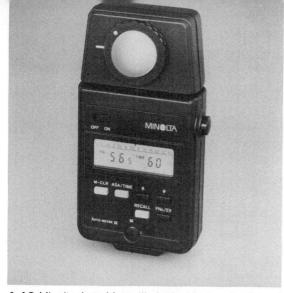

4.13 Minolta Auto Meter III. An incident and reflected light meter with digital readout and graphic indication of an analog meter. It is equipped with a memory for up to two measurements. *(Courtesy of Minolta Corporation)*

4.14 Belco/Denove Cinemeter. Digital/analog incident light meter designed to compensate for such variables as frames per second, filter factors, and shutter angle. The reading scale is designed with low light values in mind—a reading of ten foot-candles falls on the center of scale. A liquid crystal vertical bar graph serves as light level indicator. A feature called the *float-ing zone* gives a visual display of the lighting range of a scene. Cinemeter can memorize three separate measurements. *(Courtesy of Alan Gordon Enterprises, Inc.)*

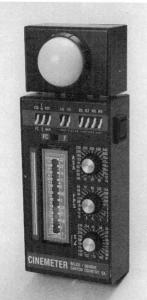

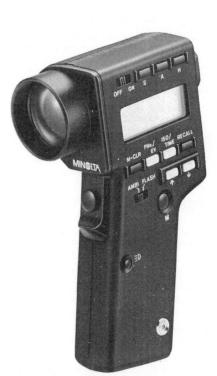

4.15 Minolta Spotmeter F. A reflected light meter with 1° acceptance angle. Digital readout in 0.1 f-stop increments, analog readout in .5 f-stop. Memory recall of highlight and shadow readings. *(Courtesy of Minolta Corporation)*

depending on incident light meters when in the studio, although they usually carry one of each.

There are two types of reflected light meters. The common type has a rather wide angle of acceptance and therefore measures *and* averages the brightness levels in a wide area. Although satisfactory for determining the average brightness range, this meter must be used with special alertness. Such things as a very light or very dark background, light sources in its view, or any other extremes in scene brightness will influence the reading and possibly lead to exposure errors. For example, a close-up is taken against a setting sun. When measuring the face, some light from the bright sunset could very easily enter the meter and drastically affect the reading. As a result the face would be underexposed.

The second type of reflected light meter is the spot meter. It overcomes the problems mentioned above by featuring a very narrow angle of acceptance (such as

85

86 CINEMATOGRAPHY

1°). It permits scanning the entire scene so that individual brightnesses can be measured and compared. This becomes particularly useful when there are translucent surfaces or self-luminous objects in the scene, such as stained glass windows or neon signs, practical lamps, or sunsets. Looking through the meter, the cameraman can see the exact spot he is measuring. The calibration on some digital spot meters is equal to 1/10 of one stop, making it quite easy to measure the brightness ratios between parts of the scene.

EIGHTEEN PERCENT GRAY CARD

It is very important to keep in mind that reflected light meters are calibrated for so-called "medium-gray" (18 percent reflectance). A reflected light meter always indicates the exposure required in order to have the measured subject represented as medium-gray on the film (or its equivalent in terms of color brightness). Therefore, a cameraman using a reflected light meter must ask himself if he wants the subject to be represented as medium-gray. Obviously, the answer is quite often no.

For example, a Caucasian face has about 35 percent reflectance. On the other hand, a black face reflects less than 18 percent. If the reflected light readings are blindly followed, both faces will be represented as similar shades of gray (on black-and-white film). The Caucasian face will appear a bit dark and the black face a bit light. For a more faithful representation, the Caucasian face should be given a half stop to one stop "overexposure" and the black face the same amount of "underexposure." This is actually not over- or underexposing, but intelligently interpreting the readings so that the subjects will be correctly represented.

One way to avoid guesswork is to use an 18 percent gray card, measuring it instead of the subject. This guarantees that objects that are medium-gray in the scene will be medium-gray on film. Thus the reading is not biased by the shades (light or dark) of the objects in the scene. When using a reflected light meter with an 18 percent gray card, the readings will be as objective as those taken with an incident meter. An incident meter, as you remember, reads the light coming from the source. Its spherical light collector approximates a medium-gray readout.

When using a medium-gray card and reflected light meter, the card should be angled halfway between the light angle and the camera to get the most accurate reading.

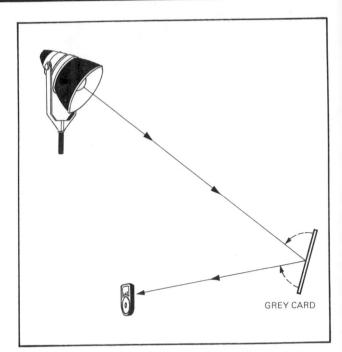

4.16 Eighteen percent gray card angled halfway between the light and a reflected light meter.

CONTRAST-VIEWING GLASSES

When looking through a viewing glass, a cinematographer can see approximately how the contrast ratio will appear on film. For an inexperienced cameraman this is invaluable in setting the relative values of the key, fill, back, and kicker lights.

There are three types of contrast-viewing glasses: one for black-and-white film (panchromatic) and two for color film (tungsten and daylight). The cinematographer should not keep the glass to his eye for long periods, because if the eye is given time to adapt to the filter the judgment will be less accurate.

MEASURING CONTROLLABLE LIGHT

Indoors, when all light sources are under control, cinematographers like to use one f-stop for an entire scene. This dictates the number of foot-candles of light required. Considerations for choosing the f-stop-footcandle combination include the depth of field required, the actor's comfort, and economy of electric power.

Supposing a cinematographer chooses f/2.8, which requires 100 foot-candles with Eastman Color Negative (#7291). For this hypothetical example, he will use an exposure of f/2.8 for the entire scene and light with key plus fill sources of 100 foot-candles for the areas he wants to keep at a key level. In order to keep the lighting interesting he uses a range of exposure values. Some areas in the frame will receive higher light levels, while others will be kept darker.

Because of the need for setting the exact light levels, the incident light meter, which is calibrated in foot-candles and/or f-stops, has become the basic tool for studio lighting. Sometimes an additional reflected light meter (especially a spot meter) is helpful in evaluating highlights and some special problems, such as translucent and self-luminous objects.

It should be noted that light meters are merely a tool for measuring light; the mood of the lighting is principally established by the eye and the sensibility of a cinematographer.

The traditional lighting ratios of fill light to key light plus a fill light are actually measured mainly when shooting tests and in basic school lighting courses that acquaint students with the moods created by varying light contrast on the human face. A good percentage of the lighting today is done with soft, diffused light that "wraps around" the face, making the distinction between the key and fill more blurred.

Testing for lighting and exposure is important when familiarizing yourself with the film stock to be used in the production. From a well designed test one can learn how much over- and underexposure the film can handle in terms of reproducing highlights and shadows, grain structure, and color. Such tests can also include lighting ratios in order to discover how much darker one side of a face can be before details start disappearing into shadows. Lighting ratios should include four setups: 2:1, 4:1, 8:1, and 16:1.

For the actual exposure test the cinematographer should create the 4:1 ratio. This means that the brighter side of the face, lit by key plus fill, should measure (in foot-candles) four times higher than the darker side that is lit by the fill light alone; for example, 100:25. This indicates that the one side is two stops brighter than the other.

To make the difference between the sides of the face easy to watch in these tests, the key light should be 90° to one side. The fill light should be near the camera. Also, when shooting the test, make sure that the model is not affected by light reflected from the wall or coming from the windows or house lights.

For accurate flesh tones a woman can make a better model. It is customary to position her against a white background and have her wear black cloth to see the extremes of the brightness range. A gray scale and color chart should be also included in the frame. The cinematographer should start the test with a correctly exposed image. After ten or more seconds of normal exposure, he should stop the camera and reset the f-stop to underexposure one half-stop. He should continue shooting these series to cover three stops underexposure and three stops overexposure in half-stop increments.

At the end of the test, the cinematographer should shoot with the correct exposure once again. When this film is developed, he should instruct the lab to make two prints. The first print should be made at a onelight printer setting, set for normal exposure. The second print should be timed by changing printer lights to correct the underexposed shots back to normal. Lab reports should indicate the printing lights (levels of light intensity) used on the printer for the three primary colors (red, green, and blue).

To evaluate the results of this test one needs to make certain that the projector provides the required screen brightness, which has been established at 16 foot-lamberts. Most cinematographers do not own a foot-lambert meter, but there is a way to use a regular reflected meter as a substitute. The meter should be set at 100 EI/ASA and $\frac{1}{50}$ second. The meter then is pointed at the screen, which is illuminated by a projector running without the film in the gate. The reading of f/3.2 will represent 16 foot-lamberts.

Analyzing these tests* will give several indications. The one light print will show how much latitude the film possesses before its quality starts to deteriorate. The timed print, on the other hand, shows how much of over- and underexposure can be corrected in printing. It is essential to shoot tests and discuss them with your lab. After getting familiar with the emulsion characteristics, a cinematographer can feel more comfortable in interpreting his light readings.

A question often asked by film students is: What is the proper way to aim an incident light meter when

^{*}See Stephen H. Barum, ASC, and Rob Hummel, Technicolor, describing such tests in "Making the News Films Your Own," *American Cinematographer*, Vol. 64, No. 6, June 1983 pages 35-36.

measuring a key light that comes from a three-quarterback angle? When describing an incident meter, I mentioned that the light-collecting dome represents the shape of a human face and, therefore, when pointed directly at the camera it should register the amount of light falling on the actor's face. And yet if we rigorously follow this rule in the case of a threequarter-back key light, we will be reading mainly the fill light. As a result, the face will be correctly exposed where there is fill light and grossly overexposed where it is lit by the key. This, most likely, was not our intention.

We can still opt to read the fill light but not necessarily follow the meter's recommendation concerning the f-stop used. We may decide that the shady side of the face will be two stops darker than the mediumgray and adjust the f-stop accordingly (i.e., underexpose two stops).

On the other hand, if the key light hits only a small portion of the face, we may want to expose for the fill light. Despite the fact that the key light is still quite hot we may find the "blooming out" effect acceptable.

Oftentimes when the key light comes from the side or from three-quarters back, a cinematographer will not point his incident meter's dome directly toward the camera but will instead angle it halfway between the key and the optical axis. This allows a mid-point reading between the key and the fill. Some cinematographers like to read the lights individually by pointing at them with an incident meter equipped with a flat disc instead of the light-collecting dome.

Establishing exposure becomes a process of interpretation. The light meter is merely a technical device, and a cinematographer has to decide for himself what he wants to expose more and what less. It may even be that for dramatic reasons the wall behind the actor needs to be the brightest spot and the face has to be underexposed altogether.

Therefore, how to expose different parts of a scene becomes a creative decision. For instance, when two actors are facing each other in a scene and one of them is a stop darker, who can say which is "correctly" exposed? After all, in real life four people in a room can have four different levels of illumination on their faces. One of them standing near the window in a shaft of strong sunlight will be, according to the meter reading, overexposed, yet this is an accurate representation of reality. Another actor in a dark corner will be two stops underexposed and still the whole scene may be perfectly acceptable.

While the keys are set with the help of a meter, the

levels for the back light and kicker will depend entirely on the subject and the situation. The color and texture of the actor's hair and costume are sometimes the factors that influence the amount of back light reflected toward the camera.

For example, in color photography one could use color gels over the lights to give a blonde an amber back light or a brunette a blue back light to further increase the feeling of depth. Actors seen against a dark space may require a back light to separate them better from the background. On the other hand, an actor standing in front of a well-lit wall may be sufficiently separated without a back light.

With a full brightness range in the frame we may have a difference of seven stops between the whitest white and the blackest black. Sometimes it is desirable to have such a range of tones because without something bright in the frame we cannot have rich blacks. Without this contrast, black looks just gray. Color negative is better suited for this brightness range. Color reversal film will lose some details in highlights and shadows.

When appraising the brightness ratio of face to background, the incident meter is not much help because it does not take the subject's color brightness into consideration. Here a spot meter can be very useful. Depending on the mood of the scene, the face may be lighter or darker than the background, but in most cases it should not be the same. One also uses the spot meter when determining the brightness of so-called practical lamps. Take, for example, a man sitting at a table on which there is a practical lamp. As a rule of thumb, this lamp will look convincing if it is approximately 2½ stops brighter than the face. (The exposure is set for the face.)

Practical lamps are very difficult to judge by eye. They usually photograph at least a hundred percent brighter than they look on the set. With practice, a cinematographer learns to depend more on his eye and less and less on his meter. Fast emulsions allow one to shoot in lower light levels, which makes a visual evaluation easier.

Yet, after many hours of work the eyes will get tired and less reliable. This is the time when a contrast viewing glass will help the most. Some cinematographers substitute gray sunglasses that they put on for a few seconds to evaluate the light balance. Some also take Polaroid pictures to evaluate the contrast ratio. With experience, a black-and-white Polaroid photo can indicate how the contrast will be rendered on the film.

4.17 Practical lamp 21/2 stops brighter than the face. (Photo by author)

LIGHTING EQUIPMENT

Today there are enough types of lighting equipment available to fill volumes. We will try to cover the most important types. One should pay particular attention to the practical working characteristics of each light, namely, the *quality* of the light produced by the given instrument and its physical capabilities in the way of mounting, controlling beam size, and so on.

The first thing to understand about the lighting instrument (also referred to as the fixture or luminaire) is the type of light source it employs. The two principal sources used in film lighting are the tungsten incandescent globe and the arc light.

The first group takes its name from the tungsten filament made incandescent by electric current. Tungsten globes of the quartz halogen type are the ones mostly used in film lighting. They are generally known as quartz lamps. They retain a steady color temperature of $3,200^{\circ}$ K and are smaller in size than the household-type incandescent. A quartz bulb should never be touched with bare fingers, as the acids of the skin weaken the quartz glass. Any fingerprints should be removed immediately with alcohol.

Arc Lights

Arc lamps can be categorized as carbon arc and mercury arc (such as Hydrargyrum Medium arc-length Iodide or HMI^m). The carbon arc works on the principle of a gaseous arc that is formed between two carbon rods connected to a direct current (DC) supply such as a generator or a powerful battery.

A mercury arc enclosed in a glass envelope with metal halide additives is a gas discharge metal halide light. The HMI lamp is a widely used lamp of this type. It produces daylight-matching light of $5,600^{\circ}$ K.

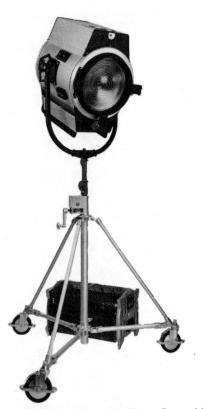

4.18 Arc spotlight. 225-amp Baby Brute Molarc. (Courtesy of Mole-Richardson Co.)

It is five times more efficient than a carbon arc. A 12,000-watt HMI actually will outperform a Brute arc in terms of its power. But many cinematographers believe that the quality of the arc still remains the most sunlike light.

HMI lamps work on alternate current (AC) that has to be locked up at an exact number of cycles (60 cycles in the U.S.A.) to prevent the lights from flickering. Therefore, a crystal controlled AC generator or the power company source are used to run the HMIs. To avoid the flicker of the lights, a camera with a crystal control motor should be used, and high speed is ruled out unless highly sophisticated devices are employed.

Between the AC power supply and the HMI lights a "ballast" unit is required. This serves several functions, such as providing very high voltage for the initial startup and for adjusting voltage while the light is still burning. Unfortunately, such a ballast is rather heavy and makes HMI lights less portable than incandescent luminaires.

HMIs, however, are still much more convenient than the carbon arcs, as they do not need an operator at all times. HMI lamps also have the additional advantage of producing very little heat.

Incandescent Spotlights

The second group of light sources contains the family of spotlights, including the spherical reflector, Fresnel lens lights and ellipsodial reflector spotlights. Of this group, the Fresnels are the most widely used studio instruments. They are available in many sizes, ranging from 50-watt to 10,000-watt, with either traditional heavy-duty housing or lightweight aluminum construction.

The Fresnel lens remains stationary while the bulb and spherical mirror can be moved together, either closer or farther from the lens, allowing us to control the beam of light, either "spotting" or "flooding" it. When the bulb and mirror are furthest away from the lens, the light rays are more converged. This is the spot position, and it narrows the beam to a smaller area of coverage. Flooding the lamp moves the bulb and mirror to the front of the housing, near the lens. When in the flood position the lamp throws a wider beam, il-

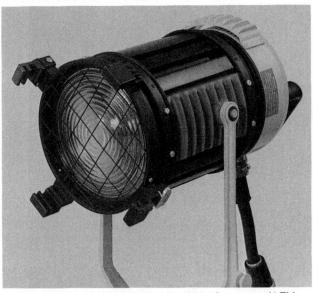

4.19 575-watt HMI light. Luxarc 575 (Courtesy of LTM Corporation of America)

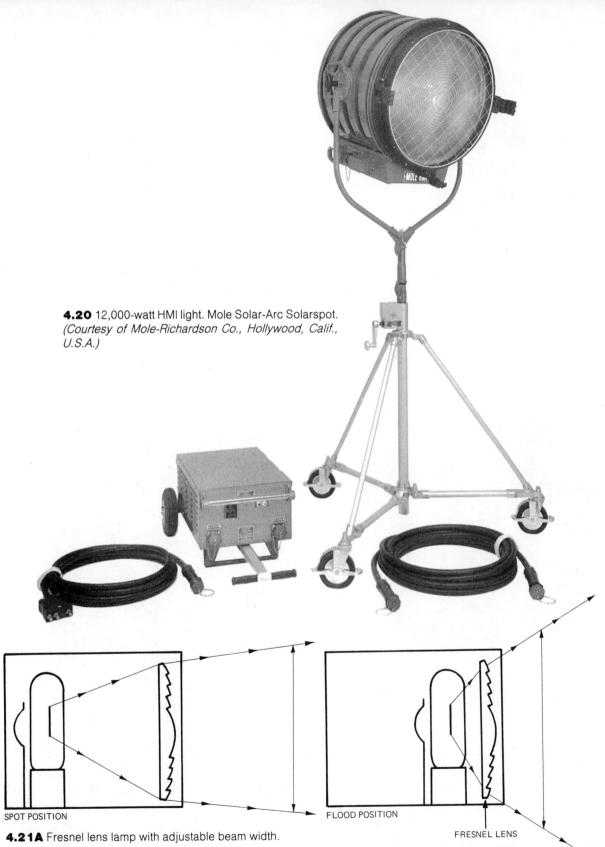

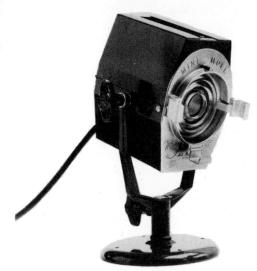

4.21B Very small Fresnel instruments accepting bulbs from 50 watts to 200 watts are popularly called "inky-dinks." This particular version is a Mini-Mole Solarspot. Inky-dinks are very convenient when shooting on location with fast emulsions. *(Courtesy of Mole-Richardson Co.)*

luminating a broader area. When working in a hurry, the spot/flood adjustment can be used to set the intensity of the light. Flooding spreads the light over a greater area, therefore making it less intense than when spotted into a small area. It is quite common for the cameraman or gaffer to stand in the actor's position, reading a meter while an electrician follows his orders to spot or flood the lamp until the desired level is obtained.

When pointing a Fresnel at a subject it is first spotted. This narrows the beam so the electrician can clearly see exactly where the center of the beam falls. He turns the lamp until the beam is hitting the center of the area to be illuminated. The Fresnel is then flooded to the desired degree.

Strangely enough, when the lamp is flooded the shadows are sharper than when it is focused. The reason is that when the lamp is focused (spotted), the

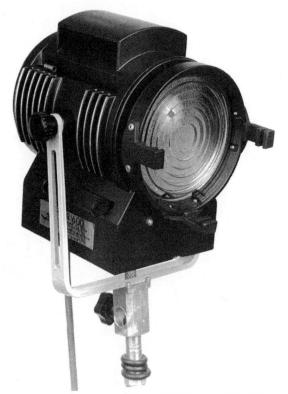

4.21C 650-watt Fresnel light. LTM Pepper 650. (Courtesy of LTM Corporation of America)

4.21D Fresnel light, 2,000-watts. Molequartz Baby Junior Solarspot. (*Courtesy of Mole-Richardson Co.*)

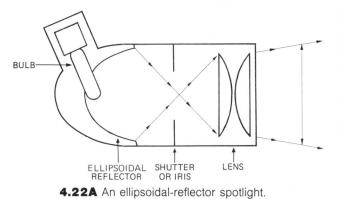

entire lens acts as a light source. When flooded, the bulb is in the front of the lamp and almost visible, thus constituting a smaller light source and creating sharper shadows. If the spotted position seems sharper it is only that the greater intensity makes the shadows more prominent. To obtain the sharpest shadow from a Fresnel lamp one can remove the lens altogether.

The other type of spotlight is the ellipsoidal reflector spotlight. It casts a sharp-edged pattern that can be shaped by irises or shutters or by inserting a cutout pattern. Lights of this design originated in the theater, and so their rating is generally low, ranging from 250 to 2,000 watts.

Open Lights

Open lights—also known as open face lights, open reflector lights, or open bulb lights—are those instruments that do not have lenses. They are generally more light-efficient than Fresnel spotlights of the same wattage, but they are far less controllable. Open lights come in many variations. The oldest type used in cinematography is the scoop, which has been employed for many years as a source of soft light. Scoops

4.22B A Lekolite ellipsoidal spotlight. (Courtesy of Century Strand, Inc.)

4.23 Obie 1—camera light. Can be adjusted within a 21/2 stop range, without changes in either color temperature or beam angle. *(Courtesy of Arriflex Corporation)*

4.25 A 2,000-watt Molequartz scoop. Note the diffuser scrim further softening the light. *(Courtesy of Mole-Richardson Co.)*

4.24 5,000-watt Skylite. (Courtesy of Mole-Richardson Co., Hollywood, Calif., U. S. A.)

range from 500 watts to 2,000 watts. Even larger are sky-pans or sky lights (5,000 watts) used for soft lighting of large backdrops.

Soft lights, as their name implies, are open reflector lights that produce very soft and shadowless light. This light is so even that it is often compared to northern-sky illumination. The quartz bulbs are not visible. The light is completely diffused by being bounced off the white surface at the back of the housing. None of the light reaches the subject directly. Some modern designs can be collapsed into suitcase size. Soft lights are available in sizes from 750 to 8,000 watts. To maintain a constant color temperature, the white reflecting surface must be kept clean and periodically repainted.

A soft lighting style sometimes requires an even overhead illumination. This is provided by what is called a "chickencoop." A chickencoop is an open

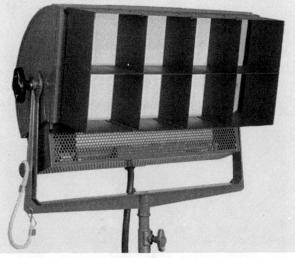

4.26 2,000-watt Baby "Zip" Softlight with an egg crate light controlling grid. (*Courtesy of Mole-Richardson Co., Hollywood, Calif., U.S.A.*)

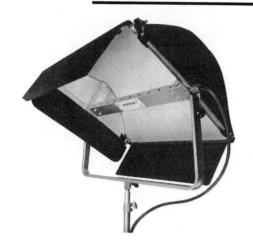

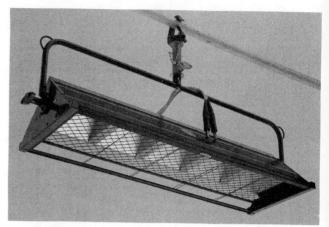

4.28A Molequartz Five-Light Overhead Strip. (Courtesy of Mole-Richardson Co., Hollywood, Calif., U.S.A.)

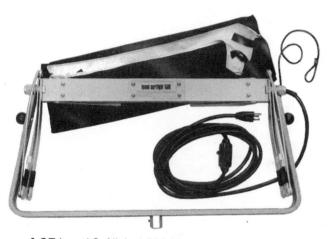

4.27 Lowel Softlight 1,500. Uses two 750-watt lamps. (Courtesy of Lowel-Light Mfg.)

metal box that houses a six-lamp cluster of 1,000-watt silver bowl globes. This soft light can be further diffused by stretching bleached muslin or silk beneath the fixture.

Sealed beam lights provide focused illumination and are compact and lightweight like open reflector lights. These globes are officially coded as PAR, which stands for parabolic aluminized reflectors. Both the lens and reflector are built into the globe. To change the beam angle, one must change to a different globe. The globes are available in wide flood, medium flood, spot, and narrow spot variations.

Within the PAR grouping there are many subtypes, each described by a three-letter designation that

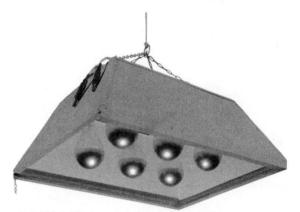

4.28B 6,000-watt Six-Light Overhead Cluster. (Courtesy of Mole-Richardson Co., Hollywood, Calif., U.S.A.)

specifies the variable characteristics, such as beam width, voltage, wattage, color temperature, etc. For example, a FAY bulb is one of the more popular types within the PAR group. A FAY bulb is 650 watts and has a color temperature of 5,000° K, making it useful as an outdoor fill light. The terms for the instruments themselves and for the bulbs seem somewhat confused in popular usage. The larger 1,000-watt PAR instruments are commonly referred to as "Par" lights, while the instruments accepting the smaller 650-watt PAR lamps are often called "Fay" lights. In the Mole-Richardson line, the lights are designated as Molepars and Molefays, while the Colortran nomenclature is Maxi-Brutes and Mini-Brutes.

96 CINEMATOGRAPHY

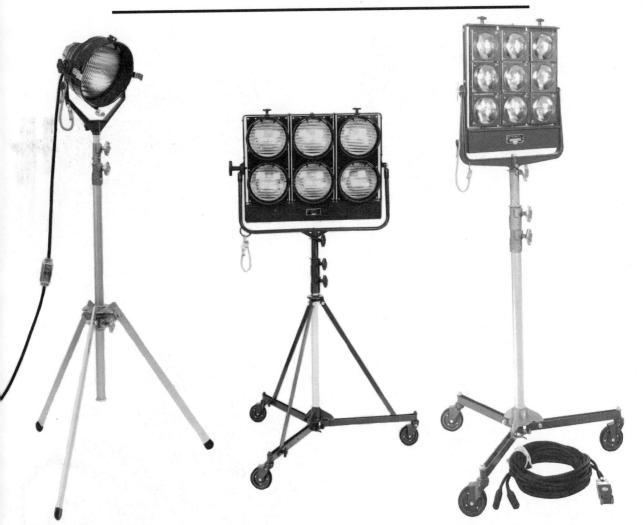

4.29 Single PAR lamp, 1000-watt Molequartz Molepar. *(Courtesy of Mole-Richardson Co.)*

4.30 Six-bulb PAR cluster, 6000watt Molequartz Molepar. (Courtesy of Mole-Richardson Co.) **4.31** Nine-light with daylight color temperature. Molequartz Molefay. *(Courtesy of Mole-Richardson Co., Hollywood, Calif., U.S.A.)*

The 1,000-watt PAR 64 (3,200° K) is a good choice for situations that require a far-reaching beam—for instance, if you want to back light a street block at night or hide lights in trees to give more depth to a night forest. Individual PAR lamps are too hard a source for lighting faces, unless their light is bounced or diffused. A cluster of PARs is often used as powerful general fill light. However, these lights should be kept at a distance from the subject, in order to avoid multiple shadows. Among FAY lamp clusters "nine-lights" are the most popular in daylight use, but HMI lamps are taking their place because they are more power-efficient and cooler in use.

Compact lights are designed to meet the varied demands of location work. Not as "punching" as the PAR lamps, these open reflector quartz lights have a smooth beam pattern and generally a rather hard light quality. The largest, a 2,000-watt unit like the Mighty Mole (Mole-Richardson Company) is a favorite of

4.33 Lowel Tota-light. (Courtesy of Lowel-Light Mfg., Inc.)

4.32 Cinepar 1,200-watt light which uses an HMI type bulb with a sealed PAR 64 reflector. A set of lenses is used for changing the beam spread. *(Courtesy of LTM Corporation of America)*

many gaffers for bouncing. In a cramped location, from a distance of a few feet, a Mighty Mole will cover a four-by-four sheet of reflective material, such as foam-core or a styrofoam board. It has a tremendous light output for its size.

Several companies offer location lighting kits. Very innovative location lighting systems are made by Lowel-Light Manufacturing, brainchild of cinematographer Ross Lowel. This company's lighting instruments and accesories constitute very efficient systems with interchangeable modular parts. Many lights can be adapted to 30- or 12-volt battery power. Taking advantage of today's fast films and lenses, Lowel has designed low-wattage, small units that are combined into several functional, portable kits. Sophisti-kit, which weighs only 36.5 pounds, consists of five lighting instruments (three 500-watt and two 250-watt maximum) with stands and various accessories for bouncing and diffusing light.

A simpler but enormously efficient kit for location shooting is the Lowel-Light System. It makes use of the R-type reflector bulbs that are available in a wide range of sizes. Of these the R-40 bulb is recommended.

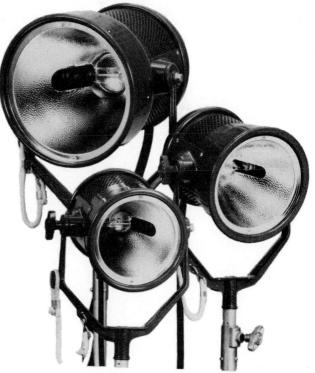

4.34 A family of open reflector quartz lights: 650-watt, 1000-watt, and 2000-watt. *(Courtesy of Mole-Richardson Co.)*

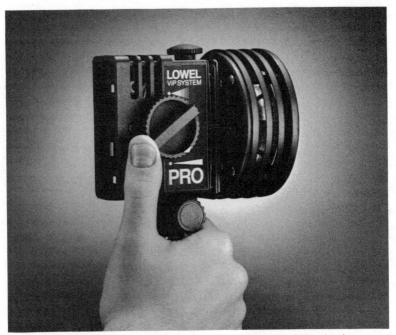

4.35 Lowel Pro-light. (Courtesy of Lowel-Light Mfg., Inc.)

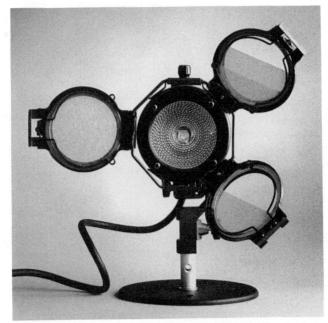

4.36 Lowel i-light. (Courtesy of Lowel-Light Mfg., Inc.)

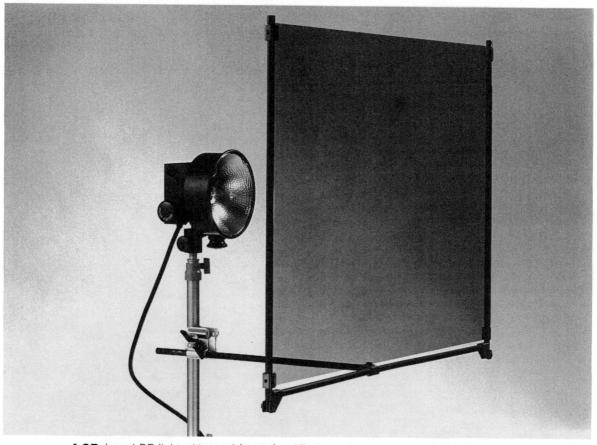

4.37 Lowel DP light with a gel frame for diffusion materials, daylight correction, and other gels. (*Courtesy of Lowel-Light Mfg., Inc.*)

A lightweight barndoor attaches directly on this reflector lamp and the ingenious base plate can be easily mounted on walls, pipes, and furniture.

The small-size bulbs, like R-14 (25 watts) and R-20 (30 or 50 watts) are small and easy to hide. Even smaller, the so-called peanut bulbs are often used in practical lamps or inside cars. They can be 1% inches long (6-watt bulb #6S6), or 2% inches long (10-watt bulb #10C7.)

Much can be learned about the state-of-the-art in lamp designs for various applications from the current catalogs of such lamp manufacturers as General Electric and Sylvania. Certain situations require a battery operated light. Besides the incandescent units, like the Lowell Omni, there are also battery powered HMI heads available. Because of their efficiency, a 200-watt HMI provides an equivalent of close to 1,000 watts of light, balanced to daylight.

The HMI head is also used in an ingenious system designed by LTM that uses fiberoptics to light confined spaces, such as a car interior or a scale model set. From an HMI light box, glass fiber cables are run to wherever the light beams are required. These glass fiber cables do not conduct electricity, which allows their use in underwater environments.

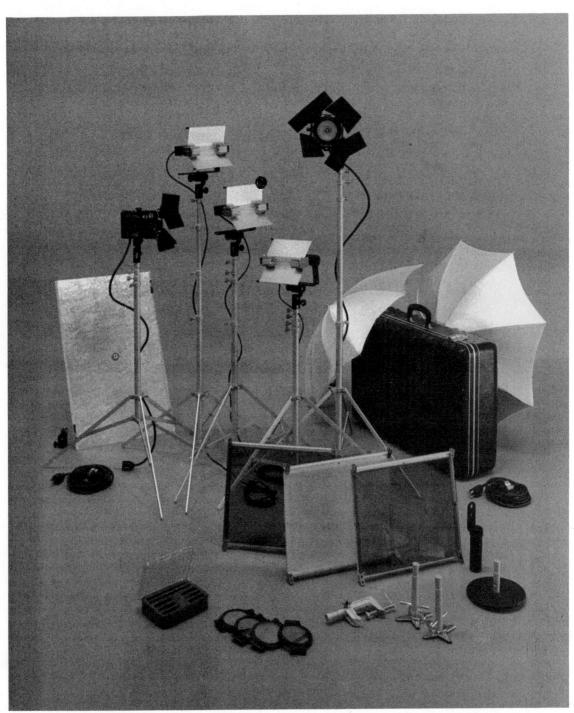

4.38 Lowel Sophisti-kit portable lighting package. (Courtesy of Lowel-Light Mfg., Inc.)

4.39 Ultra-compact 125-watt light. Great American Market's Stik-up.TM *(Courtesy of the Great American Market)*

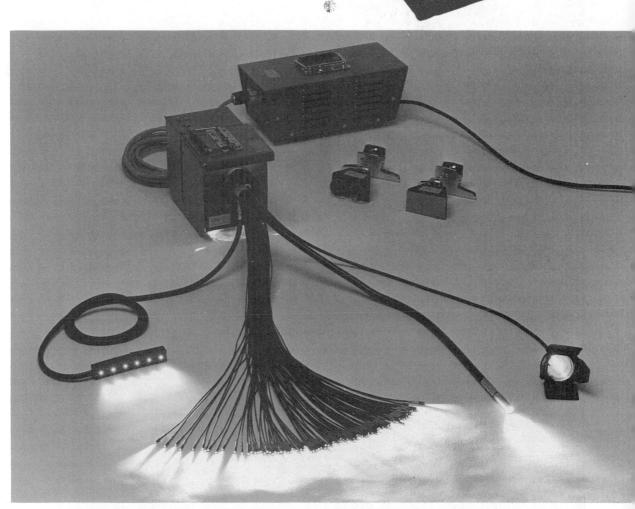

Stik-U

4.40 Fiber optics. Micro Set Lighting system by LTM. An HMI lamp contained in the box emits light that travels through fiber strands or cable to lenses which provide cool illumination and can be submerged in water. *(Courtesy of LTM Corporation of America)*

4.41 A Lowel-Light and barndoors affixed to a wall with gaffer tape. (Courtesy of Lowel-Light Mfg., Inc.)

4.42 A Lowel-Light attached to a chair. *(Courtesy of Lowel-Light Mfg., Inc.)*

4.43 HMI portable, battery operated, 250-watt light. (Courtesy of LTM Corporation of America)

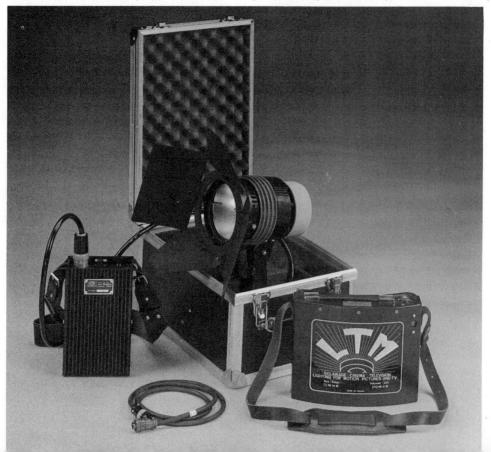

103

4.44 A lightweight stand. (Courtesy of Mole-Richardson Co.)

Mounting Accessories

A studio light usually can be ordered as either a hanging model or a standing model. The hanging model comes with a shorter cable and without an on/off switch. It should be ordered with a C-clamp that is the proper size for the grid. The standing model comes with a 25-foot cable and an on/off switch.

Stands vary in size from heavy-duty to lightweight. Some are equipped with casters. They are adjustable for different heights and can be equipped with many types of side extenders, boom arms, etc. Some are

4.45 A light stand on casters (pedestal). (Courtesy of Mole-Richardson Co.)

power-operated for elevating large heavy lights.

Other available mounting instruments include trombones, wall plates, base plates, etc.

In studios equipped with a grid of fixed height we may have to use lamp hangers of various designs, such as telescoping Anti-G hangers or ordinary adjustablerod hangers in various heights.

Scaffoldings (also called parallels) are often used for mounting lights, both in the studio and at outdoor locations.

"Polecats" are extremely useful as compact portable grids for indoor locations.

104 CINEMATOGRAPHY

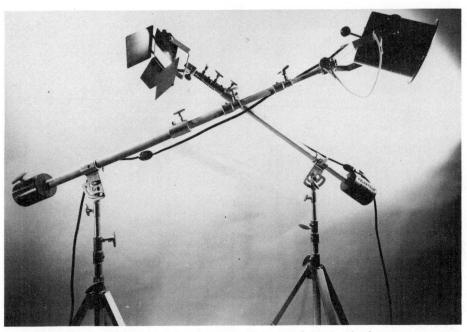

4.46 Boom arms. (Courtesy of Berkey Colortran, Inc.)

4.48 Wall plate. (Courtesy of Mole-Richardson Co.)

4.47 A trombone. The arms hook over the top of the set wall and the light mounts on the pin at the bottom. *(Courtesy of Mole-Richardson Co.)*

LIGHTING 105

4.49 Telescoping Anti-G Hanger. (Courtesy of Berkey Colortran, Inc.)

4.50 Adjustable rod-type hanger. *(Courtesy of Mole-Richardson Co.)*

Securing Devices

Every lamp on the grid and every barndoor, snoot, etc., must be secured with a safety chain or cable. The bases of lightweight lamp stands-especially on location-should be steadied with sandbags. Stands can also be taped or lashed to almost any supporting structure, such as a wall, furniture, or a window frame. Light stands are pulled over most frequently by people tripping on badly secured cables left lying loose on the floor. All cables, especially those in areas where people will be walking, should be taped to the floor with gaffer's tape, an extremely strong heat-resistant adhesive tape sold in film-supply houses. Sometimes a ring is provided at the base of the stand and the cable is put through it, so that if someone trips on the cable the jerk will be less apt to pull the lamp over. For extra stability, one leg of the stand should point in the direction of the light-that is, it should be directly under the lamp.

Accessories for Controlling Light

An ability to control and manipulate light is necessary for its creative use. There are five objectives in controlling a light beam: changing the intensity, changing the effective size of the source (diffusing), manipulating the pattern, adjusting the color, and, in special circumstances, eliminating heat.

To cut down *light intensity*, scrims can be introduced between the light and the subject. These are usually made of metal mesh and may come in round or square shapes to fit in the holder on the front of the light, or they may be of larger size for positioning at some distance in front of the light. There are two common densities for scrims. A "single" scrim cuts the light by half a stop. A "double" reduces the light by one stop. Scrims are available in different shapes, such as half-scrims, which cover only half the light. Often several scrims are used at once.

By placing a diffusing material in front of the light

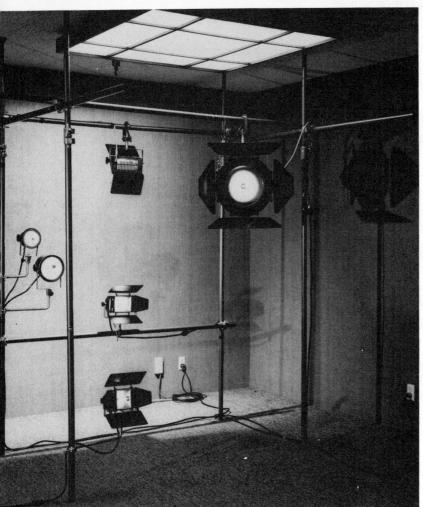

4.51 Colortran Pole Kings. (Courtesy of Berkey Colortran, Inc.)

4.52 Sandbags steadying a stand. (Photo by author)

4.53 Scrims. Left to right, a single, a double, a half single scrim, and a half double scrim. The physical size varies according to the size of the light instrument. *(Courtesy of Mole-Richardson Co.)*

4.54 Two-leaf barndoors. (Courtesy of Mole-Richardson Co.)

source, we are able to change the effective size of the source, making the light softer. Like scrims, diffusers are often made of a mesh material, but a mesh will only diffuse if the gaps between the threads are narrower than the thickness of the threads themselves. Common diffuser materials are silk, Dacron, bleached muslin, heat-resistant plastics, and tracing paper. The diffusion effect increases with the size of the diffusion frame.

"Barndoors" are the most versatile instruments for controlling the *light pattern*. Almost any light (all Fresnels and most types of open reflector quartz lights) should always be equipped with barndoors, preferably of the rotating four-leaf variety. They can be used to keep lighted areas from overlapping. By restricing the light pattern they can prevent unwanted shadows, such as from the sound boom, and they can keep light off shiny surfaces and protect the camera lens from direct light. They can also be used to create desirable shadows such as the "fall-off" at the top of an interior wall. Barndoors generally enable the cameraman to create the desired lighting patterns.

"Snoots" are similar in function. These funnellike devices of different diameters are even more restricting, casting circles of light.

"Flags," "dots," "fingers," and "cookies" differ in

4.55 Four-leaf barndoors are preferable. (Courtesy of Mole-Richardson Co.)

4.56 Snoots. (Courtesy of Mole-Richardson Co.)

size and shape, yet they are all used for introducing shadow patterns. Unlike barndoors or snoots, they are usually on "century stands" or goosenecks that hold them between the light and the subject. One very important use of a flag is shading the camera lens from direct light. The "cucaloris," or "cookie," can be used to create the random shadow pattern usually associated with foliage. Some cookies are made of a

4.57 Flags (black) and scrims (nets). (Bardwell & McAlister, courtesy of F & B Ceco of California, Inc.)

frosted plastic material and give a very soft shadow pattern. A cookie will often substantially improve the appearance of woodwork or furniture, giving it a deep, rich look.

These shadow-making devices serve many functions, not the least of which is the breaking up of evenly illuminated areas. Often, and especially when lighting set walls, an even illumination gives the set a flat, uninteresting look. A few random shadows here and there will break up the monotony, making the background seem more alive and three-dimensional. The shadows do not need an established reason for being there, yet they shouldn't directly violate logic. For example, a couple of flags and fingers may be used to create shadows that might be coming from the crosspieces of a window. We don't see the window in the scene, yet as long as it's logical that a window might be there and cast such a shadow, the audience will accept it without even thinking. The darker the set is and the more random its design and colors, the more one can get away with. The opposite is also true. A lightly colored bare wall will advertise the shadows thrown onto it, so they have to be especially logical to prevent the audience from being distracted. In all such cases, subtlety is advisable. Remember too that by using shadow patterns to make a set more alive, its visual appearance becomes more pleasing. Therefore, be sure that an attractive appearance is not in conflict with the mood the director is trying to create.

In placing any shadow-making device, the shadows will be more distinct if the light is from a hard source such as a Fresnel, and they will also be sharper if the device is farther from the lamp.

For *adjusting the color*, a gelatin filter can be mounted on the front of most lights in a special holder

4.58 Assortment of dots and targets. (Bardwell & McAlister, courtesy of F & B Ceco of California, Inc.)

4.59 A cucaloris (cookie). (Photo by author)

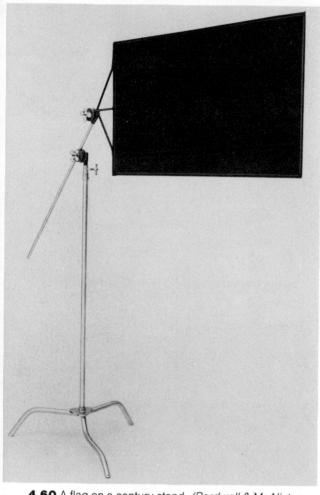

4.61 "Gobo Head" on the arm of a century stand. (Bardwell & McAlister, courtesy of F & B Ceco of California, Inc.)

4.60 A flag on a century stand. (Bardwell & McAlister, courtesy of F & B Ceco of California, Inc.)

4.62 A "gooseneck"—a hinged arm that holds a flag. (Courtesy of Berkey Colortran, Inc.)

that positions it some distance from the lens. Gels that are not heat-resistant will have to be mounted on a stand and held farther away from the lamp.

Glass *heat-removing filters* can be used to prevent excess heat in special applications, such as in filming an ice cream commercial or in close-up zoological work. These filters cause a slight loss in color temperature and reduce the amount of light by about a third of a stop.

ELECTRICAL CONTROL AND DISTRIBUTION IN THE STUDIO

The requirements of television have stimulated the development of many highly efficient lighting systems with elaborate dimmer boards equipped with preset electronic memories. For schools and small production companies, the most economical grid system consists of ordinary 1½-inch gas pipes suspended from the ceiling, with outlet boxes along the pipes, spaced about one every four feet. A simple breaker box can

serve as the switchboard. Each outlet should be on its own 20-amp circuit and have its own switch in the breaker box. Convenient spacing of the pipes is about four feet apart. When building a grid and buying lights, much time will be saved by making sure to order all compatible plugs.

A variety of portable dimmers are available in many sizes and capacities, some with remote-control devices. One must be careful when using dimmers with color film productions, as varying the voltage will change the color temperature of the light. If a midscene dimming is required when using color film, it should be done with a purely mechanical shutter that operates like a venetian blind.

LIGHTING PROCEDURE AND RIGGING ORDER

It goes without saying that the cameraman (director of photography) must be familiar with the script. He will talk it over with the director, determining the

4.63 A simple grid system constructed from 11/2-inch gas pipe. (Photo by author)

4.64 A shutter. (Courtesy of Mole-Richardson Co.)

mood, time of day, etc., of each scene. At this stage, close cooperation with the art director and set designer is invaluable. Before he does anything, the cinematographer must know the size and shape of the sets, the number of actors and extras, and all the color schemes of the sets and costumes.

Once the set is erected, the gaffer will rig the lights according to the cameraman's direction. The set walls and backdrops can be lit before the actors arrive. Practical lights, since they are props as well as light sources, will also be prepared. The key lights, fill lights, back lights, and kickers can be hung in likely places, but they will not be focused in their final settings until the actors arrive and the director blocks the scene.

During the blocking, the cameraman cooperates with the director in lining up the shot and marking camera and actor positions. When the blocking is over, the real lighting starts. In professional studios the actors usually take this opportunity to go off and either rest or practice their lines, leaving the cinematographer to light the scene with stand-ins. This is why it is important to mark each actor's position on the floor. The incident meter is especially vital when lighting without stand-ins.

First the key lights are positioned and adjusted to the proper levels. Second come the fill lights, then the back lights and/or kickers. It often happens that one light may serve several functions. For example, one actor's key light may be another's kicker.

When the lighting is completed the first full rehearsal follows for cast, camera crew, sound crew, special effects, etc. After this rehearsal any necessary changes will be made before more run-through and the actual shooting.

THE LOGIC OF LIGHTING

Unless the production is intended to be unrealistic, the lighting will generally follow the logical scheme of the natural light sources within the scene—windows, practical lamps, candle flames, fireplaces, etc.

The most common of these is the window. If a window is visible in a daylight scene, we might have strongly backlit curtains or an illuminated backdrop, either painted or photographic. (For a realistic effect of bright daylight, these backdrops should be about two stops brighter than the faces in the key light.) Because this window is the logical source of light, the general direction of most of the key lights will therefore come from the direction of this window. We may also want to introduce the window-pattern shadow on the opposite wall by using a cutout in an ellipsoidal spotlight, or by using a shadow-forming device such as a flag in the path of a Fresnel.

Practical lamps in the scene look best if they are two to four stops brighter than the face. Here a dimmer is useful in obtaining the right level. The practical lamp can even be used as the key light, in which case you will need a strong bulb. The camera side of the lampshade may have to be shaded in order to maintain a two- or three-stop difference between the face and the lampshade. To do this we could place a scrim between the bulb and the lampshade, or use a neutral density gel cut to fit the inside of the lampshade. Still another method would be to cut out the back of the lampshade and allow the bulb to shine directly upon the actor's face. The rest of our lighting must also simulate the light supposedly coming from this practical.

To further illustrate this, let us consider the similar example of a candle flame. The candle flame is a very weak source, and therefore it must be supplemented with artificial light. When faced with candles or other weak sources, some cinematographers will use low illumination to make the candle seem brighter compared to the face. For example, say the key is 100 foot-candles. In comparison, the candle appears dim. If the key is reduced to 25 foot-candles, the candle will seem brighter in relation to the key light. Keeping the flame against a dark background will help.

In lighting the scene in figures 4.65 to 4.70, our key lights must appear to be coming from the candle. To maintain a realistic effect, very little or no fill light is used in this scene. The circle of candlelight on the table can be simulated by a Fresnel with a snoot pointing directly down from above (figure 4.67). Two 500watt baby Fresnels are used as key lights. This is called a "back cross" because the paths of the key lights cross behind the actors (figure 4.65).

The two key lights are angled so that the shadows of the candle do not fall upon the actors. Barndoors are used to keep the woman's key light off the man's

4.65 A "back cross" of key lights.

4.66 The bottom barndoor of each key light is raised until the key no longer illuminates the top of the table, thus eliminating the candle shadow.

back and vice versa. For a realistic effect, these two key lights are positioned at about the same level as the candle flame. The candle should not cast a shadow across the table because it supposedly is the only source of light. Therefore the bottom barndoor of each key light is raised until the key no longer illuminates the top of the table, thus removing the candle shadow (figure 4.66).

In this particular scene there is no logical reason for back lights, but we may use them with great discretion to separate the actors slightly from the background (figure 4.69). These minor violations of logic are acceptable as long as they remain subtle.

Now in looking at the scene as we have lighted it so far, we notice the large black void behind the actors. It would be nice to break up the area and perhaps see the back wall. To illuminate it flatly might make it uninteresting and would certainly be in conflict with the shadowy depth created by the rest of the lighting. By simulating a window pattern cast on the back wall by moonlight, we can break up the monotony of the large black area and show the back wall (figure 4.70). The effect is created by using flags to shape a square some distance from a Fresnel. A Fresnel is chosen for its distinct shadows. A scrim is placed on a century stand near the flags and crisscrossed with gaffer's tape to obtain the shadows of the window's crosspieces. One could also use an actual window frame, perhaps with venetian blinds, mounted on a century stand.

If shooting color film, it might be effective to put amber gels over all sources that are supposed to be coming from the candle and a pale blue one over the source of the moonlight window pattern.

Thus we finish lighting the candle situation. This is just one of many ways we could have approached it. Probably no two cinematographers would have lit it the same way. However, the one thing most of their techniques would have in common is logic. Each light performs specific tasks. If a given effect is not realistic, yet is still needed (in this case the backlights), it is very subtle. But each light has a reason for being used.

Another difficult variation of this is an actor *walk-ing* with a candle. In this case he may be illuminated by a hand-held Fresnel (such as an inky-dink) with a snoot. A dimmer could be used to achieve the flicker effect.

When working with a large candle or a lantern, there is the possibility of hiding in it a small bulb (operated by battery or a hidden cable), or using a special candle with a double wick.

For imitating larger fire sources, such as fireplaces,

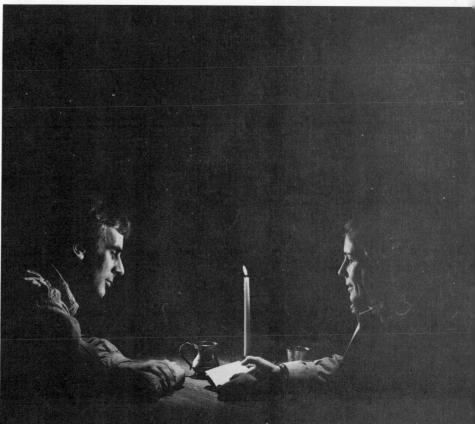

4.67 The circle of candlelight on the table can be simulated by a Fresnel Baby, with a snoot, pointing straight down from above.

4.68 The candlelight on the faces is created by two key lights in the back-cross fashion.

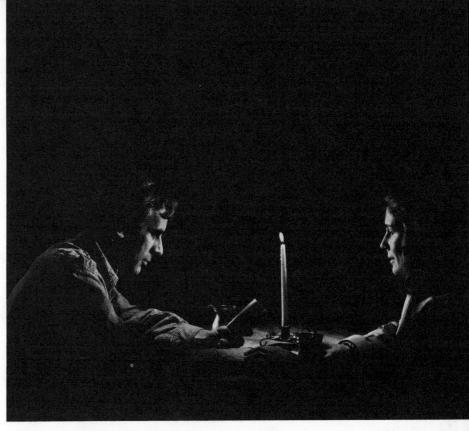

4.69 A bit of back light is added to separate the actors slightly from the background.

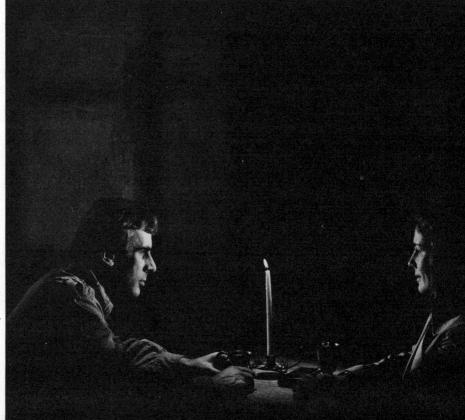

4.70 A window pattern (supposedly coming from the moon or a street light) is used to show the back wall slightly. *(Series of photos by Roger Conrad)*

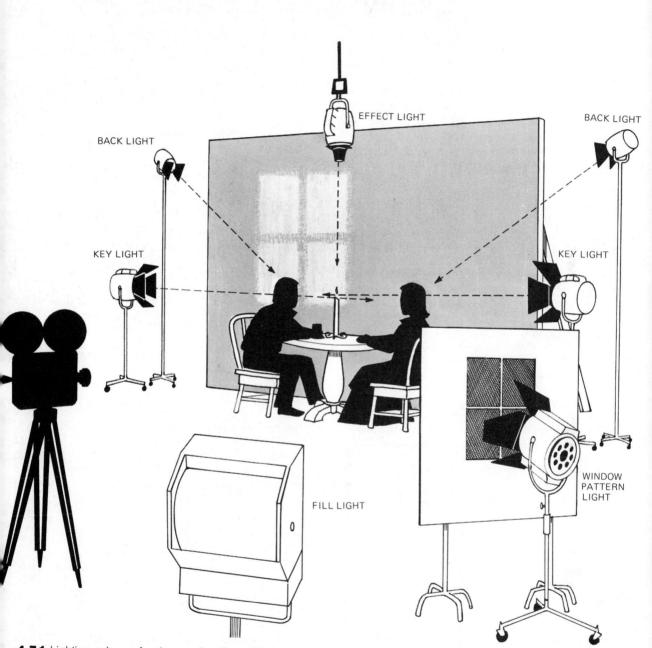

4.71 Lighting scheme for the candle effect. Fill, from the soft light, would be used if less contrast was preferred.

a flickering effect can be cast on the subjects by moving a fringed flag in the light beam or by reflecting the light from a rotating drum covered with wrinkled orange tinfoil.

When an actor is switching a practical lamp on or off, our lighting must react simultaneously. The practical switch can be connected to the lighting circuit, or the electrician can rehearse the movement with the actor. In the latter case it helps if the actor partly covers the switch with his hand and turns it with a smooth movement.

Frequently, sets create problems that the cinematographer must overcome in order to obtain the best visual result. For example, a medium shot of a person in bed may create a lighting problem if the linen is white. Here we don't want the white sheets to be too much brighter than the face. Therefore the light should be controlled so that the face is illuminated but the light on the sheets is reduced. There are several ways to do this. When using small Fresnels, such as inky-dinks, it may be sufficient to spot the lamp and use the barndoors to limit the beam width. With larger instruments we may need other shadow-creating accessories, such as flags and fingers. If only a slight reduction is necessary, we can use a large scrim on a flag stand, some distance from the lamp, with a cutout portion in the shape of the face. This problem should have been at least partly remedied through cooperation with the art director, who could have ordered a low-reflectant material for the sheets. However, when using borrowed locations and props the cinematographer must do his best with what he has.

There are many less obvious situations that require such control. For example, the upper portions of interior walls should be softly shadowed for more realism and better composition. This is easily done with a barndoor or a flag.

One of the most common lighting problems arises when the scene requires an actor to move toward or away from his key light. If we wish the light levels to remain the same throughout the scene, we use halfscrims on the front of the light. Because the intensity of the lower part of the beam is reduced by the halfscrim, the actor's illumination level will remain the same as he moves throughout the area.

Another difficulty is that our lights may create unwanted shadows, the most common of these being multiple shadows of people and objects and the shadow of the sound boom. Generally, we try to keep the actors several feet away from the walls, especially if the walls are light-colored, which makes the shadows more visible. Shadows on the floor are generally less noticeable. Sometimes having two shadows from a single person is unavoidable, but three shadows become distracting and unrealistic. The crossing sound boom casts moving shadows and is most objectionable. We can try to position our lights so that the boom shadows fall outside the frame. If the key light is causing a boom shadow on the back wall, it can be eliminated by using a flag or barndoor to remove the key light from the wall without removing it from the actor. The wall is then illuminated by another light. The cinematographer needs a lot of cooperation and understanding from the sound man, who may be able to help by changing the boom position or using some method other than a boom mike. One advantage of soft lighting is that this problem becomes less critical.

4.72 A half scrim is used to equalize the illumination as the actor moves closer to the light.

DEPTH

Most of the time the cinematographer is trying to recreate a three-dimensional reality on a two-dimensional screen. This depth can be controlled through the manipulation of many variables: shapes and volumes, scales and distances, color and light, movement (subject and camera), and lenses (perspective). An understanding of these variables is essential to all involved in visual arts. Most of them are the direct responsibility of other members of the production team, such as the art director, set designer, make-up artist, and film director. The director of photography, or cinematographer, is involved in the coordination of all of them, but he concentrates on his own contribution, the lighting.

For individual subjects, depth can be accentuated by back and side lighting. This highlights prominent features, leaving the rest in shadow. The three-dimensionality of the set can be augmented by using pools of light separated by dark objects or areas. For example, a long hallway has more apparent depth if only a few parts of it are lit with many shadow areas in between. When shooting color, the depth will be further expressed as chromatic separations, thus adding to the three-dimensionality. Conversely, black-andwhite lacks this advantage, therefore black-and-white films are harder to light than color because more time and care must be invested to obtain a three-dimensional image. With color film color gels can sometimes be used over light sources to enhance the depth. For example, the actors can be lit with warm tones and the background with slightly cooler colors.

TEXTURES AND SHAPES

The texture of a rough surface is best accentuated by lighting from the side or back. The texture is revealed through many small shadows. Because sharp shadows will be most effective for this purpose, a hard light source is used. Conversely, if we wish to smooth out a surface (such as a face), a soft frontal lighting would prove most advantageous. As shape and texture are expressed by shadows, designers sometimes have shadows painted on their sets to create a desired physical appearance, such as in *The Cabinet of Dr. Caligari*. The early Disney animation films, such as *Snow White and the Seven Dwarfs*, gained much depth and realism through the use of dramatic lighting achieved by meticulously painted shadows that move with the characters.

When dealing with shiny surfaces, it is essential to remember the high school physics principle that the angle of incidence equals the angle of reflection. In situations where it is impractical to change the light, perhaps the surface can be tilted or moved. In the case of a hanging mirror or picture on a wall, a matchbox can be placed under one corner to alter its plane.

Curved, shiny surfaces such as car bumpers or bathroom fixtures represent a greater problem. Like any shiny surface they can be toned down with dulling spray that is available from most photographic and art-supply shops. In emergencies, soap and other substances have been used.

In the case of water surfaces, a back-lit reflection may be desirable, especially at night.

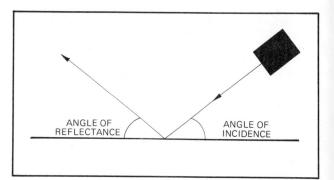

4.73 The angle of incidence equals the angle of reflection.

Often the "texture" is not a surface but a substance suspended in the air. Rain, fog, dust particles, steam, and other such elements can be seen best when backlit. For the effect of an aura or halo one might suspend gauze in that area of the scene. If the background is dark, the gauze can be back-lit for the desired effect. Barndoors, flags, etc., will be used to limit the area illuminated by this particular back light.

Of all the shapes in nature, the human face is the one that interests us most in cinematography. Every face is different and may require a different treatment. The shape and size of the nose and depth of the eye sockets are perhaps the most challenging elements of a subject's face. A long nose shadow can be ugly, and to diminish it we move the key light to a more frontal, medium-height position. To prevent deeply seated eyes from appearing as dark cavities we can lower the key light or use a soft fill light positioned close to the camera lens. An eye light (discussed earlier) will fill in the eye sockets and give the eyes a sparkle. A small Fresnel light such as an inky-dink makes an excellent eye light. Similar procedures may be needed to eliminate shadows created by a wide-brimmed hat.

Through placement of lights we can also control the contours of the face. To elongate a round face we will move the key light higher. This will accentuate the cheekbones and diminish the chin. Some slim faces also benefit from this treatment. Josef von Sternberg, who created lighting for Marlene Dietrich, used high and frontal lighting to bring out Marlene's cheekbones and to create a butterfly shadow under her nose.

A back light, which usually serves to define the shape of the head, should be avoided with a bald head. Large protruding ears are better left in the dark. The shape of the head can be affected by the background. Usually a light side of the face will be positioned against the darker background to define the shape and to create separation and depth.

When setting up kickers, one has to be careful not to hit the tip of a nose, creating hot spots in the middle of the face. The key light coming at 90° from one side of the face leaves the opposite side dark, which solves the problem of unpleasant nose shadows. When a side key light is used, we have to watch out for long and thick eyelashes, which will cast a heavy shadow on the nose. Soft lighting helps a lot in softening these shadows.

Facial proportions can be changed by various camera angles as well. Experienced older actresses often object to being filmed from below, knowing that the low camera accentuates jowls and the double chin. A longer lens (50 to 100mm for 16mm film) is usually used for close-ups because it does not exaggerate the nose. On the other hand, a wide-angle lens is useful if the exaggeration of facial proportions is desired.

Reflections from eyeglasses may betray the presence of film studio lights. It is most objectionable when the glaring reflections hide the actor's eyes, interfering with the audience's ability to see his full performance. Using empty frames with the glass removed, is an easy but unrealistic solution. Normally the glass *should* have some shine. Some cameramen prefer the actors to wear flat surface glasses in place of normal convex lenses. The flat surface will not reflect as many light sources, but at certain angles the full surface will capture the reflection. This may be used to advantage as an interesting effect.

Sometimes moving the glasses forward, pushing them up, or lifting them a bit off the ear will help. You can hire specialists in film eyeglasses who will bring with them boxes full of glasses, flat and curved, with matching frames set at different angles. Moving the key light high and as far around the subject as possible minimizes the reflection problems. On the other hand, big soft sources positioned low and frontal will easily be reflected in the glasses.

The choice of eyeglasses should be discussed before production, remembering that they restrict actors in relation to the lighting.

STUDIO LIGHTING

Some film makers are shooting on location rather than in the studio. Location shooting saves money on studio rental and set materials and gives greater authenticity and realism. Nevertheless, the film studio still offers some very real advantages: full control of the environment and weather, an overhead lighting grid, extensive electrical power (including, in bigger studios, DC current for the use of arcs and for quiet operation of incandescent lights), ideal sound quality control, a smooth and level floor, set construction (flexible ceiling heights and removable walls and floors), and so on.

One advantage that is unique to the studio is the possibility to attain the abstract situation called the "limbo effect." To create the limbo effect (apparent infinite space), the studio must be equipped with a cyclorama. The "cyc" can be a permanent installation —such as those made out of plaster—or not so permanently made out of a plastic or cloth material stretched from the floor to the grid. A wedge-shaped "foot" is used to merge the curtain invisibly into the floor. This wedge may be positioned away from the curtain in order to hide the cyc strip lights. Other cyc strips will be hung from the grid. The object is to illuminate the floor and wall evenly, creating the illusion of infinite space. Therefore, for smooth lighting the cyc strips should not be too close to the cyclorama.

To obtain the full limbo effect of the subject suspended in a white void, the cinematographer doesn't want any shadows on the floor. To achieve this, use all diffused light, such as several large soft lights on the subject. Another excellent diffused source is a large lightweight Dacron screen stretched above the scene and illuminated from above by several powerful lamps. Whatever type of instruments are used, the

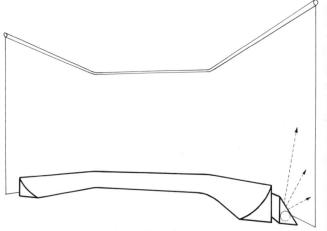

4.75 A quartz cycstrip. (*Bardwell & McAlister, courtesy of F & B Ceco of California, Inc.*)

light should come from all sides in order to achieve the shadowless quality.

The studio can also provide a black limbo effect. In this case the cyclorama and floor will be black and one will not have to light the cyc. Black surfaces still may reflect a certain amount of light. To keep the light off the back wall use a controllable light, such as a Fresnel spotlight or ellipsoidal spotlight. The lamp is equipped with barndoors and placed in either a three-quarterback or side position. This keeps shadows off the back wall and the back stage floor. If fill light is necessary, it should be weak enough so as not to illuminate the background. These three things should be remembered when trying to eliminate shadows from a darkcolored floor and walls of a set: The fewer the lights, the fewer the shadows. Softer lights create less distinct shadows but need larger flags to control the spread. Finally, shooting from a low angle eliminates the floor from the frame.

When lighting a black limbo effect, our eye may mislead us into thinking the background is too visible. A spot meter is invaluable in giving the number of stops difference between the faces and the cyc, enabling us to determine whether the latter will be visible on the film. In most cases, six stops difference should be enough to render the background black.

LOCATION LIGHTING

The studio provides the ideal lighting situation, but the director may see greater advantages in location shooting. There, limited working space and insufficient power make the cinematographer's job more difficult, but the results are often more interesting.

The first problem is power. Most modern houses in

the United States have a total power supply of 100 amps. This power is distributed into several circuits, each with its own amperage limit, which is usually 15 or 20 amps. Each circuit may go to a different part of the house. Suppose the bedroom is on a circuit with a 20-amp fuse. From the wall sockets on this circuit we can use a maximum of 20 amps. It is wise to remember the equation: watts = amps \times volts. Therefore, amps = watts \div volts. For example, say we are using two 1,000-watt lamps. Added together they make a total of 2,000 watts. To find out how many amps are required, we divide 110 volts into our 2,000 watts. This yields approximately 18 amps.

Therefore, we can use up to 2,000 watts in this 20-amp circuit. A 2-amp margin is allowed for safety. There is also a shortcut method useful when the voltage is 110. Total watts divided by 100 gives the approximate amps, with a margin of safety.

In Great Britain and other European countries the voltage is usually 220 to 240 volts. In this case, our 2,000 watts divided by 240 volts would equal a little more than 8 amps. So when the voltage is greater, the same lamps will require less amperage. However, European houses generally have a lower total amperage and the fuses are also of lower denominations. For example, 13 amps is a common circuit. The exact electrical situation varies from country to country and from district to district and will also depend on the age of the house.

Trying to get more than 20 amps out of the 20-amp circuit will cause fuses or breakers to blow. The wires in the wall are not designed for a higher amperage, and if the circuit is overloaded, the wiring may overheat and start a fire. Fuses and breakers are safety devices designed to turn the circuit off if it becomes overloaded. Therefore, simply installing a larger-capacity fuse or bypassing the breaker switch is dangerous.

If you need more than the maximum amperage of the circuit, you can use extension cables to bring power in from another circuit, possibly in a different part of the house. We can find what outlets belong to which circuits by turning the breaker switches on and off or unscrewing the fuses. Such extension cables should be heavy enough to carry the expected amperage load. A # 12 cable will carry up to 2,000 watts and is therefore a standard cable for such a location. A # 8cable should be used for the same load if the distance is longer than 100 feet.

A cable with an inadequate gauge will heat up due to overloading and eventually will melt or crack the insulation, the plug, or the switch.

120 CINEMATOGRAPHY

Working with lights, especially on location, requires constant alertness and common sense. All the light instruments should be grounded as required. On wet locations cable connections should be sealed with a silicon gel. For your personal safety avoid holding a light fixture in each hand. Faulty wiring inside the light may cause the current to travel across your body. It would be particularly dangerous if these lights were drawing power from two separate phases. The potential voltage between them would read 240 volts instead of 120 (or 480 volts instead of 240 in Europe). It is therefore an essential rule of safety that in a situation where the original three-phase, 240-volt electric supply is divided into two 120-volt legs, the cable distribution is arranged in such a way that lights on one phase are at a safe distance from the lamps powered by the other phase.

4.76 Gaffer grip. (Courtesy of Berkey Colortran, Inc.)

4.77 Mitee grip. (Courtesy of Berkey Colortran, Inc.)

To help overcome power limitations, professional film crews usually employ the services of an electrician. He will bypass the circuit breaker switches or fuses and use a distribution box of his own. He takes power from the incoming line after it has passed the main house fuse. Extension cables of the proper capacity run from his distribution box to the lights. This eliminates the hassle of crisscrossing cables from room to room and the worry about blowing fuses. Bypassing the breakers without the aid of a qualified electrician is dangerous and illegal.

For larger lighting jobs a gaffer does not depend on a household's power supply but provides his own from a generator. This can be a huge 750-amp generator on a tractor, providing 90,000 watts, a small Honda generating 4,500 watts, or some size in between, depending on the job.

The second limitation encountered when filming on

4.78 A "space blanket" used as a reflective surface for bouncing light. (Photo by author)

location is space. The amount of available working space will dictate the size and placement of the lighting instruments. The low ceiling and lack of a grid forces the cameraman to place lights closer to the subjects. This creates two problems: hiding the lights and achieving an even illumination. First, the lights must be kept out of the field of view. Therefore, smaller instruments and ingenious mounting devices are required. Because of their higher output and smaller size, quartz lamps (especially the open reflector types) will be used more often than they were in the studio. Inky-dinks and babies will be the most useful Fresnel lights on location. The main mounting devices will be compact, lightweight lamp stands. In addition, a temporary gridlike structure (such as a polecat) will permit mounting lights very close to the ceiling without using a floor stand that might otherwise be visible in the picture. This temporary grid could be of stronger construction for supporting larger instruments. Gator grips, Gaffer grips, and Mitee grips are useful in attaching lamps to doors, fixtures, furniture, etc.

The other space problem is that the close positioning of lights will create an uneven illumination and will be uncomfortable for the actors. Whenever space permits, it is preferable to use a more powerful light from farther away in order to even out the light. This is not always possible. A very even illumination can be achieved by using bounced light. If a light is pointed at the wall or ceiling, the reflected illumination will be evenly distributed, resembling a daytime interior effect.

A wall that is not pure white is not always the best surface for bouncing a light. White show cards, foamcore, or styrofoam boards may be used. For higher reflection but also harder light, silver surfaces are employed. One of the cheapest and most easily available silver sheets is the so-called "space blanket" sold in many sporting-goods and surplus stores. Space blankets are not only highly efficient reflectors but also protect the walls and ceilings from the hot lights. However, even with a space blanket the lamps should be positioned at least a few feet away from the reflecting surface.

When trying to create a night interior effect, the cameraman uses only a little bit of bounced light for overall fill and depends more heavily on practicals and directional lights such as Fresnels.

122 CINEMATOGRAPHY

Aside from the limitations of power and space, the third major interior location problem is dealing with the mixed color temperatures of light sources (daylight, tungsten, fluorescent) and the exterior-interior lighting situation. We have already discussed the filtration solutions for mixed color temperatures. Let's now look at scenes when the outside world is visible through the window and the exterior light level will most likely be a few stops higher than the interior.

This situation creates the problem of a brightness range wider than the emulsion latitude is able to handle. There are a few ways to solve this problem. If we are already applying color-correcting gels on the windows, and still more light attenuation is needed, neutral density gels may be added. Unfortunately, multiplying the gels will augment the problem of light reflection, wrinkles, and rustling noise. Happily, not all is lost, because combination gels, composed of #85 and neutral density, are available in three densities (#85N3, #85N6, and #85N9). Another way to darken the windows utilizes Rosco Blackscrim, a perforated plastic that works like a net. When the windows are seen in a long shot, this scrim appears invisible, but close-ups shot next to the window would unfortunately reveal the texture.

It is often desirable to have the exteriors slightly overexposed for a sunny, hot feeling, or actually bluish for a rather cold effect. But a difference larger than three stops between the interior and exterior may, on color negative, completely "wash out" the recognizable exterior by overexposure. Replacing a #85 gel with a lesser color correction, such as Rosco #3408, Roscosun Half CTO, or Lee #205 Half CTO, will leave the windows slightly blue. Overly hot sky can sometimes be helped by "dressing" the outside with green plants.

Exterior Location Shooting

When planning to shoot an exterior location scene, scouting the location is essential. On such occasions a magnetic compass should be on hand so that it can be used to predict the sun's position at different times during the day. With this knowledge the order of shooting can be planned.

All the long shots will need to be shot in close succession to create the same lighting angles. They should be scheduled for mornings or afternoons, to avoid flat midday light. Shots can also be staged in a more convenient time under a "butterfly" scrim, using an arc to create sunlight that comes from a logical

4.79 A reflector board kit. (Courtesy of Berkey Colortran, Inc.)

angle. Butterflies or larger overhead textile materials have exchangeable screens, such as white silk, black net, and solid black, depending on the character of light required.

Direct sunlight is generally too harsh for the human face. If we wish to use it without any diffusion, then it is best used as three-quarter crosslight or direct back light. Such an angle of light makes the background appear more interesting. One can, for example, introduce a smoke effect that will lend a marvelous three-dimensionality to the scene.

With the sun as a back light or a three-quarter crosslight, we need to provide adequate fill, either from the reflector boards or from daylight balanced lamps. Traditional, silvery reflectors known as "shiny boards" reflect light that is generally too harsh for faces but serves well when pointed at bushes or buildings. Much softer is light reflected from white surfaces such as foam-core or large white plastic screens made of Griffolyn.

When more light is needed, HMI lamps are often employed. Unlike carbon arcs, they run on AC power. This makes it sometimes possible to plug them into adjacent buildings.

Shooting Sunsets

When exposing for a sunset, we have to make judgments based on the understanding that a reflected light meter is calibrated for medium-gray. We do not want the hot sky, and particularly the sun, to be represented as medium-gray. We want it hotter, but not to the point that it will lose its color.

When shooting on color negative, overexposing the sun $2\frac{1}{2}$ stops will also preserve some of the orange hue. But when the sun is small in the frame, then the sky density becomes more important. We now want the sky to be hot, but not to the point of blending with the sun. Certainly not more than three stops over medium-gray.

Much of sunset exposure decisions will depend on such atmospheric conditions as clouds and smog. On a smoggy day the large orange sunball may be only

4.80 Butterfly scrim. (Courtesy of Mole-Richardson Co.)

two stops hotter than the sky. If there is a stratum of clouds, the cinematographer may be able to decide which part of the sky has medium-gray density, measure this area with a spot meter, and expose the sky accordingly. Then the brighter areas will be naturally hotter in relation to the chosen spot.

When there is no smog or clouds and the blazing sun is far from pleasing, we can bring this brightness ratio down with a graduated filter. A two-stop "grad" with a soft blend in the middle, or an attenuator, will be typical choices. Sometimes an orange graduated filter may be used. To fill 50 percent of the frame with the sunball use a long lens (such as a 300mm lens for 16mm film). In trying to preserve the sun's color one may stop down to f/22 and still have to put on a heavy neutral density filter (such as ND 0.6 or ND 0.9).

A word of caution here: Gelatin filters positioned behind the lens may occasionally burn up when a long lens is focused on the sun.

Also, if the lens is heavily stopped down to preserve the color of the setting sun, any figures in the foreground will be rendered as silhouettes.

A spot meter is an obvious choice for the exact measurement of sunsets, but it is not the only one. After all, cinematographers were exposing sunsets long before the modern spot meters were invented. With an experienced eye and a regular reflected meter, fairly accurate exposures can be achieved. Some cameramen use their incident meter for this purpose. The rule of thumb is to turn your meter toward the part of the sky away from the sun, and this reading should give you a correct sunset exposure. Personally, I would rather stay with the spot meter.

SHOOTING NIGHT SCENES

A night effect is not achieved by simple underexposure. Most of the objects will be dark, but given objects will be correctly exposed and some points may in fact be quite bright. The night appearance is really achieved by creating many dark shadow areas in an otherwise correctly exposed scene.

Night-for-Night

The most convincing night scenes are shot at night. As usual, the logic of the lighting will have to follow the practical light sources in the scene, such as street lights, campfires, or the moon. In addition, we must

124 CINEMATOGRAPHY

consider the audience's preconceived notions about the appearance of night light. Night light looks best if the key light sources come from the side or back and usually from a low angle, creating many long shadows. Night lights in reality are usually small sources, and therefore it is best to use hard lights so that the shadows will be appropriately sharp. There is also a popular notion that moonlight is pale blue, and therefore, when shooting color, pale blue gels would be put over any sources supposedly coming from the moon. We can suggest depth by lighting selected separated areas, to obtain pools of light with shadow in between. Another technique, especially useful with buildings and city streets, is to wet down the area with water, obtaining high-contrast textures that reflect the lights. When shooting night-for-night scenes, the actors' costumes should be of lighter tones to separate them from the dark sets.

Day-for-Night

For the sake of expediency and greater visibility in the background, night scenes are sometimes shot during the day. The main objective is to create the preponderance of dark areas in the frame. The shadows can be increased by staging the scene so that the sun comes either as a back light or a three-quarter crosslight.

The morning or the late afternoon on a clear day are the best times to shoot day-for-night, because the low angle of the sun creates longer shadows. A strong key light may be needed to balance the sunny back light. HMI lights are a likely choice, but shiny boards (metallic reflectors) can at times be very effective. The powerful amount of sunlight reflected on the foreground allows the cinematographer to underexpose the background and still have the area of action at a desirable level of illumination.

However, one doesn't want to achieve underexposure by stopping down the lens, as this would give more depth of field, undesirable for night effect. Instead, use neutral density filters and keep the lens more open. It all comes down to having the back- or cross-lit foreground against a dark background, and a shallow depth of field. Together, all these elements give the illusion of night.

After the direction of light, next comes the problem of the sky. For all practical purposes it is much better when the sky is not visible in the frame. Therefore, the best results are achieved by elevating the camera or shooting against hills whenever possible.

If the sky cannot be avoided, it can be darkened

with filters. In black-and-white photography, red filters are used, such as #23A or #25. These darken the sky considerably but also render the faces chalk white. A combination of a #23A (red) with #56 (green) will correct the flesh tones. Of course, in order for a red filter to darken the sky, the sky must be blue. Wherever smog or an overcast day occurs, a red filter will have no effect.

When shooting color day-for-night, the sky may be darkened with polarizers and/or graduated filters. Polarizers will darken the sky when the sun is 90° from the optical axis. Unfortunately, white clouds or pale whitish sky near the horizon will not be affected. A neutral density graduated filter should be carefully positioned so that the soft border dividing the dense and the clear areas matches the horizon line. An attenuator is even better, as it does not have a dividing zone.

Unfortunately, using these filters limits the movement of the camera. Polarization changes when the optical axis shifts in relation to the sun, and graduated filters allow for panoramic movement only when the horizon line is straight.

To obtain the effect of blue moonlight, many cinematographers use a tungsten-balanced emulsion without the #85B filter. For less bluishness it is often replaced by a #81EF, which functions as one half of the #85B color correction.

Whether the sky is included in the frame or not, a day-for-night effect requires controlled underexposure. Cinematographers generally agree that the best results are achieved when underexposing two stops for long shots and one and a quarter stops to one and a half stops for close-ups, if more details in faces are desired. ND 0.6 filter cuts down the light by two stops, so it is convenient to use it without changing the f-stop.

One should generally pay more attention to the overall character of the night than to the clarity of faces. Unless the facial details are very crucial, a shadowed look better conveys the reality of night. While in night-for-night shooting, lighter costumes are preferred; in day-for-night the opposite is true. Bright colors tend to give away the illusion of night.

Dusk-for-Night

The most rewarding day-for-night effect scenes are shot during the magic hour of dusk. During this period there is still enough light to see the shadowed details and the horizon, yet the windows and the neon

4.81 Dusk-for-night effect. (Photo by author)

signs appear realistically bright. The twilight period is brief and so the actors and crew must be well-rehearsed.

Checking the brightness of the sky with the spot meter indicates the light adjustment necessary to keep the relationship between the sky and the foreground illumination (on faces) in constant balance. One should have a good assortment of scrims to cut down lamp intensity as the daylight fades away. On the other hand, if only one master shot of the scene is all that is needed and one intends to do close-ups later on with the help of artificial lights, then every subsequent take of this master does not have to match the previous one. Under these circumstances, as the sky light fades away more fill is necessary to maintain the required exposure on the actor's face. In such a situation, start with several scrims on the lamps, and then as it gets darker remove them to keep a constant light level on the faces.

In order to secure a number of takes in this short period, start shooting before perfect dusk. The first take should be shot when the sky reads on the spot meter the same value as the actor's face. In the second take, the sky may be already one stop darker than the face, and in the third take two stops darker. One of these three takes should yield the desired look.

In the dusk-for-night effect the attenuator filter can successfully darken the sky if the camera will remain static. On tungsten-balanced emulsion many cinematographers do not use a #85 filter; this will endow the image with a bluish hue, blue being a color that is psychologically associated with night.

PICTURE QUALITY CONTROL

Up to now we have been analyzing the different aspects of cinematography as separately as possible. Yet the final aim is the total coordination of these many elements to create the image on the screen as it first existed in the film maker's mind.

The photographic quality of a film has a broad range of possibilities, from naturalistic to stylized to abstract. By manipulating the color, composition, image quality, and lighting, we are able to evoke the atmosphere of a given period, place, or time or suggest a state of mind or impression. Cinematographers may imitate the paintings or etchings of a given period and culture or perhaps constantly introduce a visual effect that will complement the mood of the film. A classic example of such an application is John Huston's film *Moulin Rouge*, in which cinematographer Oswald Morris used the color schemes and compositions typically found in paintings by Toulouse-Lautrec to create the atmosphere of the Parisian cabarets of the late nineteenth century.

Whatever artistic concept is employed, the cinematographer must be in full control of his technology in order to ensure success. This chapter will explore techniques of image quality control, using the basics introduced in previous chapters.

LENS CONTROL

Quality control starts with the preparation and testing of equipment. Optical performance of lenses is of great concern, as even the most expensive ones may have slight aberrations, particularly in their color rendition.

A useful setup for the color test consists of shooting a female face appearing in a cutout of white cardboard (a show card). A few feet of film should be spent on each lens. After the film has been developed, five frame clips of each lens test are compared side by side on a light box. If the lenses are well color corrected, the white card will be consistently white from lens to lens. But if a particular lens renders some slight color cast, there is a need for a color compensating (CC) filter permanently mounted on this lens.

Sometimes a zoom lens gives a slightly warm color bias. If this color rendition is desirable, you may decide to put a "warming" filter like 5Y or 10Y on the remaining lenses in use.

For testing lens resolution a newspaper spread on the wall makes an adequate test chart. The first test consists of focusing the lens by eye and then checking with a measuring tape if the lens barrel calibration is accurate. This should be done for different distances, such as standing at 5 feet, 7 feet, and 8 feet.

The second test consists of shooting the newspaper with each lens. The light level should be set to allow the cinematographer to shoot at the widest f-stop, and then it should be adjusted so the lens can be closed down two f-stops. Every shot should include an identification card with such data as: 50mm, f/2.8, 50fc (foot-candles), and serial number.

EXPOSURE CONTROL

Before testing lenses, check light meters against one another. The light meters should also be serviced periodically by a qualified technician. New, fast films and lenses allow for shooting in low light levels that show at the lower end of scale on traditional meters. Many cinematographers and gaffers order their meters to be recalibrated for a new scale, reading low light values only. For example, a certain Spectra may be calibrated to measure from 0 to 50 foot-candles only. This would make it easier to read the different light values in this range.

Exposure tactics will differ for the negative and for the reversal emulsion. The rule of thumb concerning negative film is: Expose for the shadows and print for the highlights. In practical terms, this means that it is advisable to slightly overexpose the negative and get it denser but then in printing to make sure that the highlights are not too bright (overexposed). This allows for richer blacks, and the image will hold up better in subsequent printings, such as interpositive and dupe-negative. A rich negative is essential when any opticals, such as dissolves or freeze-frames, are contemplated.

Quite the opposite advice should be given to film makers shooting on reversal emulsions. For richer colors and deeper blacks, reversal can be slightly underexposed ($\frac{1}{2}$ stop). Remember, this is a much less "forgiving" emulsion than negative, with very little margin for error. But if you aren't sure of your exposure, it is better to err in the direction of underexposure when shooting on a reversal film.

In a studio situation, experienced cinematographers measure mainly their key lights and judge the lighting balance by eye, unless some lighting effect requires additional checking with a spot meter. On the other hand, exterior locations may require a more careful light evaluation. Landscapes with brightnesses ranging from white snow to dark forest will influence our light readings tremendously. Snow, for instance, generates so much reflected light that the light meter usually indicates stopping down the lens too much, which would result in underexposure. A close-up reading of a face with a reflected light meter (a spot meter particularly) will give a more accurate reading.

For outdoor scenes with large vistas in long shots, a triple light measuring technique is sometimes used. It consists of the following steps:

- 1. Reading with the incident light meter pointed toward the camera.
- Reading with the incident light meter pointed first to the sky and then to the the ground, averaging the exposure.
- 3. Evaluating selectively the scene with a spot meter.
- On the basis of these readings and of our desired emphasis on particular subjects, we decide the exposure.

COLOR AND CONTRAST

There are three stages at which color can be controlled: in front of the camera, in the camera, and in the lab. It starts with the cooperation between the cinematographer and the art director. Blue, red, and yellow draw attention and can be used to direct the eye to different parts of the frame. Make sure that the walls are not too bright, because they tend to distract the viewer. Wall paint with a large content of yellow is particularly troublesome and should be generally avoided by set designers. White fabrics can be "teched" down, which means rinsing them in special solutions to make them off-white. Sometimes a weak tea rinse will do the job.

When a color scheme is created for sets, costumes, and make-up, the cinematographer's input is mainly advisory. But once the scheme is set, the cinematographer can still affect the final outcome by using color gels on lights, color filters on the lens, and color changes during printing. All these corrections can change hues.

The cinematographer can also manipulate the saturation of colors with a variety of fog and diffusion filters or by the use of smoke in the air or by flashing the film in the lab. Mixing cool and warm lights in a scene is often a desirable visual and psychological efPICTURE QUALITY CONTROL 129

fect. For instance, using an orange key light with a bluish fill resembles a sunset with blue shadows. At night in a warm interior, a blue rim of light could indicate moonlight coming through the window.

Aside from color gels, reflective materials are also available in colder or warmer tones. In the Rosco line of products there is a silver-blue Roscoflex D and a golden Roscoflex G. Gold reflectors are useful for "warming up" black skin tones, which often show up too blue, particularly when the light comes from a back angle.

On the exterior the main concern is the color of the sky. The bluishness of the sky differs vastly depending on the direction of the sunlight, the time of day, and the atmospheric conditions. These changes are very noticeable when different shots are edited together. There are a few ways to deal with this problem. In the Oscar-winning film *Butch Cassidy and the Sundance Kid*, cinematographer Conrad Hall consistently over-exposed the sky to render it white. He felt that different blues would not cut well and that blue was also too strong as a background, drawing too much attention from the remaining colors.

The sky can be darkened by a graduated filter, either neutral density or color. Such filters are quite popular now. They can warm up the sky (as in orange filters) or make it deeper blue.

Colors that are too rich (deeply saturated) can be softened by diffusion and a lower contrast ratio. Atmospheric conditions like fog and haze act as natural diffusers. These can be imitated by the use of smoke. To be effective, smoke has to be back-lit. Lighting it means actually lighting the air. What is seen is the reflectivity of the smoke. It provides the image with a sense of depth. It is difficult to establish the correct exposure for smoke. One should measure the scene without smoke and then with smoke to see the difference. The smoke will read brighter. Try to overexpose it, so if smoke moves away during the shot, there will still be enough exposure for a progressively darker scene.

Smoke or fog creates a sense of depth that cannot be achieved with a fog filter. But to cut down the contrast and to desaturate colors, filters are effective. Some cinematographers prefer black nets to filters. First, the nets do not create reflections, as from the headlights of a car at night. Second, the nets desaturate colors without softening the sharpness of the image. Finally, they render the same effect toward and away from a window, whereas with fog filters the windows will "bloom" (flare out). When bright lamps are in the frame, the nets will give a slight cross-star effect. Overall netting gives the scene a rather lyrical effect.

All these filters are widely used in the 35mm format. Sixteen-millimeter film is less sharp to begin with. Lowering contrast and saturation is mainly used to obtain more pastel results from "contrasty" reversal emulsions. Tests are essential in these situations.

At times, the best way to even out the contrast of different scenes, or within one scene, is to flash the film. For example, overcast and sunny scenes can be evened out by flashing the latter. Contrasty night scenes with fires will also benefit from flashing.

LIGHTING CONTROL

Lighting is often referred to as painting with light. Cinematographers, like painters, use broad strokes and fine strokes. In chapter 4 we were more preoccupied with broad stokes, trying to see the overview of lighting technology. Now we will look at some practical ways of how to control light more effectively. Due to lack of space, these are limited to few useful hints.*

Modern lenses and film stocks allow cinematographers to work with low light levels, and therefore the existing light sources in the scene (practicals) play a much greater role. Their brightness needs to be balanced with the rest of the frame.

When the use of dimmers is not possible, some cinematographers resort to either hiding or darkening the hot spots. When incandescent filaments are visible, as in ornamental chandeliers with bulbs in the shapes of candle flames, stick on small pieces of Scotch Tape to cover the hot spots. The density of tape can be built up by additional layering. If it is necessary to darken a whole bulb, it is customary to spray it with Streaks'n' Tips,[®] a brownish hair spray. The spray is applied until the bulb looks right. Afterward, the spray can easily be washed off with water. Overly bright neon signs can be covered or wrapped up with black netting to bring down their intensity.

Cinematographers usually ask the art director for as many practical lamps on the set as possible. These lamps can be rigged to dimmers. This will allow the

^{*}A more specialized book, *Film Lighting*, by the same author, delves deeper into this field.

dimming of lamps that are in the frame in a given shot while allowing the boosting of the ones out of the camera's view, so that they can serve as actual sources of light in the scene. Even the least expensive household dimmers can usually handle up to 600 watts.

Photo enlarger bulbs, such as the G.E. 150-watt PH/212 (3,050° K) are often used in practical lamps because they are closer to $3,200^{\circ}$ K than household bulbs. A flashlight used in a scene can also be regarded as a practical light. It should have a krypton gas bulb to provide more light. The flashlight beam will be better utilized if white surfaces are positioned in areas where the light is aimed. This will allow the light to bounce back and illuminate other areas of the scene.

Practical lamps play an important role in adding depth to the set. One can create soft sources of light that look like practical lamps. A typical example of this is the Japanese lantern. This round paper shade can be easily hung just outside the frame line as a source of soft light. Depending on the size of the lantern and the lighting need, various bulbs can be used. A photoflood such as the G.E. 250-watt ECA, burning at 3,200° K, is often employed. To control the spread of light the lantern can be partially sprayed with black paint. An added feature of the lantern is that its visible reflection in any glass surface on the set will not cause problems because it will appear to be a practical.

If the set walls and furniture look too evenly lit by soft light, "break it up" with the skillful use of the cucaloris (cookie). To make its effect more subtle, put a silk between the light and the cucaloris. Experiment by moving them closer and farther away from the light and from the walls in order to get the desired effect. Broken shadows can also add interest to wooden paneling or furniture.

Lighting dark paneling, as in board rooms or court rooms, requires special attention. One can either light it for its texture, with directional light coming from one side, or it can be lit with large white surfaces (bounced light or large diffusion screens) to be reflected in the paneling.

When creating diffused light, there are a few points worth remembering: Hard light spread by a diffusion screen will give a more controllable light than a bounced light. In order to control diffused light with a net or flag, these should be positioned in front of the diffusion screen and not between the screen and the light; therefore, diffused lighting requires large nets and flags.

When the diffusion screen is farther from the light, it gives more even lighting because the whole screen becomes an even source without a hot spot in the middle. To make the diffused light more random, score the diffusion screen with a razor blade. Sometimes this may create a more interesting pattern of light. When light is bounced or diffused, its softness depends on the size of the reflecting board or the diffusion screen.

A very soft light can be achieved with these methods that is not available with commercially produced soft lights, whose softness depends on the size of their boxlike reflectors. The largest, an 8,000-watt soft light, measures 36×30 inches—not much, compared with the 12×15 feet of the diffusion or reflecting screen. But there are merits to both methods. Box fixtures create more directional light. A grid, descriptively called an "egg crate," attached to the box helps control the light. Not only does it limit the general spread of light but when the light is tipped up, it gradually cuts the area of light intensity closer to the lamp. This allows for a more even lighting of an actor coming toward an instrument.

A soft light does not produce distinct shadows. Strong shadows are created by lights with a physically small light source. When the scene calls for venetian blinds creating distinct shadows on the walls, don't immediately think in terms of arcs outside the windows. Often a large incandescent lamp, such as a 5,000-watt Senior or a 10,000-watt Tener, could be used for this effect. A Fresnel lens can be removed to create a sharper shadow. This light can also be used for a rain effect. For example, by lighting through a window, the water sprayed on the panes will be projected on the actor's faces and onto the set. Unfortunately, when lamps of this magnitude are used, a generator is often needed as a power source. Faster films will allow one to attempt these effects with a 2,000watt light if the scene is lit with a low-key light.

Moving now to the exterior, let's start by stating that daylight, in all its forms and nuances, is still the most interesting and pleasing light known to man. Therefore, it should be used to advantage as much as possible. And yet, direct sunlight producing harsh shadows, particularly during the midday hours, is not very flattering to the human face. This does not necessarily mean that shadows must be filled with a lot of artificial light. There is, instead, a subtractive way of lighting, and its tools consist of various overheads, large flags, and reflectors.

When a frame with silk or other material is supported above the scene from two or more points, it is called an overhead; when it is held up by one stand only, it is called a butterfly. All the materials used on these frames help us modulate the sunlight. A black net (scrim), will cut its intensity, a white silk will soften it, and a black solid will create a shadow. Depending on the size of the frames and the height at which they are set up, the frames will produce a stronger or a weaker effect. The black material, described as "solid," can be used as a light "valve." The lower it comes, the less ambient light penetrates the scene.

When such a light "valve" is created for the foreground action, it is important to have the background dark, so that the exposure difference between the foreground and the background is no more than $1\frac{1}{2}$ to $2\frac{1}{2}$ stops. A dark forest would be certainly more accommodating, exposure-wise, than a wheat field.

The direction of light also makes a difference. Background will be darker and more three-dimensional when it is backlit. The solid overhead can also be used on an overcast day. Overcast produces a lot of top light. A regular flag positioned overhead will cut down the top light for an individual actor. This will leave him with a rather flatly lit face, as the same amount of ambient light will be coming from both sides.

To create more directional lighting, put another black flag on one side. In effect one has subtracted light from above and from one side. On a bright overcast day this technique can produce very beautiful results. On a heavily overcast day this system may require additional artificial light—just a little fill with diffusion is usually enough. Shooting outdoors in the green surroundings requires some caution. There is a danger of a green reflection on the actors' faces. This is not quite obvious to an untrained eye at the time of shooting, but it can be very noticeable on the screen. When careful observation or a color temperature meter indicates such color bias, a light with the correct color temperature is used to "clean" the faces. HMI lamps, FAY globes, or blue gels in front of the tungsten sources will do the job. A reflector board carefully positioned so that it reflects only the sun and the sky can also be used. To "cool" faces, use a blue silvery reflector, perhaps through some diffusion.

Reflectors and mirrors can be used to direct light into some very difficult places, such as caves. Skillfully positioned mirrors can redirect the sunlight, reflecting it a few times on its way. Particularly in commercials, small mirrors are used to add strong highlights that make glasses or pitchers containing liquids sparkle. A small mirror reflecting sunlight becomes a very powerful source of directional hard light.

With experience, a cinematographer's arsenal of creative lighting techniques will grow. Perhaps the most important thing about lighting to remember is that one is not creating an individual pretty or powerful picture, but that all shots and scenes have to match. Remember, it is easier to match shots in the controlled environment of a studio. The changing light conditions of daylight require much more planning and alertness. Detailed knowledge of the script is essential, and much can be learned in a cutting room.

SOUND RECORDING

.........

Beginning film makers frequently underrate the importance of obtaining good original sound. They think that if the original recording is at least audible, it's good enough. They forget that the original recording will be re-recorded many times and put through many generations, each slightly deteriorating the quality before it reaches the screen. If the original recording was poor, the film sound track will suffer greatly. For this reason, the original recording should strive for excellence. Only the best professional equipment and techniques should be used if the final sound track is to be of high quality.

SYNCHRONOUS SOUND

There are basically two methods of maintaining synchronous sound—mechanically and electronically. The first, called "single-system," employs a single-perf film stock with a narrow magnetic track laminated to the edge of the film. The sound signal from the microphone goes through a portable central unit and then into the camera, where it is recorded onto the magnetic stripe on the film. After the film is processed, the original can be viewed (with sound) on a magnetic projector. Today, single-system sound is mainly used with Super-8 film. "Double-system" sound offers higher quality and greater flexibility. It electronically interlocks the camera with a tape recorder. The most popular systems of coordinating these two machines are either by way of sync "pulses" or by using a time code. This second method is by far the best one and is rapidly gaining popularity.

Crystal Sync

The sync pulse is really a 60-Hertz sync tone. "Hertz" describes the cycles of electricity per second. Sixty-Hertz is a measurement that applies to North America, where the power is sixty cycles per second. In Europe, where the power is fifty cycles per second, the sync tone is also fifty. Some countries use twenty-five and some use one hundred Hertz. The sync pulse must match (in cycles per second) the power used to transfer the sound from the quarter-inch tape, the 16mm magnetic film.

The best sync pulse system utilizes highly accurate crystal speed controls for the camera and the sound recorder. Through the use of crystal sync, the camera speed is held constant at exactly 24 fps by one crystal control, while the other regulates the sync tone device built into the tape recorder. This sync tone generator provides pulses that are recorded sixty times per second on a magnetic tape. They can be considered as "electronic sprocket holes" that allow for an accurate sound transfer to 16mm magnetic film at exactly the same speed at which the sound was originally recorded.

Time Code

The most exciting advancement in the technology of synchronous sound is the development of time code. It works on the principle of the camera and the recorder being equipped with time code generators that can be set to run in perfect synchronization. Time measured by these clocks is being recorded on both the film and the sound tape.

The Aaton camera, a pioneering instrument in this field, is equipped to expose a data track on the film edge using a set of light-emitting diodes (LEDs). These clear figures indicate (once every second) the following data: year, month, day, hour, minute, and second. The camera can be additionally programmed to indicate production number and equipment number, as well as the scene, the take, and the roll numbers. These are the man-readable communications. Next to them, the same information is being exposed in machine-readable code on every frame and transferred into electronic time code used in video and audio post-production. Simultaneously, a tape recorder, such as Nagra IV-STC, equipped with a time code generator, records its signal on a quarter-inch tape.

Both the camera and the recorder are set (initiated) at the beginning of each shooting day either by the master clock or to each other to maintain synchronous operation. Subsequently, when the quarter-inch tape is transferred to 16mm magnetic film, a printer, such as Aaton Adage 4, reads the electronic signals and prints in letters and figures on the back of the magnetic film the time code and any other address information, which is electronically encoded on the magnetic track.

As a result, the clear time code visible on the optical film can be compared with the same information printed on the magnetic film, and the two can be synchronised with great ease.

Slate

When the time code is not used, we must provide sync marks on both picture and sound so that the two can be matched up. This is traditionally achieved through that well-known symbol of film making, the clapper board, or slate. The scene and take numbers are written on the slate and voiced by the assistant, who then claps the board hinged to the slate. This provides identification marks on both the sound track and the film, telling which scene and take is being shot. Later, the "clap" on the track is aligned with the frame on which the slate closes and the film is in sync.

In situations where the use of a clapper board at the beginning of a shot would disturb the subject (such as when filming wildlife or children or in cinéma vérité) a "tail slate" is used. At the end of the take the camera and the recorder are left running and the assistant "slates" the take as before. The only difference is that the clapper board is held upside down to inform the editor that it is a tail slate. The assistant should say "tail slate" and then give the scene and take numbers.

RECORDERS

Among the professional quarter-inch reel-to-reel recorders for sync sound operation, the industry's favorites are the Nagra[®] 4.2 and Nagra IV-S models. Stellavox[®] Sp8 represents another excellent professional tape recorder.

An electronically even more extended Nagra T-Audio serves during the post-production sound operations, such as sync keeping during a sound transfer to 16mm magnetic film, double system video editing, and computer-assisted sound "sweetening."

MICROPHONES

Microphones are classified in two ways, first by structure and second by reception pattern. In motion-picture application most microphones fall into two structural categories—dynamic and condenser.

Dynamic microphones are the most durable type. Because they employ a strong magnet, it is advisable to keep them away from magnetic tapes and recorder heads. Condenser (capacitor) microphones require power from a microphone battery, an external power supply, or directly from the recorder in order to operate. When using condenser microphones, one must know which microphone input has a proper preamplifier to accommodate these mics. The most sophisticated of the condenser mics are the r.f. condensers, such as the Sennheiser 416 and the 816. Mics in this category are rather expensive.

6.1 Nagra IV-S TC 1/4-inch recorder. (*Nagra information and photos supplied by Nick Morris, V.P./general manager of Nagra Magnetics, New York.*)

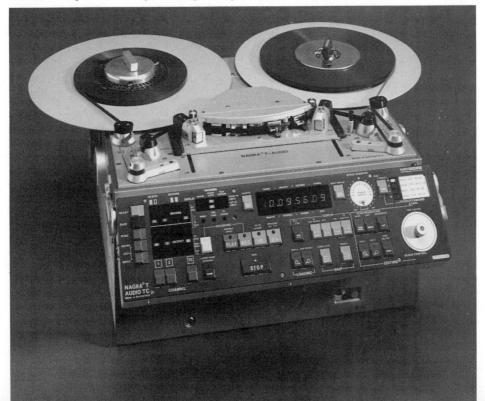

6.2 Nagra T-Audio 1/4-inch tape recorder. (*Nagra information and photos supplied by Nick Morris, V.P./general manager of Nagra Magnetics, New York*)

Electret condenser microphones are simpler in their construction than the r.f. mics, and subsequently less expensive. They are very small and require a miniature battery. Lapel mics, such as Sony ECM 55, are good examples of this type. Condenser microphones are considerably more sound sensitive than the dynamic ones.

Microphones are classified by reception patterns as unidirectional or omnidirectional. The directional (cardioid) mic favors sound coming from a particular direction, approximately within a 160° angle. As a sound source moves away outside of this angle, the high frequencies are the first to vanish.

A mini shotgun (hypercardioid) such as the Sennheiser 416, has a narrower reception pattern (approximately 120°), and its design is particularly favored for film audio work.

A ultra directional shotgun (supercardioid), such as the Sennheiser 816, has a narrow reception pattern (approximately 60°), which makes it especially suitable

OMNIDIRECTIONAL

6.4 Reception pattern for an omnidirectional microphone. (Drawing by Robert Doucette)

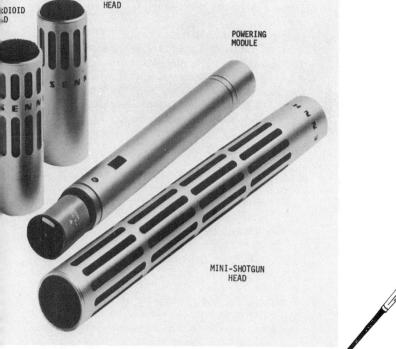

6.3 Sennheiser K3-U modular condenser microphone system. (*Photo printed with permission from Sennheiser Electronic Corporation, U.S.A*)

6.5 Reception pattern for an unidirectional microphone. (*Drawing by Robert Doucette*)

6.6 Reception pattern for a supercardioid microphone. (Drawing by Robert Doucette)

6.7 Reception pattern for an ultracardioid microphone. (*Drawing by Robert Doucette*)

for outdoor shooting where the background noise has to be avoided.

An omnidirectional mic accepts sound coming from all directions. It is useful for background effects or group discussions where the mic must remain stationary. Unfortunately, it picks up so much background noise that it is very rarely used in film work.

The lapel lavalier microphone is clipped or taped to the subjects' garments. Lavaliers are designed to favor high frequencies in order to compensate for the overabundance of low frequencies originating from the chest area. For this reason they should be placed against the chest.

These microphones are generally omnidirectional in their reception pattern. They eliminate the need for a sound boom and keep the mouth-to-mic distance constant. The localized pickup tends to eliminate ambient noise. Unfortunately, some older designs may be susceptible to cable noise caused by the cable rubbing against the actor's clothing. Lapel lavalier mics are often connected to radio transmitters for wireless operation.

Not all microphones are compatible with all recorders. All parts of the sound system have some resistance to alternating current (AC), which is known as impedance and measured in ohms (Ω). The different parts of the system should roughly match. Microphones with a higher impedance than the recorder should never be used. In film work, low impedance equipment is preferred (not over 600 ohms). It allows for very long microphone cables and reduces the danger of electromagnetic interference.

Other Equipment

For outdoor filming, wind screens are a necessity. They can range from acoustic foam rubber to a "zeppelin" made of plastic fiber mesh and foam. Soundmen will often use their sound screens for indoor shooting as well. Sound screens protect the microphone from the rustle of air caused by boom swinging and from accidental impact. In emergencies, woolen caps, stockings, and other soft covers can be used to protect the mic from the wind.

Because the best microphone position is generally above and in front of the speaker, there is usually a need for some sort of boom. Depending on the production needs and the budget, the boom could vary from a telescopic fishpole to a sophisticated studio boom (such as those made by Fisher or Mole-Richardson). In any case, the microphone must be mounted so that it is mechanically isolated from any hard surfaces. It can be suspended by a rubber shock mount, or in an emergency, it may even be taped to the pole with a piece of foam rubber in between.

Microphone cables are designed to protect the sound system from picking up electromagnetic hum. The balanced cable is best suited because the signals travel through two isolated conductors inside a shield. In an unbalanced cable, only one conductor is used, with the shield performing as the second. A balanced cable can be recognized as having three contacts. Trying to eliminate a hum when the rest of a crew is ready to shoot can be an unnerving experience for a soundman.

Microphone cables require considerable attention and care. They should be protected from being run over by equipment on wheels or having heavy objects pin them to the ground. There is a set way of coiling them to avoid the constant twisting of the delicate wires (see figure 6.8). Kinks must *never* be pulled out. They should always be carefully untwisted.

Maintenance of Sound Equipment

Like all other equipment, the tape recorder must be checked and tested before use. The first thing to check is the batteries. If some batteries are weak, always replace the full set. Make sure that the recorder is compatible with your microphones (impedance) and with your tape (bias). Bias is a high-frequency signal generated by the recorder and added to the incoming signal to linearize the magnetic information, thereby reducing distortion. High-frequency bias is set by a qualified technician for any type of tape.

On the recording deck you should pay particular attention to the heads. The most common problem is the magnetizing of the heads. The recording and playback heads should be demagnetized regularly with a small band degausser. One should make sure that the recorder is switched off before demagnetizing. Demagnetizing has to be done properly or the heads will end up more magnetized than before. So read the instructions provided with your degausser carefully. It is advisable to demagnetize the heads after every ten to twenty hours of use or after the head has come within the proximity of any magnetic tools.

Dirt is frequently left on the head by the passing tape. It should be removed by using a cotton swab moistened with liquid head cleaner, such as Freon TF solvent (DuPont). In an emergency, clear alcohol may also be used. When cleaning, never touch the head with any hard instrument. Heads need to be cleaned after every couple of tapes. The rollers and guides should be cleaned as well. Occasionally the head may become misaligned. Unless you are experienced yourself, leave the alignment to a trained technician.

Troubles with recording equipment are often evident on the sound track. Sound distortions known as "wow" and "flutter" are usually caused by a faulty transport mechanism that advances the tape at an uneven speed. Hums and hisses can be caused by a faulty amplifier or low batteries, but these could also have their source in electromagnetic interference as discussed in the section on microphone cables. Interference could also be received through the tape recorder's AC power supply. For this reason it is always a good idea to have batteries on hand when using AC power to run the recorder. It should always be kept in mind that the hum may be acoustical, possibly generated by some audible source nearby. Fluorescent lights and refrigerators are notorious for this.

The sound recordist who hears a hum via the microphone and his earphones may not realize its true origin. Crackling noises are usually due to faulty connections. If the tape recorder is left in the hot sun it may overheat, causing it to hum or in some other way operate improperly. Therefore, whenever filming in extremely hot conditions, try to keep the recording equipment cool.

Care of Tapes

For professional recording, use only new, high-quality tapes. Cheap tapes have rougher surfaces and may be wearing out the sound heads at a quicker rate. Tapes are made of two types of base materials: acetate and polyester (Mylar). Polyester has the advantage of being much stronger and less affected by humidity. Widely used professional tapes, such as 3M Scotch 808, use polyester base.

Tapes should be protected from dust. Although it isn't visible on tape as it is on film, dust will cause high-frequency dropouts. When not in use, tapes should be placed in their boxes, and during recording the recorder's plastic lid should be closed.

Before recording, some soundmen degauss (bulk erase) all their tapes, just in case they were partially magnetized during storage or transport.

After recording, the tape should be left tail out

6.8 The proper method of coiling sound cables. *A:* The first loop is normal. *B & C:* The second loop is given an inside twist. *D:* The third loop is normal. And so on, alternating a twisted loop with a normal loop.

because fast rewinding leaves the tape unevenly wound on the reel and increases the likelihood of print-through. An unevenly wound tape is not suited for long-term storage. Room temperature and humidity of about 30 to 70 percent is acceptable for storage. Never store tapes in places where they could be exposed to extremes in temperature and humidity.

OPERATION OF TAPE RECORDERS

Some recorders have a choice of tape speeds. The standard in the film industry is 7½ ips (inches per second) for dialog. At this speed a 5-inch reel—which is the most commonly used size—runs for about sixteen minutes, which comfortably matches the 400-foot magazine of 16mm film usually used with self-blimped sound cameras.

When threading up a new reel of tape, the first thing to do is to put a voice identification at the beginning of the tape. Include the following: production title, production number, recordist, tape roll number, and date. This same information will also appear on the sound report sheet and on the tape box, in addition to the recorder number, the type of tape, and the speed at which the tape was recorded. After the voice identification, a reference tone is recorded onto the tape for about ten seconds. This reference-tone oscillator is built into many professional film tape recorders. The tone is used by the sound technicians in setting the volume for the transfer.

The level of an incoming sound signal is displayed on a meter. The most common is the volume unit (VU) meter, but for much more accurate reading a peak reading meter (modulometer) is used. Industry standards such as the Nagra 4.2 use a modulometer. It is essential to familiarize oneself with the meter by recording different types of sound at various levels. Our goal in recording is to obtain sound at the highest possible recording level but below the threshold of distortion.

Recording levels are set ahead of time during rehearsal. A gentle adjustment can be made during recording, but significant "pot riding" would cause noticeable changes in background noise. Many recorders are equipped with an automatic gain control (AGC). This is used mainly in documentaries, when there is no time to worry about sudden volume changes. Normally, sound recordists prefer the manual volume control. Some recorders prevent overmodulation by the use of limiters, which will cut drastic volume peaks.

BASIC ACOUSTICS AND MICROPHONE PLACEMENT

Generally, the microphone should be placed as close to the subject as possible, depending on the design of the mic. If the microphone is farther away, the recording level has to be set higher, and a higher recording volume raises the background noise. To avoid this, try to place the mic closer so that a lower volume level can be used. Perhaps have the actor speak up.

Generally, the best microphone placement for voice recording is slightly above and in front of the performer's face, within arm's reach. The mic should usually be pointed directly toward the actor's mouth. One exception might be in the case of an actor or actress with a sibilant voice, which can be favorably modified by pointing the microphone slightly to one side, losing the high frequencies. A sound boom is used to hold the microphone just out of the frame, in proper position. If the actor turns or another person starts speaking, the mic must be rotated to keep it pointing directly into the speaker's mouth. Otherwise there will be a considerable change in voice quality.

Room acoustics are of vital importance for the sound recordist. A room with hard, smooth surfaces will cause the sound waves to reverberate for a long time, creating live ("boomy") acoustics. An interior with different textures, such as soft furniture, carpets, and wall hangings, may be acoustically dead. Some degree of reverbaration may be needed to enrich the sound and create the sense of space.

On interior locations the sound conditions are generally too live ("echoey"). A quick solution is the use of blankets and rugs. Spread them on the floor, under the microphone, hang them on the walls, and drape them over any hard surface, such as table tops. Avoid smooth parallel walls in front and behind the microphone. They may create a standing wave effect in which the sound waves bounce, sometimes cancel, sometimes complement each other, making even recording difficult. Whenever possible, the mic should be positioned so that its axis runs at a diagonal through the room.

In some scenes, more than one microphone is used to cover the action. In such instances the sound recordist must pay particular attention to the distance between them. When they are too close, the sound waves will be reaching the microphones out of phase, and phase cancellation will result. To avoid this, the distance from the same sound source to the farthest mi-

140 CINEMATOGRAPHY

crophone should be three times longer than to the closest one. For example, when actor A speaks to a microphone two feet away, the microphone for actor B should be six feet from actor A. The phase cancellation phenomenon takes place only when signals from both microphones are recorded on the same track. In the case of two microphones connected to a stereo track recorder that offers two-track recording, each microphone provides a signal that is unaffected by the other. Another advantage of recording on separate tracks is the ability to control the voice levels of two actors independently.

When filming an announcer or recording narration, a few simple steps should be followed. If the mic is on a table, cover the table with a blanket. If the mic is on a stand or hand-held, the announcer must not cover it with his script or the high frequencies will be lost. The announcer should try to keep his mouth at a constant distance from the mic and not turn away, such as to glance down at his notes. Similarly, if the mic is not directly in front of his mouth he must not turn his head suddenly *toward* it or the unexpected rise in volume may cause distortion.

Sound Perspective and Presence

The sound and picture perspectives should match. For realism, if an actor appears far away in the picture, he must not sound as though he were close. Similarly, the sound quality must fit the location. For example, a huge cathedral should have a rather live, "echoey" sound. It should not have the relatively dull presence of a carpeted living room. These rules, like any others, are often broken for creative reasons.

To preserve the same atmosphere throughout an entire scene the sound man will record a length of "room tone" to be used on the sound track over any silent footage, or to back up dialog replaced after shooting. Even if silent footage is not to be used, the room tone should be recorded, as it is often invaluable to the sound editing and mixing technicians who may use it, for example, to fill in for some unwanted noise occurring between lines. The room tone should always be recorded for every location, with actors, props, equipment, etc., all exactly the same as during the scene.

Other "presence" tracks may also be recorded, such as street sounds that will later supposedly be coming from a set window, etc.

Camera Noise

The sound man is frequently fighting a noisy camera. Many self-blimped cameras are not quiet enough for close-up work, especially in confined areas. There are also nonblimped cameras available with sync pulse. Padded covers, called "barneys," are available for these cameras, and they reduce the sound somewhat but should never be expected to render these cameras as perfectly quietly as, say, a well-maintained Arri SR. There is no way of filtering out camera noise during mixing. Therefore, when using a noisy camera, steps should be taken to reduce the noise while shooting. Noise can be decreased by using a blimp, shooting through a window, or, when filming outdoors, using a longer lens and shooting from farther away. The sound man can also help to avoid camera noise by using a shotgun mic, or perhaps a localized mic such as a lapel lavalier mic.

Dialog Replacement

Often because of poor recording conditions, such as airplanes, traffic noise, interferences, or partial equipment failure, it is impossible to get a high-quality track on location. In such cases the producer may save time by going ahead with the shooting, recording an unusable track. This "guide track" will be recorded in sync and will later be used in a mixing-and-dubbing theater when those lines of dialog are "dubbed" by the actors. The guide track is played with the picture while the actor watches and listens to recall his exact delivery. The film is run again and the actor delivers his line in sync with the picture. This process is expensive, and so everyone hopes all will go well on location and dialog replacement will not be necessary.

CUTTING AND LAB WORK

After the film is shot and taken out of the camera it does a lot of traveling, first to the lab, and then to the cutter or his assistant. Along the way to the release print there are many different processes, procedures, and optional routes available. To take best advantage of them, the competent cutter is thoroughly familiar with laboratory services and capabilities. Because the technical cutting and lab work must be so coordinated, the two subjects are treated here in the same chapter.

SUBMITTING MATERIALS TO THE LAB

Labs require information sheets with *all* submitted materials. The information must be as explicit as possible. Time and care must be taken to fill out the form completely to ensure that the material receives *exactly* the work intended for it. The information should usually include:

- 1. Name of the company or individual
- 2. Purchase-order number
- 3. Account number at the lab
- 4. Production title
- 5. Production number
- 6. Roll number
- 7. Type of film being submitted

- 8. The job to be done:
 - a. If the raw footage is to be post-flashed, indicate this *first* in a very visible manner.
 - b. If test footage was shot on this roll, indicate where and how much.
 - c. Indicate whether it is to be developed. When submitting *already developed* material, indicate it to avoid a second development.
 - d. If the film is to be pushed in processing, give the EI/ASA index at which it was exposed.
 - e. If it is to be printed (as with dailies), state whether the print is to be:
 - (1) Black-and-white or color
 - (2) One light or corrected
 - (3) Single or double perf
 - (4) Whenever possible, insist that the original edge numbers be printed through.
 - f. Usually a "Negative Report Sheet" is also submitted, stating which takes are to be printed and giving their location by footage.
- 9. Indication of any suspected breaks or sprocket damage
- Instructions on where to send the print (Perhaps it is to be held for a pickup. Also indicate whether the original is to be held in the lab vault or returned.)
- 11. Mark whether the print is to be put on a core or a reel with can or case.

Finally, if you are working with one particular lab technician who is familiar with you and your project, send the order to his attention. This is a lot of information, but each item is vital to the fast and efficient execution of the work.

EDITING-ROOM EQUIPMENT

The most basic editing equipment consists of rewind arms, reels, synchronizer, sound reader, viewer, a tape splicer, and an editing table with a light well. Use plastic reels for sound.

When storing film, to economize on reels the film is wound onto a plastic core that uses a "split reel," which comes apart, allowing the core to be seated in the center. Another indispensable piece of equipment is the film bin, where the footage being worked on can be separated and each shot conveniently hung on a separate peg. Film bins can easily be homemade.

It is not a recommended practice, but if necessary an action viewer may be used for very careful viewing of originals. It must not be permitted to scratch the film. The Zeiss Ikon Moviscop is one of the safest viewers available.

The synchronizer and rewinds should be of the four-gang type (capable of running up to four rolls of film in sync at once). All reels must have centers of equal size, in order to keep a constant tension on all rolls when winding two or more strips through the synchronizer at once.

Tape splicers are always used for editing the work print and sound. Unlike cement splices, tape splices can easily be taken apart without losing a frame. This

7.1 An editing table with basic equipment.

7.2 Split reel. (Photo by author)

7.3 Film bin. (Photo by author)

7.4 Moviola rewind with spring clamp and spacers to hold four reels in position. *(Courtesy of Magnasync/Moviola Corp.)*

7.5 Parliament Guillotine tape splicer. (Photo by author)

CUTTING AND LAB WORK 145

7.6 Revisquick Tapesplicers. Straight cut (right) for picture and diagonal cut (left) for sound. (Photo by author)

allows the editor to make a mistake or change his mind. He may intercut the film in many ways before finding the version he likes best. There are two basic types of professional tape splicers. The Parliament Guillotine splicer uses clear, very thin tape without sprocket holes. The splicer punches the holes after the tape is applied. The second type (such as the Revisquick Tapesplicer) uses sprocketed tapes to provide a cleaner splice. Both types are available in either straight-cut or diagonal-cut models, straight for picture and diagonal for sound cutting. Splicing tape is applied to both sides of the film to facilitate movement through projectors and editing machines. For sound, it is applied only to the base side.

A work print with tape splices is reprinted when we need a guide print for a composer or when too much tape splicing prevents the work print from running smoothly through the projector.

For splicing the original, cement splicers are used. They are usually "hot splicers" that warm the cement as it dries, producing a fast, strong join. A small scraper is provided to remove the emulsion from one of the pieces of film so that the base of one piece can be glued directly to the base of the other without the emulsion in between. The fastest and best hot splicers are foot-operated. They are usually too large and expensive for individuals or small organizations, but the laboratories often use them. When operated by a professional, these large machines make excellent splices. For this reason many film makers allow the lab do the final splicing of the original.

Hot splicers can be either "positive" or "negative," depending on the width of the overlap. The positive type is used mainly for repair jobs on release prints, as it has a wide $\frac{1}{16}$ -inch overlap. The negative type has a narrower $\frac{1}{32}$ -inch overlap and is the kind used for splicing original.

For serious film making this equipment must be supplemented with an editing machine. There are many designs, all of which fall into two categories: vertical and horizontal. The Moviola is the bestknown brand of vertical machine, and other machines are often called moviolas. It can be equipped with extra sound or picture heads. Several horizontal editing machines are manufactured in Europe, where they were originally developed. Recently, this type is gaining popularity in the United States. Apart from the imported designs, moviola manufacturers are also making their own versions. The advantages of the horizontal design include a large bright screen and quiet operation. Some models have facilities to project the picture onto an even larger screen.

7.7 Moviola Console Editor ("Flat Bed"), horizontal editing table with one composite sound/picture and two sound heads. *(Courtesy of Magnasync/Moviola Corp.)*

Entire editing rooms, including equipment, can be rented from some laboratories, studios, etc. When reserving such a place, it is wise to make certain the room is equipped with everything that will be needed and that the facilities are clean and in good repair.

Apart from editing equipment there are many small items that are needed: grease pencils (usually red and yellow), felt pens, scribes, spools, cores, a can of film cleaning fluid, empty film cans and blank labels, quarter-inch masking tape, log books and paper, rubber bands, white gloves, tissue paper, a demagnetized film punch and scissors, a demagnetizer, white leader, black leader, academy leader, and "fill" leader for the sound track, which could be of any color.

DAILIES

The camera original, whether negative or reversal, should always be given utmost protection and care. Before the advent of electronic news recording, television crews had been shooting on reversal film. For the sake of time, the camera original was used for projection. In regular film production the original is never projected under any circumstances, in order to avoid causing irreparable scratches. To protect it, a lab makes work prints called "dailies" or "rushes."

Dailies are printed in contact, emulsion to emulsion, from the original. They are viewed by the cinematographer and his director, usually the next day. The lab should be required to print through from original the edge (key) numbers appearing every twenty frames on 16mm film. These numbers serve the purpose of matching the edited work print to the original.

When shooting color film, some budget-conscious film makers order black-and-white dailies. Unfortunately, this deprives the film maker of judging the quality and editorial values of the color. It may also disguise slight flaring, which is more apparent in color.

Dailies can be ordered as "one-light" or "timed." This means that the timer at the lab will either assign one setting of light intensity and color values to the printer, or he will evaluate the images shot by shot and time them separately for the best result. Cinematographers should understand this process well and keep in close contact with the timer.

The printer machine at the lab has a range of fifty or more light intensities to choose from. On most printers, eight "lights" equal approximately one lens stop in exposure. In black-and-white, exposure for a

7.8 Time code application flow-chart. Time code can be used as a replacement for the traditional ink and key edge numbers in film post-production. The diagram above shows how time code is used in the new style of video post-production of film originated material. The key to time code for video post-production is the ability to synchronize the negative and 1/4-inch audio during the film-to-tape transfer process, and the capability of preserving the film time code number throughout the post-production chain, thereby enabling the conforming of the film negative and/or workprint to the video edit. Video post-production can be used for projects with a final product in video and/or film.

given shot is indicated by one light number. In color, every exposure has to be set for the three primary colors—red, green, and blue. Some printers may work with complementary colors—cyan, magenta, and yellow.

The light number 27 is considered to be standard exposure for a correctly exposed film. Asking, therefore, for "one-light" dailies could mean that the color negative will be printed at 27, 27, 27 across the board for all three colors.

In practice, "one-light" sometimes means really three or four light settings. A cinematographer may shoot tests and establish with the timer that all his day exteriors will be printed on a certain light, night exteriors on another, and all interiors on yet another. Day and night interiors could even have different lights. In 35mm dailies, this "multi-one-light" system is wellaccepted practice.

Cinematographers like to "lock" the printing lights, which gives them a yardstick against which to measure their lighting and exposure. This way, if the dailies show exposure or color problems, the cinematographer sees it right away and is able to adjust his exposures. When watching dailies, the production team knows what is a "one-light" print, and minor color exposure shifts can be corrected later when the edited film will be timed for the "first answer" print.

One-light dailies may not be the best solution when shooting commercials, however. First, there may not be time to shoot tests and establish the best printer values for a one-light print. Second, dailies for commercials are viewed by people not intimately familiar with timing. Client representatives for a margarine commercial, for instance, may not know that the slight tinge of green will show up as a perfectly healthy color in the final print. Therefore, timed dailies are a much safer way to go, since dailies in various stages of editing will be viewed by important people not familiar with the range of possible correction.

Finally, a cinematographer should take a keen interest in the screening conditions of his dailies. If the screen brightness varies from the 16 foot-lamberts standard, the screening will not do justice to all the shooting and timing efforts.

Syncing Up Dailies

After receiving the dailies from the lab and the magnetic film from the transfer service, the sound takes are "synced up." This is usually done on a film viewer and synchronizer with magnetic sound head, but it can also be done on an editing machine with picture and sound heads, such as a moviola. The clap on the sound track is located and marked. Then, on the picture, the place where the clapper board closed is located and marked. If the picture has time code numbers on the edge and the same numbers are transferred as ink printings on the 16mm magnetic film, these numbers will serve as syncing points. The picture and sound are locked into the synchronizer and aligned with their slate markings or time codes, opposite one another. Picture and sound should now be in sync.

After winding ahead to the next take, it is frequently found that because the tape recorder is usually started before and stopped after the camera, there will be more magnetic film than picture film. This excess of sound film should be removed, and the cinematographer should make sure that the identification of the next sound take, before the clap, is left intact. Whenever editing picture and sound, professional editors do all their splicing on the *left* side of the synchronizer. In this way, as the film is wound from left to right through the synchronizer, the editor knows that everything on the *right* of the synchronizer (the finished side) will always be in sync and he has only the left side to worry about.

After syncing up, one should order the lab to print corresponding ink edge numbers on both the picture and magnetic film. This is because when the intercutting starts, the slated frames will be removed. The corresponding numbers printed every 20 to 40 frames along the edge of the picture and sound track are a convenient method of maintaining sync.

LOGGING

All footage (sound, silent, and library) should be logged. This involves writing down the original edge numbers with a short description of the action. As edge numbers appear every half-foot, frames will usually have to be counted in order to establish the exact beginning and ending of each shot. Although logging is a very tedious job, in the long run it usually saves time and often money as well. For example, an accurate log book enables you to look up the exact length of a given shot when planning overlaps for dissolves. Without it, you would have to look at your original, thus exposing it to unnecessary hazards. See figure 7.9.

DDUCER Alfons			CAMERA RO	19 \$ 20
DD. TITLE "To BE Ali	VE is Illed	AI''		0. 412 BW 10
OD. NO. 2001				NO. 212619
CATIONS John	's hous	E - H	all way a	E Living room
CODE NO.	EDGE NO.	NOTES	SC/TK	DESCRIPTION
B0004 - 030	26 19739-791		1-1	JOHN ENTERS Hallwhy, 100 KS, SEES MARY (Mary poos)
B 00031 - 050	19792-836		1-2	Some. (John forgets line)
B00051-080	19872-927		1-3	SamE. (good)
300081-089	19969-20002		1A - 1	C. U. John _ gives lines
80099-165	20006-140	MOS	18-1	C. U. Mary - reacts
30166-228			2-1	LIVING ROOM - John & Mary ENTER, Fait
B 0229 - 285	20470-512		2-2	SAME - JOHN VERY GOOD
B286-299	20513-532	Mos	ZA-1	C.U. Mary reacts - Poor
00300-314	20533-543	Mos	2A-2	L.U. Mary reacts.
B0315-325	20544-550	NO	ZX	John Falls on RollEr State
B0326-350		TAIL	28-1	John Falls on Roller Skate
	end of foll			
Tari talah dari				

150 CINEMATOGRAPHY

ASSEMBLY

Once the logging is completed, the next step is to assemble the scenes into the order indicated in the script. The first step is to break up the rolls into individual shots. After removing the slates and clearly labeling the picture and sound takes, hang them in the film bin or store them on cores.

Now, splice them together in sequential order. If the best takes were not yet chosen at this time, leave the alternative takes in, to see them in the context of the whole scene. Some editors may prefer to build up the assemblage by looking for the necessary takes in the synced-up (synchronized) dailies, and they may then incorporate them, in scripted order, directly into the assembly roll without using the film bins as intermediary storage.

The assembled rolls will be fitted with head and tail leaders.

Picture leader will depend on the sprocket characteristics of the work print. Most often picture leader is a double-sprocket stock. It is essential to use singlesprocket leader for sound film. Editors like to use white leader for the picture and yellow or red for sound. If we use the same color for both, at least the writing to identify the rolls should be done in different inks.

Any marking on the magnetic film itself should be done with an indelible marking pen, but not with a grease pencil. If grease pencils were used on sound film they would smear and clog the magnetic heads. Another precaution in order to protect the heads is to splice the sound leader in such a configuration that it is running with its base (shiny side) against the head. Therefore, the emulsion will not flake and clog the magnetic heads.

ROUGH CUT AND FINE CUT

During the next step, called the "rough cut," the shots will be intercut closely together. Close-ups will be inserted into master shots, but the work print will be still much longer than eventually intended. As an editor works on a film, he may change his mind many times, and so he does not throw any footage away. All "outtakes" and "trims" must be saved and filed according to their scene and take and their edge numbers.

The "fine cutting" is the next step in editing. The editor strives to say more with less, making the film

structure more meaningful in a shorter period of time. It is very helpful to be editing to music as early as possible, as the music will influence the cutting rhythm of the picture. In documentary films, the narration will usually dictate the structure of picture editing.

Fine cutting is also the time to build up the various sound tracks. Most dialogue will be broken up to accommodate different voice levels on separate tracks. Music may require several tracks as well to facilitate gradual fades and dissolves. Finally, sound effects can be quite complex and may even demand premixing to reduce the number of tracks before the final mix. Different sounds should never be laid next to each other on the same track. A five-second pause between them allows the mixer to control them effectively. Building tracks in relation to a picture is usually done on an editing machine with multiple sound heads and transports. Horizontal "flat beds" are much more practical for this job. Due to their quiet operation, one is able to make a better judgment on the quality of the sound.

Sometimes sound effects are purchased from an effects library. When ordering them one must be very specific. For example, if a motorcycle sound effect is needed, every possible bit of information should be included, such as the manufacturer of the cycle; its size, displacement, and horsepower; a description of its age and condition of repair; and what it is doing—whether starting, accelerating, cruising, and at what speed, etc. Of course, whenever possible it is good to record your own sound effects at the location where the footage was shot. If the sounds are picked up *during* the actual filming, this further eliminates the problem of syncing them up, although the sound mixer does lose the ability to balance the effects relative to the dialog.

PREPARING FOR THE MIX

The whole purpose of editing the various sound components of the film onto separate tracks is to enable the mixer to record them onto one master track, which will be finally transferred to an optical sound track on the release print.

It is advantageous to have the master recorded on 35mm magnetic film, even when the individual sound tracks are in 16mm gauge. The 35mm magnetic film contains a few parallel sound tracks, allowing the cinematographer to have dialog (or narration), music, and effects recorded separately, yet in perfect sync.

7.10 Sound tracks and work print assembled in a synchronizer.

Should any of these tracks require corrections or the need for foreign narration arise, such changes can be introduced without affecting any of the remaining tracks (music and effects).

Mixing sessions are very expensive and therefore the better prepared the sound tracks and the mixing cue sheets are, the faster and the more economical mixing will be. Always consult the sound mixing lab about their particular requirements regarding cue sheets, leader lengths, cue marks, and anything else that could save time during the session.

Precise mixing cue sheets will indicate what various tracks are, where they are to come in and out, the changes of relative levels, and a description of particular sound effects. Some effects, such as room tone, traffic, or birds, may be provided by prepared loops or cassettes which can be fed directly into the mixing console without the need for additional tracks.

Tracks have to be carefully prepared for a flawless mix. The parts of the tracks where there is no sound are spaced with single-perforated fill (called "slug" or "spacer"). For reasons of economy, this is not regular leader but rather some old-release prints inexpensively purchased from editorial suppliers. This must be spliced base up so that the emulsion of the spacing footage does not rub off onto the sound heads.

Splicing the spacer the incorrect way is one of the most frequent mistakes of the novice film maker. Many mixing sessions have had to be canceled when this error was discovered by the mixing technicians.

It is also important that this fill has not shrunk too extensively. The distance (pitch) between the sprocket

PROD.	PROD.	PROD.	PROD.	PROD.	PROD.	PRUD.
REEL	REEL	REEL	REEL			
TRACK / (D14)	TRACK Z (DIA)	TRACK 3 (F.K)	TRACK 4 (FX)	TRACK 5 (FX)	TRACK 6 MUSSIC	TRACK 7 (JUSIC)
20 SYNC POP	ZO SYNC POP	ZO SYUC POP	20 SYNC POP	ZO SYNC POP	20 SYNC POP	20 SYNC POP
23 DOVA: Why dant		30 car door open		23 EXT. CITY 8.6.	23 Mystery Theme	
		•	40 Thurder			
L42	42 CRAIF: But		_			
			L45			
		47 car door chise				
61 mut: A.L.	191 F					
1 10						
			69 Bis Dar Onen			
LZ	23 LYNN 'O.A"		+			
	+	74 Bats Flying				
			L79			
	L \$3			-83 fade	-83 fade	23 Jonys Theme
86 Dovo: Gee, 1m		L 86	86 Footsteps			07
hugey				L 100	2100	100
	105 CRAIG: "Hey		L105			
L107	1 ack "					-
	L 1/3					
		115 Refrig. Deor Open		115 Refrig. hum		
125 DOUG: "Well?"		-	125 footsteps	~		
L127	127 LYNN: "Cold					
	Pizza?	\$				
	L 133	133 gun shot	L 133			
140 Dove: Un Oh"		、			140 Suspense	
				>		

DATE 6-23-89

Including the house of the second sec

holes should be compatible with the magnetic film. All sound tracks and the work print to be projected during the mix are furnished with head and tail leaders of identical length. Sound leaders are perforated on one side only (single-perf). The head leaders are usually about fifteen feet long.

A punched sync mark indicates the start of the film. It is usually placed six feet from the head. Farther down, a "sync pop" (also called "sync beep" or "blip tone") is usually placed forty-eight frames before the start of the sound track. The pops are available as prerecorded sound tone on tape that has an adhesive backing. The tape is cut into one-frame lengths and is then stuck onto the surface of the tracks. As the film tracks are run for the mix, the "pops" should all be synchronized so they will beep at the same time that an X appears on the screen. Sometimes, instead of an X the word *pop* is written on the corresponding frame of the work print leader.

The work print must have good, double-sided tape splices to allow it to run smoothly through the projector during the mix. Sometimes the work print is in such poor shape that instead of risking it on the projector, it is sent to the lab to make a relatively cheap copy called a "dirty dupe" or a "slush print" to be used during the mix. It is quite advisable to use a dirty dupe even when a work print is in a good shape. After all, the work print constitutes your edited image, and the original camera footage will be matched (conformed) to it during the formation of the A-B rolls (see page 154).

To avoid any risk of magnetizing the sound tracks, they should be placed on plastic reels. The appropriate diameter of the inside core of these reels is approximately four inches.

Customarily, the mixing session is preceeded by an "interlock" session in which the film and all the tracks are run in the mixing theater. This gives the mixer an opportunity to ask for necessary changes in the distribution of sounds on the tracks. When such changes are made, it is customary to have a preview that serves as a practice mix. During an interlock or preview the mixer will decide whether premix sessions for the dialogue, effects, and music are necessary.

Usually, at least some premixes are recommended. First to be done is a dialog premix that allows the mixer to mix all the dialogs down to one track. A large number of effect tracks may dictate the need for a premix as well. When music tracks are not too numerous, it is generally better to mix them all during the final mix. This way the mixer has a better feel for balancing music to the rest of the sound and to the picture.

Well-prepared sound tracks are the first step to a successful mix. A good sound editor will make a tremendous difference in this respect.

BASIC LAB EFFECTS

When making first-trial and release prints there are four basic optical effects normally offered by the labs at no extra charge: fade-outs, fade-ins, dissolves, and superimpositions.

A fade-out is a gradual darkening of the image until it becomes black. The printer light is gradually diminished as the film is being printed. A fade-in is just the opposite, a gradual lightening of the scene from black to normal. For this the light is gradually increased while printing. When these two effects occur simultaneously they make a dissolve, where one scene gradually disappears as another scene appears in its place. This is sometimes called a "cross-dissolve" or "lapdissolve." It is done in two printer operations. The first scene is printed until the beginning of the dissolve and then faded out. The raw stock is then rewound and run a second time. The printer light is out until the beginning of the dissolve, and then the second scene is faded in over the same place that the first one was faded out. Fades and dissolves can differ in length depending on the type of printer being used at the lab. Therefore, the standard lengths vary. The lab should be consulted for their specific capabilities.

Superimposition is achieved by printing two scenes over the same piece of film. This usually starts by fading a second picture in over the first. The two are then seen together for a period and one of them is faded out. It is much like an extended dissolve. Frequently, "burn-in" titles are superimposed over a liveaction background. When a project is filmed on reversal original, the burn-in "supers" are usually also shot on reversal. They are white letters on a black background, and when superimposed, they make white letters over the background footage. Instead of white, the letters could be colored. To ensure that the letters will be visible, the area of the background over which they are to appear should be dark.

There is no color that will "super" over a white background without becoming almost completely washed out. The letters themselves should either be very white, or if colored, highly saturated. When the

154 CINEMATOGRAPHY

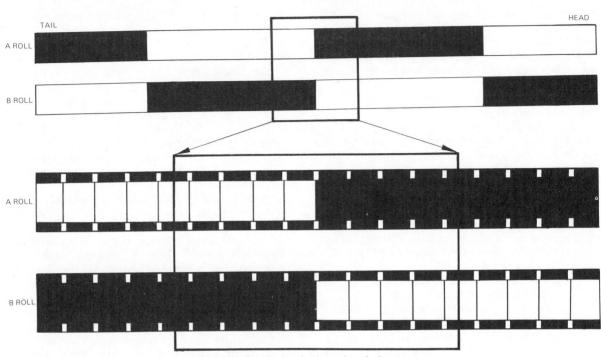

7.12 A-B roll checkerboard technique.

original is negative stock, many complications arise. Burn-in titles for the film shot on negative will have to be prepared on the optical printer (see chapter 8).

First, the live action footage that is desired as the background is printed onto an interpositive stock. This positive image is then threaded in the projector component of the printer and projected onto the internegative stock threaded in the printer camera. After the background is rephotographed in this fashion, the camera internegative is rewound (with the shutter closed) to the beginning of the roll. Now the positive footage of the titles (white or color) is threaded in the projector. The film in the camera will then be reexposed to these titles. After development, the printercamera footage will be in negative. The white titles will show up as black. Finally, this footage will be spliced into the A-B rolls of the original negative to produce an answer print with white titles (as in our case) "burnt" into the live action background.

The title cards are not always shot on the same stock as the rest of the film. When the titles are black or white, you will find that High Contrast Positive 7362 (which can be developed as negative or reversal) offers the crispest letters. It has a very low exposure index (about 12 EI/ASA) and tests should be made to determine the best exposure. When we need white titles on black background, they can be prepared as black letters on white background and shot on 7362 to be processed as negative.

A-B ROLLS

Cutting the original into "A-B rolls" that relate to the work print is called "conforming." The A-B roll "checkerboard" technique (see figures 7.12 to 7.14) is used only in 16mm film. A-B rolls may be used in 35mm as well, but mainly to provide the overlaps required for dissolves and superimpositions. The splices in 35mm fall entirely between frames and therefore don't show. In 16mm film, however, the splices overlap part of one frame and are therefore visible when projected. So, in 16mm, A-B rolls have the additional purpose of achieving invisible splices by using the checkerboard technique.

Before the conforming can begin, the work print must be "locked down." That is, all shots must be cut

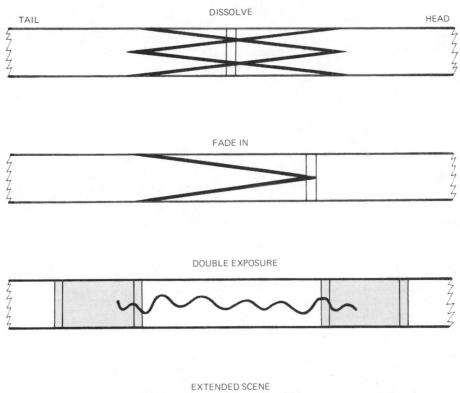

7.13 Work-print marks.

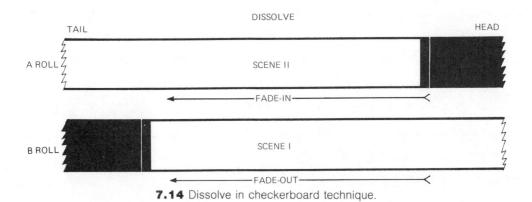

NAME W. VOLO TITLE "STICKY BUILD-UP" COMPANY GABLOTA Films PROD.NO. 521 ADDRESS # 3 SANTA ANNA ST. EDITOR BACON ValEncia, Calif EDITOR'S PHONE 255-1405 91355 TYPE OF ORIGINAL 7252 AND PHONE 255-0789 7242

FT	FR	A ROLL	B ROLL	C ROLL	SOUND
00	00	Print Start	Print Start		Edit SYNC
08	02	F.I 24			
09	24		F.I24		
13	31		F.O 24		
16	18		F.I 24		
22	09		F. 0 24		
27	39	F. 0 48	F.I48		
32	21	F.I 24	F.O 24		
41	36		F.I48		
106	30		F.O 12		
113	16	F.O 48			

7.15 Sample cue sheet showing location and lengths of effects.

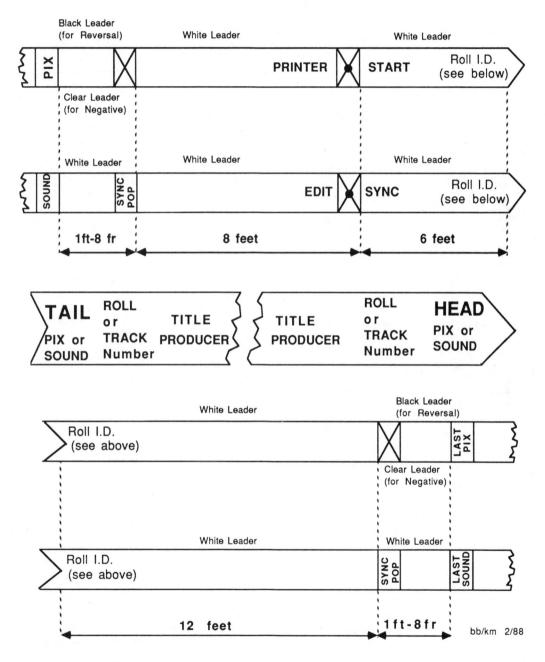

7.16 Example of typical leader arrangements for the A-B rolls.

158 CINEMATOGRAPHY

to the exact final length that will appear in the finished film, with all anticipated optical effects marked with a grease pencil. Dissolves and superimpositions require the two adjacent shots to overlap each other in the A-B rolls. Therefore, to maintain sync, the full lengths of the original shots will not appear in the work print. Remember that the length of the dissolve represents the two scenes overlapped. You cannot physically overlap the two shots of the work print as they would jam in the equipment. Therefore, the two scenes are cut and spliced together in the middle of the dissolve and it is understood that each scene extends into the other. For example, a forty-eight-frame dissolve in a work print will show twenty-four frames of each shot. When planning the lengths of dissolves, we must be sure that the original is long enough by checking in the log book.

A cue sheet should be made, indicating the location and length of each effect. The location is given as the distance from the "printer start" frame on the head leader to the beginning of the effect.

If the budget permits, one could submit the untouched originals along with the finished work print and cue sheet to a professional negative cutter, allowing him to do the actual conforming. Otherwise, the editor will conform the originals himself. Even if the editor performs this task, he will usually not make the actual splices himself. He will mark where they should come and leave them for the negative cutter to do. Stronger, cleaner splices offered by the professional service are worth the expense.

Before beginning to conform the original, the leaders are set up. They should correspond exactly to the work print leader, which was prepared for the sound mix. Tail leaders will later be prepared for the end of each roll.

When marking A-B rolls, all information must be written with an indelible marker—never a grease pencil. Anything other than an indelible marker may come off or be smeared all over the picture. Also, the lab will often clean the film with high-frequency sound waves before printing. India ink does not come off in this process.

As you begin to assemble the A-B rolls you will appreciate the meticulous preparation of the log book and the orderly storage of the rolls of original. This gives you the exact location of each shot in the original. Before beginning, you will go through the work print and list the edge numbers of each shot that was actually used. Next, take this list and mark these shots in the log book. When you have finished, for any given roll of original the log book will show which takes were used and where they will appear in the finished film. For example, original roll number two might contain the shots appearing first, ninth, thirteenth, and twenty-first in the work print. Using the log book, it will be easy to remove just those shots from the roll of original and place them in order with a minimum of wear on the original.

You are now ready to begin conforming.

The first thing to do is to "sterilize" the editing room. Tape clean paper to the top of the editing table and the floor around it, especially at each end of the table. Remove all tools from underneath the film path. "Scrub up" and put on white editing gloves.

BREAKING DOWN THE ORIGINAL

Take the first roll of original, *tail out*. Look in your log book to see what takes were used from this roll. Carefully remove each such take, *in its entirety*. Keep everything from camera start to camera stop. You will trim or divide it later. Wind it *tail first* onto a clean core. This way it will be *head out* on 'the core, ready to be wound directly onto your A or B roll. Now label it, giving its number according to its appearance in the work print. Place it on the shelf. Continue this process until all the *chosen* takes have been removed and arranged *in consecutive order*.

ASSEMBLING THE A-B ROLLS

On the right rewind you will need three take-up reels with equal hub diameters. On the first "gang" of the synchronizer, the work print is positioned *base up*. On the left rewind, or on a separate "horse," place a roll of black leader. Next, the head leaders for A-roll and B-roll are placed in the synchronizer, *emulsion up* and in sync with the work print. Their heads are wound onto the second and third reels on the right rewind. Now you are ready. See figure 7.17.

Although some budget-minded film makers perform the original cement splicing themselves, I prefer to scribe and temporarily tape my originals, allowing the lab to make the permanent cement splices. This service is well worth the usually reasonable price. The location of a future splice is indicated by two marks, one on either side of the nearest sprocket hole. See figure 7.18. These marks are scribed (scratched) with

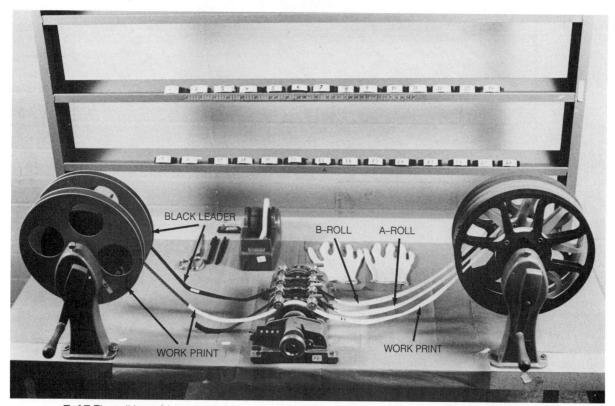

7.17 The editing table, prepared for assembling the original into A-B rolls. Note the originals broken down by "takes" and numbered according to their order in the work print. Numbers appear on bend strips of double weight paper (usually index cards), holding in place the outside coil of each film roll. Masking tape is not used, as it could leave residue marks on the negative.

the corner of a razor blade on the films edge *outside* of the picture area. Now the excess is trimmed away, leaving at least a one-and-one-half-frame margin. When trimming this excess be extra alert and make certain to trim it on the correct side of the scribe mark or you will destroy something you need to use. Once trimmed, the two pieces to be joined are exactly overlapped and taped so that the future splice lines exactly coincide. The sprocket holes must be aligned so that the overlap will move easily through the synchronizer. One must always use the masking paper tape which when pulled off will leave no trace on your original. When using such tape it is customary to tape picture over the black leader.

Let us say your first shot is an A-roll. We will leave the black leader extending from B-roll. Take scene number one from the shelf and match its edge numbers to those on the work print. Lock them into the synchronizer so that they are in sync. Scribe the scene one original on either side of the sprocket hole opposite the first splice in the work print. Cut off the unwanted portion before the first frame, leaving one-andone-half frames before the future splice line. Next, on the A-roll leader, scribe the sprocket hole opposite the first splice and trim it, leaving the one-and-one-halfframe margin. See figure 7.19. Tape the two pieces of film (the first scene overlapping the A-roll leader) so that their scribe marks exactly overlap each other and their sprocket holes are aligned. See figure 7.20.

At this point we have the first scene scribed and taped to A-roll. Its edge numbers are in sync with those of the work print. See figure 7.21. We have black leader opposite this on B-roll. Now we wind in sync ahead (film moves to the right) until we come to the

7.18 When the actual splices are left to be done by the lab, the splice line is indicated by scribe marks scratched into the emulsion on the edge of the film as seen here. The excess is then trimmed away, leaving a $1\frac{1}{2}$ -frame margin.

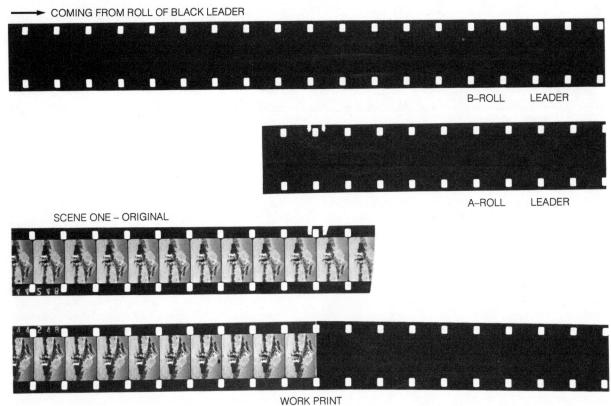

7.19 The first scene (original) is aligned with the work print so that the original edge numbers are in sync. Scribe marks are made to indicate the splice line. (*Photo by author*)

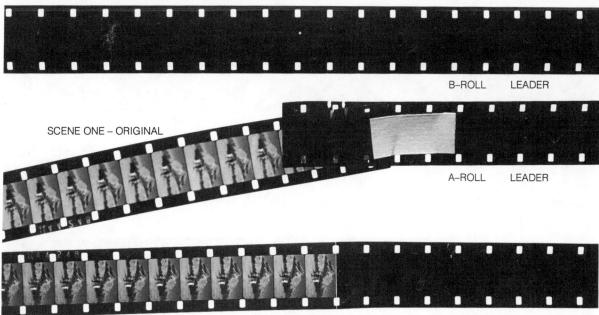

WORK PRINT

7.20 Scene one is taped to the end of the A-roll leader so that the scribe marks overlap. Notice that the tape does not extend into the picture area to be used. It is kept on the black leader side of the splice line so that it touches only the black leader and the $1\frac{1}{2}$ -frame margin. (*Photo by author*)

end of the first scene in the work print. Here the second scene will be placed on B-roll and the black leader will be joined to A-roll. To do this, find the splice between scenes one and two in the work' print. Opposite this splice put scribe marks on the end of scene one (on A-roll). Trim the excess from A-roll, leaving the one-and-one-half-frame margin. Also scribe the black leader on B-roll opposite this splice. This leader is coming from a large supply roll on your left. You cut it from B-roll and scribe and tape it to A-roll at the end of scene one. See figure 7.22.

COMING FROM ROLL OF BLACK LEADER

Now take down scene two. Match its edge numbers to those of the work print. Scribe the sprocket hole on the original that coincides with the splice in the work print. See figure 7.23. Overlap and tape it to B-roll. Scene two is now on B-roll. Black leader is opposite it on A-roll. See figure 7.24. You are now ready to wind ahead, in sync, to the end of scene two where you will put in scene three. As you work, be constantly checking to make certain your edge numbers are always in sync. Keep repeating this cycle, except when dealing with dissolves or supers—to be discussed next. When cutting negative original, fades must also be handled differently.

In passing, we should note that single-sprocket original will *only* fit *base up* on a normal synchronizer.

Therefore, when conforming, you are forced to back the film out of the synchronizer and turn it over in order to scribe the *emulsion side*. This is somewhat awkward. This is *one* reason that single-perf film is usually avoided in the camera original, work print, and all other steps until the release print.

Dissolves

Dissolves must be very clearly indicated on the work print so that you don't forget one of them and A-B roll it like a straight cut. Some labs require that the center of the dissolve be scribed. See figure 7.14.

Superimpositions

Supers are cut much like dissolves. The important thing is to give good timing instructions, especially indicating which image you want to be more visible. To indicate the super in the work print, small sections of the shot to be supered are cut into the work print at the beginning and end of the area over which it will be superimposed. When possible, these sections should contain edge numbers to help the editor find the original before conforming.

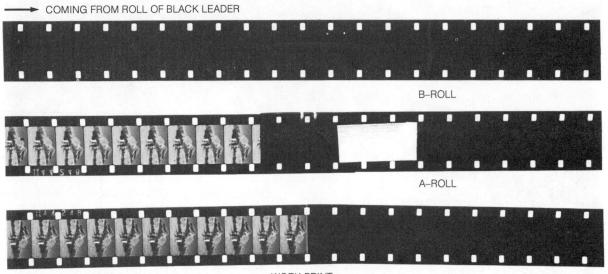

WORK PRINT 7.21 The first shot, scribed and taped to A-roll. (Photo by author)

7.22 After the end of scene one, the black leader is removed from B-roll and scribed before taping to the end of scene one on A-roll. (*Photo by author*)

 COMING FROM ROLL OF BLACK LEADER

END OF SCENE ONE - ORIGINAL

A-ROLL

SCENE TWO

WORK PRINT

SCENE ONE

SCENE TWO – ORIGINAL

SCENE ONE - ORIGINAL

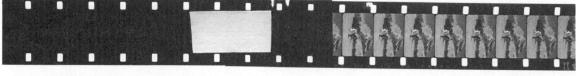

COMING FROM ROLL OF BLACK LEADER

A-ROLL

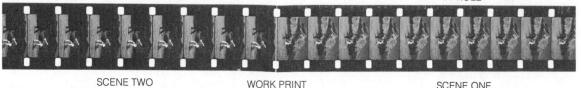

SCENE TWOWORK PRINTSCENE ONE7.23 Scene two is aligned (via edge numbers) to the work print and the splice line is scribed. (Photo by author)

7.24 The end of scene one and the start of scene two have been scribed and taped in checkerboard technique. *(Photo by author)*

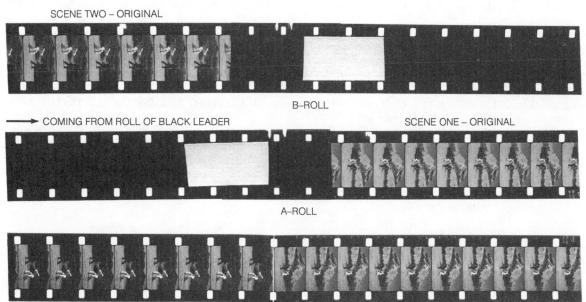

SCENE TWO

SCENE ONE

WORK PRINT

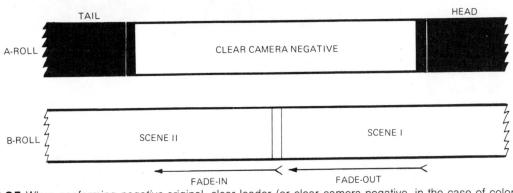

7.25 When conforming *negative* original, clear leader (or clear camera negative, in the case of color) must be placed opposite any fade-ins or fade-outs. (This does not apply to dissolves in negative.)

Fades

With reversal originals, fade-outs and fade-ins will be indicated on the work print and cue sheet but do not require any other special treatment. However, in the case of negative original, the fade-out and fade-in sections must have transparent leader (in the case of color made from the same negative stock) on the opposite roll. When a fade-out is followed by a fade-in on a negative original, *both* of the original shots should appear on one *roll* with the clear leader on the other. See figure 7.25.

Lengths of Effects

For fades and dissolves, some labs require a few frames of extra overlap. For example, a thirty-frame overlap might be advisable for a twenty-four-frame dissolve. Similarly, different labs will offer their effects in different lengths. For example, the shortest dissolve possible might be sixteen frames with other specific limited lengths available, such as twenty-four, forty-eight, sixty-four, and ninety-six. Other labs may offer different lengths in between. Before even the work print is edited, the editor should have consulted with the lab to find out what lengths are available.

Minimum Spacings

The minimum distance between effects is dictated by the length of the effect and the printer used. If the printer fades out in twenty-four frames, it will require twenty-four additional frames to open back up. Usually a few more frames are required as a safety margin. Therefore, if A-roll fades out in twenty-four frames, there must be at least twenty-four frames before the next shot on A-roll. If the shot on B-roll is less than twenty-four frames, the next shot on A-roll will start dark and lighten as the fader finishes opening. There are two common ways of dealing with this. One could use a C-roll-an additional roll like the A-roll and B-roll. The extra expense of running the third roll is often not desirable unless the C-roll has more than one purpose. Additional rolls are always possible, and some films (frequently experimental) use A-, B-, C-, D-, and E-rolls, although there could be even more. If money is not plentiful and the problem only occurs once, the solution is frequently just to splice the shot onto the same roll as the shot before, so that in the above example, A-roll fades out and then the next two shots are on B-roll. The splice will be visible, but it saves the expense of a C-roll.

SUBMITTING THE ORIGINALS TO THE LAB

The A-B rolls should be submitted to the lab on cores, wrapped in tissue paper and placed in a can or box. A precise cue sheet and the finished work print should be included. The lab will again require the same information as listed at the beginning of this chapter.

ANSWER PRIN"

The first print made from the finished A-B rolls is called the "answer print" or "first trial" print. It is like a release print, except that its primary purpose is to get the errors worked out before running off the release prints destined for theaters and wherever. This first trial print could be silent, although it is usually a "composite" ("married") print—that is, it carries a sound track. See figures 7.26, 7.27, and 7.28.

The first trial print is more expensive than later release prints, because all the effects, timing, and color corrections must be set up for the first time.

At the lab the timer views the edited work print on a video analyzer to evaluate the color balance and density. He notes which scenes require minor color balancing and decides what density corrections might be made.

When describing the printing of the dailies we already looked at the printer with its fifty light values in three colors, which are used for exposure (density) and color corrections. For people familiar with printing still photography in a darkroom, the relationship between the density of a negative and the amount of printing light will be familiar. For others, some of the vocabulary used may be slightly confusing at first. Printer lights increase in intensity as their numbers increase. Therefore, an underexposed, thinner negative will require lower number lights, although this is referred to as "printing up." On the other hand, an overexposed, dense negative requires higher lights, and this is called "printing down." Printing up means printing lighter; printing down means printing darker. Remember, negative emulsions will offer a greater latitude for timing corrections than reversal films, but even a negative cannot be saved if an exposure error exceeds the emulsion/printer combination range.

The color and density modifications, along with the fades, dissolves, and supers, will all be programmed onto tapes that will control the printer while the print is made.

When the first trial is ready it is viewed by the film makers with the timer present. Some corrections are

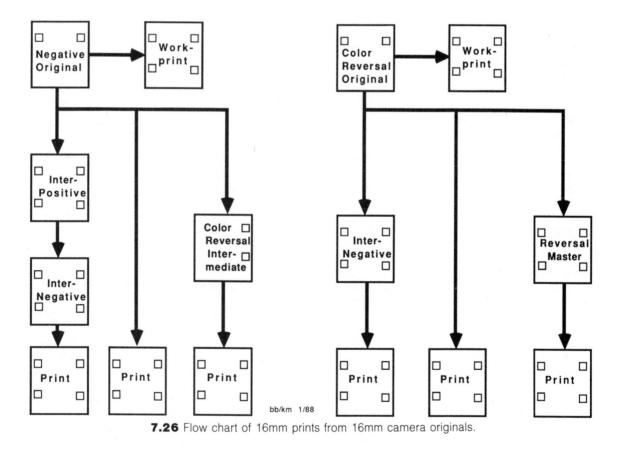

166 CINEMATOGRAPHY

usually necessary. These are taken into account and another print is then produced. This could repeat itself several times until the producer is satisfied. If the print is unsatisfactory because of mistakes or oversights made by the lab, then the customer can usually insist on and get a replacement print, free of charge.

When submitting your A-B rolls to the lab, be sure to specify what kind of answer print you want, whether for television transmission or screen projection. This is very important, as the color bias in the case of color prints and the contrast range in the case of either black-and-white or color will be different for each. If a color television print is projected onto a screen, it will appear bluish. A television print also generally has less contrast.

MASTERS AND DUPES

Having at last obtained a satisfactory print, we are now ready for release printing. If only a few prints are desired they can be made directly from the A-B rolls. However, if it is intended to have many prints made, it is the normal procedure to make an intermediate negative copy and print from it rather than from the precious originals. In some cases, especially when greater numbers of prints are required, it is *cheaper* to do release printing from a negative.

If the originals are negative to begin with, a "master positive" will first have to be made. Then, from the master positive, a "dupe negative" is printed, which will be used in making the release prints. If the originals are reversal, an "internegative" can be made right from the A-B rolls.

CONTACT PRINTING AND GENERATIONS

Most lab work involves "contact printing." That is, the original and print stock come together, emulsion to emulsion, while the print is made. Because of this, with each succeeding generation the film will alternate its wind.

If for some reason you wish to make a print with the same wind as the material it was printed from (A-wind from A-wind or B-wind from B-wind), it will have to be optically printed instead of contact-printed. Optical printing is less common and more expensive than contact printing.

It should be restated that A-wind and B-wind depend only on emulsion position. Do not confuse them

1st Generation B-wind	2nd Generation A-wind	3rd Generation B-wind	4th Generation A-wind
Reversal			
A-B rolls	Answer print, release prints, or inter- negative	Release print	
Negative			
A-B rolls	Answer print, release prints, or master positive	Dupe negative	Release print

with A-B rolls. On B-wind film, the lettering reads correctly when the observer is looking through the base; that is, the emulsion is on the side away from the viewer. A-wind, on the other hand, reads correctly when looking at the emulsion side. Whether a film is single- or double-sprocket has nothing to do with it at this stage.

Single-sprocket film is not as easily manipulated as is double-sprocket film during the editing. Therefore, single-sprocket film is usually avoided until the final release prints with sound. Except under certain circumstances, such as when using single-system sound, the camera original, work print, and all intermediate negatives are usually double-sprocket.

SOUND ON RELEASE PRINTS

Sound can either be electroprinted or optically printed onto the sound track of a release print. Electroprinting optically records the mag track onto the film. Alternatively, we could make a high-quality "sound negative" on a separate piece of film, and then print the sound onto each release print. For fewer prints, electroprinting is cheaper; however, often the quality control is higher in the negative process. The initial expense of the sound negative makes the second method more

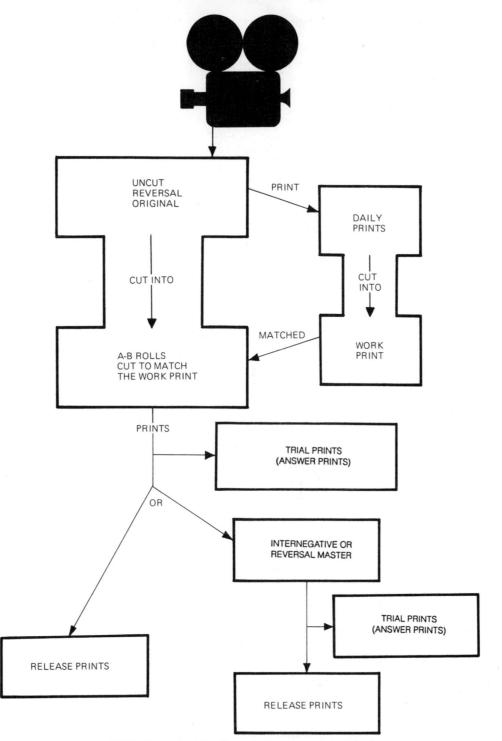

7.27 Flow chart for films shot on reversal original.

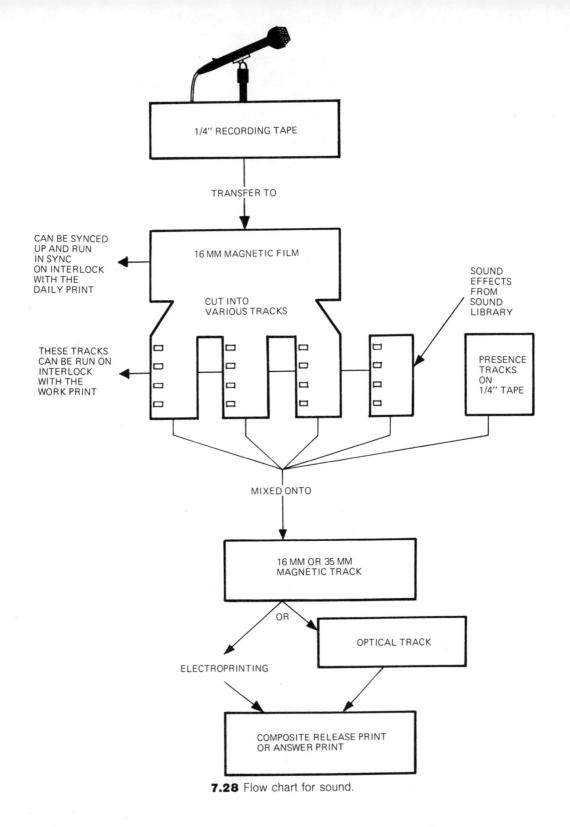

expensive for only a few prints, but it is cheaper in the long run if many release prints are to be made.

When making release prints from internegatives or dupe negatives it is customary to provide a sound negative. Be sure to order the sound negative with the same emulsion position (A-wind or B-wind) as your picture negative. That is, when printing from an Awind internegative, order an A-wind sound negative. Otherwise the sound will have to be printed through the base, resulting in a loss of high frequencies. (See illustrations on pages 167 and 168.)

PRINT DAMAGE

Some labs offer services designed to conceal scratches. When "wet gate" prints are made, both films are submerged in a liquid during the exposure. The liquid fills in scratches in the base so that the light is not refracted

7.29 Film with torn sprocket holes. (Photo by author)

7.30 Repairing torn sprocket holes. Perforated splicing tape is applied to both sides of the sprocket-hole area, without overlapping into the picture. The excess tape is then trimmed away with a razor blade. (*Photo by author*)

and the scratches are less visible. This will only diminish scratches in the base. There is no way to repair deep scratches in the emulsion.

If old or damaged footage is to be given to the lab for printing, the lab should be notified that it may be in poor condition. There are many precautions that can be taken to ensure its gentle treatment. For example, it can be "waxed" so that it will move more easily through the projector gate. If the footage is to be printed, the lab might alert the technician to run the printer somewhat slower than normal and to be especially alert to stop the printer should a break occur.

Torn sprocket holes can be repaired with many techniques. One method that seems to work well is to use sprocketed tape over only the area of the torn sprockets. The picture area is left as clear as possible. If the tape is applied so that the *right* side of the tape fits over the sprocket holes on the *left* side of the film, the excess tape can be trimmed away with a razor blade, leaving the sprockets reinforced. The overlap into the picture area is minimal. Special film repair tapes and tools are also available.

Some laboratories specialize in salvaging damaged prints. One should consult a reputable lab for their recommendations.

THE BASICS OF OPTICAL PRINTING

The optical printer is almost as old as film making itself. In recent years experimental film makers, aided by more flexible lab techniques and new film stocks, have created a new art form with almost limitless possibilities. Due to the great variety of effects available in optical printing, film makers often end up developing their own techniques. In this chapter we will try to introduce enough of the basic principles so that the student can begin to experiment on his own. Then we have some specific examples, given to help the reader understand how these techniques can be coordinated.

BASIC OPTICAL PRINTER FUNCTIONS

The most basic function of the optical printer (see figure 8.1) involves a rephotographed-image technique. It differs from contact printing in that a lens is introduced between the image being photographed and the raw stock. Because the lens reverses the image, the film in the projector side must move from bottom to top to keep the photographed image right side up. Both the camera gate and the projector gate must have good registration to assure perfect steadiness. Otherwise, images combined through several printer runs would appear to vibrate slightly in respect to one another.

There is no effective way of calculating exposures for an optical printer. Tests must be run. The best test is to get some Kodak test film, print it on reversal, and compare it to the original. Most optical printers have an adjustment that will dim or brighten the light. However, this should be kept constant because a change in voltage will vary the color temperature. The best results are obtained if the f-stop is kept constant at a given setting about the middle of its range and the exposure is controlled with a set of neutral density filters.

The basic printer functions are:

1. Fade-outs, fade-ins, lap-dissolves, and superimpositions (multiple exposures), similar in effect to the normal optical transitions performed by the lab during contact printing from A-B rolls. However, the optical printer offers much greater control over the lengths and rates of these effects.

2. Freeze-frame (the action stops and remains on one frame). That frame is arrested in the printer gate and continuously printed onto consecutive frames of film stock. On low-budget productions a freeze-frame can be achieved without an optical printer by stopping the frame in the gate of a moviola and filming it with a camera. This technique is not officially to be recommended, yet it has yielded some usable results. A similar effect can be used to extend footage without the appearance of a freeze-frame. To achieve this we might print three consecutive frames over and over, back and forth. This avoids the stillness of a freeze-

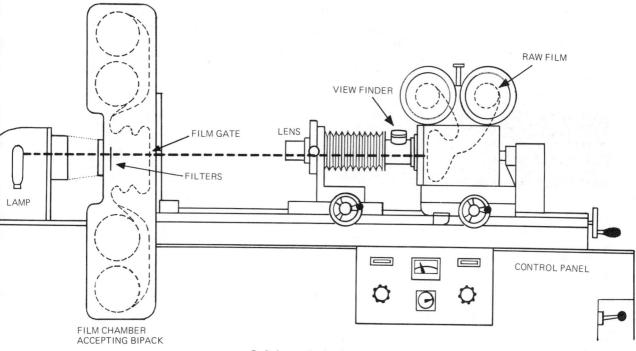

8.1 An optical printer.

frame because the grain and such things as leaves, etc., may move slightly. Of course, any movement by an actor will spoil this effect.

3. *Stretch printing.* By printing every second frame twice, the action is slowed down. This is to convert footage shot at 16 fps to 24 fps. Of course, by skipping frames, we can speed up the action.

4. *Change in composition.* New frame limits can be established within the limits of the old frame—for example, obtaining a close-up from a medium shot.

5. Zoom effect. A gradual change of the frame limits will create a zoom effect that did not exist in the original footage.

6. Printing without changing the emulsion position, such as obtaining a B-wind print from a B-wind original.

7. *Reverse printing.* The image can be turned around so that left becomes right.

8. Transition from black-and-white to color. Gray tones can be introduced into a color picture. If a finegrain black-and-white positive is made from the color original, the two can be superimposed, the amount of gray controlled or even faded in or out, making the picture go from color to black-and-white, etc. 9. Optical transitions. The limitless varieties of optical transitions, such as "wipes," "push-offs," and many others are too numerous to be described here.

10. Bi-packing. We have already discussed double exposures in which two pieces of film are individually printed one at a time onto a third. Instead of printing them one at a time, we could instead "bi-pack" them. That is, we could overlap them and hold them together in the printer gate while they are exposed onto a piece of raw stock. The effect of bi-packing is quite different from that of double exposure. When bi-packing, the densities (shadow areas) will add up, whereas when double-exposing, the light (clear) areas will add up. The effect of bi-packing can be judged by looking at two pieces of film overlapped against the light. Bearing in mind that dark areas will dominate, reversal materials shot especially for bi-packing should be as light as possible. Otherwise, the image resulting from the bi-pack may turn out to be almost black. The opposite is true about film shot for superimposing. In double-exposing ("supering"), the transparent areas add up, and therefore when shooting film for superimposition, the two images should be shot so that light areas do not overlap, washing each other out.

11. *Matting*. This is probably the most important optical-printer function. Matting means blocking out a certain area of the frame by bi-packing the original film with a piece having a high-contrast silhouette image that blocks out an area in the shape of that silhouette. This blocked-out area can be filled in with another image in the second run. Many optical-printer operations depend on this two-part process, which usually involves many additional intermediate steps to be discussed later. Some of the many basic effects made possible by matting include split-screen, inserting a picture into a prop television set, and adding a background behind a studio foreground.

Combining the Operations of the Optical Printer and the Animation Stand

For certain optical processes, such as matting, the animation stand serves as a companion apparatus to the optical printer. To illustrate the use of these two machines let's look at figure 8.2 and imagine that we are making an experimental film in which small still photographs are appearing on a screen that is otherwise filled with live action. The photographs are matted in, so that the background live action will not show through in the areas occupied by the photos.

Let's imagine that one hundred photographs will appear in different configurations and for various durations during a thirty-minute film. We will start by positioning the photos on clear animation cels (cellophane). The cels must have prepunched animation peg holes. Each photo should have a black paper backing to make it opaque for light from below the animation stand. The reason for this will become clear later.

The cels are placed, one at a time, on an animation stand. A black card serves as a background for the cels. With the top lights on, a cel is shot for predetermined length. Next, the top lights are switched off and the bottom lights are switched on and the cel is rephotographed to provide a matte of the previous image. This procedure is followed for all the cels.

In our hypothetical film, we are shooting on a color negative. All the color negative footage that will be optically printed needs to be first reprinted as an interpositive (IP), to enable us to work with positive images. We will discover that this film stock is not contrasty enough to provide good mattes. Therefore, the footage showing the silhouettes of our still photos should be rephotographed on an optical printer onto a high contrast emulsion, such as Eastman High Contrast Positive 7362. After this is done, we will reprint this matte once more to have a negative and a positive of the same matte.

As a result of our work so far, we would have shots showing the photographs against a black background and we have matching, negative and positive, mattes. The lengths of the mattes correspond to the desired duration of the photographs on the screen.

Now we will continue our work on the optical printer. On the projector side of the printer we will thread live action footage bi-packed ("sandwiched") with high-contrast matte. The matte film covers the live action footage so that when the printer is running and live action footage is projected into the camera, the areas designed to display still photographs will be protected from exposure, whereas the rest of the frame will be exposed to the live action image. When this printer run is finished, the freshly exposed stock is rewound in the camera with the shutter closed.

Now, on the projector side we have our film shot on the animation stand, showing all the still photographs in their proper position in the frame. This footage is bi-packed with a new matte that is a negative of the first one (a countermatte). In this second run of the printer, these photographs will be printed into the previously unexposed windows on the camera stock, and the countermatte will protect the already exposed background, where the live action was previously printed. Only after the second run would we send the exposed film to be developed in the lab.

Printer Stocks

The effects generated on the optical printer have various applications. Most often they are incorporated into a film printed on a conventional contact printer. They may also be transferred to video, to become part of a television show. Finally, there may be an experimental film created entirely on an optical printer.

Whenever optical effects are prepared to be incorporated into a film, one must end up with footage compatible with the film, whether negative or positive, A-wound or B-wound.

Working on an optical printer with reversal emulsions is easier because the cinematographer is dealing with a positive image, there is no orange mask inherent in the negative, and the emulsion does not scratch so easily. Yet, much of the optical printer work is done for films shot on a negative stock. In such a case, start by printing the negative footage into interpositive, thus obtaining a positive image. The next generation will be printed on an internegative (dupe negative),

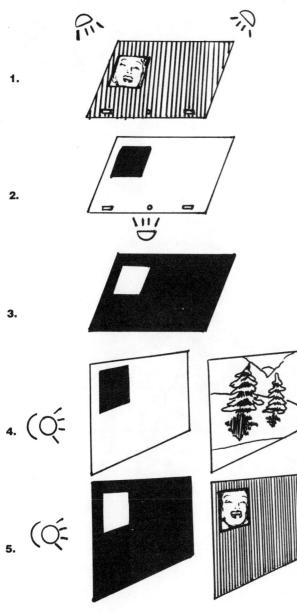

1. A close-up photo is positioned on a clear animation cell, with black card as a background. It is filmed with light coming from above.

2. Black card is removed and the cell is filmed with light coming from below, to obtain a black matte of the photo.

3. A countermatte is produced through contact printing of the first matte onto a high contrast negative stock.

4. The first matte and a print representing a landscape are bi-packed and optically printed.

5. The printing stock exposed in step 4 is rewound for the next printing; the countermatte and the close-up photo are bi-packed and optically printed on this stock. Only now is it developed to produce the result seen in step 5.

Note: The dense diagonal lines on the top drawing represent the black background card, indicating that it will never be photographically as black as the high contrast mattes. (Drawing by Robert Doucette)

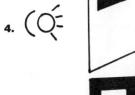

6.

1.

2.

3.

8.2 Combining the operations of the optical printer and the animation stand.

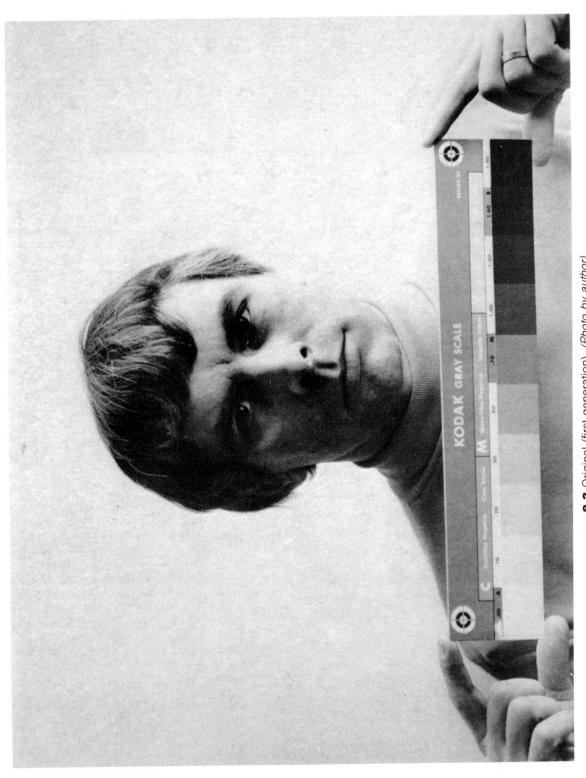

8.3 Original (first generation). (Photo by author)

which can be incorporated into the original negative of the film (A and B rolls) to be printed as a positive answer print.

Complicated optical effects may require many generations to obtain the desired result, but the cinematographer must always end up with an internegative matching the original negative footage. Fortunately, placing the film in the correct emulsion position is not a problem, because, unlike contact printing, the film does not have to be placed emulsion to emulsion.

HIGH-CONTRAST MANIPULATION

Contrast manipulation is at the heart of the more complicated optical printer operations that employ matting techniques. Eastman High Contrast Positive 7362 (a black-and-white print stock) is commonly used as an intermediate step for matting. It provides extremely high contrast. Any given density in the original will be represented (on 7362) as either deep black or clear (white), with very few gray tones in between. After printing through two or sometimes three generations of 7362 there will usually be no midtones. The density at which this rapid drop-off occurs can be controlled by varying the exposure in the printer. This shrinking of the midtones in the consecutive generations of 7362 is used for creative image manipulation.

An interesting application is a multicolored outline effect (see figures 8.3, 8.4). From the black-and-white original we make several high-contrast 7362 prints, but they are printed at graduating printer lights. This will yield a different black-and-white cut-off point in each print. From each of these prints we make another 7362 print, again processed as negative. This (the third) generation will have positive images. From each of these prints yet another 7362 print is made, all processed as negative. Now if prints from the third generation are bi-packed with fourth-generation prints that descended from the adjacent lower density, the result will be a fringe. If prints from the third and fourth generations are bi-packed in this fashion and each pair is printed through a different color filter, the result will be a multicolored image.

Another popular manipulation is the "Rorschach" effect (see figure 8.5). This is a symmetrical repetition of the same image in both halves of the frame. It is named for the psychological testing device made by staining a piece of paper and folding it in half to produce identical imprints on both sides of the fold. The simplest way to achieve this on film is to print the

original onto the raw stock twice, once correctly and once sides reversed. If the original shows a dancer standing in the left side of the frame, the print will show the dancer there and also on the right side, symmetrically reversed. But if the dancer is in the middle, her two images will be superimposed. To achieve a cleaner Rorschach effect with no ghost images, we can bi-pack the original with a roll of clear film that is opaque over half of the frame. In a second printer run we reverse the sides of the original and print again, this time bi-packing it with a negative printed from the half-frame mask. We do not use the original mask reversed. Using a negative of the original mask ensures that the mask for the second pass exactly matches the area left blank in the first pass. If the same mask was used reversed in the second run, we would run the risk of a gap showing if the edge of the mask wasn't perfectly vertical and exactly in the center of the frame.

When exposing the original footage from which we will make 7362 high-contrast prints, we must consider what we intend to do, in order to know how to expose the original. For example, if we intend eventually to produce a high-contrast silhouette of a person against some background, then the original must be exposed with plenty of contrast between the man and the background, that is, the background white and the man dark, or vice versa. If we had instead made the mistake of lighting the original scene flatly, the background and certain parts of the man might have been recorded in the same shade of gray in the original, making it impossible to separate them with 7362. Therefore, the film maker exposing original to be used later for optical printing effects must use lighting, set colors, and make-up to his advantage. To take an example, say we intend to insert passing clouds or a landscape behind a person's eyes. As an intermediate step we would need a high-contrast image in which just the eve sockets are black and everything else is clear. This is easily achieved if, when we shoot the original close-up, we put black make-up over the actor's closed eyelids and then light him and the background with all soft light from the front and sides. This will wash out all the shadows and leave an image in which there is a high enough contrast between the eye sockets and the rest of the picture to obtain the 7362 prints required. One 7362 print will have the eye sockets black and the rest clear. It will block out the eyes when bi-packed with the footage of the man's face. A negative of that 7362 print will have the eyes clear and the rest black. This will be bi-packed with footage of clouds, which will appear in the eye sockets.

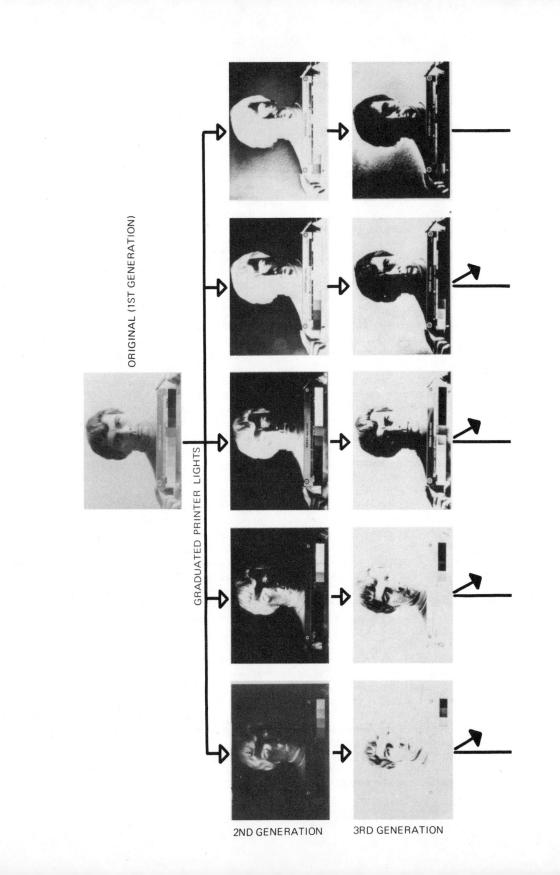

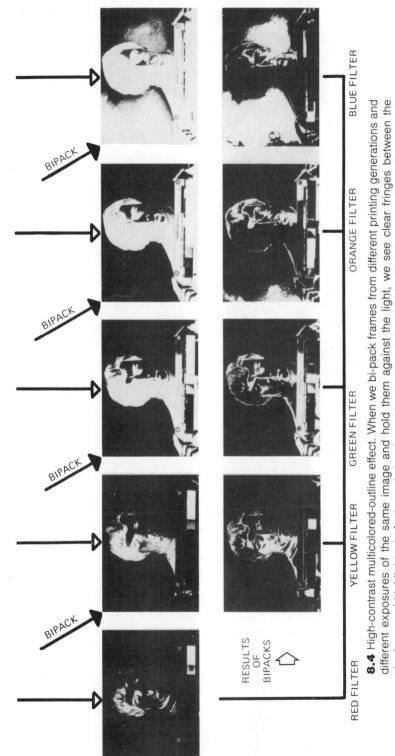

shadows and highlights. In further printing these clear areas can be filled with colors by using color filters on the printer. Colors chosen in this example would result in a somewhat psychedelic effect.

178 CINEMATOGRAPHY

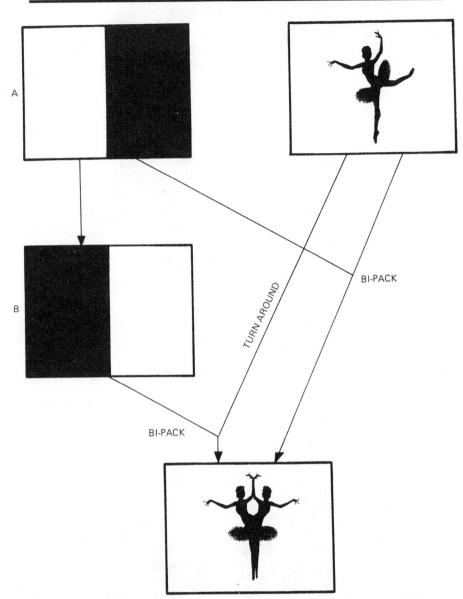

8.5 "Rorschach" effect. *A:* 7362 high-contrast mask. *B:* Complementary 7362 mask, printed from the original mask (*A*).

AERIAL IMAGE

The aerial-image principle borders on magic and at first contact is somewhat hard to believe. To understand it, consider a normal projector casting an image onto a screen. If we remove the screen, the image is still focused at that plane in midair. Of course we cannot see it because it isn't reflected by any solid surface such as a screen or a ground glass. But if we position a camera on the other side of the "screen," opposite the projector, and focus this camera onto the "air frame" where the screen was, the camera will

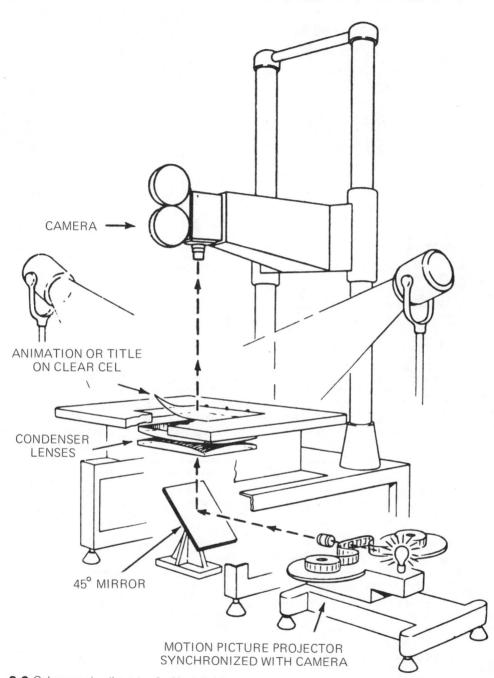

8.6 Oxberry animation stand with aerial image unit. *(Courtesy of Oxberry, division of Richmark Camera Service, Inc.)*

180 CINEMATOGRAPHY

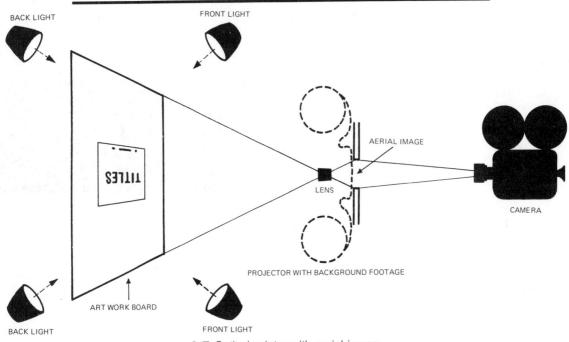

8.7 Optical printer with aerial image.

photograph the image formed in midair, even though there is no image-forming surface. It sounds impossible, but it works.

One such aerial-image system is available with the Oxberry animation stand (see figure 8.6). Here the projected image coming from below via a mirror and condenser lens is focused as an aerial image in the plane of the clear-glass artwork table. If artwork or objects are positioned on this surface and lit from above, they will be photographed with the aerial image showing through around them.

For example, to show animated effects against a realistic background we can draw on animation cels, leaving clear areas in which we will want background. When lit from above, the camera will see the drawings, which block out the parts of the background they cover. The light from above can be polarized so that it just illuminates the artwork. The light goes right through the glass surface and aerial image (there is nothing there to reflect it), and therefore does not wash out the background. Instead of drawings on animation cels we could use small three-dimensional objects.

Of the many configurations of aerial-image optical printers, perhaps the simplest is achieved by removing the lamp house from a normal optical printer and putting a lens in its place (see figure 8.7). An illuminated artwork area is focused by the lens to form an image in the projector gate. The lens on the optical printer camera is also focused at this same plane. This system is less expensive as it can be set up by modifying a normal optical printer. Unlike the Oxberry, we must make two runs. For example, if we wish special titles superimposed, on the first run background footage is put into the projector. The lettering is painted on a clear cel and placed on the artwork board, which is illuminated from behind so that the letters appear black, silhouetted against a luminous background that acts as a source of light. These letters are focused onto the film plane in the projector. Thus the camera will see the background footage in the projector gate, illuminated from behind with the black letters superimposed across it. For white or colored titles, a second pass will be made. The background footage is now removed from the printer. The back lights are turned off and the front lights are turned on so that the titles are illuminated only from the front. A piece of black cardboard is placed behind the cel, so that the area around the letters will be completely black and therefore will not affect the picture area that was earlier filled in with background. During this second pass only the letters will be printed, fitting into their corresponding areas left unexposed in the first pass.

VEHICLE AND UNDERWATER CINEMATOGRAPHY

VEHICLE CINEMATOGRAPHY

We are living in such a mobile society that a good portion of screen time is devoted to scenes taking place inside cars, planes, trains, and other moving vehicles. When planning such scenes an important decision is whether to shoot on location or on a sound stage setup with a back projection. Shooting inside a moving car offers more authenticity but severely limits the lighting, camera angles, and sound quality. Yet, often enough, for monetary considerations many film makers have no choice but to work inside a moving vehicle.

Many creative techniques were developed to achieve the best quality under these circumstances. Unfortunately, the most sophisticated equipment is quite expensive. The top of the line in vehicle shooting techniques is the insert car setup. This is a specially designed vehicle with outrigger brackets to tow the action car alongside or behind it. It is also possible to tow a low flatbed trailer with an action car sitting on top. Insert cars have platforms for lights and camera, and they have a DC generator on board to provide enough power for a couple of arcs.

When such sophistication is unnecessary or unavailable, a camera and a few lights can be attached to the car itself. A platform can be rigged on the hood, or a "limpet" mount with suction cups can be attached directly to the hood, door, or any other part of the car body (see fig. 1.50). Safety cables and ropes are essential and should be rigorously tested and checked because filming on a moving vehicle always presents serious hazards to crew safety and equipment.

When lighting inside the car, there is often a tendency to use too much light. In daylight our main problem is to balance the background, visible outside the car, with the light level of the inside. A neutral density gel, stretched on the windows visible in the frame, will usually take care of this problem; and a white card rigged on the hood or outside the side window may be sufficient to fill in the interior. It depends, of course, on the weather and the location. Quite often FAY clusters or HMI lights are mounted on the hood next to the camera.

Reflections of the sky on the windshield represent a problem. A simple way to deal with this is to build a black awning over the windshield and hood and use lights rigged under this black "tent" on the hood. There is also a more imaginative way to handle it. If the scripted scene allows, choose a road with tree branches stretching over it. Such a location allows for a picturesque play of light and shadow on the front glass and on people inside the car. If the reflections are not needed, the camera should be placed at approximately a 34° angle to the glass, and a polarizing filter on it will cut out the reflections.

182 CINEMATOGRAPHY

Usually the car ceiling is not visible in the frame. It can be covered with white or silver plastic to bring up the general light level. Bouncing light off it from a lamp hidden behind the seat is sometimes done, but this doesn't create a very realistic light direction. Bouncing off a white card positioned on one side would provide a better angle. Battery-operated small HMI units are often used as light sources for bouncing.

Night shooting inside the car requires more elaborate lighting schemes. The traditional unrealistic "dashboard light" effect, producing low-angle illumination, may still be used on gangster-type characters, but generally a more sophisticated lighting is required these days. State-of-the-art in lighting is fiberoptics (see fig. 4.40). From the light source hidden in the trunk or on the floor, glass fiber cables transmit light to several desired positions.

When this sophisticated equipment is not available, other light sources can be successfully employed. Particularly useful are incandescent tubes originally developed for display cabinets. These Lumeline lamps come in twelve- and eighteen-inch lengths and are one inch in diameter. They come in 40-watt and 60-watt tubes, respectively, and can be run from a 120-volt battery pack. A small rheostat can be used to control their intensity. These lightweight lamps can be attached to visors or any other place in the car with gaffer's tape or Velcro ribbons.

Small light domes used for lighting recreational vehicles can also be used. Small 12-volt bulbs can be plugged (via a cable) into the cigarette lighter circuit. Catalogs of such major lamp manufacturers as General Electric and Sylvania, as well as the supply lists of the motor home trade, have information about the availability of various useful bulbs. To run regular 120-volt lamps from a 120-volt battery, inverters made for mobile homes are available. They can usually handle up to 700 watts.

To be able to balance a car interior with light levels in the streets at night, keep lighting quite low. Backcross lighting will create a more realistic night scene. Car scenes at night that are overlit stick out like a sore thumb.

The illusion of driving along the street requires sporadic light effects. These are sometimes augmented by intermittently bouncing light off a white card rigged on the hood. When the action takes place on a dark country road, the only images that one can see in the background are the headlights of passing cars. When rainy weather is not ruled out by the script, the driving can be can be simulated in a stationary car. Remember, in order for rain to show up on film it must be back-lit. A wind machine can splash water on the windshield and the windows, while at the same time pieces of cardboard with horizontal slots can be moved vertically in front of one or more lamps to simulate the headlights of passing cars.

Train interiors represent a bit of a cross between a location interior and a car. In daylight, windows will often need neutral density gels to balance the exterior brightness. Bounced lights from white cards work well, but we have to depend on battery operated lights, as the train power is completely different and cannot be utilized to run our lamps.

Airplanes have good levels of ambient light that can be augmented with some bounced light or small lamps ("peanut lamps"), with diffusion, hidden behind the seats.

When simulating flying conditions in a plane on the ground, a strong light source outside the plane, moved up and down, could simulate plane movements in relation to the sun.

UNDERWATER CINEMATOGRAPHY

The underwater cinematographer must be an experienced diver, and so must the entire film crew. When using actors or when filming under hazardous conditions, a safety diver should also be employed.

Underwater, the cameraman is faced with a different optical medium than above the surface. Water absorbs and diffuses the light. The intensity of sunlight decreases as it travels farther through the water. It penetrates deepest when it comes from straight above, because the more acute the angle of penetration is, the greater the effective distance the light must travel, and so the light level falls off rapidly. Therefore, the best shooting time is the four to six hours in midday.

Locations must be chosen that provide shallow areas, clear water, and a high sun. Generally, uncloudy weather is also a must.

Artificial light is used as a last resort. It looks unrealistic. In addition, it fades away rapidly as it travels farther from the source, making it impossible to light large areas evenly. In some cases, where the actors have practical lights, we can logically justify uneven lighting.

Underwater lighting should be done from the sides,

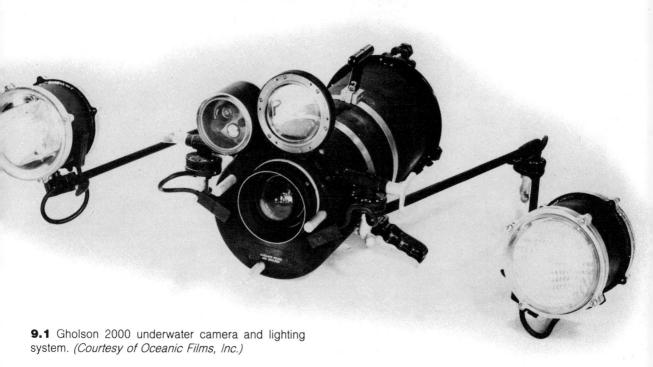

because frontal lighting is reflected back into the camera, creating a foggy effect. This "back scatter" is similar to what happens when you try to use your high beams while driving in a thick fog.

Power problems also add to the argument against using artificial lights underwater. Battery-powered underwater lights are hopeless, as they run down after a very short period. A small DC generator on the boat, with cables running to the lights, is a clumsy answer. The best solution is to avoid underwater lights whenever possible and try to depend exclusively on the sun. If lights have to be used, they must have a closed reflector, i.e., a piece of glass that keeps the water away from the bulb and reflector.

Measuring light levels underwater is difficult. There are differences of opinion as to the best measuring techniques. Incident readings do not account for the light that is lost on its way from the subject to the camera. (The light is absorbed by the water.) Reflected readings, taken from the camera position, are perhaps better in this respect, but they are easily influenced by bright bottoms or dark backgrounds, common factors in underwater photography. The best tool is probably a narrow-angle reflectant light meter, such as the Sekonic Marine, which features a comparatively narrow acceptance angle and has a waterproof case. Ordinary light meters can be used if a waterproof housing is provided.

Another important consideration is color. Underwater, the colors change with increased depth, gradually becoming bluish green. At ten feet there are no reds. By about thirty feet orange vanishes, and sixty feet down there is nothing left but green with a bit of blue. To counteract these color deficiencies, use filters to favor the warmer colors. This will improve skin tones. Red and magenta CC filters of various strengths will be used, depending on the depth. When filming at fifteen feet, CC.40R (red) is sufficient for *partial* correction. Partial correction will leave it more realistic; full correction may remove the underwater appearance. Pushing color film shot underwater is not advisable as the color turns even more green.

In black-and-white, the concern is the contrast range. The water scatters and diffuses the light, thus decreasing contrast with added depth. A yellow or orange filter will improve the contrast.

Another effect the water has on light is magnification. Underwater, distances appear one-quarter closer.

9.2 Teledyne DBM self-housed underwater camera with 400-foot magazine and speeds ranging from 16 to 48 fps. *(Courtesy of Teledyne Camera Systems)*

Therefore, an object forty feet away appears to be thirty. This effect applies to both the eye and the lens. Therefore, if we *guessed* the distance to the subject, estimating by eye that it is thirty feet, and we set the focus accordingly, it would be in focus. Reflex focusing could also be accurate, but it is physically difficult to get your eye very close to the eyepiece because of the underwater camera housing and the face mask.

Wide-angle lenses are the ones most commonly used. This allows the cameraman to come closer to the subject. There is less water between the subject and camera and the picture is therefore clearer. The standard set of lenses used on the Gholson 2000 underwater camera contains 5.9mm, 10mm, and 12mm lenses.

Underwater cameras can be either self-contained or housed. The above-mentioned Gholson 2000 is a good

example of the self-contained group. It takes a 400foot load. Another popular self-housed underwater camera is the Teledyne DBM 9-1 with a 200-foot magazine and speeds ranging from 16 to 48 fps.

Housings have been designed for many of the allpurpose cameras, like Arriflex, Bolex, and others. Housings can be rented or bought from dealers. Many underwater cinematographers build their own.

It must be remembered that the airtight compartment requires great care to prevent humidity, which results in fungus growth or emulsion softening. After shooting, the outside of the housing should be rinsed off with *fresh* water and then the camera should be taken out of the housing (or opened, in the case of self-housed cameras) and allowed to air. While shooting, a humidity-absorbing substance is sometimes placed inside the housing as an added precaution.

The most important consideration in selecting an underwater camera is its maneuverability, which depends on the unit's buoyancy. If buoyancy can be adjusted, it gives the operator many advantages. An operator's buoyancy can be adjusted with the amount of air in his or her inflatable vest and with the weighted belt. Maneuvering underwater is the opposite to maneuvering on dry land in one respect: Moving shots are smooth and the cameraman can glide in any direction, but steady shots are difficult because of water movement. One solution is to increase the weight of the camera. In other cases a weighted tripod may be necessary.

Remember that everything is more difficult underwater. Communication is limited to hand signals and buzzers. There are many cumbersome problems and delays, such as air running out or crew members and actors getting cold. Therefore, when planning underwater work, allow extra time. Much time can be saved if the locations are all in shallow water, not deeper than thirty feet. Factors favoring shallow water include expediency of shooting, more light, better color and contrast, comfort (warmer water and less pressure), and less danger, especially if you are using actors who are not experienced divers.

PRODUCTION

...................

Unfortunately, film is a very expensive medium, and therefore the scope of any film project must depend heavily on the amount of available money. There are various ways of financing a film. You can start with an idea and shape it to the limits of your funds, or search for sufficient backing to accommodate your concept. Sometimes, with limited funds, it is better to complete a small part of the total project and use it in the search for further money. In situations where small budgets are allocated annually (such as in some film schools), it is possible to produce one or two small films each year, for a few years, planning them so that later they can all be edited together to make a feature.

Whatever way a film is financed, it must be thoroughly budgeted if one expects to finish what is started. Otherwise, unforeseen and wasted expenditures may leave the production out of money before it is completed.

The following is a broad and rather general list of expenses to be reckoned with in film making. The list is long and includes some expenses that will not always be encountered. Small productions could start with this list and scale it down to meet their needs.

- 1. Story
 - a. Rights to the original material
 - b. Screenwriter(s)
 - c. Secretarial and mimeograph work

- 2. Producer and his staff
- 3. Director, assistant(s), and script girl
- 4. Cast
 - a. Featured players
 - b. Day players
 - c. Extras and stand-ins
 - d. Stunt men
 - e. Other costs, including a nurse or teacher for juvenile actors
- 5. Crew and equipment
 - a. Director of photography
 - b. Camera operator
 - c. First and second assistant cameramen
 - d. Electricians, grips, and prop men
 - e: Camera and equipment rental
 - f. Lighting equipment rental
 - g. Miscellaneous supplies, such as replacement bulbs for lamps, etc.
- 6. Sound recording
 - a. Recordist, boom man, cable tender
 - b. Equipment rental
 - c. Quarter-inch magnetic tape
 - d. Sixteen-millimeter sprocketed magnetic film and transfer service
- 7. Preproduction tests
- 8. Set costs
 - a. Set designer
 - b. Sound stage and set rentals

- c. Materials and construction labor
- d. Strike crew (cost of taking the sets down)
- e. Furniture, props, etc., either rented or purchased
- f. Losses or damage of borrowed or rented materials
- g. Special effects (such as fire, etc.), both rental and labor
- 9. Animals and their handlers
- 10. Location costs
 - a. Location rentals
 - b. Transportation
 - c. Accommodations
 - d. Location scouting and advance arrangements
 - e. Miscellaneous costs, such as electrical current, local permits, etc.
- 11. Make-up and wardrobe
 - a. Wardrobe supervisor, costume purchasing, rental, and cleaning
 - b. Make-up artist and supplies
 - c. Hairdresser and supplies
- 12. Film costs
 - a. Raw stock
 - b. Development
 - c. Daily prints
 - d. Negative cutting
 - e. First trial print
 - f. Masters and dupes
 - g. Optical track
 - h. Miscellaneous smaller costs, such as printing corresponding edge numbers, etc.
 - i. Optical effects
 - j. Release prints
- 13. Editing
 - a. Editor and assistant
 - b. Cutting equipment and editing room rental
 - c. Projection
 - d. Materials and supplies
- 14. Music
 - a. Music rights
 - b. Performance rights or composer
 - c. Conductor and musicians
 - d. Recording stage, music mimeograph, recordist, rental and transportation of instruments, etc.
- 15. Sound mixing
 - a. Dialog replacement
 - b. Sound effects
 - c. Mixing
- 16. General
 - a. Legal

- b. Taxes (payroll, sales, property)
- c. Office rental
- d. Telephone bill
- e. Accountant
- f. Insurance
- g. Miscellaneous
- 17. Contingency

In order to ensure that the film will have funds to finish, about 10 to 15 percent of the budget should be a contingency fund for dealing with unexpected expenses. With more production experience, this percentage can be decreased.

A well-developed script is essential in planning the budget. If the film idea is not your own, the first consideration is copyright. If the written material is more than fifty-six years old it should be in the public domain and no longer protected by copyright. For further information on researching the copyright status of a work in the United States, write to the Registrar of Copyrights, Library of Congress, Washington, D.C. 20540.

The final shooting script will evolve gradually. Step by step, the directorial approach is determined and the casting is completed. Story boards are often prepared at this stage.

In the shooting script, the characters appearing in a given scene will be typed in capitals, to indicate clearly that actors playing these parts will be needed on the particular days of shooting.

Very rarely will a film be shot in consecutive order. For this reason a producer will need a breakdown showing what scenes will be shot on what day. A typical breakdown sheet for a scene shows its location and the set, the time of day and the season, the cast and the extras, props and animals, special effects, and finally the number of script pages and one-sentence descriptions of shots.

While the breakdown is being made, the crew is also being organized. There is a tendency on lowbudget student productions to assign too many functions to one person. This may be unavoidable on certain documentary projects, but on larger productions each key crew member should be able to concentrate on one job. An inexperienced director would be wise to concentrate on the actors and not try to be his own cinematographer as well. For a first-time director a more experienced cinematographer can be the most valuable ally. A less experienced cameraman can also benefit tremendously from working with a seasoned gaffer. PRODUCTION 187

Camera assistants need to be truly reliable. Mistakes do happen, but cinematographers must be confident of being alerted immediately to any mistakes if, for example, the loader exposes a roll of film to light, or if a focus puller misjudges the distance during the take. All crew members are always expected to be on time and to concentrate on their jobs.

As soon as there is enough information to determine what equipment will be required, a cinematographer, the sound recordist, and the other technicians will provide the producer with their input. When selecting lighting equipment, one can benefit from the manufacturer's data sheets providing the angles and intensities of coverage for particular instruments.

LOGISTICS

All locations must be scouted on a reconnaissance trip. The choice of a location will depend on the accessibility of the area, the availability of power, the topography, the sound conditions (check air-traffic routing charts and road-traffic noise), the average weather conditions, what permits are required, the availability of local help (such as policemen to redirect traffic, electricians, catering services, etc.), and the local accommodations for the cast and crew. Travel arrangements will have to be made. When filming out of the country, passports will have to be secured; they should be applied for well in advance in case of delays. All foreign-made equipment has to be listed with serial numbers and declared to the customs authorities when leaving. This is absolutely necessary in order to bring the equipment back without having to pay customs duties. Familiarize yourself in advance with custom regulations of the countries of your destination.

Naturally, all the equipment used on a production should be insured. Liability insurance may also be necessary if there is any risk involved in the filming. Sometimes property owners will demand that you have such insurance before using their premises.

INVASION OF PRIVACY

When shooting on location, one should know something about the laws concerning invasion of privacy that might apply to persons not under contract who appear in the film. Such participants might willingly help you while filming but then sue you later. However, if they can be persuaded to sign a simple release, the chance of a suit is reduced. The following is one type of release.

Authorization to Reproduce Physical Likeness and Voice

For good and valuable consideration from Productions, the adequacy and receipt of which is hereby acknowledged, I hereby expressly grant to said _____ Productions, or any third party it may authorize, and to its and their employees. agents, and assigns, the right to photograph me and/or make recordings of my voice, and the right to use pictures, silhouettes, and other reproductions of my physical likeness (as the same may appear in any still-camera photograph and/or motion-picture film) and/or recordings of my voice in and in connection with the exhibition and/or broadcast, theatrically or on television or radio, of any motion-picture film or tape in which my physical likeness and/or voice may be used or incorporated, and in connection with the publication in magazines, newspapers, or otherwise of any articles in which my physical likeness may be printed, used, or incorporated, and in the advertising, exploiting, and publicizing of any such motion pictures, television programs, radio programs, magazines, and newspapers. I certify and represent that I have read the foregoing and fully understand the meaning and effect thereof and, intending to be legally bound, I have hereunto set my hand this _____ day of _____, 19____.

(Signature)

I hereby consent and agree to the above as the Parent/ Guardian of ______.

(Signature)

Witness:_____ Date:____

This is a long and very thorough version. Sometimes it is easier to get people to sign this simplified but still-binding short form:

Release Form

For consideration received, I give permission without restrictions to ______ Productions, its successors

188 CINEMATOGRAPHY

and assigns, to distribute and sell still and sound motion pictures and tape recordings taken of me for a motion picture tentatively titled _____

	Signed
	Date
Signature	of Parent or Guardian
Witness: _	Date:

Whichever release is used, after signing, the person should be given a token payment such as one dollar *in cash* (not check) to make the arrangement binding.

In some situations a similar release might be necessary from the owner of the premises to allow you to photograph his property. If the actors are not under contract it is often a very good idea to have them sign a release also. This will prevent them from suing you later, should the film unexpectedly make money.

SCHEDULING

Before shooting, the script has been broken down and a schedule drawn up showing the exact scenes to be shot each day and listing the actors, props, and sets that will be needed. Such scheduling is necessary for efficient operation and will reduce wasted time. When time is especially limited, it is wise to study each scene to determine the quickest shooting order for the various shots.

During production, the crew and cast must be kept well informed about all times, dates, and locations. Lists of phone numbers are mandatory. Professional production managers supply everyone with daily call sheets.

SHOOTING TESTS

To ensure high photographic quality, time, money, and facilities must be allocated to the director of photography for shooting tests. Tests may include emulsion characteristics, lens and camera performance, filters, color schemes of sets and costumes, lighting, make-up, and out-of-the-ordinary camera movements or special effects.

The sound recordist may also want to test certain things, such as performance of the sync system, the recorder, the mics, and cables; sound interferences, such as a radio station being picked up, etc.; and acoustics of the sets and locations.

SHOOTING

If make-up is required, the make-up man and the actors will be the first to arrive. The director will first block out the scene, marking the camera and actor positions. The lighting and microphones are then set up and the first full rehearsal follows. Any necessary adjustments are made. When the actual shot is taken the recorder and camera are started, the scene is slated, and then the actors begin. In coordinating this procedure there is usually a dialog something like this:

ASSISTANT DIRECTOR (when everyone is ready): Quiet, on the set.
DIRECTOR: Sound.
SOUND MAN (starts recorder and when it is up to speed): Speed.
DIRECTOR: Camera.
CAMERA OPERATOR (starts camera and when it is up to speed): Rolling.
ASSISTANT DIRECTOR: Mark it.
CLAPPER (holding up slate in front of camera): Scene

one, take one *(claps slate and quickly exits).* DIRECTOR: Action.

Now the scene takes place. When it is over the director will call "Cut" and the camera operator and recordist will switch off their machines. What is important here is not the specific words or who says them, but the fact that a systematized procedure is developed to get the recorder and camera started, slated, and stopped with a minimum of wasted film.

	territoria de la constante de	PORT CAR								
CAMERAMAN PLEWA DIRECTOR DUNSKI PROD. NO. 1065										
CAMERA Arri BL # 5112 MAG. NO. 4 FOOTAGE 400										
DATE LOADED 2-22-72 LOADER TONER FOOTAGE EXPOSED 380										
TYPE 7252 EMUL BATCH 75220131-D CAN NO. 6										
Scene SHOT NUMBER Dial REMARKS				Scene No.		NUMBER Silent	Dial Feet	REMARKS		
5		(4z)	42	PRT	INT.	17	179		380	DAY EXT.
		13	55				\sim			
		(15)	70				6	-	20	01
SA		(10)	80	EFF	ELT		GUI	22	50	
SB	35		115				NG		1	2
	(37)		152	Y	V		WA	STE	2	0
8 C	24		176	DAY	EXT.				40	0
	25		201	+	*					

10.1 Camera report card.

231545

camera report sound report

COMPANY TARNAWA F. DIRECTOR DUASK				CAMERAMAN PIEWA Et Gets & Hockey Puch				
35 MM COLOR	35 MM B/W		16	MM COL	OR	16 MM B	l/W	
ONE LIGHT	TIMED DAI	LIES	K	ONE LIG	HT	ONE L	IGHT	
TIMED DAILIES	-	-		TIMED D	DAILIES	TIME	DAILIES	
TYPE OF FILM/EMULS		Y:			NSTRUC	TIONS		
SCENE NUMBER			2 0	KES 3 7	4 .	DAY	MARKS INTERIO OR EXTE	R Di
_		2		0	4 0	OR NIGHT	OR EXTE	RIOR
5		42)	13	5		Night	INT	. 5
5 A		10	_	-		1 effe	et 1	7
51	3	201	37)			1	1	
0	A .	247	3			DA	E	-#
	-	3	9			VAY	EN	10
1.1	9	19				4	4	1
								-
								96
							~	

All contracts with this company are accepted with a line understanding that all him derivered to its covered by the owner against loss. This company takes every necessary precaution for the safekeep-ing of the film, but assumes no responsibility for its loss.

NUMBER CANS TO LABORATORY	BALANCE NEGATIVES ON HAND
GOOD FOOTAGE 308	RECEIVED
N.G. FOOTAGE	EXPOSED
WASTE FOOTAGE 20	ON HAND
	EMULSION NUMBER 7252 20151-D

TRACK SPECIFICATIONS

10.2 Negative report sheet. (Courtesy of DeLuxe General, Inc.)

			D SERVICES, INC.				
Producer			Date 30 Nov 71				
Productio	n No.	128	Roll No. 1 Sheet No. 1 of 1				
Mixer	Tac	kson					
Boom Ma	an S	mith	Recordist				
Stage #			Recorder # 16				
Location		with the	Microphone # 815/0825				
		Print Circ	led Takes Only				
Scene No.	Take	Footage	REMARKS				
10	1	105	Syn 5				
	2	213	1				
	3	315					
	9	425	•				
52	Ĩ	456					
	a	490					
52A	$\widetilde{\mathbb{O}}$	698					
	2	757					
	3	820					
1.1.1	4	892	1				
FS	-	901	Folse Start				
		6					
E	na	of	Roll				

10.3 Sound recording report sheet. (Courtesy of Ryder Sound Services, Inc.)

190 CINEMATOGRAPHY

After each take, the director will usually ask the camera operator and recordist if there were any problems or mistakes. The script girl has constantly been making notes on every possible detail that, if changed, might spoil the continuity, such as the relative positions of all the fixtures, actors, and props; the lens focal length and the camera position; and the actions of the actors, such as how they picked up an object, in their right or left hand, etc. She makes notes as to whether the director wants the take printed ("P") or thought it was no good ("NG"). The script girl is sometimes aided by a Polaroid camera.

Professional camera crews also fill out camera report cards during the shooting. They partially duplicate the script girl's notes, indicating footage of each take, effects, the "P"/"NG" indication, etc. This information will later be transferred to a negative report sheet that will accompany the film to the lab.

POST-SHOOTING PROCEDURE

When the magazines are unloaded and prepared for the film lab, it is important to note what magazine each roll of film was shot with, in case that magazine is defective and, for example, is scratching the film or has a light leak. If possible, it is convenient to have one person doing all the paperwork involved, including the negative report sheets, etc.

A log sheet is also kept for the sound. It accompanies the original quarter-inch tape when it is sent to the sound department for transfer to magnetic film.

POST-PRODUCTION

Post-production expenses will primarily involve editing, sound mixing, music scoring and recording, optical effects, titles, negative cutting, and all the lab expenses along the way to the release print.

It is preferable to score a picture rather than "lift" the music from a record. Many excellent student and amateur films are not releasable because the producer cannot pay the price demanded for the rights to the music. Music libraries will sell the rights to "stock music" at fairly reasonable prices. However, stock music is never original and is often overused and dull. Having a picture specially scored is usually better. When music is composed for the picture, a likely expense is an additional work print for the composer to study and to use during the scoring and rerecording. It is often better to print this from the editor's "fine cut" work print, rather than from the A-B rolls. Once the A-B rolls are prepared, they are difficult to change, so it is advisable to remain flexible as long as possible, leaving the negative cutting until after the mixing and dubbing. If, on the other hand, there are many optical effects, visible only in the print, the composer's print may have to be taken from the A-B rolls.

COPYRIGHT

To copyright a film, the first thing you have to do is to print the copyright symbol, ⓒ, followed by your name and the year on the title credit of the film. For example "ⓒ 1984, William Shakespeare." This first step to copyright should always be taken. It signifies a claim to the right to the material.

To make the copyright truly binding in the United States, the film has then to be filed with the Registrar of Copyrights, Library of Congress, Washington, D.C. 20450. Write to this address and ask for form L-M and information regarding film copyrighting. Following the Library of Congress directions, you can copyright the film for twenty-eight years. The copyright can be renewed once for another twenty-eight years. The first time a film is copyrighted you are sometimes required to deposit two prints with the Library of Congress, or a blown-up still photo from each shot, whichever the copyright office recommends. Having your film copyrighted makes it illegal for someone to make copies of all or part of it. It unfortunately cannot prevent someone from taking the same idea and applying his own interpretation.

VIDEO TRANSFER

TRANSFER TO VIDEO TAPE

Today, a majority of film releases are transferred to video tape, either for the home video market or for personal portfolios of film makers. It should, therefore, become the responsibility of a conscientious cinematographer to supervise the process.

The flying spot scanner technology, such as Rank Cintel, offers a superb quality transfer, which becomes, in fact, yet another opportunity for fine adjustments in color and contrast of the video image.

A video transfer should be considered a normal part of film post-production. It should be made when both the original picture and sound are fresh and clean. Considering that the video transfer engineer has an impressive range of control over the outcome of the transfer, one should not relegate the responsibility of supervision to anyone not intimately understanding the visual concept of the film. For example, a dusk-fornight scene may end up looking like day if left to an uninformed engineer.

The flying spot scanner scans the film line by line, by a roster of white light projected through the film. A series of color photocel receptors (red, green, blue) positioned behind the film react to changes in color and density encountered by the scanning light. The flying spot scanner allows one to choose a portion of the frame by limited panning and zooming movements. The advantage of the flying spot scanner over film timing as image control is the ability to make corrections during the shot and not just from shot to shot. For example, if within the shot the camera makes a pan from a very dark to a very bright part of the set, these two extremes can be corrected individually. Shadows can be altered without affecting the highlights and vice versa. This allows for flattening the contrast, which is similar in effect to flashing.

As impressive as the possibilities of correction offered by the flying spot scanner are, one should start with a well-timed original material, either a low-contrast answer print, an interpositive, or internegative (dupe-negative). Before doing any video transfer work, one should have an answer print, corrected by the timer in a film lab. Only then would one order a corresponding print on low contrast stock, such as Eastman 7380. This print will be used for the video transfer. Even less contrasty than the 7380 stock is an interpositive 7243.

Interpositive stock is used in post-production when the cinematographer plans to make many prints from the negative. To protect it from the hazards of repeated printer runs, one needs to take a few intermediate steps. First print from the negative to interpositive, then to dupe-negative, and finally to multiple release prints. Each of these intermediate prints has its own characteristics.

When striving to preserve in the video transfer all the fine nuances of highlights and shadows, one discovers that some scenes look better when transferred from an interpositive print rather than from a low-cost answer print. Particularly very dark night scenes may benefit from this treatment.

Needless to say, not every production can afford the luxury of transferring from various generations of prints to achieve the best rendition of individual scenes. There may be times, particularly with commercials, when the transfer is done directly from the negative without a timed print in between. By changing polarity a positive video image can be generated directly from the film negative. In that event, the whole timing process (the corrections of color and exposure) is performed during the transfer.

The reason why so much material designed for television is still being originated on film stems from the image quality defined as the "film look." The main elements of the film look are seen as better rendition of highlights, greater overall contrast range, and a selective depth of field. Critics of the video cameragenerated image point to its infinite depth of field, which doesn't allow for concentrating viewer's attention on important areas by selective focusing. A technical feature of the video camera is that its electronic video beam tries to create sharp edges on every object in its field of view. This edge enhancement is created by special circuits that produce a fine white line along the transition between sharply defined areas. Fortunately, when the image is originated on film and then transferred to video, it still preserves its film look.

Another advantage of shooting on film has to do with the universal acceptance of film standards. At present time there is no universal system in video. The world is divided among NTSC, PAL, and SECAM, to mention only the major systems. Tremendous advances in new technology, such as high-definition television (HDTV) and digital video recording, will bring still new problems for broadcasting the already existing video tapes.

Under these conditions of constant change, it makes sense to shoot on film. There will always be a way to transfer it to the future video systems. As the color stability of film printing stocks has improved and much more technology is available today for film preservation than in the past, producers feel more secure having their productions shot on film. Film manufacturers justify this loyalty to their products by designing even faster and better emulsions, which, for the time being, are unsurpassed by any other image recording medium.

- A-B Rolls. A method of preparing the original footage for printing from two rolls (A and B) onto a printing stock. Roll A may contain takes 1, 3, 5, . . . and roll B takes 2, 4, 6, The process requires two printer runs. This method prevents the splices from showing on the print and permits dissolves and other common optical effects without the use of an optical printer.
- A-Wind, B-Wind. Terms designating the position of sprocket holes and emulsion on rolls of a raw stock perforated along one edge only. See figure 2.15. In popular usage the terms could apply to single- or doublesprocketed film generations in the lab as well.
- Academy Aperture. A frame area enclosed by an Academy mask, giving screen proportions of approximately 3:4.
- Acceptance Angle. A characteristic of an exposure meter describing the angle of the light cone reaching the photocell. Applies also to the camera-lens angle.
- Acetate Base. Also called "safety base." A film base made of cellulose tri-acetate with slow-burning characteristics.
- Aerial Perspective. Perspective augmented by water and dirt particles in the air, which gradually obscure the view of distant objects.

- Ambient Light. Light surrounding the subject; generally of a soft, low-con-trast quality.
- Anamorphic Lens. A lens used to produce a wide-screen image. It optically "squeezes" the picture, allowing a wider horizontal angle of acceptance, and then it "unsqueezes" it during the projection.
- Answer Print. See first trial composite print.
- Anti-Halation Backing or Layer. An opaque layer on the back of the film base to prevent internal light reflections in the film base. It prevents or minimizes the halo effect around the images of strong lights such as car headlamps or street lights.
- Aperture, Lens. The opening through which light passes within the lens. Its diameter is adjustable by means of a lens iris (diaphragm).
- Aperture Plate. In camera: a plate with a rectangular opening that limits the area of a film frame being exposed. In projector: a plate that defines the frame being projected.
- Apple Boxes. Wooden boxes in three basic sizes (full, half, and quarter) used on the set in a variety of ways to raise actors, furniture, lights, etc. ASA Speed. See EI/ASA speed.
- ASC. American Society of Cinematographers.
- Arc Light. A powerful lamp in which the electric current flows between

two electrodes. A carbon arc operates in the normal atmospheric pressure, while a mercury arc works with the current flowing through an enclosed mercury vapor. This pressure can sometimes be very high.

- Aspect Ratio. The ratio of height to width of a film picture frame and of the projected image.
- Assembly. The first stage of editing, when all the shots are arranged in script order.
- Attenuator. A filter with a continuous gradual change from a specific density to clear glass, or from heavier to lighter density. Sometimes used to designate a graduated filter.
- **Baby.** Focusable studio lamp with a Fresnel lens and a 500-watt to 1000-watt bulb.
- Baby Tripod, Baby Legs. Very short tripod used when shooting low camera angles.
- **Backdrop.** Painted or photographed background used behind the set windows and doors.
- Back Projection. See process projection.
- **Barndoors.** Two or four metal shields hinged in front of a lamp to limit and shape the pattern of light.
- **Barney.** A padded camera cover, shaped to allow the camera operation. It reduces mechanical noise and

sometimes contains electric heating elements.

Base, Film. See acetate base.

- Batch, Emulsion. A quantity of raw stock with emulsion made at the same time and under the same conditions, therefore maintaining identical sensitometric and color characteristics.
- **BCU** (Big Close-up). A single feature such as eyes, mouth, hand, etc., filling the screen. Also known as XCU (extreme close-up).
- Belly Board. A board for mounting a camera as low as possible.
- **Bin.** A boxlike or barrellike container with a frame from which to hang lengths of film during editing. It is usually lined with a disposable linen bag to prevent scratching.
- **Bi-pack Printing.** 1. Printing in contact with printing stock, using a contact printer. 2. Printing two bipacked films, sandwiched together, onto the third film (printing stock), using an optical printer.
- **Bleaching.** A step in color film processing when the metallic silver image is converted into halides, which are later removed during fixing.
- **Bleeding.** A phenomenon in the developing process appearing on the border between high- and low-density areas, when vigorous development action spreads from the highlights into the shadows and degrades the sharp cut-off line between these areas. It is often noticeable around a figure silhouetted against the sky.
- Blimp. Soundproof camera housing to prevent mechanical noise from being picked up by the microphones. Many modern cameras are self-blimped, i.e., built to operate noiselessly.
- Blocking the Scene. Establishing the positions and movements of actors and/or camera in the scene.
- **Bloop.** 1. A noise caused by the splice in an optical sound track passing in front of the exciter lamp. 2. A patch or fogging mark covering the splice line to eliminate this noise. 3. A sound signal recorded on tape simultaneously with a light exposing a few frames of film to establish the synchronization between the two. Also

called "clap." See slate, electronic. 4. Colloquial for sync pop.

- Blue Coating. Magnesium fluorite deposit on the glass-air surfaces of a lens. This antireflective coating greatly improves the light-transmitting power of the lens and therefore prevents reflected and scattered light from flaring the image.
- **Boom, Microphone.** A sound dolly with a long extendable arm enabling the operator to position the microphone and move it silently around the set, following the actors.
- **Booster Light.** Usually an arc lamp or cluster-type quartz lamps used on exterior locations for boosting the daylight, especially when filling the shadows.
- **Breaking Down.** Separating individual shots from a roll of rushes in the early stage of editing.
- **Brightness.** Ability of a surface to reflect or emit light in the direction of the viewer.
- **Broad.** A single or double lamp designed to provide even illumination over a relatively wide area. Used as a general fill light.
- Brute. A type of arc lamp that draws 225 amps. "Mini-Brute" and "Maxi-Brute" are trade names of clustertype quartz lighting instruments produced by Berkey-Colortran, Inc.
- **Buckle-Trip or Buckle Switch.** A circuit breaker in the film path of many modern cameras that acts as a safety device in case of a camera jam.
- **Butterfly.** A net sometimes stretched over an outdoor scene to soften the sunlight.

B & W. Black-and-white.

- **Candela.** A unit of light intensity. The luminance of a light source is often expressed in candelas per square meter.
- **Capstan.** A spindle that drives the tape in a sound recorder at a constant speed.
- CC Filters. Color-compensating filters. A series of filters in yellow, cyan, magenta, blue, green, and red, growing in density by small steps. Used for precise color correction at the printing stage, but sometimes

also when filming, especially in scientific cinematography.

- **Cement, Film.** An acetone-based solution used for splicing films by partially dissolving the base and thus welding them together.
- **Century Stand.** A metal stand for positioning a lighting accessory such as a flag, cookie, scrim, etc.
- **Cinch Marks.** Scratch marks on film, chiefly caused by pressing on the edges of an unevenly wound roll of film, or by pulling on the end of a loosely wound roll.
- Cinéma Vérité. Style of documentary filming when maximum authenticity of the photographed real action and dialog is preserved, without narration, optical effects, or added music.
- Cinemascope. A wide-screen system utilizing an anamorphic lens.
- **Cinex Printer.** An instrument for printing a strip of adjacent frames using a series of standard printer lights.
- **Cinex Strip.** A strip of positive film printed on the cinex printer, which allows the cameraman to judge the original as printed at different printer lights.
- **Circle of Confusion.** A circle representing on film an image point formed by a lens. .001 inch is the largest acceptable circle of confusion in 16mm cinematography.
- Clapper Board. Also called "clapstick" or "clapper." Two short boards hinged together and painted in a matching design. When sharply closed, they provide an audible and visible clue which is recorded on film and sound tape simultaneously. This helps to synchronize the picture film with the magnetic film in the editing process. A slate with relevant information, like scene and take number, is usually attached to a clapper board. Modern cameras are often equipped with an electronic slate. See slate, electronic.
- **Claw.** Part of the camera pull-down mechanism; a metal tooth that engages film perforations and moves the film down one frame at a time.
- Code Numbers. Progressing ink numbers printed usually at one-half-foot

intervals on the edges of both picture and sound dailies to help the syncing-up process in editing.

- Coding Machine. A machine used for printing code numbers.
- **Colorblind Film.** Black-and-white emulsion sensitive to only one color, usually blue. See also orthochromatic film.
- **Color Chart.** A test chart representing the colors of the spectrum. Sometimes the color steps are parallel with the fields of gray that have the same visual luminosities as the corresponding steps of the colored half, as on the Illford Test Chart. Other test charts may have gray steps from white to black growing in logarithmic progression of blackening and independent of the color fields.
- **Color Sensitivity.** Corresponding photochemical reaction of film emulsion to different wavelengths, representing colors in the visible spectrum.
- Color Temperature. A system of evaluating the color of a light source by comparing it to a theoretically perfect temperature radiator called a "black body." At lower temperatures a black body emits reddish light, and when heated to high temperatures its light changes to bluish. Color temperature is measured in degrees Kelvin. A degree Kelvin is the same as a degree Centigrade, but the two scales have different starting points, 0° K = -273° Centigrade.
- **Complementary Colors.** Colors obtained by removing the primary colors from the visible spectrum. Minus-blue (yellow), minus-red (cyan), minus-green (magenta).
- **Composite Master Positive.** A composite print made to generate picture-and-sound duplicate negatives, which are in turn used for printing release prints.
- **Composite Print (Married Print).** Positive print with picture and sound in projection sync.
- **Conforming.** Cutting the original footage to match the finished work print.
- **Contact Printer.** A printing machine in which the printing stock and the film being printed are in contact, emulsion to emulsion.

- **Contrast.** Scene contrast refers to the brightness range of a scene. Lighting contrast refers to the light intensity differences between the sources. Emulsion and/or development contrast refers to the density range of the developed original and/or any subsequent generations, as compared with the scene contrast.
- **Cookie.** Also called "kukaloris" or "cucaloris." An irregularly perforated shadow-forming flag, opaque or translucent, made of plywood, plastic, etc.
- **Core.** A centerpiece around which a film is wound. Made of plastic, metal, or wood.
- **Covering Power.** A lens characteristic denoting the capacity to produce a sharp image over a film frame of a given size.
- **Crab Dolly.** A camera-mounting device with wheels that can be steered in any direction. Usually fitted with an adjustable-height column.
- **Cradle.** A lens support for heavy lenses, used to improve steadiness and protect the lens mount from damage.
- **Crane.** A large camera-mounting vehicle with a rotating and high-rising arm, operated electrically or manually.
- **Crystal Motor.** Also called "crystal controlled motor." A motor operating at a precise synchronous speed, regulated by reference to an accurate crystal frequency source.
- Crystal Sync System. A double system of synchronous filming not requiring connecting cables between the camera and the recorder. Both mechanisms are regulated by very precise crystal-control systems.
- **CS** (Close Shot). Head and torso down to the waist line filling the frame.
- CU (Close-up). Head and shoulders filling the frame.
- Cucaloris, Kukaloris. See cookie.
- **Cut.** The point of joining two shots by splicing, thus creating an immediate transition, as opposed to fade or dissolve.
- **Cutter.** 1. Term used either interchangeably with "editor" or to define a person who is responsible for the

mechanical rather than the creative elements of editing. 2. Shadow-forming device, usually rectangular in shape; a type of flag.

- Cutting Copy. See work print.
- **Cyclorama (Cyc).** Stage background, usually white with rounded corners, that is used to create a limbo or sky effect. Made of plaster or stretched plastic.
- **Cyc Strip.** Lighting instrument shaped like a trough with up to twelve bulbs for even illumination of a cyclorama.
- D Log E Curve. Also called sensitometric curve, characteristic curve. H&D curve, or gamma curve. The graph curve representing a relationship between the film density and the logarithm of exposure. Its shape changes depending on the time and temperature of development. It enables the cameraman and the lab technicians to evaluate the photographic characteristics of a given film emulsion.
- Dailies. Also called "rushes." The first print from original footage, with or without synchronous sound tracks, delivered from the lab daily during the shooting period, for viewing by the director, cameramen, etc.
- **Daylight Loading Spool.** Metal spool with full flanges to protect the film stock from exposure to light during the loading and unloading of camera or magazines.
- **Definition.** Ability of an emulsion to separate fine detail, depending on several factors, such as graininess and subject contrast.
- **Degausser.** An instrument used for the process of demagnetizing. See also **erasing.**
- **Densitometer.** An instrument for measuring the density of a processed photographic emulsion.
- **Density.** The light-stopping power of silver deposit in the processed photographic emulsion.
- **Depth of Field.** The distance through which objects will appear sharp in front of and behind the point at which the camera is focused.
- Depth of Focus. The distance through which the film can be moved back-

ward and forward behind the lens, before the image of a flat object becomes unsharp. Has little application in cinematography, as the film is held at a fixed distance from the lens by the gate.

- **Dialog Replacement.** Technique of recording dialog under the acoustically perfect conditions of the dubbing studio, to replace the poor dialog of scenes already shot on location. Actors time the delivery of their lines so as to match their lip movement as viewed on the screen.
- **Diaphragm, Lens.** Also called "iris." An adjustable opening that controls the amount of light reaching the film through the lens. Calibrated in fstops or T-stops.
- **Dichroic Filter.** A filter used on tungsten lamps to convert their color temperature to that of daylight. The filter reflects excessive red and transmits light that is bluer than originally.
- **Differential Focus.** Also called "split focus." Focusing at a point between two subjects in depth, to accommodate them both in the depth-of-field range, i.e., both in sharp focus.
- **Diffused Light.** Light originating from a physically large source. It is either reflected or directed through a diffusing medium.
- **Diffusers.** For lenses: Fine nets, muslin, or granulated or grooved glass positioned in front of the lens. For lamps: Cellular diffusing materials such as silk, spun glass, etc., placed in front of the lamp.
- **Dimmer.** An instrument used to change the voltage of lights on the set, regulating in this way their intensity. Not recommended for color cinematography, as the color temperature of the lights will also change.
- **Discontinuous Spectrum.** Characteristic of light sources, such as fluorescent tubes, which emit energy only in a few wavelength bands of the spectrum. Some colors are not represented in the discontinuous spectrum.
- **Dissolve.** Also called "lap dissolve." An optical effect representing a tran-

sition through a superimposed disappearance of one scene and appearance of the next.

- **Dolly.** A wheeled vehicle for mounting a camera and accommodating a camera operator and assistant. Often equipped with a boom on which the camera is mounted.
- Dot. Shadow-forming device in the form of a small round scrim or flag.
- **Double Exposure.** Two pictures exposed on the same frame of film, resulting in superimposition.
- **Double-Headed Projection.** A synchronous projection of separate picture and sound tracks, which are run in interlock. Done on a double-system projector.
- **Double-System Sound Recording.** Synchronous shooting system in which the sound is recorded on a tape or film separate from the film in the camera. See also single-system sound recording.
- **Dubbing.** 1. See dialog replacement. 2. Another term for rerecording.
- Dupe Negative. See picture duplicate negative.
- **Dynamic Range.** The difference in decibels between the noise level and the overload level of a sound system.
- Edge Fogging. Unwanted exposure on the film edges caused by light leaks in the camera, film magazines, or film cans if faulty or misused.
- Edge Numbers. Also called "key numbers," or "negative numbers." Numbers and key lettering exposed every half foot on the edge of the raw stock and consequently reprinted on the printing stock. These numbers make it possible to synchronize the original footage and the work print at the conforming stage.
- Editing Machine. Vertical or horizontal viewing machine for running separate picture films and sound tracks in sync or independently. Modern designs achieve high levels of sophistication in the range of available operations.
- Editorial Synchronism (Edit Sync). Picture and sound track on separate films arranged and marked in synchronous relationship for editing

purposes in parallel alignment, i.e., corresponding frames of picture and sound are opposite each other in the editing equipment. See also **projection synchronism.**

- Effects Track. A sound track containing sound effects as opposed to dialog, narration, and music tracks.
- EI/ASA Speed. Film sensitivity to light as rated in numbers established by the American Standard Association (now American National Standards Institute, Inc.).
- Electronic Clapper. See slate, electronic.
- **Electroprint.** An electroprint process of transferring sound directly from the magnetic track to the optical track of the release print.
- **Emulsion.** A light-sensitive coating composed of silver halides suspended in gelatin, which is spread over a film base.
- **Erasing.** Removing of the magnetic pattern from a tape or film by passing the tape through a magnetic field that is alternating at a high frequency.
- **Establishing Shot.** A shot usually close to the beginning of a scene defining the place, time, and other important elements of the action.
- Exciter Lamp. Part of the optical sound recording and reading system; it excites a current in a phototube. This current is modulated by an optical sound track moving between the lamp and the phototube, resulting in sound reproduction through amplifiers and loudspeakers.
- **Exposure.** A process of subjecting a photographic film to any light intensity for a given time, resulting in a latent image.
- **Exposure Index.** A series of numbers, such as EI/ASA ratings, that enables one to determine the correct exposure when using a light meter, exposure tables, or even experience.
- **Exposure Meter.** An instrument for measuring the light intensity, either incident upon or reflected from a photographic subject.
- Fade-Out, Fade-In. An optical effect consisting of the picture's gradual

disappearance into blackness (fadeout), or appearance from the blackness (fade-in).

Fall-Off. 1. A gradual diminishing of light falling on the set obtained by the use of barndoors, flags, etc. 2. Weakening of light intensity when the distance from the light source increases.

Fast Lens. See speed.

- Fill Leader. Film leader, usually white or yellow, used to fill those parts of a sound roll where sound does not occur, when preparing separate rolls bearing different sounds such as dialog, music, effects, etc., for a sound mixing session.
- Fill Light. Light coming from the camera direction and illuminating the shadows caused by the key light.
- Film Chain. Also called "telecine." Technical process of showing film materials on the television screen. Also used for video transfer.
- Film Plane. Plane in which film is held during exposure. It is often marked on the outside of camera body to facilitate the tape measurement to the photographed subject for focusing purposes.
- Filter Factor. A number by which the exposure must be multiplied to allow for the light absorption of an optical filter.
- Final Trial Composite. A composite print with all required corrections accomplished and therefore ready for release.
- Fine Cut. The work print at an advanced stage of editing.
- Finger. Narrow rectangular shadowcasting device.
- First Trial Composite. First composite print, usually showing the necessity for further corrections in color, density, sound quality, etc.
- **Fishpole.** A long, lightweight handheld rod on which a microphone can be mounted in situations where the boom is not practical.
- Fixing. Film-processing stage after development, when the unexposed silver halides are converted into soluble silver salts, to be removed by rinsing in water. Fixing terminates the film's sensitivity to light.

- Flag. Shadow-casting device made of plywood or cloth stretched on a metal frame. Specific types of flag include the cutter, finger, gobo, and target.
- Flange. A disk used on a rewinder, against which the film is wound on a core.
- Flare. 1. Spots and streaks on film caused by strong directional light reflected off the lens components or filters. Also caused by leaks in the magazines and camera body. 2. Uniform, overall fog caused by reflections in some lenses.
- Flat. A section of a studio set, usually modular, eight to ten feet high and six inches to twelve feet wide. Constructed on a wooden frame covered with a variety of materials like plywood, fireproof hessian, etc. Surface treatments vary from paints to wallpapers, papier-mâché, fabrics, metals, etc.
- Flat Light. Shadowless frontal light, usually from soft-light sources.
- Flip-Over. An optical effect of the picture on the screen turning over in the horizontal or vertical axis and revealing another image.
- Fluid Head. A type of tripod head in which the slowing effect of a fluid being pushed through narrow channels is employed to cushion any jerky movements and smooth out horizontal and vertical rotations.
- Flutter, Picture. Also called "breathing." Picture unsteadiness caused by an unwanted film movement in the gate of camera, printer, or projector. Flutter, Sound. See wow and flutter.
- Flying Spot Scanner. A film-to-videotape transferring machine. Scans the film frame line by line with a white light projected through the film. A series of color photocel receptors positioned behind the film react to changes in color and density encountered by the scanning light.
- **F-Number.** Also called **f-stop.** A number obtained by dividing the focal length of the lens by its effective aperture. F-numbers represent the speed of the lens at any given diaphragm setting.
- Focal Length. The distance between the principal point (effective optical

center) of the lens and the focal point (film plane), when the lens is focused at infinity.

- Focal Plane. A plane in which the image of a distant object is sharply formed by a lens focused on infinity. It should coincide with the film plane.
- Focal Point, Principal. Point at the intersection of the lens's optical axis and the focalplane.
- Focus. 1. See focal point. 2. Colloquially, the position of an object at the exact distance at which the lens is focused.
- Fog Density. The density of a developed piece of film caused by factors other than light, such as age, temperature, etc.
- Fogging, Chemical. Film density caused during processing by certain chemicals in the developer or by excessive exposure to air during development.
- Fogging, Light. Film density caused by unwanted exposure to light.
- Follow-Focus. A technique of continuous refocusing of a lens during the shot in which the distance between the camera and the subject changes more than can be accommodated by the depth of field.
- Follow Shot. Shot in which the camera is moved to follow the action.
- Foot-Candle. International unit of illumination. The intensity of light falling on a sphere placed one foot away from a point source of light of one candlepower, i.e., one candela.
- Foot-Lambert. International unit of brightness. Equal to the uniform brightness of a perfectly diffusing surface emitting or reflecting light at the rate of one lumen per square foot.
- Frame. One individual picture on a strip of film.
- Freeze-Frame. An optical effect of arresting the film action by printing one frame several consecutive times.
- Frequency. The rate of vibration, measured by the number of complete cycles executed in one second. The unit of frequency is a cycle per second, called a Hertz (Hz).
- Fresnel Lens. A type of lens used on spotlights. The convex surface is re-

duced to concentric ridges to avoid overheating and to reduce weight. Lamps equipped with this lens are called Fresnels in popular usage.

- Friction Head. A type of tripod head in which a smoothly sliding friction mechanism regulates the camera pan and tilt movements. The amount of friction required can be adjusted.
- Front Projection. See process projection.
- FX. Abbreviation for "effects," such as sound effects or special effects.
- Gaffer. The chief electrician on the film crew.
- Gaffer's Tape. Wide and strong adhesive tape used for securing the lighting instruments, stands, cables, etc., on the set.
- Gamma. A degree of photographic contrast arrived at by measuring a slope of the straight-line portion of the D log E curve of a photographic emulsion.
- Gang, Synchronizer. A term describing the accommodation of each film in a synchronizer. Synchronizers are rated as two-gang, three-gang, fourgang, etc.
- Gate. The aperture and pressure-plate unit in cameras and projectors.
- Gator Grip. An alligator-type grip used to attach lightweight lamps to sets, furniture, pipes, etc., mainly on location. A stronger variety is called a gaffer grip.
- Geared Head. A type of tripod head in which the pan and tilt movements are operated by crank handles through a gear system. These gears can be regulated.
- **Generation.** A term used in describing how many printing stages separate a given film from the original.
- Geometry, Film. The print emulsion position (wind) in relation to the leftright picture orientation. Geometry changes in successive printing generations.

Ghost. See halation.

- Gobo. A flag is sometimes called a "gobo," particularly when it is used to protect the lens from direct light.
- Grading. A lab operation before printing to select printer lights and color filters to improve the densities and

color rendition of the original footage and thus obtain a visually more satisfactory print. The technician in charge is called a timer or grader.

- **Graduated Filter.** A filter with neutral density or color covering only a certain portion of the glass. There is a graduated transition (a bleed line), between the dense and the clear part of the filter.
- **Grain.** Fine silver particles embedded in the gelatin of a film emulsion exposed to light and developed.
- Graininess. Impression of nonuniformity in the photographic image caused by silver particles (grains) suspended in random fashion in many layers. The depth of these layers depends on the density of the image.
- **Green Print.** A print that, because of improper lab handling during hardening or drying, does not go smoothly through the projector gate.

Gray Scale. Chart representing a series of gray fields from white to black in definite steps.

- **Grip.** A member of a film crew responsible for laying camera tracks, setting flags, etc.
- Ground Glass. A finely ground glass on which an image is formed in the camera viewfinder system.
- **Guide Track.** A sound track recorded synchronously with the picture in acoustically poor conditions to be used as a guide during the post-synchronizing session.

H&D Curve. See D log E curve.

- Halation. Also called "ghost image." A halolike, blurred flare surrounding the outlines of bright objects caused by light reflected from the film base. Almost eliminated in modern emulsions.
- Halogen. Elements such as iodine, chlorine, bromine, fluorine, and astatine are classified as halogens. They are used in manufacturing tungsten halogen lamps, such as quartz-iodine bulbs.
- Head, Camera. Also called "tripod head." A device for mounting the camera on a tripod or other supports. It allows for vertical and horizontal camera movements, called

tilting and panning respectively. See also friction head, gear head, fluid head.

- Hertz (Hz). Unit of frequency. One Hertz equals one cycle per second. 1,000 Hz equals 1 KHz (kiloHertz).
- High-Key. A lighting style in which the majority of the scene is in highlights. Usually enhanced by bright costumes and sets. Low ratio of key plus fill light to fill light lowers the contrast, helping to obtain this effect.
- High-Hat. Low camera support of fixed height.
- **Highlights.** The brightest parts of a photographed subject, represented as the heaviest densities on the negative and as the most transparent on the positive.
- HMI. See Hydrargyrum Medium Arc-length Iodide.
- **Horse.** A simple cutting-room device for dispensing film. Often used for supplying the leader.
- **Hot Spot.** A very bright area in the scene, caused by excessive light or a strong reflection.
- Hue. A scientific term for color.
- Hyperfocal Distance. Distance at which a lens must be focused to give the greatest depth of field. Then all objects from infinity down to half the hyperfocal distance will be in acceptable focus.
- Hydrargyrum Medium Arc-length Iodide (HMI). A metal halide discharge lamp constituting, in effect, a mercury arc enclosed in a glass envelope. Gives off color temperature equivalent to daylight.
- Incandescent Light. Electric light produced by the glowing of a metallic filament such as tungsten. Modern quartz-type lamps, better called tungsten-halogen lamps, are incandescent.
- Incident Light. Light coming directly from the source toward the object and the light meter, as opposed to light reflected from the photographed subject toward the light meter. See also **exposure meter**.
- **Infrared.** A range of wavelengths slightly longer than those in the visible spectrum.

- **Inky-Dink.** The smallest focusable studio lamp, with Fresnel lens and a bulb up to 200 watts.
- **Insert.** A shot inserted to explain the action, e.g., a close-up of a letter, newspaper headline, calendar, gun, etc.
- Interlock System. Electrical or mechanical system in which two mechanisms will start, stop, and run in synchronization. Used for cameras, sound systems, and projectors.
- Intermittent Movement. The stopand-go movement of the film-transport mechanism in the projector or camera, making it possible for each individual frame to be stationary during the moment of exposure or projection.
- **Intermittent Pressure.** Pressure applied on film in the camera gate during the periods of rest in the intermittent-movement cycle.
- Interpositive (Master Positive) and Internegative (Duplicating Negative). The intermediary generations of printing films employed to generate required numbers of release prints. This way, the precious original negative is protected from damage that may result from multiple printings. Internegative is also used as a negative printed from a color reversal film.

Iris. See diaphragm.

- Jam, Camera. Also called "salad." A camera trouble when film piles up inside the camera body, sometimes caught up between the sprocket wheels and the guide rollers.
- Junior (2K). A studio lamp, focusable, with Fresnel lens and 2,000-watt bulb. Perhaps the most used studio lighting instrument.
- Kelvin Scale. A temperature scale used in expressing the color temperature. Kelvin degrees have the same intervals as the Centigrade scale, but $0^{\circ} K = -273^{\circ} C.$
- **Key Light.** The main source used to light the subject. Its direction and amount relative to fill light establishes the mood of the illumination.

Key Numbers. See edge numbers.

- **Kinescope Recording.** Process of recording on a motion-picture film pictures that originated in a television camera.
- Lamp. A term basically used for the light bulbs of various designs, but also employed to describe the lighting instrument as a whole.
- Lap Dissolve. See dissolve.
- Latent Image. An invisible image formed in the photographic emulsion when it is exposed to light. Latent image becomes visible after the development.
- Latitude, Exposure. An emulsion's ability to accommodate a certain range of exposures and produce satisfactory pictures.
- Leader. Uniformly black, white, colored, or transparent film used in editing processes, such as preparing sound tracks or A-B rolls, or for head and tail protection of film rolls. See also SMPTE universal leader.
- Lekolite. An ellipsoidal spotlight with pattern-forming capability manufactured by Century Strand, Inc. Very popular in theater lighting but also used in film and TV as effect light.
- Lighting Instruments. The proper term in the film industry for lighting sources (luminaries) of different designs. Sometimes they are popularly called "lamps," but strictly speaking, a lamp is just the electric bulb in the lighting instrument.
- Logging, Film. Entering in a logbook all the printed shots itemized by scene and take number, length in feet and frames, and edge numbers. A description of the action is also included.
- Long Pitch. Specific distance between film perforations designed for original camera stocks, which could also be used in projection (such as some reversal stocks), and for films used in high-speed cameras.
- Loop, Film. Slack loop formed before and after the gate in cameras and projectors to accommodate the transition from continuous to intermittent movement.
- Low-Key. Lighting style in which the majority of a scene is scarcely lit. Usually enhanced by dark costumes

and sets. High ratio of key light to key plus fill light is employed for this effect.

- LS (Long Shot). Full figure filling the frame.
- **Lumen.** The light emitted by a source of power of one candela which falls on one square unit of surface at one unit of distance from the source.
- Lux. An international unit of light intensity. One lux equals an illumination of a surface, all points of which are 1 meter distant from a point source of 1 candela. One foot-candle = 10.764 lux.
- Macrocinematography. Filming of small objects, often requiring lens extension with bellows or extension rings, but not so small as to necessitate filming through a microscope.
- Magnetic Film. Magnetic recording materials in one of the standard film gauges, with sprocket holes on one side in 16mm or on both sides for 35mm and wider gauges.
- Magnetic Head. Electromagnet containing a coil or coils of wire wound over an iron ring broken to create an air gap. Used to record electromagnetic variations on recording materials.
- Magnetic Master. A final edited or rerecorded magnetic track used for transfer to magnetic or optical release prints or to produce another master.
- Magnetic Tape. Thin plastic base, like PVC or polyester, coated with magnetic iron oxide dispersed in a binder.
- Magnetic Recording. Recording sound or picture by introducing magnetic changes in a ferromagnetic medium, such as the coating on magnetic tapes and films.
- Married Print. See composite print.
- Master Positive. See picture master positive.
- Mask. Opaque shape, often in contact with film, preventing the exposure of certain parts of the frame. Can either be in the form of a film strip traveling in contact with the film stock to be exposed, or as a plate in a camera, projector, or printer aperture to regulate the size and shape of the picture frame. Sometimes means a light-ob-

structing device of desired shape in front of the lens.

Matte. See mask.

- Matte Box. A combination of filter and/or matte holder and sun shade mounted in front of the camera lens.
- Microcinematography. Cinematography through the microscope.
- **Mixing.** Creatively combining the sound signals coming from several microphones, or several tapes, and recording them onto a single track.
- Molefays. Lighting instruments manufactured by Mole-Richardson Co. in the range from one-bulb to twelvebulb clusters, employing usually the FAY type (650-watt) bulbs. Used for an even illumination of large areas, often to provide a fill light in outdoor filming. FAY bulb has a color temperature of 5,000° K. but can be replaced by bulbs of other color temperatures.
- Molepars. Lighting instruments manufactured by Mole-Richardson Co. in the range from one-bulb to ninebulb clusters, employing the 1,000watt PAR lamps.
- MOS. Filming without sound (silent). A humorous coinage from the early days of cinema, when immigrant German technicians spoke of shooting "mit out sound."
- Moviola. A trade name of an editing machine that allows viewing picture film or films synchronously, with one or more sound films. Often used as a generic term in referring to editing machines in general.
- **MS (Medium Shot).** Frame composition in which a three-quarter-length figure fills the screen.

Negative Numbers. See edge numbers.

- NG. "No good." notation for picture and sound takes that will not be used in the final edited film.
- **Negative Image.** A photographic picture with reversed brightnesses of the photographed scene. What was bright in the scene is dark (dense) in negative and vice versa.
- Neutral Density (ND) Filters. Colorless filters in range of densities, used to cut down the amount of light entering the lens. Employed on the camera or on the windows. ND fil-

ters do not affect the color rendition of the lens. Used when the light is too intense for a given film, or a required f-stop.

- Newton Rings. Ring patterns on film print caused by optical interference when light passes through two film surfaces slightly separated by the imperfect contact in a contact printer.
- Nitrate Base. Film base made of cellulose nitrate, highly inflammable and self-igniting under certain conditions. Used up to 1951, when it was superseded by the tri-acetate safety base.
- **Noise.** An unwanted sound or signal generated in the sound or video system or transferred by these systems from other sources, such as the power supply.
- **Opacity.** A ratio of the light incident upon the measured portion of film frame to the light transmitted. The logarithm of the opacity equals the density.
- **Optical Effects.** Special effects such as fades, dissolves, superimpositions, freeze-frames, split screens, wipes, etc., usually created at the printing stage.
- Optical Negative Track. See sound release negative.
- **Optical Sound Recording.** Process of converting electrical sound signals into light-beam intensity or width, in order to record these signals on lightsensitive emulsion, creating in this fashion an optical sound track of variable density or variable area, respectively. Today used mainly in the preparation of release prints.
- **Original (Negative or Reversal).** Film stock that was exposed and processed to produce either a negative or a reversal picture.
- **Orthochromatic Film.** Black-andwhite film emulsion sensitive only to blue and green.
- **Out-Takes (Out).** Shots or takes that will not be used in the final version of the film.
- **Overload.** An amplitude distortion in sound recording when the system receives a signal of higher amplitude than it can carry.

- **Panchromatic Film.** Black-and-white film with an emulsion sensitive to all colors of the visible spectrum.
- Pan, Panning. Camera pivotal movement in a horizontal plane. Sometimes used when describing pivotal camera movements in other planes.
- **Parallax.** A displacement of an image as seen by the independent viewfinder in relation to the image as seen through the lens. Especially evident in close-ups. Independent viewfinders are usually adjustable to match the view area of the lens but not the lens's perspective.
- **Parallel.** A wheeled scaffolding with raised platform to accommodate the camera crew for high-angle shots, or the lamps and electricians.
- **Perforations, Film.** Accurately spaced holes along one or both edges of the film, used to position and move the film through various mechanisms, such as cameras, printers, and projectors.
- **Persistence of Vision.** The phenomenon of the eye retaining for a short period of time the image just seen. Therefore a stream of images of short duration (such as projected frames of film) are seen as a continuous picture without flicker.
- **Photoflood.** Type of light bulb in which voltage overcharges the filament, boosting the light output and color temperature, but shortening the life of the bulb itself.
- **Picture Duplicate Negative (Dupe).** Negative printed from a master positive, or a reversal printed straight from the picture negative.
- Picture Master Positive. Special print made as an intermediate step in producing a picture duplicate negative.
- Picture Print. Film print bearing positive images.
- Picture Release Negative. Edited picture negative from which the picture part of release prints will be printed. Pilot Pin. See registration pin.
- **Pilot Print.** A color test strip provided by the lab with the black-and-white rushes printed for economy reasons from a color original. A pilot print gives the cameraman an indication of how his shots will look when printed

in color through various filter combinations.

- **Pitch.** The distance between the leading edge of one perforation and the leading edge of the next along the length of the film.
- Plate, or Process Plate. Background materials (still or motion picture) shot to be used in back or front projection.
- Playback. Instant playback of recorded materials to check the quality of recording. Playback also means a reproduction of previously recorded music, vocals, etc., when filming the performers in acoustically adverse conditions. In this technique the sound is recorded (prescored) in the sound studio and the picture is filmed on a visually desirable location while playing back the previously recorded sound.
- **Polarity.** Correct polarity in connecting the batteries or other power sources means that the plus terminal on the power source is connected to the plus terminal on the equipment, and the minus terminals are connected accordingly. Plus is usually marked red.
- **Polecats.** Extensible metal tubes to erect a lamp support in the form of a pipe wedged between the walls, or floor and ceiling, of a room, or used in conjunction with other tubes to form a more elaborate scaffolding for holding lamps. Pole Kings manufactured by Berkey Colortran, Inc. are a good example of this equipment.
- **Post-Flashing, Post-Fogging.** A method of reducing contrast of some scenes by additional exposure of the already exposed but not developed film, by a weak and even light. This procedure causes a slight overall fogging, which affects the shadows more than the highlights of the picture, hence reducing the contrast.
- Post-Synchronization. See dialog replacement.
- **Practical.** A lamp or other prop on the set that is rigged to be operational during the scene action.
- **Prescoring.** Recording of sound track to accompany the action, which is shot to the playback of this sound track. Used often when filming sing-

ers or musicians performing in acoustically inferior locations.

- **Pressure Plate.** A part of film gate in the camera, optical printer, or projector that presses the film, keeping it flat against the aperture plate during the exposure.
- **Primary Colors.** Blue, green, and red. By mixing these three colors of light, all other hues can be obtained.
- Print, Picture. See picture print.
- Print, Reversal. See reversal print.
- Printer. Machine for printing from one strip of film (exposed and processed) to another strip of film (raw stock), by moving both these films in front of an aperture with regulated illumination. There are continuous and step printers, depending on the mode in which the film moves. Another division, mainly among step printers, distinguishes the contact printer, in which two strips of film touch each other emulsion to emulsion, and the optical printer, in which the picture is exposed on the raw stock via an optical system. This allows for picture modifications such as change in frame size and shape, zoom effect, freeze-frame, flip-over, wipe, rotation, etc.
- Printer Light Scale. A scale of variations in printing light intensity, allowing one to print the original images brighter or darker, to obtain an evenly exposed print from an original with uneven exposures. The light scale is also used when executing optical effects such as fades and dissolves.
- **Print-Through.** A condition where the signals recorded on tightly wound magnetic tape affect the coating of adjacent layers, causing an echo effect when the tape is played. High recording levels and high temperature in storage will augment the print-through effect.
- **Processing.** All the chemical and physical operations necessary to convert a latent image into a satisfactory picture on film.
- **Process Projection.** A technique of filming live action staged in front of the screen on which the background view is projected. This background plate can be projected either from be-

hind the translucent screen (back projection), or from the front on a highly reflective screen (front projection).

- **Process Shot.** A shot of live action in front of a process projection.
- **Projection Synchronism (Projection Sync).** A twenty-six-frame displacement between the optical sound track and the 16mm picture on the composite print, to accommodate the distance between a film gate and an exciter lamp on the 16mm projectors.
- **Props.** Short for "properties," i.e., movable objects used on the set in the filmed scenes.
- **Protection Print (Protective Master).** A master positive print made from the assembled original (A-B rolls) and kept as a protection in case the original is damaged or lost.
- **Pull-Down.** The action of moving the film one frame at a time for exposure or projection by the intermittent mechanism of the camera, printer, or projector. See also **intermittent movement.**
- Pup Light. See baby light.
- **PVC Base.** Tape or film base made of polyvinyl chloride.
- Quartz Lights. Popular name for tungsten-halogen lamps. Tungsten filament and halogen gas are sealed in an envelope made of quartz or other materials that permit bulb temperature up to 600° C. The particles evaporating from the filament combine with the halogen gas and are redeposited back on the filament. This recycling process prevents the darkening of the bulb so that the color temperature stays fairly constant during the lamp's life.
- **Radio Microphone.** A microphone with a miniature transmitter and a piece of wire as an aerial. The receiving station can amplify the signal and transmit it to a recorder located even farther away.
- **Raw Stock.** A film that has not yet been exposed and/or processed.

Rectifier. An instrument to convert alternating current into direct current.

- **Reduction Printing.** Optical printing of a film onto a raw stock of a smaller gauge.
- **Reflector.** A board with a light-reflecting surface, hard or soft depending on the texture of the surface, used mainly for redirecting the sunlight to fill light into the shadows in the scene.
- **Registration.** The positioning of film in the aperture gate of a camera, printer, or projector in precisely the same place for each consecutive frame.
- **Registration Pin.** A part of the intermittent mechanism in more elaborate cameras. It secures the steadiness of the film by engaging the perforation during the period of exposure.
- Release Negative. See picture release negative.
- Release Print. A composite print made in projection synchronism for general distribution, after an approval of the final trial composite print.
- **Rerecording.** Transferring several sound tracks, e.g., dialog, music, and effects, onto a single track, creatively mixing sounds by controlling levels and other characteristics.
- **Reticulation.** A phenomenon of emulsion cracking in a leather-grain pattern, caused by too high a temperature in processing.
- Reversal Print. A print made on a reversal material.
- **Reversal Master Print.** Sixteen-millimeter reversal print used to make other prints.
- **Retrofocal Lens (Inverted Telephoto Lens).** A lens of a special optical design that allows a longer physical distance between the rear end of the lens and the film plane. Convenient in the design of lenses with extremely short focal length; the retrofocal design increases physical size and facilitates mounting and operating.
- **Rewinds.** Geared devices for rewinding film. Manual rewinds are usually used in editing rooms, and electric ones in projection rooms and libraries.
- **Rigging.** Positioning lamps in the studio according to the preliminary lighting plot.

Riser. A low platform to raise an actor, camera, or furniture a few inches off the ground.

Rough Cut. Roughly edited film at the work-print stage with finer changes to be made before the fine cut.

Rushes. See dailies.

Safety Base. See acetate base. Salad. See jam.

Sample Print. See final trial composite print.

- Saturation. The criterion of the purity of a color. It indicates the distinctness and vividness of hue. Color is most saturated when it appears the strongest and most brilliant, least saturated when a color is approaching a neutral gray.
- Scoop. A studio lamp of a soft, wide, round pattern; 500 to 2,000 watts.
- Scratch Print (Slash Print). A print made from an assembled original (A-B rolls), but without the printerlight corrections. Used for music or narration recording and similar applications where the visual quality is of little importance.
- Scratch Track. See guide track.
- Scribe. Sharp, pointed instrument to scratch the emulsion when marking film edges in preparation for conforming original footage for splicing.
- Scrim. Lighting accessory made of wire mesh, silk, spun glass, or plastic translucent materials, positioned in front of a light source when attenuation or diffusion of light is required.
- Script. A written screenplay that undergoes several phases from an outline and rough treatment to the final shooting script where all the scenes are described in detail.
- Secondary Colors. See complementary colors.
- Senior (5K). Focusable studio lamp with a Fresnel lens and 5,000-watt bulb.
- Sensitometer. An instrument in which a strip of film is exposed to a series of light intensities in logarithmic steps, which will produce corresponding densities when the film strip is developed.
- Sensitometry. The science of measuring a film emulsion's sensitivity to

light and of evaluating the development.

- Sensitometric Strip. Film strip exposed to a series of logarithmically growing light intensities in a sensitometer, developed and measured for densities to establish a proper developing time for the given emulsion.
- Shooting Script. See script.
- **Shot.** A homogeneous element of the film structure between two cuts or two optical transitions.
- **Shutter.** A mechanism for covering the aperture of a camera during the period in which the film is moved between exposures.
- Silver Halide. Light-sensitive silver compound such as silver bromide, silver chloride, silver fluoride, or silver iodide, used in photographic emulsions.
- Single-System Sound Recording. A technique of recording synchronous sound simultaneously with the picture on the magnetic track adhering to the edge of a picture film.
- Sky Light (Sky Pan). A nonfocusable studio lamp with a 5000-watt to 10,000-watt bulb providing illumination over a broad area, such as set backdrops.
- Slate Board. A board with written information such as production title and number, scene and take number, and director's and cameraman's names, photographed at the beginning or end of each take as identification. See also clapper board and slate, electronic.
- Slate, Electronic. An electrical device synchronously exposing a few frames in the camera and providing an electric signal that is recorded on the magnetic tape, so that the two can later be matched in editing.

Slip Focus. See differential focus.

- SMPTE. Society of Motion Picture and Television Engineers.
- SMPTE Universal Leader (Society Leader). Film leader introduced in 1965 with numbers from eight to two, each printed over twenty-four frames, i.e., one second at standard projection speed. A rotating line covers a full circle in each second.
- Snoot. A funnel-shaped light-controlling device used on lamps in place of

barndoors for more exact light-beam pattern.

Sound Boom. See boom.

Sound Displacement. See projection sync.

- Sound Master Positive. Special sound print made from a sound release negative in order to produce sound duplicate negatives used for making release prints.
- Sound Print. A positive print with sound only, made from (1) a sound negative; (2) sound positive through reversal process; (3) direct from magnetic tape, as positive recording.
- Sound Release Negative. An optical sound negative from which final sound printing onto the release print will be made.
- **Sound Speed.** Standardized speed of filming and projecting at 24 frames per second, when picture is synchronized with a sound track. Applies to films of all gauges.
- Sound Track. An optical or magnetic band carrying the sound record alongside the picture frames on a motion-picture film. Also any magnetic or optical sound film at the stage of editing and mixing.
- Spectrum, Visible. A narrow band of electromagnetic waves from approximately 400 to about 700 millimicrons, which produce in the human brain a sensation of light.
- **Speed.** 1. Camera speed is the rate of film advancement, expressed in frames per second (fps). 2 Lens speed is the full amount of light a lens is capable of transmitting, expressed as a lowest f-stop (purely geometrical computation), or as a lowest T-stop (real-light transmission as measured individually for the given lens). 3. Emulsion speed is the emulsion sensitivity to light, expressed as an index of exposure.
- Splicer. A machine for joining pieces of film together. Depending on the method used, there are tape splicers and cement splicers. Cement splicers can be cold or hot (heated for faster splices), negative or positive (making narrower or wider splices respectively), and hand- or foot-operated, the latter being much faster in operation.

- Splicing. Technique of joining separate film pieces into a continuous film strip. At the work-print stage, transparent tape splices are the most common, as the tape can easily be removed for changes in editing. Originals or damaged release prints are joined with a cement splice, which welds together the two pieces of film in a more permanent way. A negative splice, used for joining original footage, is narrow and therefore less visible, and the positive splice, used to repair broken prints, is wider.
- Split Reel. A reel with a removable side, so that the film on a core can be placed in or removed from the reel without rewinding.
- Spotlamp. A general name for many studio lamps of similar design but different in size, such as the baby, junior, and senior. Equipped with Fresnel lens and focusable from spot to flood beam pattern.
- Static Marks. Unwanted exposures in the form of random lines caused by discharges of static electricity. They occur when unexposed film stock is rewound, especially at an uneven speed, or when the rewinds are not grounded. They may also happen in the camera through too much friction, particularly in low temperatures and low humidity.
- Step Printer. See printer.
- Still. A static photograph as opposed to the motion picture.
- Stock Footage. Film-library footage of famous or typical places and situations, historical events, and the like, which can be used more than once in different film productions.
- Story Board. A series of drawings as visual representation of the shooting script. Sketches represent the key situations (shots) in the scripted scenes. Dialog or indication of music, effects, etc., appear below the pictures.
- Superimposition (Super). Two scenes exposed on the same piece of raw film stock, one on top of the other. Superimposition is usually done in the printer but can be performed in the camera, although this offers less control of the operation.

- Swish Pan. A very fast panoramic movement of the camera, resulting in a blurred image. Used sometimes as a transition between sequences or scenes.
- Sync Motor. (Synchronous Motor) Constant-speed motor for camera or projector that can be electrically or mechanically synchronized, i.e., run at the same speed along with the sound-recording and/or sound-reproducing machines.
- Sync Pop. One-frame sound signal placed near the heads of the edited sound tracks to confirm proper synchronization during mixing operation.
- Sync Tone Oscillator. Small oscillator in the camera producing electrical signals that indicate exactly the speed of the camera motor. These signals are transmitted to the sound recorder and recorded on magnetic tape as a guide enabling precise synchronization of sound and picture at the later stage. Sync pulses are inaudible on normal playback and do not interfere with the sound recording on tape.
- Synchronism. Coordination of picture and sound. See editorial synchronism, projection synchronism.
- Synchronous Speed. Camera speed of exactly 24 frames per second synchronized with the sound recording.
- **T-Stop.** Calibration of the lens lighttransmitting power arrived at by an actual measurement of the transmitted light for each lens and each stop individually. T-stops are considered more accurate than f-stops (f-numbers).
- Tachometer. A meter indicating the camera speed in frames per second.
- Take. A scene or part of a scene recorded on film and/or sound tape from each start to each stop of a camera and/or recorder. Each shot may be repeated in several takes, until a satisfactory result is achieved.
- Target. A black or translucent disk up to ten inches in diameter that is used to control the lamp beam and create desirable shadows. A type of flag. Telecine. See film chain.

- Tenner (10 K). A studio focusable lamp with Fresnel lens and 10,000-watt bulb.
- Test Strip. Several feet of film left at the beginning or end of the roll for lab tests before the rest of the roll is developed. Test strip can be of unexposed footage to be used as a sensitometric strip, or of footage of a gray scale exposed in the same manner as the rest of the roll to be tested for the optimal development time necessary to obtain the most pleasing picture. This second method may be used when the cameraman has some doubts about the correctness of his exposure calculations.
- Threading. Also called "lacing." Placing film in a proper way for correct passage through all the film transport mechanisms of camera, printer, projector, or other film-handling machine.
- Tilt, Tilting. Camera pivotal movement in a vertical plane. Sometimes called vertical panning.
- Time Code. A system of synchronizing picture and sound by way of generators installed in cameras and recorders that provide time signals registering on film and sound track as year, month, day, hour, minute, and second.

Timing. See grading.

Timing Card. Listing of printer lights to be used for printing from the given original. This card is then kept for future reference.

Tracking. See Dolly.

- Transfer, Sound. Process of duplicating sound recording, e.g., from quarter-inch magnetic tape to 16mm magnetic film for editing, or from 16mm or 35mm magnetic master to 16mm optical track in the preparation of a composite print.
- **Treatment.** A literary presentation of an idea for a future film before a proper script is developed.
- Trial Composite Print. See first trial composite print.
- **Triangle.** A triangular device made of metal or wood and used as a tripod base to prevent the tripod legs from slipping.
- Trim Bin. See bin.

- Trims. Leftover pieces of film from the shots that were incorporated into the work print and the final composite print. These unused trims are filed in case the editor changes his mind.
- **Trombone.** A tubular device for hanging small studio lamps from the top of set walls.
- **Tungsten Light.** Light generated by an incandescent lamp with a tungsten filament.
- **Turret, Lens.** A revolving lens mount for two to four lenses, enabling the cameraman to make a fast choice of lens for the next shot.
- Ultraviolet. A range of wavelengths shorter than those in the visible spectrum but detected by film emulsions. An ultraviolet (UV) filter is used to stop this radiation.
- Universal Leader. See SMPTE universal leader.
- Variable-Area Track. An optical sound track on which the electrical signals are recorded as the varying width of a constant-density image.
- Variable-Density Track. An optical sound track on which the electrical signals are recorded as the varying density of the image.
- Variable-Focus Lens. See zoom lens. Variable-Speed Motor. See wild motor.
- Vignetting. Blurring of the photographic image on the sides of the frame, caused by close-range objects obscuring the view. Unintentional vignetting is sometimes caused by a sun shade extended too far in front of the lens or a badly positioned flag to protect the lens from flare. In some camera designs a long lens mounted in an adjacent turret socket can cause vignetting.
- **VO** (Voice-Over). Indication in the script that the shot, scene, etc., will be accompanied by a voice not visibly originating in the picture. Voice-over can be in the form of narration, inner monologue, "voice from the past," etc.
- VU Meter. Volume-unit meter, indicating the recording level on sound recording equipment.

- Walk-Through. First rehearsal on the set, for camera positions, lighting, sound, etc., when the director describes the scene in detail to the crew and the actors. Sometimes stand-ins are used instead of actors for this operation.
- Waxing. Applying wax to the edges of film to improve the film passage through the projector and prevent the piling up of emulsion, which is likely if the film has been incorrectly dried during processing.
- Weave. Undesirable sideward movement of film in the camera or projector.
- Wild Motor. Camera motor that does not run at an exact synchronous speed. Usually adjustable for different speeds.
- Wild Recording. Sound recording not synchronized with the picture. This recording results in a wild track.
- Wind. Film wind refers to the emulsion position on the roll of a single sprocket film. See A-wind, B-wind.
- **Work Print.** A print built up from dailies. It undergoes editorial improvements from the assembly stage through rough cut to a fine cut. Finally it is used to guide the negative cutter when conforming the original.
- Wow and Flutter. Sound distortions in recording or playback caused by speed variations in the tape movement.
- XLS (Extreme Long Shot). Distant landscape or vast interior shot in which the human figures appear relatively small.
- Zoom, Zooming. The magnification of a certain area of the frame by bringing it optically to the full screen size and excluding the rest of the frame in the process.
- Zoom Lens. A lens with a continuously variable focal length over a certain range allowing the change of subject magnification during the shot. On many modern cameras zoom lenses substitute for the standard complement of primary lenses.

BIBLIOGRAPHY

.......

...............................

General Books on Film Techniques and Production

.................

- Arijon, Daniel. Grammar of the Film Language. Boston: Focal Press, 1976.
- Baddely, W. Hugh. The Technique of Documentary Film Production, 4th ed. Boston: Focal Press, 1981. The Focal Encyclopedia of Film and Television Production Techniques. Boston: Focal Press, 1981.
- Happe, L. Bernard. Basic Motion Picture Technology. New York: Hastings House, 1978.
- Lipton, Lenny. Independent Filmmaking. Rev. ed. New York: Simon & Schuster, 1983.
- Pincus, Edward, and Ascher, Steven. *The Filmmaker's* Handbook. New York: New American Library, 1984.
- Roberts, Kenneth H., and Sharples, Win, Jr. A Primer for Film-Making: A Complete Guide to 16mm and 35mm Film Production. New York: Pegasus, 1971.

Camera and Lighting Techniques

- Almendros, Nestor. A Man with a Camera. New York: Farrar Straus Giroux, 1986.
- Campbell, Russell. Photographic Theory for the Motion Picture Cameraman. New York: A.S. Barnes, 1974.
- Campbell, Russell. Practical Motion Picture Photography. New York: A.S. Barnes, 1970.
- Carlson, Verne and Sylvia. Professional Cameraman's Handbook. Boston: Focal Press, 1986.
- Carlson, Verne and Sylvia. Professional Lighting Handbook. Boston: Focal Press, 1985.
- Detmers, Fred H., ed. *American Cinematographer Manual.* 6th ed. Hollywood Calif.: American Society of Cinematographers, 1986.

Eastman Kodak Company. *Eastman Professional Motion Picture Films.* 3d ed. Rochester, N.Y.: Eastman Kodak Company, 1982.

- Fielding, Raymond. The Technique of Special Effects Cinematography. 4th ed. Boston: Focal Press, 1985.
- GTE Products Corporation. Lighting Handbook for Television, Theatre, and Professional Photography. 7th ed. Danvers, Mass.: GTE Products Corporation, Sylvania Lighting Center, 1984.
- Malkiewicz, Kris, J. Film Lighting: Talks with Hollywood's Cinematographers and Gaffers. New York: Prentice-Hall Press, 1986.
- Millerson, Gerald. The Technique of Lighting for Television and Motion Pictures. Boston: Focal Press, 1982.
- Rainsberger, Todd. James Wong Howe: Cinematographer. San Diego, Calif.: A.S. Barnes & Company, Inc., 1981.
- Ray, Sidney F. The Lens in Action. Boston: Focal Press, 1976.
- Ritsko, Alan J. Lighting for Location Motion Pictures. New York: Van Nostrand Reinhold Company, 1979.
- Samuelson, David W. Motion Picture Camera Techniques. Boston: Focal Press, 1984.
- Ray, Sidney F. Motion Picture Camera and Lighting Equipment. Boston: Focal Press, 1986.
- Ray, Sidney F. Motion Picture Camera Data. Boston: Focal Press, 1979.
- Schaefer, Dennis, and Salvato, Larry. Masters of Light: Conversations with Contemporary Cinematographers. Berkeley, Calif.: University of California Press, 1984.
- Wilkie, Bernard. Creating Special Effects for TV and Film. Boston: Focal Press, 1977.
- Wilson, Anton. Cinema Workshop. Rev. ed. Hollywood, Calif.: ASC Holding Corp., 1983.

Post-Production Techniques

- ACVL Handbook, 4th ed. Association of Cinema and Video Laboratory Services, P.O. Box 20817, Bethesda, Md.
- Burder, John. The Technique of Editing 16mm Films. 4th ed. Boston: Focal Press, 1981.
- Case, Dominic. *The Motion Picture Film Processing*. Boston: Focal Press, 1985.
- Churchill, Hugh B. Film Editing Handbook: Technique of 16mm Film Cutting. Belmont, Calif.: Wadsworth Publishing Company, Inc., 1972.
- Happe, L. Bernard. Your Film and the Lab. 2nd ed. Boston: Focal Press, 1983.
- Hollyn, Norman. The Film Editing Room Handbook. New York: Arco Pub., 1984.
- Reisz, Karel, and Millar, Gavin. The Technique of Film Editing. 2nd ed. Boston: Focal Press, 1982.
- Walter, Ernst. The Technique of the Film Cutting Room. 2nd ed. Boston: Focal Press. 1982

Sound Techniques

- Alkin, E.G.M. Sound Recording and Reproduction. Boston: Focal Press, 1987.
- Alten, Stanley R. Audio in Media. Belmont, Calif.: Wadsworth Publishing Company, 1986.
- Clifford, Martin. *Microphones.* 3rd ed. Blue Ridge Summit, Penna. Tab Books, 1986.

- Eargle, John. *The Microphone Handbook*. Plainview, N.Y.: Elar Publishing Co., 1982.
- Frater, Charles, B. Sound Recording for Motion Pictures. New York: A.S. Barnes. 1979
- Manvell, Roger, and Huntley, John. Revised and enlarged by Richard Arnell and Peter Day. *The Technique of Film Music.* Boston: Focal Press, 1975.
- Nisbett, Alex. The Technique of the Sound Studio: For Radio, Recording Studio, Television, and Film. 4th ed. Boston: Focal Press, 1987.
- The Use of Microphones. 2nd ed. Boston: Focal Press, 1984.

Production Planning and Budgeting

- Chamness, Danford. The Hollywood Guide to Film Budgeting and Script Breakdown. Rev. ed. Los Angeles: S.J. Brooks Co., 1986.
- Garvy, Helen. Before You Shoot: A Guide to Low Budget Film Production. Santa Cruz, Calif.: Shire, 1985.
- Hurst, Walter E. Copyright: How to Register Your Copyright & Introduction to New and Historical Copyright Law. Hollywood, Calif.: Seven Arts Press, 1977.
- Squire, Jason E., ed. The Movie Business Book. New York: Simon & Schuster, 1986.
- Wiese, Michael. Film and Video Budgets. Westport, Conn.: Michael Wiese Film Productions, 1984.

time code and, 133 **XTR. 46** Aaton Adage 4 printers, 133 A-B rolls cutting into, 154, 158 submitting, to lab, 164 Acoustics, microphone placement and, 139-40 Aerial image, optical printers and, 178, 180 American Cinematographer Manual, 12, 15, 48, 61, 65 American National Standards Institute, 55 American Standards Association, 55 Angenieux zoom lenses, 14, 15 Animation stands, 172 Answer (first trial) prints, 164-66 Anton-Bauer Lifesaver[™] Fast Chargers, 8 Quick Chargers, 8 Arc lights, 89-90 Arriflex cameras, 39, 184 S. 20 16 HSR, 46 16 S/B, 46 16 SR2, 46 viewing system of, 5 Arriflex lenses, 22-23 Arriflex lens mounts, 22-23 ASA values, 55-56 Assembly of footage, 150 of A-B rolls, 158-60, 164

Aaton cameras

Backdrop lights, 83 Back lights, 82 Batteries, 8 Beaulieu R16B cameras, 46 Bell & Howell 70 series cameras, 39, 46 Black-and-white film choosing, 58-60 using filters with, 65-66 Bolex cameras, 184 H-16, 46 H-16 EMB, 46 Reflex, 5, 39 Rex. 20 Rex-5. 5 self-threading mechanism of, 2 viewing system of, 5 Bolex 160 Macro-zoom zoom lenses, 15 Butch Cassidy and the Sundance Kid, 129 Cabinet of Dr. Caligari, The, 117 Cameras

batteries for, 8 care and operation of, 48 choosing, 39, 46 ditty bag for, 48–49 dollies for, 26–27 film gate of, 1–2 front projection and, 38–39 hand-held work with, 33, 36 intermittent movement of, 1–2

magazine of, 8-9 motor of, 5, 8 problems with, 47 reverse action of, 37-38 shutter of, 2, 4 speeds of, 2, 37 supports for, 23-24, 26-27, 30, 32 testing of, 48 tripods for, 23-24, 26, 30, 32 underwater, 184 viewing system of, 5 See also Lenses; individual camera models Canon cameras Scoopic, 2 Scoopic MS, 46 self-threading mechanism of, 2 Canon Macro Zoom Lens Fluorite zoom lenses, 15 Checkerboard technique, 154 Circles of confusion, 11 Clapper boards (slates), 133 Close-up work, lenses and, 15 Color and contrast picture quality control, 128-29 Color film choosing, 58-60 using filters with, 66-68 Color temperature meters, 68 Colortran dollies, 27 Colortran lights Maxi-Brutes, 95 Mini-Brutes, 95 Compact lights, 96-97 Condenser microphones, 133, 135 Conforming, 154 Contact printing, generations and, 166 Contrast and color picture quality control, 128-29 Contrast manipulation, optical printers and, 175 Contrast-viewing glasses, 86 Copyrights, 186, 190 CP-16R cameras, 46 Crew members, 186-87 Cross-dissolves, 153 Crystal sync, 132 Cutting. See Editing Dailies (rushes), 146, 148 Daylight, 68-69 daylight versus tungsten exposure index, 56 picture quality control and, 130-31

in vehicle cinematography, 181-82

Depth, lighting and, 116–17

Depth of field, 11-12

Dietrich, Marlene, 117

Diffusion filters, 73-74 Diopters, 15 Directional microphones, 135-36 Disney animation films, 117 Dissolves basic description of, 153 cross-, 153 labeling of, 160 lap-, 153 Ditty bag, contents of, 48-49 Dollies, 26-27 Dupes, 166 DuPont Freon TF solvent, 137 Duro-Test Corporation fluorescent tubes Optima 32, 69 Vita-Lite, 69 Dynalens gyro-stabilized lens system, 27 Dynamic microphones, 133, 135 Eastman Kodak Company Kodak film, 60-61, 87, 170, 172, 175, 191 Kodak Wratten filters, 62, 67 ordering directly from, 61 pamphlets, 61 Eclair cameras, 39 ACL, 46 CM3, 46 NPR, 22-23, 46 viewing system of, 5 Eclair lens mounts, 22-23 Editing A-B rolls, assembly of, 158-60, 164 A-B rolls, cutting into, 154, 158 answer (first trial) prints, 164-66 assembly, 150, 158-60, 164 basic lab effects, 153-54 breaking down the original, 158 contact printing and generations, 166 dailies (rushes), 146, 148 damage to prints, 169 dissolves, 153, 160 dupes, 166 equipment for, 142, 145-46 fade-ins, 153, 164 fade-outs, 153, 164 fine cut, 150 lengths of effects, 164 logging, 148 masters, 166 mixing, 150-51, 153 release prints, sound on, 166, 169 rough cut, 150

spacing between effects, 164 superimpositions, 153-54, 160 EI values, 55-56 Electrical control/supply/distribution location, 119-20, 182, 183 studio, 110 Electromagnetic spectrum, 62 Elemack dollies, 27 Ellipsoidal reflector spotlights, 93 Expenses, production, 185-86, 190 Exposure characteristic curve, 51-54 Exposure picture quality control, 128 Exposure values. See F-stops Exterior location shooting, 122-23, 131 Eye lights, 83 Fade-ins, 153, 164 Fade-outs, 153, 164 Fader devices, 75 FAY lights, 95-96 Fill lights, 82 Film apparent definition and size of, 58 ASA values for, 55-56 basic description of, 50 black-and-white, 58-60, 65-66 choosing, 58-60 color, 58-60, 66-68 EI values for, 55-56 exposure characteristic curve for, 51-54 exposure values (F-stops) for, 10, 54-56 forced processing (pushing) of, 56 graininess of, 57-58 ordering, 61 post-flashing of, 57 resolving power of, 58 sensitometry and, 51 sharpness of, 58 storage and handling of, 60-61 See also individual brands Film gate, 1-2 Filters all-purpose, 73-75 for black-and-white film, 65-66 for color film, 66-68 diffusion, 73-74 factors for, 64-65, 75 fader devices and, 75 fog-effect, 74, 129 gels, 69, 77-78, 108, 110, 122, 129 heat-removing, 110 low-contrast, 74

neutral density, 73 physical characteristics and maintenance of, 77-78 polarizing, 74-75 theory of, 62, 64-65 ultraviolet, 73 underwater, 183 See also Light Fine cut, 150 First trial (answer) prints, 164-66 Fluorescent light, 68-69 Flying spot scanners, 191 Focal length, perspective and, 15-16, 18, 20 Focusing, 11-12, 14-15 follow-focus, 20 Fog-effect filters, 74, 129 Forced processing (pushing), 56 Fresnel lens lights, 90-92, 93 Front projection, 38-39 F-stops, 10 calculation of, 54-56 daylight versus tungsten exposure index, 56 Fuji film. 60 Gels, filter, 69, 77-78, 108, 110, 122, 129 General Electric, 99, 182 bulbs, 130 Chroma 50 fluorescent tubes, 69 Generations, contact printing and, 166 Gholson 2000 underwater cameras, 184 Graduated tonality lighting, 80, 81 Graininess, film, 57-58 Gray cards, 86

Hall, Conrad, 129
Hand-held camera work, 33, 36
Hard light, 130
Harrison & Harrison, 78
Scenic Fog Filters, 74
Heads, tripod, 30, 32
Heat-removing filters, 110
High-key lighting, 80, 81
HMI[™] lights, 68, 69, 89–90, 96, 99, 123
Hyperfocal distance, 12

Incandescent spotlights, 90–92, 93 Incident light meters, 84–85 Intermittent movement, 1–2

Jonathan Jib, 27

GSMO cameras, 46

Key lights, 81 Kicker lights, 82-83 Kodak film, 60-61, 87, 170, 172, 175, 191 Kodak Wratten filters, 62, 67 Lab basic effects created in, 153-54 submitting A-B rolls to, 164 submitting materials to, 141-42 Lap-dissolves, 153 Lee Filters, 78 gels, 69 Lenses basic description of, 9 circles of confusion and, 11 close-up work with, 15 depth of field and, 11-12 focal length and perspective, 15-16, 18, 20 focusing of, 11-12, 14-15, 20 F-stops for, 10, 54-56 gyro-stabilized system for, 27 macro, 15 maintenance of, 20-21 mounts for, 21-23 one-third-distance principle and, 14 optical attachments for, 15 optimal range, 14 picture quality control and, 127-28 practical use of, 20 speed of, 10-11 supports for, 23 T-stops for, 11 underwater, 184 zoom, 14-15, 22 See also Filters; individual lens models Light characteristics of, 79-80 daylight, 56, 68-69, 130-31, 181-82 electromagnetic spectrum, 62 fluorescent, 68-69 hard, 130 measurement of, 84-88 mixed sources of, 68-69 soft, 130 tungsten, 56, 68-69 See also Filters; Lighting Lighting accessories for controlling light, 105, 107-8, 110 arc lights, 89-90 backdrop lights, 83 back lights, 82 compact lights, 96-97

contrast-viewing glasses, 86 depth and, 116-17 electrical control/supply/distribution, 110, 119-20, 182, 183 ellipsoidal reflector spotlights, 93 eye lights, 83 FAY lights, 95-96 fill lights, 82 Fresnel lens lights, 90-92, 93 functions of, 81-83 graduated tonality, 80, 81 gray cards, 86 high-key, 80, 81 HMI[™] lights, 68, 69, 89–90, 96, 99 incandescent spotlights, 90-92, 93 key lights, 81 kicker lights, 82-83 location, 119-24, 126, 130-31, 181-84 logic of, 111-12, 116 low-key, 80, 81 mounting accessories, 103 open lights, 93-97, 99 PAR lights, 95-96 picture quality control and, 129 practical lamps, 83, 130 quartz lamps, 89 rigging order and lighting procedure, 110-11 scoop lights, 93-94 sealed beam lights, 95-97 securing devices, 105 set lights, 83 shapes and, 117-18 sky lights, 94 soft lights, 94-95, 130 studio, 118-19 styles in, 80-81 textures and, 117 tungsten incandescent globes, 89 types of equipment, 89-92, 93-97, 99, 103, 105, 107-8, 110 underwater cinematography, 182-84 vehicle cinematography, 181-82 See also Light Light meters incident, 84-85 measuring controllable light with, 86-87 reflected, 84-86 underwater, 183 Lights. See Lighting Location lighting basic problems of, 119-22

daylight, 130-31, 181-82 electrical control/supply/distribution, 119-20, 182, 183 exteriors, 122-23, 131 night scenes, 123-24, 126, 182 space for, 121-22 sunsets, 123 underwater cinematography, 182-84 vehicle cinematography, 181-82 Locking down, 154, 158 Logging of footage, 148 Low-contrast filters, 74 Lowel, Ross, 97 Lowel-Light Manufacturing lighting systems, 97, 99 Low-key lighting, 80, 81 LTM, 99 Macro lenses, 15 Magazine, camera, 8-9 Masters, 166 Microphones condenser, 133, 135 directional, 135-36 dynamic, 133, 135 placement of, 139-40 Sennheiser 416 and 816, 133, 135-36 Mini-cam 16 cameras, 46 Mitchell cameras, 39 Mixing, 150-51, 153 Mole-Richardson lights Mighty Mole, 96–97 Molefay, 95 Molepar, 95 Motor, camera, 5, 8 Mounts, lens, 21-23 Movement, intermittent, 1-2 Moviola machines, 146 Nagra[®] sound recorders 4.2, 133, 139 **IV-STC**, 133 T-Audio, 133 Neutral density filters, 73 Night scenes, shooting day-for-night, 124 dusk-for-night, 124, 126 night-for-night, 123-24 in vehicle cinematography, 182 O'Connor 50 tripod heads, 30

One-third-distance principle, 14

Open lights, 93-97, 99 **Optical** printers aerial image and, 178, 180 basic functions of, 170-72, 175 contrast manipulation and, 175 printer stocks for, 172, 175 using animation stands with, 172 Optimal range, 14 Panaflex[®] Elaine[®] cameras, 46 Panaglide[®] system, 36 Parallax, 5 Parliament Guillotine splicers, 145 PAR lights, 95-96 Perspective, focal length and, 15-16, 18, 20 Photosonic Actionmaster/500 cameras, 46 Picture quality control. See Quality control, picture Pixilation, 37 Polaroid pictures, 88, 190 Polarizing filters, 74–75 Post-flashing, 57 Practical lamps, 83, 130 Printers, optical. See Optical printers Prints answer (first trial), 164-66 damage to, 169 release, sound on, 166, 169 Production copyrights, 186, 190 crew members, 186-87 expenses of, 185-86, 190 invasion of privacy and, 187-88 logistics, 186 post-production procedures, 190 post-shooting procedures, 190 release, sample, 187-88 scheduling, 188 scripts, 186 shooting procedures, 188, 190 shooting tests, 188 Projectors front projection and, 38-39 speeds of, 2 Pushing (forced processing), 56 Quality control, picture color and contrast, 128-29

exposure, 128

importance of, 127

lens, 127-28 lighting, 129 **Ouartz** lamps, 89 Range, optimal, 14 Rank Cintel flying spot scanners, 191 Reciprocity failure, 37 Recorders, sound maintenance of, 137 operation of, 139 types of, 133 Reels. 142 Reflected light meters, 84-86 Release, sample, 187-88 Release prints, sound on, 166, 169 Resolving power, film, 58 Reverse action, 37-38 Revisquick Tapesplicers, 145 Rewind arms, 142 Roscolab gels, 69, 122, 129 Rough cut, 150 Rushes (dailies), 146, 148 Schneider Variogen 7 to 68mm zoon lenses, 14 Scoop lights, 93–94 Scotch 808 sound tape, 137 Scotchlite screen material, 38 Scripts, 186 Sealed beam lights, 95-97 Sekonic light meters, 84, 183 Sensitometers, 52 Sensitometry, 51 Set lights, 83 Shapes, lighting and, 117-18 Sharpness, film, 58 Shooting. See Location lighting; Production Shutter, 2, 4 Sky lights, 94 Slates (clapper boards), 133 Snow White and the Seven Dwarfs, 117 Soft light, 130 Soft lights, 94-95, 130 Sony ECM 55 microphones, 135 Sound recording care of tapes, 137, 139 crystal sync, 132 importance of, 132 maintenance of equipment, 137 microphones, 133, 135-36, 139-40 other equipment, 136-37

recorders, 133, 137, 139 release prints, sound on, 166, 169 slates (clapper boards), 133 synchronous sound, 132-33 time code, 133 Spectra light meters, 84 Speed(s) camera, 2, 37 lens, 10-11 projector, 2 shutter, 2, 4 Splicers, tape, 142, 145-46 Spotlights, incandescent, 90-92, 93 Steadicam® system, 36 Stellavox[®] Sp8 sound recorders, 133 Sternberg, Josef von, 117 Streaks'n' Tips® spray, 129 Studio electrical control/supply/distribution, 110 Studio lighting, 118-19 Sunsets, shooting, 123 Superimpositions, 153-54, 160 Supports camera, 23-24, 26-27, 30, 32 lens, 23 Sylvania, 99, 182 Synchronizers, 142 Synchronous sound, 132-33 Tapes sound, 137, 139 video, 191-92 Teledyne DBM9-1 underwater cameras, 184 Telephoto extenders, 15 Textures, lighting and, 117 3M Scotch 808 sound tape, 137 Scotchlite screen material, 38 Tiffen®, 78 Time code, 133 Titles, 154 Tripods, 23–24, 26 heads for, 30, 32 T-stops, 11 Tungsten incandescent globes, 89 Tungsten light, 68–69 tungsten versus daylight exposure index, 56 Ultraviolet filters, 73 Underwater cinematography, 182-84

Vehicle cinematography, 181–82 Video transfer, 191–92 Viewing system, 5

Zeiss Vario Sonnar zoom lenses, 14, 15

Zoom lenses basic description of, 14–15 focusing of, 15 mounting of, 22 See also individual models